Culture, Democracy and the Right to Make Art

Related titles from Bloomsbury Methuen Drama

Theatre in Education in Britain:
Origins, Development and Influence
Roger Wooster

British Musical Theatre since 1950
Robert Gordon, Olaf Jubin and Millie Taylor

Verse Drama in England, 1900-2015: Art, Modernity, and the National Stage
Irene Morra

Clowning as Social Performance in Colombia: Ridicule and Resistance
Barnaby King

British Theatre Companies: 1965–1979
John Bull

The Contemporary Political Play
Sarah Grochala

Culture, Democracy and the Right to Make Art

The British Community Arts Movement

Edited by Alison Jeffers and Gerri Moriarty

Bloomsbury Methuen Drama
An imprint of Bloomsbury Publishing Plc

B L O O M S B U R Y
LONDON · OXFORD · NEW YORK · NEW DELHI · SYDNEY

Bloomsbury Methuen Drama

An imprint of Bloomsbury Publishing Plc

Imprint previously known as Methuen Drama

50 Bedford Square	1385 Broadway
London	New York
WC1B 3DP	NY 10018
UK	USA

www.bloomsbury.com

**BLOOMSBURY, METHUEN DRAMA and the Diana logo are
trademarks of Bloomsbury Publishing Plc**

First published 2017

British Library Cataloguing-in-Publication Data
A catalogue record for this book is available from the British Library.

ISBN:	HB:	978-1-4742-5835-7
	ePDF:	978-1-4742-5837-1
	eBook:	978-1-4742-5838-8

Library of Congress Cataloging-in-Publication Data
A catalog record for this book is available from the Library of Congress.

Cover artwork by John Powell-Jones

Typeset by Integra Software Services Pvt. Ltd.
Printed and bound in Great Britain

To find out more about our authors and books visit www.bloomsbury.com.
Here you will find extracts, author interviews, details of forthcoming events and
the option to sign up for our newsletters.

*This book is dedicated to all those who have taken
part in a community arts project.*

Contents

List of Figures

Contributors

Oliver Bennett established the University of Warwick's Centre for Cultural Policies Studies in 1999, having previously established the MA in European Cultural Policy and Management in 1993. He has published widely on cultural policy, intellectual history, and cultural politics. He is the founding editor of the *International Journal of Cultural Policy* and a founder member of the Scientific Committee of the International Conference on Cultural Policy Research (ICCPR). In 2012, he was awarded a higher doctorate (DLitt) by Warwick for his contributions to cultural policy research. Professor Bennett's current research focuses on the institutional promotion of hope, conceived as a form of 'implicit' cultural policy. He has a long-standing interest in questions of pessimism/optimism and has recently completed a sequel to his book *Cultural Pessimism: Narratives of Decline in the Postmodern World* (2001). Entitled *Cultures of Optimism: The Institutional Promotion of Hope* (2015), this book explores how and why powerful institutions propagate 'cultures of optimism' in different domains, such as politics, work, the family, religion, and psychotherapy.

Nick Clements studied fine art at Cardiff and then set up The Pioneers Art Group in 1981. They were an artist-led community arts team, specializing in the use of creativity (multi-art forms) in areas of high social need. He has worked in over 300 schools, institutions, and charities enabling literally tens of thousands of people to express themselves using creativity. He is presently working for Valley and Vale employed by the NHS to train managers and staff in the inclusion of creativity in care plans for the elderly and those with mental health issues. His outstanding contribution to the field was recently recognized when he was made an Honorary Professor at Staffordshire University.

Andrew Crummy was born in Craigmillar, Edinburgh, in 1959. His mother Helen Crummy was the organizing secretary of The Craigmillar Festival Society from 1962 to 1985. He studied as an illustrator at Duncan of Jordanstone College of Art, and then completed an MA Design course at Glasgow School of Art. His professional life started as an illustrator in London following which he went on to complete many murals and community projects. He has designed for

The Great Tapestry of Scotland and other similar large-scale community embroidery projects involving over 2,000 stitchers.

Janet Hetherington is a senior lecturer in civic engagement and regeneration at Staffordshire University working in the Creative Communities Unit. With a background in theatre education, Janet established the Arts Programme at Birmingham Children's Hospital Foundation Trust, and was a project manager and researcher for a range of organizations including Save the Children UK, Playtrain and Children's Express. She was a joint founder of the MA in Community and Participatory Arts at Staffordshire University with Mark Webster and has taught many short courses and undergraduate modules in participatory arts and is currently completing her PhD exploring cultural commissioning practices associated with participatory arts work within the NHS. Janet is a Director of Creative Health CIC, the West Midlands regional development agency for arts, health, and well-being. Since 2013, she has worked on European projects including RESIDENCY, a project in Partnership with Warsaw University and Barcelona University funded through the European Union focusing on developing a model of arts residency applied to civic engagement across the three countries; Amores, developing approaches in using e-artefacts in literacy teaching; and @Mindset, developing resources to support teachers to manage social diversity in schools. Janet also delivers freelance consultancy and provides evaluation to support cultural organizations to develop family and community engagement in their work.

Sophie Hope, BA (Hons), MA, PhD, is a lecturer in the Film, Media and Cultural Studies Department at Birkbeck, University of London. Sophie's practice-based research investigates the relationships between art and society. Current projects include hosting dinners in different parts of the world about art and politics in the year 1984 (1984dinners.net); exploring physical and emotional aspects of immaterial, service labour (manuallabours.co.uk); and creating Social Art Maps that trace conflicting narratives and experiences of recent socially engaged art commissions in the UK (socialartmap.org.uk). Sophie has also written and co-devised programmes to explore the ethics and politics of work in the cultural and creative industries and notions of employability within higher education (criticalworkplacements.org.uk).

Alison Jeffers, PhD, is a lecturer in applied theatre and contemporary performance at the University of Manchester. Her research has considered theatre and performance practices with refugees and asylum seekers in the UK,

and her monograph *Refugees Theatre and Crisis: Performing Global Identities* came out of this research. She has written about community theatre practices and the use of the arts in consultation in Northern Ireland and recently completed a project reflecting on practices of hospitality with refugee groups in Bristol, UK. She taught in the Arden School of Theatre in Manchester for many years and prior to that worked as a community artist when she set up Cartwheel Community Arts in Rochdale, UK (with Gerri Moriarty and Dave Chadwick) and worked as a freelance artist throughout the North West of England.

Owen Kelly was born in Birkenhead, England. From 1975 to 1991, he worked as a community artist in Brixton, South London. Since 1998, he has lived in Helsinki, Finland. In 2015 he gained a doctorate from Aalto University for research in the field of art education. He has spent his life as a community artist, cultural consultant, computer trainer, digital artist, web designer, and writer. He is the author of several books and reports, including *Community, Art & The State* (1984), *The Creative Bits* (1994), *Digital Creativity* (1995), and *Ambient Learning and Self Authorship* (2015). He is currently principal lecturer in online media at Arcada, a university of applied science in Helsinki. His research explores the under-discussed pedagogical implications of dividuality, virtuality, and immersive simulation. He is also engaged in practical experiments in learning through teaching. He is an active member of the board of the Pixelache network, an international and transdisciplinary platform for emerging art, design, research, and activism. Since 2010 he has published a daily photograph online in the ongoing series 'One Day at a Time'. His personal website can be found at owenkelly.net.

Gerri Moriarty began working in community arts in 1974 for the Beaford Centre in North Devon and then helped to set up High Peak Community Arts and Cartwheel Community Arts in the North West of England. For twenty years, she worked in Belfast, making theatre with those working-class communities that experienced the worst impact of the conflict in Northern Ireland. She has taught in Further and Higher Education in the UK and worked internationally in Africa, Asia, and Europe. She now works as an independent cultural consultant, critical friend, and mentor, collaborating across professional disciplines and sectors and with large- and small-scale organizations and individual artists. She is a facilitator, an evaluator, and a story-teller.

Mark Webster is a freelance development worker, researcher, and trainer working in the arts and in community development. Until 2016, he was head of The School

of Art and Design at Staffordshire University. Along with being a member of the Creative People and Places consortium in Stoke delivering *Appetite*, he was also a member of the Get Talking Team at Staffordshire University responsible for evaluating the project through Participatory Action Research. He started his career as a community artist and has worked in the voluntary sector, as a local authority community arts officer and as an NHS funded Arts and Health manager. Between 2013 and 2015, he was project manager of RESIDENCY, a project in Partnership with Warsaw University and Barcelona University funded through the European Union focusing on developing a model of arts residency applied to civic engagement across the three countries. Mark was a joint founder with Janet Hetherington of the MA in Community and Participatory Arts at Staffordshire University and has taught many short courses and undergraduate modules in participatory arts as well as contributing articles to a range of publications. He is the editor and co-author of *Finding Voices, Making Choices: Creativity for Social Change*.

Jennifer Williams is an artist who founded the Centre for Creative Communities (1978–2008). Among the Centre's projects was Creative Community Building through Cross-sector Collaboration, which traced links between arts and education collaborations, community development, and social inclusion. The findings of this were published as *Creative Community Building Through Cross-sector Collaboration: A European Mapping and Consultation* by Jennifer with Cristina Losito and Joanna Cottingham in 2004. Currently, she is a member of the International Futures Forum and works as an artist making books, illustrations, and photographs.

Acknowledgements

We would like to thank Stephen Bottoms, Lizzie Devlin, Kate Dorney, Maggie Gale, Lindsey Garrett, Jenny Hughes, Aoileann Ní Mhurchú, and James Thompson for reading drafts of this work. Their support and collegiality has been so valuable during this research. Thank you to Mark Dudgeon and all the staff at Bloomsbury Methuen Drama. Thank you also to our anonymous reader whose comments have helped to shape this book.

We acknowledge the time and commitment of the artists who we interviewed and are deeply grateful to them for sharing their thoughts about how community arts has developed and changed over the years. Their names are listed in Chapter 1. We'd also like to thank all the artists and the groups that took part in Unwrapping Hidden History, an event held in July 2015 in the Martin Harris Centre at the University of Manchester as part of the research for this book. Thank you to the Paul Hamlyn Foundation for supporting this event.

Thank you to John Powell-Jones for providing the image for the front cover and to Annie Woodson of TripleDotMakers for making the film about the Unwrapping Hidden History event which can be seen at https://vimeo .com/146771673.

1

Introduction

Alison Jeffers

Consciousness really does change, and new experience finds new interpretations: this is the permanent creative process.

Williams 1961: 381

The Community Arts Movement in Britain between the late 1960s and the early 1980s was concerned with giving people access to the production of all forms of creative expression. Community artists believed that this would open up creative possibilities for wider involvement in the arts and culture, thus possibly enhancing engagement for communities on a whole range of levels. Community arts 'offered new possibilities of more democratic forms of art and new ways for art to act as a catalyst for social change' (Crehan 2011: 11). Some community artists reacted to the perceived injustice of the situation where many people had little opportunity to practise the arts due to a lack of resources and opportunity imposed on them by unequal distributions of social and cultural capital. Some artists had a political project in mind. They saw community organizing around these events as part of a conscientizing project that would reawaken political awareness and lead to stronger challenges to the authorities, if not the overthrow of authority altogether. All those involved believed that the way in which the arts were created, taught, curated, produced, and supported was fundamentally inequitable and needed to be changed.

This book traces the development of community arts, primarily in the UK, from the late 1960s. It maps a journey from the countercultural movements epitomized by events in 1968 and tries to understand some of the influences of community arts of that time on contemporary arts practices and policies. It is not a comprehensive route map because that kind of detailed study would be impossible within the confines of one book. Instead, it is divided into two parts: the first one focusing on community arts in the 1970s and early 1980s,

and the second part reflecting on some of the marks left by the early community artists and how these have been adopted and adapted to artwork that focuses on the relationship between people and art. Our strategy has been to pay attention to the idea of community arts in the 1970s and early 1980s as a movement, a discrete body of practice that can be placed and dated, a body of work based on ideas about art, about politics, and about the relationship of people to the making of art that can be shared, discussed, and debated by the artists involved. We could be accused of trying to pigeonhole what was a very diverse movement, of trying to smooth the edges to try to fit it into a 'movement-shaped' box, but this is a risk we are prepared to take for three reasons. First, creating boundaries around a body of work of a certain period and location allows us to define and discuss it with a greater degree of clarity, drawing attention to work that has been ignored or sidelined for a considerable time. Second, the clarity which comes from envisaging community arts of the 1970s as a movement allows us to see how it has influenced contemporary practice. Finally, we are simply taking our cue from many of the community artists of the time who saw themselves as an artistic and a political movement.

It would be impossible to name all the hundreds of community arts organizations and projects that emerged in the 1970s and 1980s in towns, villages, and cities throughout the UK. By 1982, 135 community arts organizations were named as receiving support across England and Scotland (*Another Standard* May/June 1982).[1] While many groups set up in the major conurbations and industrial areas of Wales, Scotland, England, and Northern Ireland, community arts was not an exclusively urban phenomenon and just as many groups were started in rural areas, small towns, and villages. Initially companies were very loosely constituted, often as workers' co-operatives – a small group of friends and associates who settled in an area and who wanted to find a creative way to connect to the communities they encountered there. To some extent, each region developed certain characteristic practices depending on the communities and the artists who lived and worked there, and what resources and structures of support were available. As community artist Steve Trow wrote of his company Jubilee's approaches in 1980, 'if a company elects to work through a borough the size of Sandwell, with a population of 300,000; 57,000 council tenancies, and a large proportion of ethnic minority owner-occupiers, it may be that some of the choices have already been made for you' (Trow 1980: 25). Sally Morgan elegantly sums up the movement of this time as 'Edgy, argumentative and intensely political, the British Community Arts Movement saw art as a form of revolutionary cultural action employing co-authorship and individual and

collective "empowerment" through active participation in creative processes' (Morgan 2003: 140). R.G. Gregory describes it succinctly as 'a love child of alternative arts and community action' (1980: 20). The work was often grounded in grass-roots community and political campaigns – for better resources for a specific area, for example – or to highlight poor conditions in housing, lack of play facilities, or other aspects of the public realm: arguing for what Amin and Swift call 'redistribution of resources and engagement as a means of building critical ability, voice and argument' (qtd. Pearson 2013: 73). Despite the variety of approaches, arts forms, locations, groups, and communities involved, community arts practices were underpinned by a belief that communities could benefit by getting involved with the arts and creativity, thus creating stronger ties within and between groups and a stronger sense of community identity and investment in the people and places within that community.

R.G. Gregory summed up community arts in 1980 at a conference called 'Principles and Practices' in Barnstaple, Devon, one of many national gatherings of community artists. This is worth quoting at length because it captures much of what community artists were beginning to articulate about their practice as the movement developed and expanded:

Figure 1.1 Going against the grain

Arts that belong (at all formative levels) to the artists cannot be community arts. Arts that can be let loose only within established citadels of the arts cannot be community arts. Community arts are those arts that are created wholly or in part by a community of people (however lightly defined); at the least they must arrive in the hands of the people in an unfinished form so that the gathering of the people has a clear part in the completion of their product. Such products cannot be pre-packaged; the process must still be on-going, and the products must bear the clear imprint of the community for which they were intended [...] It follows though, for the present, that the community artist is an *enabler* or *animator,* and cannot be taking part in the process in order to make a complete personal statement, or to exhibit a private ego in a public way, or to enforce a political, moral or aesthetic view upon a passive audience [...] It cannot be the purpose of such arts or skills to astonish a body of watchers into a delighted reception of already-perfected achievements; but to be able to reduce, withhold or allay themselves sufficiently so that the incipient skills of that community can begin to find expression. (Gregory 1980: 20)

Despite its scale and influence in the 1970s and early 1980s, the community arts movement has gone largely undocumented and is certainly under-discussed. It has been too easy to dismiss as politically and socially inconsequential on the one hand and of limited artistic merit on the other: popularly stereotyped as work that involves, as the *Fontana Dictionary of Modern Thought* suggested in 1977, 'movement, games, live and recorded music, and the use of inflatables' (Bullock et al. 1977: 148) or 'festivals, face painting and murals' (Hawkins 1993: 25). Community arts has often been wrongly characterized as being focused on children and young people but their involvement, valuable in and of itself, was usually seen as a gateway to other, less accessible, adults in that community. It has received a little more attention, and greater understanding, in recent years. In 2012, Claire Bishop named the community arts movement as one of two post-1968 attempts to 'rethink the artist's role in society' (Bishop 2012: 163), the other one being the Artist Placement Group (APG) founded by John Latham and Barbara Steveni in 1966. The community arts movement was operating 'at a grass roots level of community activism' (Bishop 2012: 177) which seemed to place it at a remove from performance art, but there are many fascinating links between community arts and performance art that we will explore next. Bishop characterizes the community arts movement as

positioned against the hierarchies of the international arts world and its criteria for success founded upon quality, skill, virtuosity etc. since these conceal class interests; it advocated participation and co-authorship of works of art; it aimed

to give shape to the creativity of all sectors of society; but especially to people living in areas of social, cultural and financial deprivation; for some it was also a powerful medium for social and political change, providing the blueprint for participatory democracy. (Bishop 2012: 177)

The examples that Bishop pursues are the Black-E in Liverpool,[2] set up by Bill and Wendy Harpe in 1968, and Inter-Action founded by Ed Berman in London in the same year. Berman actually distanced himself from community arts in 1983 claiming that Inter-Action had 'moved in different directions' and that he had been only tangentially involved in community arts since the early 1970s (Brooks 1983: 8). However, Bishop is right to suggest that academic literature on both of these movements is scanty though, she suggests, the APG has received some attention since Latham's death in 2006. While we agree with Bishop's broad definition of the community arts movement, and accept her ideas about its influence in rethinking the role of the artist, we are in the fortunate position of being able to enlarge upon these and to offer a longer, more extensive and detailed view of the community arts movement. Through interviews with community artists who were involved in this work in the 1970s and early 1980s, and access to unpublished or inaccessible literature, we are able to offer a detailed picture of the work that took place and insight into the impulses, influences, and approaches of the artists involved.

'Cheerful and militant learning' – the educational and political influences on emerging community artists

We begin this account with a discussion of the artists who were involved in the beginning of the Community Arts Movement because they are primarily responsible for initiating and developing community arts in Britain. This opinion is supported not only by personal experience (which we discuss later) but also from the findings of various official Arts Council enquiries of the time. In 1974, Professor Harold Baldry noted that community arts projects were not reliant on 'organisational form, nor bricks and mortar, but the commitment and dedication of the individuals involved' (Arts Council of Great Britain 1974: 7). So, who were these early community artists and why did they feel the need to create art in a different way to their predecessors? Community artists were mostly formally trained in the arts and, as they emerged from theatre schools, art colleges, and universities, young artists encountered a huge range of new ideas and propositions for the arts, both at home and abroad.

In theatre and performing arts, they had been introduced to ideas about acting as a 'social and educational force' (Hodgson 1972) based on ideas that theatre and performance had many functions in education, play, therapy, and social settings that went far beyond their more limited uses in a theatrical context. They had encountered radical new ways of making their own work that did not depend on a playwright's script. They were influenced by initiatives such as Charles Parker's documentary radio ballads for the BBC which used the recorded voices of the subjects whose stories were being told; indeed, Parker worked on some community arts projects in Telford in the 1970s (Mackerras 2015). Community artist Cilla Baynes explained, 'My skills were largely drama, theatre-based – I wanted to create theatre with people. I didn't know about community arts because I didn't have that label but [collaborative theatre-making] was an option at college, so I had had a chance to explore a lot of it there' (Baynes 2010). They had been influenced by ideas about improvisation, techniques based on games and spontaneous creativity through the work of Clive Barker and Keith Johnson (Turner 2012). Community artist Stephen Lacey describes working with Barker as a drama student at Birmingham University on a documentary about the Spanish Civil War called *Sad Presentiments of Things to Come* (Lacey 2012). Graham Woodruff at Birmingham was a very influential figure and it is notable that Gerri Moriarty, Steve Trow, Stephen Lacey, Chrissie Poulter, and Cathy Mackerras all studied under Woodruff and all went on to set up community arts companies. Mackerras remembers Woodruff urging his students to look at the work of Albert Hunt and Ed Berman and telling them, 'Never mind what's going on at Stratford – the most interesting theatre in the country is happening up in Stoke' (Mackerras 2015). In this way, they were introduced to Peter Cheeseman's musical documentary work at the Victoria Theatre ('The Vic') in Newcastle-under-Lyne/Stoke on Trent with plays like *The Knotty* (1966) which aimed to bring working-class voices and experience to the stage. Community artist Graham Marsden developed his career as a designer on Cheeseman's musical documentaries based on the stories of local people – *Hands Up! For You the War Is Ended* (1971) and *The Fight for Shelton Bar* (1974), part of a campaign to save the local steelworks (Marsden 2010).

Joan Littlewood was a contemporary of many of the early community artists and her ideas about Fun Palaces had a lot in common with the work of many of the early community arts companies (Littlewood 1994; Holdsworth 2011). Community artist Maggie Pinhorn recalls Littlewood coming to see a film that she had made with a group of boys in 1973: 'When I was a student at Central

I'd been to see *Oh What a Lovely War* and she was developing work down in Stratford. I wasn't consciously copying her or anything but it influenced what I was doing' (Pinhorn 2014). Mary Turner of Action Space Mobile recalls working with Littlewood on 'a prototype Bubble City in the shopping Precinct [in Stratford East] with participatory structures by artists and architects' (2012: 13) and again in the following year at a festival organized by Littlewood against the war in Vietnam (2012: 27). Crehan recounts stories about community arts company Free Form Arts Trust's (Free Form) work with Littlewood who paid them to run an event called Stratford Fair which was 'intended to bring her theatre out of its box and into the local community and to get the local community into the theatre' (2011: 58). The partnership was ultimately unsuccessful because Littlewood was not prepared to reshape her vision of working-class engagement in the arts in order to open up the creation of new work beyond the professional sphere (Crehan 2011: 59). The young community artists with whom she worked had a more radical vision of engagement which was beginning to shape their ideas about participation, access, and creativity.

In the visual arts, many young artists turned their backs on what they saw as the conservative traditions of art creation, delivery, and appreciation in an aim to move beyond 'those neutralized white cubes called galleries' (Morgan 1995: 137). In the words of Mary Turner who set up Action Space Mobile in the late 1960s, 'the arts had become a commodity and a commodity that was controlled by dealers and investors' (Turner 2012: 4). In 1966, art teacher Albert Hunt's unwelcome realization that he was part of 'an education industry' led to a highly experimental phase of work in the Regional College of Art in Bradford (Hunt 1976: 18). He wanted to find a way to create a curriculum based on the needs and wishes of the students rather than one driven by teachers and administrators – to foster 'cheerful and militant learning' (Hunt 1976: 65). In 1967, Hunt famously coordinated a restaging of the Russian Revolution of 1917 on the streets of Bradford 'not in order to re-enact the October Revolution so much as to set up a city-wide participatory game' (Heddon and Milling 2006: 75), one of a number of what he called 'experimental learning situations'. Young artists were also encouraged by the experimental practices of Jim Haynes and his Arts Lab set up in Drury Lane, London, in 1967; and Owen Kelly points to Haynes as an influential figure in Chapter 11. Although short lived, the influence of the arts labs was far-reaching, creating an open space for experimentation described by Haynes as 'an experiment with such intangibles as people, ideas, feelings and communications' (Haynes 1969). In enjoying the benefits of radical education in the arts and turning to the 'underground' movement and the experimentation of

arts labs and other experimental learning situations young artists explored new possibilities that they were opening up for their generation.

It is also worth noting that some of these young artists were from the same working-class backgrounds as the communities within which many of them developed community arts. Having benefitted from the introduction of free compulsory secondary education following Butler's Education Act of 1944, many young people, who could not have previously considered it an option, were enabled to enter higher education. And they had a growing range of universities from which to choose after the Robbins report of 1963 initiated a major growth in university education in Britain with the introduction of nine so-called plate glass universities (Beloff 1968). This was followed by the building of twelve further universities in the major cities of England, Wales, Scotland, and Northern Ireland. This growth in universities, plus government support in terms of grants and the payment of fees, made it possible for a whole generation of young people to experience higher education even if they were not from affluent backgrounds (Crehan 2011). Furthermore, they could pursue interests in art, drama, music, and dance rather than feeling bound to professions where financial gain was more likely on graduation.

In other ideas about education at the time Ivan Illich asked how society could be 'de-schooled' (Illich 1981). As part of his mistrust of institutions generally, Illich's argument was that pupils are schooled to 'confuse teaching with learning, grade advancement with education, a diploma with competence, and fluency with the ability to say something new' (Illich 1981: 9). In the same period, Paulo Freire discussed 'education as cultural action for freedom' (Freire 1972: 13) and both envisioned the role of systems of education and other public institutions as promoting gross inequalities and maintaining the political status quo. Freire's *Pedagogy of the Oppressed* was later to play a major role in the work and thinking of Augusto Boal but, for the community arts workers at the time, combining Freire's radical thinking on education with innovative ideas on the making of art proved a potent combination on which to base an emerging set of practices. In his description of 'radical monopolies', Illich describes how, in 'watershed' moments of industrial institutions, new knowledge is initially applied to social problems. However, in the second watershed moment, the progress that emerges from this is used 'as a rationale for the exploitation of society as a whole in the service of a value which is determined and constantly revised by an element of society, by one of its self-certifying professional elites' (Illich 2009 [1973]: 7). These radical views about the role of the arts, and culture more generally, in maintaining or challenging inequalities fed directly into the thinking and

work of many early community artists, and Illich's ideas on 'radical monopolies' were to prove influential for many emerging community artists as Owen Kelly explains in Chapter 11.

Ideas about art, culture, and education emerging from France in the 1960s were also influential. Andre Malraux, the minister for Cultural Affairs, had set up the *Maison de la Culture* network in 1961, an attempt to open up possibilities for people to experience the arts, cinema, and music closer to where they lived, decentralizing cultural opportunities for people in the large French cities. Also in France, in the late 1960s, theatre director Roger Planchon started the *Théâtre National Populaire* in the Lyons suburb of Villeurbanne. Calling it a 'people's theatre', he aimed to bring cultural opportunities to the working-class communities of Lyons (Bradby 2009). The work of Jean Hurstel and *animation socio-culturel* was influential. *Animateurs* were skilled in working creatively within communities, often making artworks based on the lives of people whom they came in contact with. Community artist Cathy Mackerras describes Hurstel's work:

> they didn't want to just take existing culture and give it to the people, they wanted the people to create their own culture and their own art. But the other interesting thing about them, what they were doing there was they got very good artists to work with them. They didn't just have social work [or] community work people working with them, they had good artists. (Mackerras 2015)

Graham Woodruff and Cathy Mackerras set up Telford Community Arts (TCA), an influential company in one of Britain's 'new towns', after Mackerras had graduated from the University of Birmingham and spent time working in France with Hurstel. TCA was used as a case study on a number of occasions, notably by Su Braden in her influential survey of community arts and by Ros Rigby in her later survey for the Shelton Trust which is discussed next (Rigby 1982). Woodruff was one of the few community artists to place discussions of community arts work in mainstream theatre journals writing about community plays (Woodruff 1989), work at the Victoria Theatre in Stoke-on-Trent mentioned earlier (Woodruff 1995), and a summary of the work of Telford Community Arts between 1974 and 1990 (Woodruff 2004).

Political influences are easy to discuss in one way because community artists were, on the whole, firmly of the left but difficult in the sense that the left was fractured and covered a very broad spectrum of political positions and opinions. It is also challenging because, compared to discussions of cultural and artistic influences, there is less information on specific political platforms or theories

either from the writing of the time or from the interviews with community artists. Some, like Brian Blumer argued for strong connections between community arts and the labour movement (Blumer 1980) and this will be discussed in more detail later. Some community artists found inspiration in the work of Herbert Marcuse and his revisioning of Marxist aesthetics in his final work *The Aesthetic Dimension* published in Britain in 1976. Community artist Cathy Mackerras described reading Marcuse as a student and interpreting what he had to say as being about the liberating potential of art when traditional leftist structures had failed (Mackerras 2015). The name of Gramsci is sometimes directly invoked in the literature of community arts and his reinterpretation of Marx was influential, largely through the work of Raymond Williams, and especially his interpretation of hegemony which he saw as more than a passive form of dominance. Williams's belief was that '[Hegemony] has continually to be renewed, recreated, defended, and modified. It is also continually resisted, limited, altered, challenged by pressures not at all its own' (Williams 1977: 112); and that hegemonic structures of domination are not obvious in the sense that they are exerted onto the oppressed by a dominant class and are constructed through invocations to 'common sense' and 'normal reality', (Williams 1976: 145). The span of political opinion among community artists was large, encompassing everything from a romantic attachment to a pre-industrial idyll, and a belief in the capacity of the independent craftsman, to a libertarian streak, to attachments to organized labour movements to Marxist and neo-Marxist approaches – some of which are discussed in more detail in Chapter 2.

Support for community arts

The writers of the chapters about community arts in Scotland and Wales in this book suggest that the roots of community arts in those locations lie in older forms of folk art, oral cultures, and community organization. Within the limitations of the space available, it is not possible to produce an exhaustive examination of all the roots of community arts, but it is important to indicate that impulses around defining the relationship between people and the arts predate the community arts movement of the 1960s by a long way. The early work of Welfare State International, for example, was partly influenced by a pre-industrial calendar with 'traditional church and farming calendars which themselves overlaid pagan and Celtic festivals' creating the framework for their early work (Fox 2002: 50). In his account of the development of community music, Lee Higgins suggests

that '[community arts] bears traces of nostalgia for a human-scale past and Romanticist images of society prevalent before the onslaught of the Industrial Revolution' (Higgins 2012: 37). However, for reasons of space and, in order to focus on specific questions of culture and democracy, it is more helpful to start this story with the beginnings of the development of formal ties between the arts and the state.

Since the early to mid-1800s, government apparatus has developed in the UK to take responsibility for its citizens' welfare (Minihan 1977). This includes state subsidy for the arts and Minihan takes this story back to the 1830s when the number of visitors to the newly opened National Gallery doubled and a free exhibition in Liverpool in 1839 attracted huge crowds. A report on the exhibition noted that, in opening the gallery to the 'labouring classes', '[the] institution cannot but feel that it occupies the place of a public benefactor and instructor, awakening in uncultivated minds feelings and ideas calculated to soften the rudeness of manners, and to increase the happiness and virtue of life' (Minihan 1977: 52). This approach of 'taking art to the masses', or the democratization of culture, was a common approach at the time and ideas about the democratization of culture lie behind much of John Ruskin's writing in the mid- to late 1800s. It was from him that 'the public learned to consider art as an index of society's moral health' (Minihan 1977: 134). In his writing on medieval craftsman in his famous essay series 'The Stones of Venice' in the 1850s, he argued that they possessed a level of creativity denied to their Renaissance counterparts with their reliance on mechanization (Leng 2003: 192). Ruskin directly influenced William Morris, and his emphasis on craftsmanship in the decorative arts famously led him to suggest that 'nothing should be made by man's labour which is not worth making, or which must be made by labour degrading to the makers'. He had a different vision to Ruskin when it came to the role of the artist, foreseeing 'a world in which everyone was an artist' (Julian 2003: 224). This interplay between ideas about making the arts and culture more accessible to the 'labouring classes' and encouraging workers to create their own work continued into the twentieth century. According to community artist Brian Blumer, the co-operative and labour movements provided the 'largest source of public subsidy for the arts – until the creation of the Arts Council' (1980: 19), and an alternative history to the elite art forms represented by thinkers such as Ruskin and Morris stresses the role of the labour movement in the development of community arts and points to links between community arts in the 1970s, the Working Men's Institutes of the 1920s, and the workers' photography movement of the 1930s (Blumer 1980: 19). These amateur movements, along with adult education more

generally, provided another precursor for the Community Arts Movement in the 1960s and were more concerned with people having opportunities to create their own work rather than fostering an appreciation of existing art and other cultural outputs.

Later in the century, the appointment of Jennie Lee by Harold Wilson's Labour government as the first ministerial spokesman for the arts in 1964 can be taken as an indication of the growing importance of the arts and culture in the national discourse. Lee, who was also instrumental in setting up the Open University, published the first government white paper for the arts, *A Policy for the Arts: The First Steps* in 1965 (HMSO 1965). Concerned with the predicted increase in leisure time at the dawn of the new industrial age, the need for a more 'coherent, generous and imaginative approach' to arts funding was announced (HMSO 1965). The emphasis here around access to the arts lies in the direction of making existing arts more accessible to as many people as possible: 'New ideas, new values, the involvement of large sections of the community hitherto given little or no opportunity to appreciate the best in the arts, all have their place' (HMSO 1965). At the same time, in 1965, the Arts Council was moved from the Treasury to Lee's Department of Education and Science (Black 2003: 324) and they found themselves faced with 'an increasing number of applications that were non-literary, improvisational, cross-disciplinary, and multimedia-based' (Saunders 2012: 33). As a result, the New Activities Committee (1968–1970) was set up by the Arts Council to consider the applications that fell outside the usual remit of ballet, opera, theatre, and painting that 'the arts' had previously been thought to encompass. As a result of their deliberations, the Experimental Projects Committee was set up which met between 1970 and 1973 and the projects considered by this committee fell into two broad areas: community arts and performance art (Arts Council of Great Britain 1974: 37).

The overlap between community arts and performance art at this time is an interesting one which is not often discussed. In working out how best to use their formal training in the arts as they started their careers in the late 1960s, artists were experimenting in both the arts *and* social sphere. Both community arts and performance art were highly experimental in their approaches although performance art maintained its respectability *as art*, albeit radical and *avant garde*, while community arts remained more firmly rooted in the social. One example of the early interrelation of community arts and performance art can be seen in the work of community artist Julian Dunn who was involved with the setting up of GASP (Games of Art for Spectator Participation), while an art student in Wolverhampton in 1973.[3] He is remembered as being one of the

'Cyclamen Cyclists' with Roland Miller and Shirley Cameron in Bradford[4] as well as being involved with creating a piece with Joseph Beuys, Stuart Brisley, and Adrian Henri at the Tate, and creating a piece of performance art that involved redecorating the Institute of Contemporary Arts (ICA) at around that time. He describes how 'performance art moved away from the "traditional palette" of artistic mediums and the artist', and how it 'made an honest attempt to connect with more people and move away from the traditional gallery perspective' (Dunn 2010). Nevertheless, Dunn began to find that performance art became 'a little too esoteric and I thought to myself what I'm really doing here is entertaining the middle classes. And there's a lot more people out there who really ought to benefit from engaging in creativity and the opportunity to express themselves' (Dunn 2010). The growing gap that this suggests, between the apparent elitism of performance art and the urge on the part of community artists to move even further away from the gallery system, is reflected in Brian Blumer's account of the development of community arts where 'Community arts, coming as it did out of a changed role for artists, and with antecedents like arts labs, was initially more concerned with creativity and expression for its own sake. "Community" in the artists' sense developed from the idea of reaching and working with a wider audience, not specifically working class' (Blumer 1980: 18). When, through their work at festivals, print shops, video and street theatre events, community artists encountered activists and radicals for whom the word 'community' signalled a more political agenda, their work moved away from vague notions of 'access' to a way of working more firmly rooted in a social change agenda.

This difference in thinking about the role of the artist – as a generator of creativity providing a conduit for expression among those prepared to get involved, or as actively seeking out groups who would not necessarily be attracted to artistic experimentation – was reflected in the findings of the Experimental Projects Committee. In February 1974, it split into Community Arts and Performance Art with performance art being taken under the wing of the Art Panel of the Arts Council. Community Arts still had to prove itself and a Community Arts Working Party was set up under the chairmanship of Professor Harold Baldry to 'consider the relationship between experimental work and community arts projects' and to 'examine in particular the extent to which the Arts Council should be directly involved in the subsidising of community arts work' (Arts Council of Great Britain 1974: 5). The working party interviewed community artists from companies such as Welfare State International, Interplay, Bath Arts Workshop and the committee members undertook visits to projects in Leeds, Bradford, Bracknell, and Hackney (Arts Council of Great Britain 1974). Baldry's report was

far-reaching and shows a sense of insight that goes beyond the expectations of a formal bureaucratic exercise. Baldry and his colleagues recognized that

> the primary concern [of community artists] is their impact on a community
> and their relationship with it: by assisting those with whom they make contact
> to become more aware of their situation and of their own creative powers, and
> by providing them with the facilities they need to make use of their abilities,
> they hope to widen and deepen the sensibilities of the community in which they
> work and so to enrich its existence. (Arts Council of Great Britain 1974: 3)

They concluded that the Arts Council should formally recognize community arts by creating a new category of Community Arts with a separate funding stream (Arts Council of Great Britain 1974: 7). However, the Arts Council were not prepared to foot the bill for community arts on their own and pointed to the responsibility of the local authorities within whose boundaries the work took place, and to the Regional Arts Associations that, they felt, were closer to the localities within which community arts projects were organized.

This was emphasized in 1977 with a follow-up report in which Baldry's suggested two-year programme of community arts funding was evaluated. The writers of this report were similarly impressed by the work taking place noting

Figure 1.2 Troublemakers in training

that 'much of great value has been achieved' during the two-year experiment at a low cost to the Arts Council – under 1 per cent of its total budget (Arts Council of Great Britain 1977: 18). However, it had proved very difficult for the Arts Council to disentangle the art activities themselves from the role played by the arts in accruing any social or educational benefit. Paradoxically, on one hand the location of community arts projects in all parts of the UK and in places very far, both geographically and socially, from the centres of excellence in London and the major cities allowed the Arts Council to fulfil its national remit. On the other hand, the local or grass-roots nature of much of this work precluded the Arts Council from fully supporting it. In 1977, an internal working party met to consider the relationship between the Arts Council and the Regional Arts Associations (RAAs) culminating in a report called 'Towards Decentralisation'; followed in 1980 by further research activity and a report called 'Towards a New Relationship' (Brown 2010: 37). The RAAs saw themselves as a better 'home' for community arts, regarding the Arts Council as elitist, high-handed, and over-metropolitan (Brown 2010: 39). They felt, in contrast, that they were closer to the grass roots of cultural provision in their regions and able to work more closely with local politicians; and gradually, during the 1980s, community arts companies were 'devolved' to the RAAs, loosening the sense of community arts as a national movement, as will be discussed in more detail in the following chapter.

Other forms of support

Charitable bodies, trusts, and foundations were very influential in the development of community arts in the UK. The 1977 Community Arts Evaluation Group list supporters of community arts as The Calouste Gulbenkian Foundation, Sainsbury Monument Trust, Pilgrim Trust, the Joseph Rowntree Social Service Trust, Chase Charity, Granada Foundation, and Peter Moore's Trust (Arts Council of Great Britain 1977). The most influential was the Calouste Gulbenkian Foundation in terms of financial support and also in shaping the development of community arts through reports and publications, and direct initiatives like the apprenticeship scheme for new community artists in the early 1980s which is discussed in more detail by Janet Hetherington and Mark Webster in Chapter 9. The Gulbenkian Foundation also paid for administrative assistance which was crucial for the development of the Association for Community Artists (ACA) and which is discussed in more detail later in the text. Their influence extended well beyond the UK and in 1979 the Gulbenkian

Foundation initiated the first Conference of Commonwealth Arts Councils at the University of Kent, Canterbury (Battersby 1981), with a second one held in Montreal in 1981. There papers were presented by delegates from France, Great Britain, Hong King, Jamaica, Malaysia, New Zealand, Papua New Guinea, and the United States (Sweeting 1982). The influence of community arts practices on their deliberations can be clearly seen in the introduction to the conference report from Peter Brinson of the Gulbenkian Foundation which suggests that the arts

> have much to do with community activity and are not only the solitary work of individuals. Thus they have an inescapable social function and influence, whether the product of one person or a hundred. This fundamental fact has been translated and developed in different ways by the community arts movements of industrial nations, seeking to re-integrate the arts into society and re-establish the role of culture in working life. (Sweeting 1982: v)

The Gulbenkian Foundation also commissioned *Support for the Arts in England and Wales*, a report by Lord Redcliffe-Maud (Redcliffe-Maud 1976). His brief was to 'study the future pattern of national, regional and local patronage of the arts in England and Wales, including the work of regional arts associations and the role of local authorities' (Redcliffe-Maud 1976: 12). His influential report advocated greater spending on community arts primarily through the new structures of local government and the developing network of RAAs. Redcliffe-Maud saw the potential for expansion of this support, noting approvingly that 'community artists set themselves to stimulate rather than perform [...] Their conviction is that local people should not only themselves control the buildings and equipment needed by the arts, but should themselves take the decisions about what is needed and refuse the exclusive role of passive audience' (Redcliffe-Maud 1976: 157). The regional offices of the Arts Council had been closed down in the 1950s, but this new system of regional arts associations began to be put in place in the early 1960s, in part with Gulbenkian Foundation support (Redcliffe-Maud 1976: 91). As independent charitable bodies, the RAAs could get support from the Arts Council, from local authorities, and from other sources to redistribute for arts activities. By the late 1960s, the RAAs had started to take on responsibility for touring, arts centres, and community arts.

Finally, it would be impossible to make a comprehensive account of the influences on the development of community arts without taking into account the hidden subsidies. These were made partly through government support through the benefits system embedded in the welfare state. In 1981, Baldry

asked 'how are [community artists] to survive?' concluding that they were faced with 'an all-too-simple answer to their problem: being a community artist meant living on the dole' (1981: 143).[5] Artists could claim various government benefits which allowed them to live simply and cheaply off the state while they developed their art. The squatting movement could also be counted into the cost of hidden subsidies because many young community artists chose to live rent-free in this way. The Job Creation Scheme of the Government Manpower Services Commission provided salaries for many community artists in the 1970s (Arts Council of Great Britain 1977) and projects benefitted from government funds like Urban Aid and Youth Opportunities Programme even though these bodies were not set up primarily to support community arts. Other hidden subsidies, like free premises from local authorities, or allowing for the payment of 'peppercorn' or reduced rents, were also important to community arts companies. In 1977, the Community Arts Evaluation group expressed their shock at the considerable personal cost of working in community arts in that period noting 'the degree of poverty, discomfort and plain physical adversity in which many groups are working' (Arts Council of Great Britain: 14). One of the most significant hidden subsidies, not only in financial but in personal terms, was that paid by the artists themselves.

Voices and sources: Who gets to make history?

Community artist and arts consultant, Gerri Moriarty, and theatre and performance academic, Alison Jeffers, are the co-editors of this book. These positions and labels are chosen deliberately but they are unstable. Alison worked in community arts for over ten years (some of these overlapping our chosen time frame of 1968–1986). Gerri worked in education for many years too and holds a postgraduate research degree. However, in adopting our 'academic' and 'artistic' personas, we hope to offer a book that benefits from the exchange and interplay between the voice of the 'academic' and the voice of the 'artist', and one that experiments with the limitations of these boundaries. In inviting specific contributors, we have consciously maintained this double-voicing in the hope that this will create a rich dialogue between practice and theory. In part, this is also an acknowledgement of the democratizing undertow of community arts and emerges from a concern that definitions and thinking about the community arts movement need to come from a number of voices. As the editors of this volume, we are inevitably faced with the task

of editing, shaping, curating, and moulding a certain narrative, but we aim to minimize the extent to which we speak for others by opening up channels of communication to as many voices as possible.

There is an ethical question at stake here in the sense of competing to be the authoritative or authentic voice, the voice that is allowed to make definitions, create and hold the dominant narrative – we have called this the question of 'who gets to hold the umbrella?'. The person who 'holds the umbrella' is implicitly allowed to shape the narrative; they maintain control over definitions and frames, getting to say what makes up the umbrella and what is allowed to shelter under it.[6] The inevitable question of who is not permitted shelter also arises; are unsheltered narratives destined to be somehow 'washed away', lost to the history that is shaped in the iterations here? We hope not, and are optimistic that this book will open up rather than close down other narratives and accounts of work in this period. Partly, our methodology rests on questions of memory and the extent to which we permit memory to be more or less 'authentic' than the written document. As there is no official archive of community arts, and as much of the work from the 1970s and early 1980s has been very poorly documented, so the question of stability, or reliability, is a real challenge.[7] Gerri has many years of more experience of community arts than Alison and continues to work in the field. To what extent does her continued commitment to community arts affect her memories of the early days of the movement? Can she be trusted to 'hold the umbrella'? Alison did not stay in community arts but has studied the community arts movement for some years and is familiar with many of the academic discourses around cultural policy and changing ideas about education and the arts. To what extent does her 'cooler' approach to the community arts movement give her permission to 'hold the umbrella'? And what happens when we 'pass the umbrella' over to our contributors? Some have continued to work as artists, while others are now working in other fields; some have been actively involved in community arts in the 1970s and early 1980s, while some are too young for this to have been possible.

These questions are important because of what is at stake. We have an historiographical responsibility to our readers for shaping a history of the community arts movement and an 'ethical responsibility to be reflexive about the ways in which theories and practices are evidenced, documented and represented, to be alert to the ways in which the past is used to create new social imaginaries' (Nicholson 2010: 148). We have to hold this in balance with our ethical responsibility to the many artists and policy makers who shared their thoughts and experiences in order to help us to build this picture of past practice.

This responsibility is heightened by the, sometimes, fraught relationship between practice and theory that has marked the history of community arts. Relationships between researchers, artists who carry out practice, and the communities within which the practice takes place, have been cogently critiqued by Bill McDonnell in relation to his research into community theatre in Northern Ireland:

> Definition is a form of appropriation, a claim upon complex and collective processes which denies the necessary social ownership of these theatres, and the responsibility we have to include in all definitions the self-definition of communities. When we create taxonomies and classes of practice with no reference to the understandings, views, or desires of the communities whose work and experiences we describe, we are denying them the right to name themselves. (McDonnell 2005: 135)

It is beyond the scope of this study to include the thoughts, views, opinions, and memories of the many thousands of people who participated in community arts projects within the time frame discussed. Equally, it would be impossible to speak to all community arts workers and policymakers who were active in this period and there are doubtless many more experiences and ideas that have been missed here that could have further enriched our study. Nevertheless, in interviewing around twenty artists and policymakers who were active in the movement in the 1970s and the early 1980s, we hope to produce what McDonnell calls 'a proper balance between the knowledge that has come from engagement, and the knowledge which has been derived from more traditional forms of research' (McDonnell 2008: 9). Of course, we must also acknowledge our own enthusiasm for community arts; indeed, it would seem perverse to write a book about something that one is not enthused by. However, we hope that this enthusiasm does not diminish a sense of critique and, to paraphrase Dee Heddon, although we are advocates we hope we are not naïve ones (2007: 7).

Between 2010 and 2015 the editors carried out extensive interviews and discussions with a number of artists. These are the names of the people who told us about their experiences of being involved in community arts: Cilla Baynes (Community Arts North West, Manchester);[8] Linda Boyles (Arts and Minds Development Manager, Leeds and York Partnership NHS Foundation Trust); Huw Champion (community worker, South Normanton and Combined Arts/Literature Officer East Midlands Arts; now writer); Akiel Chinelo (storyteller and performer in Manchester); Brian Cross (Artivan, Huddersfield; now Artimedia); Julian Dunn (Action Factory, Blackburn; now retired); Tina Glover MBE (ex-director Junction Arts, Derbyshire; now chair in health and

charity sectors); Amy Guest (theatre practitioner and teacher); Clare Hunter, née Higney (Needleworks, Glasgow; now independent arts consultant); Owen Kelly (Mediumwave, London; now lecturer at Arcada, Finland); Stephen Lacey (Jubilee Arts, Birmingham; now professor emeritus at University of South Wales); Nigel Leach (Bath Printshop; now writer and land manager); Cathy Mackerras (Telford Community Arts; now freelance community arts worker); Graham Marsden (Telford Community Arts and Bannerworks, Huddersfield – co-founded with Jean Compton; now retired); Liz Mayne (Community Arts Officer North West Arts; now therapist and mental health advocate); Karen Merkel (Free Form Arts Trust, London; now jointly running New Media Networks); Maggie Pinhorn (Alternative Arts, London); Janet Sisson (Derby Community Arts and Head of Planning at West Midlands Arts; now consultant); Steve Trow (Jubilee Arts, Birmingham; now local politician in Sandwell); Rick Walker (Greenwich Mural Workshop; now Cartwheel Arts, Rochdale); and Jeremy Warr (community artist and writer in the northeast of England).

In addition, in the summer of 2015, we invited artists who had worked in the 1970s and early 1980s to collaborate with emerging artists in an event called 'Unwrapping Hidden History'. The outcomes of this event are discussed in detail in the conclusion to this book and a film of this project is available.[9] The artists who were involved in this event include Chris Charles (The Men's Room, film maker and photographer); Kooj (Kuljit) Chuhan (Virtual Migrants and film-maker); Sally Gilford (printmaker and founder of one69a); Caitlin Gleeson (drama worker); Yolande Goodman (drama worker); Karishma Kusurkar (community artist and print designer); Bobby Smith (drama worker); Becky Smyllie (visual artist); Klaudia Szelugowska (drama student); Tom Thompson (community arts practitioner and maker);[10] and Rhiannon White (Common Wealth). Cathy Mackerras, Graham Marsden, and Rick Walker (as above) were also involved in this event. When introducing these artists throughout the book and discussing their work, we will call them 'community artists'.

We discuss the literature of the period not simply to provide an overview of what has been published on community arts but also to draw attention to the ways in which publication can produce certain orthodoxies in the creation of history. Two books from the period remain influential – Su Braden's *Artists and People* (1978) and Owen Kelly's *Community, Art and the State: Storming the Citadels* (1984). Despite the short gap in the years between their publications, they both are very different in tone and intent, with Braden's work optimistically describing a nascent movement while Kelly's strikes a more valedictory note.

Braden was initially asked by the Gulbenkian Foundation to survey their 'artists in schools' programme but came to the conclusion that it was necessary to broaden the brief to include the growing number of new initiatives and partnerships between artists and communities. As well as schools, she identified a wave of artists working in new towns which had been built on the edges of major British cities to accommodate people being moved from older housing in British inner cities. To these, Braden added a group of artists working in less-structured environments on housing estates and other places in both rural and urban areas. Kelly's thesis was that community arts would be doomed to failure as a movement unless it began to understand its radical history, an idea that he picks up in Chapter 11 in this book. Malcolm Dickson's collection of short reflections under the title *Art with People* (1995) provides a very useful set of perspectives on the community arts movement, focusing mostly on the visual arts. Nick Clements, one of the founders of Pioneers and a contributor to Dickson's collection, gives an account of the community arts movement in Wales in this book. Another useful collection of short essays *Finding Voices, Making Choices*, edited by Mark Webster and Glen Buglass (2005), makes up the short list of books that directly address community arts in the UK. Mark Webster takes up issues of training and education for community arts with Janet Hetherington in Chapter 9 of this book.

There has been some evidence of a re-examination of community arts in recent years, no doubt partly a generational event, as artists of that era reflect on the work and ideas of their early adulthood and evaluate the battles, losses and gains, successes and failures of that time. Kate Crehan's book *Community Art: An Anthropological Perspective* provides a richly detailed account of the development of Free Form in London set up by Barbara Wheeler-Early, Martin Goodrich, and Jim Ives in 1969 (Crehan 2011). She details the work in the early years of the organization and brings her account up to date with a discussion of their most recent work. Bill Harpe, who set up the Black-E community arts centre in Liverpool in 1968 with his wife Wendy, published *Games for the New Years* in 2001; a collection of many of the games and activities that had been developed since 1968, it aimed to inspire readers to invent new games for the twenty-first century (Harpe 2001). In 2014, Carry Gorney published an account of her time as a community artist in Leeds as part of an eclectic autobiography called *Send Me a Parcel with a Hundred Lovely Things* (2014). Mary Turner's *Action Space Extended* (2012) provides a beautifully illustrated account of the work of Action Space Mobile from 1968 to the present day. A history of community music, very closely mapped onto a history of community arts, forms

a large part of Lee Higgins' book *Community Music* (2012). John Fox's *Eyes on Stalks* (2002) about the work of Welfare State International could be added to this list, though it should also be said that Welfare State never fully immersed themselves in the Community Arts Movement, preferring perhaps to be seen as fellow travellers. Partly, this was an outcome of the way in which they organized the company as they were all self-employed artists, and as Fox said at the time 'as nomadic strangers it is not always easy to relate to specific communities' (Baynes and Tucker 1982: 10). It is our ambition to add to this growing body of work from a wider perspective, offering an overview of the movement to which these important companies contributed.

The books of Kelly (1984) and Braden (1978) in particular, along with Dickson's collection (1995), remain the most frequently cited in subsequent studies of community arts, cultural production, and examinations of the role of the state in funding for arts and culture. Indeed, Kelly's notion of 'storming the citadels' is frequently invoked as a short-hand way to indicate some of the failures of community arts, usually by showing that the citadels are still well and truly standing. By depending on a small body of published literature, on which scholars who have had no direct contact with community arts must now rely, what can be overlooked is the complexity of the work as it existed at the time. Although it is almost certainly not what their authors intended, allowing these works to stand for the entire Community Arts Movement smooths over the many challenges of the work and some of the subtleties of its politics. With this in mind, we have turned to a more ethnographic approach to try to capture some of the texture of the times through the voices of those who lived through them. In talking to these artists, we became aware of a large body of literature which is no longer widely available – including reports from the conferences run by the Shelton Trust in the 1980s and the quarterly magazine *Another Standard*. Not only do these provide a more nuanced sense of the times and of the Community Arts Movement as it developed, the aesthetics of this literature take us back to a predigital era of black and white print, roneoed leaflets, poor quality photographs, and a do-it-yourself approach to printed communications. In many ways, this research began with a discussion with community artist Rick Walker at Cartwheel Arts about posters for community arts projects printed in Peopleprint, a community print shop in Rochdale in the mid-1980s (Jeffers 2010). Access to these flyers, leaflets, photographs, posters, newspapers, and magazines has considerably enriched our understanding of the Community Arts Movement and, even though it is not possible to share them directly, we hope that this book will

provide a rare insight that access to the artefacts from the time, and the people who produced them, can create.

It is important to make a generic distinction before we move on because community arts is often confused with community theatre, and we think it is necessary to distinguish both as separate entities. Despite having very similar roots in the radical and alternative arts scenes of the late 1960s, as outlined at the time by Craig (1980), Itzin (1980), and Kershaw (1992), they have certain important differences. One distinction is made on the grounds that community artists saw themselves as part of a national movement in a way that theatre makers of radical, underground, alternative, and community theatres tended not to do. Community artists organized *as* artists, saw themselves as a network, discussed and debated their work at national conferences, produced a regular magazine and even attempted to create a manifesto. The second important distinction comes from the cross-art forms of community arts. Although theatre, and the performing arts generally, played an important role in the community arts movement, it was more often the innovative combinations of performance and visual arts, including photography, printing, video and making, that provided the distinguishing hallmark of community arts.

Community arts beyond the UK

Although we have focused primarily on the development of community arts in the UK, it is important to underline two important points. First, there was an urge on the part of community artists in England, Northern Ireland, Scotland, and Wales to connect to artists doing similar work in other parts of the world. Welsh company Valley and Vale, for example, placed an international dimension as central to their work with links to Nicaragua and South Africa (Rothwell 1992: 23). There were links between community artists in England and those working in the United States which will be discussed in more detail in Chapter 2. The second important point is that, although there are sometimes differences in terminology, it is possible to trace a similar trajectory for the development of community arts in Australia and the United States.

The term 'community arts' 'obtained official currency in Australia with the creation of the Community Arts Committee of the Australia Council for the Arts in 1973' (Pitts and Watt 2001: 14) which was formalized into the Community Arts Board in 1979 (Khan 2015: 21). Filewood and Watt see the beginning of the movement in Australia and Britain as emerging from the same 'libertarian,

communitarian counter-culture generation which formed the core of the community arts movement' in both places (Filewood and Watt 2001: 47). They also note similar tensions between access and participation and the ways in which the community arts movement in Australia followed European debates in the 1970s about the development of cultural democracy. Hawkins dismisses these readings of the beginnings of community arts in Australia as 'part of a long history of radical cultural activism' of 'left romanticism' (Hawkins 1993: 18). She argues that community arts 'had no real currency in Australia until it appeared in federal arts policy as a separate programme in 1973' (Hawkins 1993: xviii) but, according to her analysis, in founding the Community Arts Committee, a number of existing arts and cultural activities were 'gathered together and *re-presented* as community arts' (1993: xix, emphasis in original). In this reading of the beginning of community arts in Australia, funders and policymakers, rather than artists, were the main drivers of community arts in the early 1970s, and this argument is picked up and developed by fellow Australian critic Rimi Khan (Khan 2015).

Despite this, we note that there were direct exchanges between community artists in Australia and the UK in the early days of community arts. The work around Craigmillar Festival in Scotland, in particular, seems to have had some impact on the Australian community arts scene. Community artist Stephen Lacey describes how the founder of Suitcase Circus, Reg Bolton, who had been very influential in community arts in Craigmillar and elsewhere, migrated to Perth, Australia (Lacey 2012). Heddon and Milling describe how Pauline and Denis Peel took ideas about working with communities from their experience in Craigmillar to set up Street Arts Community Theatre Company in Brisbane (2006: 152). Australian artist Neil Cameron, who is famous for his large-scale community shows, traces his artistic influences to Craigmillar when he worked there as a student in 1972 (Cameron 1993: 8), and Andrew Crummy writes in detail about the work in Craigmillar in Chapter 4.

In terms of the development of community arts in the United States, Arlene Goldbard sees a similar time frame operating to that in the UK: 'The present run of community arts activity in this country began in the '60s [...] part of the phenomena that came to light as the dulling fog of the '50s began to lift' (Goldbard 1999: 2). American critics around the 1980s saw community arts as part of the legacy of the New Deal initiatives when the government funding of arts projects formed an important part of the policy for America's recovery from the economic depression (Mathews 1975). Despite similar artistic and creative aims, there are important differences of terminology between Britain and the United States.

Cohen-Cruz prefers the term 'community-based' theatre or performance to describe this work in the United States although she suggests that some prefer the term 'grass roots' (Cohen-Cruz 2005: 7). Cohen-Cruz and Adams and Goldbard find the term 'community arts' problematic in the American context because it is often used to describe more conventional arts activities organized by and linked to a specific municipality (Adams and Goldbard 2002: 4). They prefer the term 'community cultural development' and Lee Higgins shows how this term plays out in the United States and in other geographical contexts (Higgins 2012: 37–39).

Detailed chapter guides are given in the introduction to each part of the book but, in general, the first part of the book, 'The Community Arts Movement: Experimentation and Growth', unashamedly privileges the voices of artists from that period. The introductory chapter draws extensively on the accounts of the artists who were involved in setting up and developing a range of companies and initiatives. As Dickson points out, 'There are differences in national characteristics [of community arts]. Eire is as different to Northern Ireland as England is to Wales. Scotland is very different again. All have their own histories of development and unique examples in action' (Dickson 1995: 13). This section of the book remembers community arts from a number of perspectives that are driven by national borders and different senses of the nation. The first chapter outlines Gerri Moriarty's work as a community artist in different locations in England; and Andrew Crummy from Scotland and Nick Clements from Wales take account of community arts from their particular national perspectives after which Gerri Moriarty recounts the beginnings of community arts in Northern Ireland. These contributors are all working from first-hand knowledge and experience although they have also tried to give a sense of how this work might sit within the wider location at the time, taking up questions of the legacy of this early work.

The second half of this book 'Cultural Democracy: Practices and Politics' delves into the question of the influence of community arts from a number of other perspectives. Three of the contributors, Oliver Bennett, Owen Kelly, and Mark Webster have direct experience of working in community arts in different capacities in the 1970s and early 1980s. Janet Hetherington and Sophie Hope have no direct experience of working in community arts in this period, but both have carried out extensive research on the period using the early days of the movement as the basis for their thinking and writing. We finish this section, and the book overall, with some concluding reflections on similarities and differences between practice and thinking then and now, using the event 'Unwrapping Hidden History: Influencing Contemporary Practice' as a starting point. This event brought together community artists from the 1970s with contemporary practitioners with

a view to working through and discussing some of the similarities and differences between practice and thinking in the early days of community arts with ideas about the work and the theories that inform it now.

There are certain important aspects of community arts practice that this book cannot cover in sufficient detail. Naseem Khan's influential book *The Arts Britain Ignores* played a significant role in bringing the work of Bangladeshi, Chinese, Cypriot, East and Central European, Indian, Pakistani, West Indian, and African artists and communities to the attention of the public (Khan 1978). Many black and minority ethnic artists worked within the Community Arts Movement in this period and, for example, a 1983 community arts conference report brings contributions from artists Errol Lloyd and Gavin Jantjes (1983: 16–18), Kwesi Owusu (1983: 19–21), and G. Eugeniou (1983: 24) under the banner of 'International Issues in Community Arts'. Cilla Baynes describes how the Black Arts Alliance partly grew out of these kinds of discussions and the ways in which black arts and community arts developed side by side and interchangeably (Baynes 2010). Nevertheless, a full and detailed account of black and ethnic minority community arts would not be possible and this deserves an account of its own. Similarly, although disability arts played a significant role in the Community Arts Movement, this too deserves its own detailed narrative. Recent publications have begun to address some aspects of these practices, in particular, theatre practices with people with learning disabilities and readers who are interested should read Dave Calvert's excellent account of Mind the Gap (2015) and Matt Hargrave's extensive study of theatres of learning disability (2015).

We would like to offer our profound gratitude to all the people who have made this book possible and especially to the artists who have been more than generous with their time, freely offering not only the wealth of their experience but often their hospitality and access to their personal archives. We hope that they understand and forgive us for occasionally having to condense rich personal encounters to quotations and examples; the medium of print cannot hope to capture the depth and range of their experience, or even of our discussions. However, their accounts of community arts in the 1970s and early 1980s, and their reflections on the legacies of community arts, have provided a rich and dynamic narrative which has fed our writing throughout the book. Hugh Champion and Janet Sisson provided a full set of *Mailout* magazines and Tina Glover, Cathy Mackerras, and Brian Cross provided back copies of *Another Standard* and other literature for which we are truly grateful. We would like to thank all our contributors and offer special thanks to those artists who wrote

in their own time and without the support structures available to full-time academic researchers. The irony of the situation, where the struggle for proper pay and conditions for artists during the development of community arts, clashes with the lack of both in the case of academic research and publishing has not escaped us. It serves to illustrate something of the passion for all those involved to, in the words of many artists we spoke to, 'get the story out there'. We appreciate that not everyone will agree with our analysis and we welcome the robust debate which we hope will follow the publication of this book. We trust that it will be a first step in writing and re-examining a vital part of our cultural narrative.

Notes

1 No figures were available for Northern Ireland and the Welsh Arts Council did not have a separate category for community arts at that point.

2 The Black-E was renamed in the early 2000s having previously been known as The Blackie, the popular name for the old church which housed the Great George's Community Arts Project.

3 This is also recorded in the archive for Jubilee Arts https://jubileeartsarchive.com /contact/ (accessed 1 November 2016).

4 See Heddon and Milling (2006) for a more detailed account of this work. Also Saunders's account of the relationship between live art and the Arts Council (2012).

5 The Dole was the common name for the system of unemployment benefits paid to individuals by the government.

6 Writing about community music Lee Higgins suggests that community arts and community cultural development (the preferred term for community arts in the US) become 'the umbrella that cloaks specific disciplinary fields such as community dance, community video, community drama, applied drama, community theater, applied theater and community music' (2012).

7 A number of archives have recently become available and one of the most comprehensive and accessible is that of Jubilee Arts co-ordinated by Brendan Jackson: https://jubileeartsarchive.com/

8 Community Arts Workshop is now known as Community Arts North West.

9 https://communityartsunwrapped.com/2015/12/09/the-right-to-make-art/

10 The term 'making' tended to be used as a generic term for all kinds of more visually oriented three-dimensional work that lay outside the other common visual forms of printing and photography.

References

Adams, Don, and Arlene Goldbard (eds.) 2002. *Community, Culture and Globalisation* (The Rockerfeller Foundation: New York).

Another Standard. 1982. *Arts Council and Regional Arts Funding – The National Picture* (The Shelton Trust: London).

Arts Council of Great Britain. 1974. *Community Arts. The Report of the Community Arts Working Party* (Arts Council: London).

Arts Council of Great Britain. 1977. *Community Arts. A Report by the Arts Council's Community Arts Evaluation Working Group*, ACGB: London.

Baldry, Harold. 1981. *The Case for the Arts* (Secker and Warburg: London).

Battersby, J. 1981. 'The Arts Council Phenomenon', https://gulbenkian.pt/uk-branch /publication/the-arts-council-phenomenom/ (accessed 13 December 2016).

Baynes, Cilla. 2010. Interview with Alison Jeffers and Gerri Moriarty.

Baynes, Cilla, and Anne Tucker. 1982. 'Cultural Guerillas. Cilla Baynes and Anne Tucker Talk to John Fox, Artistic Director of Welfare State International', in *Another Standard* (The Shelton Trust: London).

Beloff, Michael. 1968. *The Plateglass Universities* (Secker and Warburg: London).

Bishop, Claire. 2012. *Artificial Hells. Participatory Art and the Politics of Spectatorship* (Verso: London and New York).

Black, Lawrence. 2003. '"Making Britain a Safer and More Cultivated Country". Wilson, Lee and the Creative Industries in the 1960s', *Contemporary British History*, 20: 323–42.

Blumer, Brian. 1980. 'Community Arts and the Labour Movement', in Bernard Ross, Sally Brown and Sue Kennedy (eds.), *Community Arts Principles and Practices*, 18–19 (The Shelton Trust: London).

Bradby, David. 2009. 'Roger Planchon', *The Guardian,* 20 May.

Braden, Su. 1978. *Artists and People* (Routledge and Kegan Paul: London).

Brooks, Rod. 1983. 'Ed Berman. AS Interview', in *Another Standard* (The Shelton Trust: London).

Brown, Ian. 2010. 'Guarding against the Guardians': Cultural Democracy and the ACGB/RAA Relations in the *Glory* Years, 1984–94', in Kate Dorney and Ros Merkin (eds.), *The Glory of the Garden. English Regional Theatre and the Arts Council 1984–2009*, 29–54 (Cambridge Scholars: Newcastle upon Tyne).

Bullock, Alan, Oliver Stallybrass, and Stephen Trombley. 1977. *The Fontana Dictionary of Modern Thought* (Fontana Press: London).

Calvert, Dave. 2015. 'Mind the Gap', in Liz Tomlin (ed.), *British Theatre Companies 1995–2014*, 127–154 (Bloomsbury Methuen: London).

Cameron, Neil. 1993. *Fire on the Water. A Personal View of Theatre in the Community* (Currency Press: Sydney).

Cohen-Cruz, Jan. 2005. *Local Acts. Community-based Performance in the United States* (Rutgers University Press: New Brunswick, New Jersey and London).

Craig, Sandy. 1980. *Dreams and Deconstructions. Alternative Theatre in Britain* (Amber Lane Press: Ambergate).

Crehan, Kate. 2011. *Community Art. An Anthropological Perspective* (Berg: London and New York).

Dickson, Malcolm (ed.). 1995. *Art with People* (AN Publications: Sunderland).

Dunn, Julian. 2010. Interview with Alison Jeffers.

Eugeniou, G. 1983. 'Theatro Technis', in *Friends and Allies, Salisbury, 22–24 April 1983, The Report* (The Shelton Trust: London).

Filewood, Alan, and David Watt. 2001. *Workers' Playtime. Theatre and the Labour Movement since 1970* (Currency Press: Sydney).

Fox, John. 2002. *Eyes on Stalks* (Methuen Drama: London).

Freire, Pedro. 1972. *Cultural Action for Freedom* (Penguin: London).

Goldbard, Arlene. 1999. 'Postscript to the Past: Notes toward a History of Community Arts', Community Arts Network Reading Room, http://www.darkmatterarchives.net/wp-content/uploads/2011/11/GoldbergCETAsanfrancisco.pdf (accessed 13 December 2016).

Gorney, Carry. 2014. *Send Me a Parcel with a Hundred Lovely Things* (Ragged Clown Publishing: London).

Gregory, R.G. 1980. 'Community Arts and the Need for Openness', in Bernard Ross, Sally Brown and Sue Kennedy (eds.), *Community Arts Principles and Practices*, 20 (The Shelton Trust: Barnstaple, Devon).

Hargrave, Matt. 2015. *Theatres of Learning Disability. Good, Bad or Plain Ugly?* (Palgrave Macmillan: Basingstoke).

Harpe, Bill. 2001. *Games for the New Years. A DIY Guide to Games for the 21st Century* (The Blackie: Liverpool).

Hawkins, Gay. 1993. *From Nimbin to Mardi Gras. Constructing Community Arts* (Allen and Unwin: St. Leonards).

Haynes, Jim. 1969. 'The Centre of Attention. The Arts Laboratory', http://www.thecentreofattention.org/dgartslab.html (accessed 18 April 2016).

Heddon, Deirdre. 2007. *Autobiography in Performance. Performing Selves* (Palgrave Macmillan: Basingstoke).

Heddon, Deirdre, and Jane Milling. 2006. *Devising Performance. A Critical History* (Palgrave Macmillan: Basingstoke).

Higgins, Lee. 2012. *Community Music in Theory and in Practice* (Oxford University Press: Oxford).

HMSO. 1965. *A Policy for the Arts. The First Steps Cmnd. 2601* (HMSO).

Hodgson, John. 1972. *The Uses of Drama. Acting as a Social and Educational Force* (Eyre Methuen Limited: London).

Holdsworth, Nadine. 2011. *Joan Littlewood's Theatre* (Cambridge University Press: Cambridge).

Hunt, Albert. 1976. *Hopes for Great Happenings. Alternatives in Education and Theatre* (Eyre Methuen: London).

Illich, Ivan. 1981. *Deschooling Society* (Pelican Books: London).

Illich, Ivan. 2009 [1973]. *Tools for Conviviality* (Marion Boyars: London and New York).

Itzin, Catherine. 1980. *Stages in the Revolution. Political Theatre in Britain since 1968* (Methuen: London).

Jeffers, Alison. 2010. 'The Rough Edges: Community, Art and History', *RiDE: The Journal of Applied Theatre and Performance*, 15: 25–37.

Julian, Linda A. 2003. 'William Morris. English Writer, Designer and Campaigner', in Chris Murray (ed.), *Key Writers on Art: From Antiquity to the Nineteenth Century*, 223-229 (Routledge: London).

Kelly, Owen. 1984. *Community, Art and the State: Storming the Citadels* (Comedia: London).

Kershaw, Baz. 1992. *The Politics of Performance. Radical Theatre as Cultural Intervention* (Routledge: London and New York).

Khan, Naseem. 1978. *The Arts Britain Ignores. The Arts and Ethnic Minorities in Britain* (Commission for Racial Equality: London).

Khan, Rimi. 2015. *Art in Community. The Provisional Citizen* (Palgrave Macmillan: Basingstoke).

Lacey, Stephen. 2012. Interview with Alison Jeffers and Gerri Moriarty.

Leng, Andrew Robert. 2003. 'John Ruskin. English Critic and Writer', in Chris Murray (ed.), *Key Writers on Art: From Antiquity to the Nineteenth Century* (Routledge: London).

Littlewood, Joan. 1994. *Joan's Book. Joan Littlewood's Peculiar History as She Tells It* (Methuen: London).

LLoyd, Errol, and Gavin Jantjes. 1983. 'Critical Perspectives', in *Friends and Allies, Salisbury, 22–24 April 1983, The Report* (The Shelton Trust: London).

Mackerras, Cathy. 2015. Interview with Gerri Moriarty.

Marsden, Graham. 2010. Interview with Alison Jeffers and Gerri Moriarty.

Mathews, Jane De Hart. 1975. 'Arts and the People. The New Deal Quest for a Cultural Democracy', *The Journal of American History*, 62: 316–39.

McDonnell, Bill. (2005). 'The Politics of Historiography – Towards an Ethics of Representation', *Research in Drama Education: The Journal of Applied Theatre and Performance*, 10 (2): 127–138.

McDonnell, Bill. (2008). *Theatres of the Troubles. Theatre, Resistance and Liberation in Ireland* (Exeter University Press: Exeter).

Minihan, Janet. 1977. *The Nationalization of Culture. The Development of State Subsidies in the Arts in Great Britain* (New York University Press: New York).

Morgan, Sally. 1995. 'Looking Back over 25 Years', in Malcolm Dickson (ed.), *Art with People*, 16-26 (AN Publications: Sunderland).

Morgan, Sally. 2003. 'Beautiful Impurity: British Contextualism as Processual Postmodern Practice', *Journal of Visual Arts Practice*, 2 (3): 135–144.

Nicholson, Helen. 2010. 'The Promises of History: Pedagogic Principles and Processes of Change', *Research in Drama Education: The Journal of Applied Theatre and Performance*, 15 (2): 147–154.

Owusu, Kwesi. 1983. 'Transcending Neo-colonial Culture', in *Friends and Allies, Salisbury, April 22–24 1983, The Report* (The Shelton Trust: London).

Pearson, Mike. 2013. *Marking Time. Performance, Archaeology and the City* (University of Exeter Press: Exeter).

Pinhorn, Maggie. 2014. Interview with Alison Jeffers and Gerri Moriarty.

Pitts, Graham, and David Watt. 2001. 'The Imaginary Conference', in *Artwork Magazine*, 7–14.

Redcliffe-Maud, Lord. 1976. *Support for the Arts in England and Wales* (Calouste Gulbenkian Foundation).

Rigby, Ross. 1982. *Community Arts Information Pack* (The Shelton Trust: London).

Rothwell, Jerry. 1992. *Creating Meaning. A Book about Culture and Democracy* (Barry: Valley and Vale).

Saunders, Graham. 2012. 'The Freaks' Roll Call: Live Art and the Arts Council, 1968–73', *Contemporary Theatre Review*, 22: 32–45.

Sweeting, Elizabeth. 1982. *Patron or Paymaster? The Arts Council Dilemma* (The Calouste Gulbenkian Foundation).

Trow, Steve. 1980. 'Working with Organised Groups', in Bernard Ross, Sally Brown and Sue Kennedy (eds.), *Community Arts Principles and Practices*, 25–26 (The Shelton Trust: Barnstaple, Devon).

Turner, Mary. 2012. *Action Space Extended* (Action Space Mobile).

Webster, Mark, and Glen Buglass. 2005. *Finding Voices. Making Choices* (Educational Heretics Press: Nottingham).

Williams, Raymond. 1961. *The Long Revolution* (Pelican: London).

Williams, Raymond. 1976. *Keywords. A Vocabulary of Culture and Society* (Fontana: London).

Williams, Raymond. 1977. *Marxism and Literature* (Cambridge University Press: Cambridge).

Woodruff, Graham. 1989. 'Community, Class and Control', *New Theatre Quarterly*, 5: 370–73.

Woodruff, Graham. 1995. ' "Nice Girls": The Vic Gives a Voice to Women of the Working Class', *New Theatre Quarterly*, 11: 109–27.

Woodruff, Graham. 2004. 'Theatre at Telford Community Arts 1974–90', *Research in Drama Education*, 9: 29–46.

Part One

The Community Arts Movement: Experimentation and Growth

The Community Arts Movement 1968–1986

Alison Jeffers

The challenge is to find out how to instigate a party, and keep doing it, just keep doing it; whenever you get the opportunity look for it and do it.

Nigel Leach, community artist

This chapter introduces the first part of this book which draws on the voices of the artists who were involved in initiating the Community Arts Movement. The sources for this account are primarily community artists themselves and the literature produced by community artists. I begin by addressing the question of exactly how and why community arts during the 1970s and early 1980s can be described as a movement and the strengths and limitations that emerge from that. I describe the breadth of work carried out in this period and the ways in which community artists developed methods of working and engagement. Finally, I address ideas around cultural democracy and show how it played out in community arts and the effect of different understandings of the terms 'culture' and 'democracy' on the Community Arts Movement. I will begin by interrogating the terms of the title – considering community arts as a movement and justifying the dates of the life of this movement.

Between spontaneity and structure

There are references to community arts of the 1970s and early 1980s as a movement in contemporary literature (see Bishop 2012; O'Gorman and McIvor 2015). At that time artists also broadly accepted that they were part of 'a movement loosely based on the retrospective recognition of the similarities of aim and method in the work of its founders […] a fluctuating group of (mainly)

young artists who were working in ways which were, at that time, unorthodox'
(Kelly 1984: 9). Maggie Pinhorn (2014) explained:

> We used to have conferences in different regions. It was a real strength of the
> movement. And people would say 'You're not a movement. You haven't got a
> manifesto.' But we were a movement. We weren't necessarily a bunch of Marxists.
> We were a bunch of artistic and creative people that [believed in] fairness and a
> sense of social justice.

Even though not all community artists might have ascribed to this
political perspective and some may not have felt part of a movement at all
(Phillips 1983), it is helpful to pay attention to the idea of community arts in
this period *as a movement* for three main reasons. Most simply, it is a useful
way to set apart a body of work for discussion, rather than looking at the
impossibly large scope of work that might fall under the more general title of
community arts. Second, it allows for the delineation of a time scale within
which to work because the Community Arts Movement emerged in the late
1960s and changed in the mid- to late 1980s. Finally, and most importantly, in
setting this body of work apart through thinking of it as a movement, we can
isolate and discuss its characteristics, beliefs, conflicts, and tensions and look
at the ways in which, as a movement, it has had an impact on later experiments
with culture and democracy.

Social movements are diverse and hard to define but the important elements
that delineate a movement are spontaneity and structure, which sit at opposite
ends of a continuum (Freeman and Johnson 1999). At the 'spontaneous end'
lie structureless organizations defined as 'fads, trends and crowds', while well-
developed, stable organizations lie at the opposite end, and in the middle lie social
movements which 'however diverse they may be, exhibit noticeable spontaneity
and a describable structure' (Freeman and Johnson 1999: 1). We suggest that
the middle ground of Freeman and Johnson's model, somewhere between
structure and spontaneity, was occupied by the Community Arts Movement of
the 1970s. Analysing the Civil Rights movement, student protest, welfare rights,
and women's liberation in 1960s America, Freeman and Johnson suggest three
propositions for the emergence of a movement. First, there is a need for a pre-
existing communications network or infrastructure. Second, this must be co-
optable in the sense that those involved in those networks will be receptive to
the ideas of the movement. The third proposition involves precipitant actions,
sometimes seen as crises, which will galvanize the participants into action. For
community arts the first two propositions were fulfilled by a growing body of

artists who began communicating their ideas and sharing practice as they left art schools and universities at the end of the 1960s, as we have discussed in the previous chapter. The third was precipitated by the 'crisis' of the lack of funding and support for the work that these artists were doing. The loose networks of community artists were formalized into the Association of Community Artists (ACA) set up in London in the early 1970s by Bruce Birchill, Maggie Pinhorn, and Martin Goodrich. Many artists continued to network on a regional basis but the ACA's goal was to create and sustain a movement, which would provide a national platform for community artists.

In its heyday, the ACA functioned as a 'powerful lobby group/trades union and an invaluable forum for the exchange of ideas and practice' according to Morgan, who was involved at the time (Morgan 1995: 18). For community artist Karen Merkel, who had worked with Free Form Arts Trust in the 1970s, the ACA 'built a commonality and provided an important national network of artists with shared values' (Merkel 2012). The ACA decided to become regionally rather than nationally focused in 1980, shifting from being a national organization to a more federated structure. Some regions adopted the new Association for Community Arts (AfCA) that had a more open membership of anyone with an interest in community arts, as opposed to the ACA which was intended to be primarily for community artists. For Morgan, this was a mistake because it meant the 'opening up of membership to include representatives of the funding bodies [which] meant that we had no place to organise when our needs did not coincide with their desires' (Morgan 1995: 21). Cilla Baynes (2010) also described the end of national organizing as a mistake because

> we lost a national voice. What we had before was a very strong national voice. It brought together people from rural arts companies with people from urban arts companies and people from a growing black arts movement from within the community arts movement. Yes, the national structure needed evolving, to become more inclusive but it said 'this is about arts for the people', working with communities, and I think we lost that, that more politicized national voice which had a growing diverse base at the time.

In an attempt to maintain a national structure, the Shelton Trust was set up under the initiative of the ACA in 1980 'with the purpose of developing an educational and advisory role in the arts and encouraging the public debate of issues arising from Community Arts practice' (Ross et al. 1980: inside cover). The Shelton Trust organized a series of national conferences from which the organizers collated detailed reports and published papers, ran a series of

Figure 2.1 Decades of work

training seminars called *On the Road* which travelled around the country and produced *Another Standard* quarterly magazine. *Another Standard* provided a national platform on which to air opinions and grievances, discuss projects and debate practice. It included news and information on projects, training courses, jobs, sources of funding as well as interviews with prominent cultural figures and thoughtful and provocative editorial content. Moving from a rather crudely printed 8-page magazine to a sophisticated 31-page publication in the course of its life, it operated between 1981 until around 1986 when it ceased publication. The end of the Shelton Trust signalled the end of any sense of coherent national organizing of community arts in Britain and the beginning of the fragmentation of the Community Arts Movement, and this will be discussed in more detail in Chapter 7 which introduces Part Two of this book.

1968–1986

Dating something as slippery as a movement is done with a full understanding of the difficulties implied, but such dating is necessary as a way to delineate that movement. It means that the beginnings of the Community Arts Movement

can be understood as emerging from a series of conflicts at that time, providing not just context or background but suggesting in a more far-reaching way 'the mold in which general experience was cast' (Williams 1958: 49). As indicated in the Introduction, the Black-E and Inter-Action were set up in 1968, as was Welfare State International, but community arts as a movement really began to thrive in the early 1970s. Fixing the first date as 1968 allows us to, accurately, associate the beginnings of the Community Arts Movement with the international countercultural movement of the late 1960s. Marwick marks the period between 1958 and 1974 as a 'long decade' during which a 'cultural revolution' took place in Britain, France, Italy, and the United States (Marwick 1998). Although he suggests that the right and the left cannot agree on the significance of the era, there is nevertheless an agreement that '*something* significant happened in the sixties' (Marwick 1998: 4, emphasis in original). For Moore-Gilbert and Seed, there was no monolithic counterculture or coherent programme of change but 'diverse attacks on official culture' and 'transformations in the material base of cultural production' (Moore-Gilbert and Seed 1992: 1). Nevertheless, the countercultural movement has come to represent 'many and varying activities and values which contrasted with, or were critical of, the conventional modes and values of established society' (Marwick 1998: 12). It spawned many subcultures and movements, one of them being community arts that reacted against the old post-war order.

The notoriety of 1968 is generated by student and industrial unrest resulting in riots in Paris as well as in Italy, Germany, and Japan, the Prague Spring in Czechoslovakia, anti-Vietnam riots and campus unrest in the United States, and civil rights marches in Northern Ireland, among many other events in that tumultuous year. Itzin is unambiguous about the significance of 1968, calling it 'a historic year which politicized a lot of people' (Itzin 1980: 1). Community artist Graham Marsden remembered this political awakening as an art student at Nottingham College of Art: 'so there's everything happening in Paris in 1968 and it was exciting. It crossed the [English] Channel to Hornsey Art College with a sit-in so we said "We're going to do that in Nottingham!" So we wrote this manifesto which we gave to the staff' (Marsden 2010). For Hewison, 1968 marks the climax of 'the sixties' but he suggests that its influence continued until about 1975 and that the year 'anticipates the social conflicts of the seventies' (Hewison 1986: xiii). Both Marwick and Hobsbawm see 'the sixties' ending in 1973 with the international oil crisis 'when the doubling of oil prices led to widespread recession and a general crisis in confidence' (Marwick 1998: 7). But the Community Arts Movement was just getting into its stride at this

point and, as will be discussed next, was starting to make demands on public funds at just the time when these were becoming more and more scarce.

In fact, the Community Arts Movement continued into the 1980s and we mark its end as taking place around 1986 for a number of reasons. Many factors impacted on the movement from outside, but there were internal pressures too that made it very difficult to hold it together. Differences of opinion around the goals of any movement, the speed at which it should move, and disagreements about the means by which it should achieve its goals, are characteristic of all movements and the Community Arts Movement was no exception. What had been set up in the 1970s as loose cooperative organizations with shared ideals and working practices were unable to withstand the new politics of the 1980s and impositions of what many saw as more hierarchical management structures. At around this time, Landry and his colleagues examined the failure of many radical publishers that had also been set up in the 1970s (Landry et al. 1985). Similar to the situation in community arts, they argued that informal, non-hierarchical, and collective ways of working had become a dogma and that these ways of working could be as exclusionary and undemocratic as the old-fashioned hierarchical modes of organization that they were set up to oppose.

Two examples of disputes were publicly aired through *Another Standard* in 1983, when letters about a 'lock-out' at Saltley Neighbourhood Print Co-operative in the Midlands and a dispute about reorganization at Free Form were published. The editors explained, 'What we are seeing now in these disputes is the inappropriateness of certain types of organization being revealed in a difficult and unprofitable way. What we are seeing is a long history of inattention to detail beginning to catch up with us' (Another Standard 1983: 3). On the surface, these disputes were very different but, as the editors point out, 'they are both concerned with democratic working practices, and were about the internal structure of a community arts group and their external aims and objectives' (Another Standard 1983: 5). These organizational challenges continued into the 1980s as the loose working structures and alliances of workers' cooperatives increasingly fell out of favour. As recipients of public money, which was the case for many community arts companies by the beginning of the 1980s, funders wanted them to have what they saw as more 'robust' management structures. Bringing companies into the organized voluntary or third sector (not for profit in the United States) necessitated that they become companies (usually limited by guarantee) and that they apply for charitable status. For some, 'this had the effect of neutralizing the community arts enterprise in terms of its community activism' (Higgins 2012: 34) as charities had to operate within strict guidelines

around campaigning and political activity which frustrated many of the early community artists.

In addition to these internal disputes, by 1986, pressures from without the movement appeared from a number of directions. The impact of the election of a radical Conservative government in 1979, under the leadership of Margaret Thatcher, was being felt by the early 1980s. However, it was not until the Conservatives were re-elected with a strong mandate from the British public in 1983 that the full impact of Thatcherism and the New Conservatism was felt. Antony Beck suggests that 'after 1983 [...] arts expenditure was finally targeted for the Thatcher treatment' (Beck 1989: 365). This 'treatment' involved the introduction of strict monetarist policies, encouragement of free enterprise, and *laissez faire* economic liberalism characterized by senior politician Nigel Lawson as 'rolling back the frontiers of the state' (Beck 1989: 363). Although government money for the arts, administered through the Arts Council, was still rising, the rate of that increase slowed dramatically from a 23 per cent rise in 1982/1983 to 4 per cent in 1983/1984 (Beck 1989: 366). However, it was not just the total amount of money available that was a problem for community arts, it was the ideological baggage that accompanied government strategies for weaning the arts away from a 'welfare state mentality', as Arts Minister Richard Luce put it in 1987 (Beck 1989: 367). Arts organizations were to rebalance their private and public income towards the private and away from depending on public money through the government. They were to expand their commercial income by building box-office takings, renting their property, increasing merchandising, and getting business sponsorship. In the words of Harold Baldry, community artists 'rarely had a sellable product; when they had an audience, little or nothing could be expected in the way of "box-office returns"; and they could not or would not make a charge for participation in painting a mural or acting a play or making a video programme' (Baldry 1981: 142). It was never a possibility that small community arts companies were going to be in a position to significantly rebalance their income streams in this way.

The Arts Council took its earliest opportunity to remove community arts from its portfolio and, in 1982, the Shelton Trust reported on the winding down of the Community Arts Committee of the Arts Council. The editors of *Another Standard* were worried about the shift away from national organization that had been facilitated through the Arts Council which 'ensured that there was a consistent thread of intention, of philosophy, running through those groups which have formed the community arts movement' (Another Standard 1982: 3). They felt that devolution of responsibility for community arts to twelve Regional Arts

Associations (RAAs) risked diluting the practice to the extent that 'community art is in danger of becoming a trendy catchphrase' (1982: 3), with all that implied. The Arts Council's *The Glory of the Garden* (1984) cemented the decentralization of all but a limited number of community arts companies 'of national significance' to the RAAs (Another Standard 1982: 3). With many companies now part of regional networks rather than a national one, the Community Arts Movement, as a coherent body of practice with broadly agreed principles, dwindled and finally disappeared. Ironically, it seems that the Arts Council, so long the object of derision of community artists, had been one of the institutions actually holding community arts together as a movement, even if it was simply a body that united community artists against it.

The final piece of the jigsaw that leads us to suggest the date of 1986 as the end of the Community Arts Movement is the Conservative government's abolition of the Greater London Council (GLC) and six Metropolitan County Councils (MCCs), Greater Manchester, Merseyside, South Yorkshire, Tyne and Wear, West Midlands and West Yorkshire in that year. The GLC and MCCs 'stood for everything Thatcher disliked about the Labour town halls' and the way that they 'seemed to spend money like water' (Kosecik and Kapucu 2003: 87). Since its inception in 1965, the GLC had swung between Labour and Conservative dominance until the early 1980s when, under the leadership of the left-wing politician Ken Livingstone (nicknamed Red Ken) between 1981 and 1986, it instituted its most radical policies. The activities of the Arts and Recreation Committee, so often sidelined in the past, were brought into the spotlight with the determination of its members to 'try and re-define the whole notion of cultural politics' (GLC Arts and Recreation Committee 1986: 2). To resource their proposed new initiatives, they suggested 'flogging off a couple of Gainsboroughs to make ends meet' causing uproar in the right-wing press and in the Houses of Parliament with this apparent attack on the high art of 'Centres of Excellence' (GLC Arts and Recreation Committee 1986: 3). Under the leadership of Tony Banks, three subcommittees – community arts, ethnic arts, and sport were set up, generating a huge amount of activity (Mulgan and Worpole 1986). Mulgan and Worpole suggest that accounts of the GLC often risk mythologizing the work supported by the Community Arts Sub-Committee (Mulgan and Worpole 1986). Kelly has suggested that there was a level of irresponsibility in supporting so much work, including encouraging people to set up new companies with full-time workers, when there were no clear plans for sustainability (Kelly 2016). A huge number of initiatives were set up – listed as community bookshops, film and video groups, music groups, drama groups, photography groups, mural

groups, printing groups, arts centres, festivals, and multimedia work (GLC Arts and Recreation Committee 1986: 20–26). The Conservative government hoped that the abolition of these 'loony leftie' tiers of local government would 'strike at the roots of "local socialism"' (Kosecik and Kapucu 2003: 91). Whether it succeeded in that goal or not is not the main consideration here; the impact of the withdrawal of the GLC and the MCCs was seen as threatening a 'major catastrophe for the arts' (Rittner 1986: 4) and certainly struck at the roots of important policy initiatives and financial support for community arts.

Experiment, excitement, and improvisation

In 1982, after about twelve years of the Community Arts Movement's existence, Ros Rigby compiled the extensive *Community Arts Information Pack* (1982) on behalf of the Shelton Trust. By this point the Community Arts Movement was describing itself as a 'mature positive movement [...] with a well-documented history of success' (Rigby 1982: n.p.).

> It isn't just about a short-term cosmetic for brightening up unhappy neighbourhoods. It implies a long-term commitment to helping ordinary people to realise their own creative potential and to take a proper share in organizing their own lives. Community arts has proved that it has a vital place in the pattern of the arts and society as a whole.

In an attempt to create a taxonomy of work, Rigby identified certain categories of work that had developed since the late 1960s. These were set out as *Urban 1. General Projects*, giving the examples of Jubilee Community Arts in Birmingham and Nottingham Arts and Crafts. Inner-city projects in this category could be found in all major urban centres and Rigby noted that London alone had 130. Under the heading *Urban 2* could be found *Specialist Projects* that specialized in one art form or medium; examples here were Greenwich Mural Workshop (and print shops, more generally) and Tara Arts group. The next category was work in *New Towns* like Telford, Milton Keynes, Northampton, Corby, and Peterlee where community arts was often used to 'accelerate a community-building process that normally takes years' (Rigby 1982). *Rural Areas and Small Towns* had their own category represented by High Peak Community Arts (discussed by Gerri Moriarty in Chapter 3), Junction 28 in Normanton, Derbyshire, and Northumberland Community Arts. Also included in this category was St. Edmund's Arts Centre (which later became Salisbury Arts Centre) and Fair

Exchange, part of Medium Fair in Devon. *Festivals and Short-Term Projects* included much of the celebratory work discussed next as well as experiments in public broadcasting like Dunston Cable TV, one of the community broadcasting experiments like the one discussed by Oliver Bennett in Chapter 8. Work with *Young People* had its own category represented by projects Trinbago Carnival Club in London, Arts and Action in Merseyside, Mara Ya Pili (a community dance project based in Leeds), Sunderland Musician's Collective, and Intermediate Treatment for young people with multiple problems. Also included in this category is Mediumwave, which is discussed in Owen Kelly's chapter. *Work with Special Groups* covered arts work with people with disabilities and elders and art in hospitals. *Touring Groups* was the final category which covered companies like Community Arts Workshop based in Manchester, Free Form in London and Pentabus whose work was carried out across a whole region or in different parts of the country. This list, though far from exhaustive, is useful in indicating the range of work carried out and the places in which it happened; but, it would be a mistake to suggest that these categories were in any way neat or uncontested or that the journey from the beginnings of the movement in the late 1960s to the position described above in the early 1980s had been at all smooth.

In its infancy in the 1960s, and even into what Baldry called its 'turbulent adolescence' in the early 1980s (Baldry 1981: 147), community arts remained highly experimental. Community artists were forging their practice, their role, and their very job title with levels of innovation, trial and error. Stephen Lacey, who was a community artist in the Midlands in the early 1970s, characterized some of the urges behind the work in the early years of community arts:

> There was a strong sense that one did not want to work inside existing institutions, that the real work would only begin once you stepped outside institutions and started inventing alternatives. That sense of finding the alternative and changing the model, changing the way of working, became increasingly important I think. (Lacey 2012)

Carey Gorney describes her community arts work in Leeds at the time: 'We [forged] new ways of working. The roots of our work [were] not in tried and tested evidence-based practice but in innovation, respect, equality, action research and, above all, in being ourselves' (Gorney 2014: 194). Nigel Leach, who set up Bath Printshop in 1976, gives a sense of the freedom to invent at that time, as well as the eclectic nature of what was on offer from community artists – describing starting up what might be seen as a creative community centre rather than an arts centre: 'I'd found an abandoned building in Bath, got the local authority, the County Council,

to agree to let us have it for a peppercorn [reduced] rent, and set up a community centre in there. We had a print shop, carpentry, boats on the river next to it, little small-holding area, classrooms for kids who had got little or no proper education, discos at night' (Leach 2010). Community artists were compelled to develop a wide range of skills and abilities, something captured by Brian Cross who says that he

> learned through doing, and being and thinking [...] so if I learn how to do that, we could do this [...] learning to talk, to connect with people [...] there we were making badges, we were silk screen printing, we were moving towards photography [...] I became the community artist through doing, you know, there was no job advertised. (Cross 2015)

Artists at the time were not only working in innovative ways but, for many of them, experiments in their own living situations went hand in hand with this creative experimentation. Cathy Mackerras describes setting up Telford Community Arts in 1974 in Telford New Town. Telford Development Corporation provided the project with a rent-free house in which she and Graham Woodruff lived and worked: 'It was a big family house but we had a meeting room, a workshop room. Our drama group started in what was effectively the living room' (Mackerras 2015). Karen Merkel describes leaving Dartington Hall in Devon, where she studied drama, and moving to Burnley to work with Welfare State International to assist the delivery of its work with the community.

> So, this was about 1975 or 1976 and we bought two terraced houses in Burnley with money from The Dartington Hall Trust and we knocked them together. There were eight of us and three of us worked at the local Post Office, and the rest worked for Welfare State teaching the artists' children who were all living in caravans in a quarry. And we did what we would now call community arts or outreach work for Welfare State projects. We weren't paid and eight of us were living on the wages of the three with jobs in the Post Office. It was a fantastic immersion into learning all sorts of things and a couple of the lessons have stayed with me all my life. (Merkel 2012)

Experiments in methodology

Community artists were inventing methodologies and ways of working. Cilla Baynes reports on working with Free Form Arts Trust. 'What was great was that they had a methodology that they developed. When new artists were brought in they also contributed so it wasn't a case of "this is how you do it". It was evolving and I learned a lot from that' (Baynes 2010). Often, ways of working emerged

from practical necessities that threw the community artists back on their own resources and saw them working from instinct. Mary Turner reports on the early work of Action Space in public parks in Wapping, London. Being evicted by the authorities from the parks for attracting young people to their events gave the artists kudos with the young people, and imbued their projects with an anti-establishment edge. Still, the local teenagers called the artists 'the Freaks' and had to be won round by building the challenges that the young people threw at them into the process of working with them (Turner 2012: 20). Crehan describes how Goodrich and Wheeler-Early of Free Form initially set up art workshops as a form of self-defence when big groups of local children besieged the workshop where they were also living. Goodrich describes how they developed work with a nucleus of children where they explored and experimented with a range of art materials in between playing games of football with them (Crehan 2011: 45).

In addition to this very locally situated work, some groups travelled to different locations, using their lack of familiarity there to create a method which used unfinished pieces of art. The idea behind this was to begin something, often a play or a film, and to bring it to communities to enlist their efforts in order to complete it. Cilla Baynes describes an elaborate role play designed to initiate this kind of project in Toxteth, Liverpool, when working with Free Form Arts Trust which was based in London.

> We'd turn up in a street and pretend to be making a film and we'd all have characters – continuity, director, actors and we'd have a fantastic set and all the kids would watch it with their parents. And we'd start shooting the film and then a telegram would arrive saying the rest of the actors, the set, the costumes had been held up in Istanbul! So the director says 'What am I going to do? I can't finish the film!' And, of course, guess what happens – the kids shout 'We'll help you mister! We'll help!' (Baynes 2010)

Following the setting up of this scenario, the community artists worked with several groups over a week to devise the rest of the film, design, and make the costumes and sets after which they shot the film in local locations. This is at the extreme end of this kind of project but the 'unfinished-work' approach was a useful way for artists to introduce themselves to communities and to hold open the possibility of genuine engagement and input, albeit within a certain structure. The legacy of this project and others like it can be traced through the years to the Granby Street Festival in Toxteth and we will come back to this in the Conclusion.

It might now seem unnecessary to state that much of the collaborative work took place in 'workshops' because the term has become ubiquitous. However,

at that time, workshops remained relatively unknown and the writers of 'Campaign for a Popular Culture' (the report on the arts work at the GLC) felt the need to explain: 'A workshop is a session in which people come together to pool ideas, pass on skills and share in the making of things be they performances or works. It is a time when distinctions between the teachers and the taught can be broken down' (GLC Arts and Recreation Committee 1986: 19). Crehan calls workshops central to community arts practice and 'one of the characteristics of community arts' (Crehan 2011: 81). She claims that the technique offered a 'genuine challenge to the production of Art under capitalism' (Crehan 2011: 137) and that for community artists the workshop offered an accessible, democratic space. The choice of the word is interesting when we consider that one of the precedents for community arts was the arts lab, based on Haynes's lab initiative in London. The rejection of the lab in favour of the workshop is perhaps surprising given that the early community artists were mostly coming from a visual arts background but the choice seems apt. Labs are associated with order and cleanliness coming from the scientific roots of the laboratory, quiet spaces where people have set roles which they carry out with calm efficiency, perhaps suggesting a hierarchical environment where the lead researcher sets tasks for the lab workers. Workshops, on the other hand, are messy and noisy, associated more with mechanics or craftspeople, a little chaotic and haphazard. In the performing arts too, labs have stronger associations with 'serious' practices such as those associated with the experimentation of Jerzy Grotowski's theatre laboratory, whereas Joan Littlewood chose to use the term 'workshop' to describe her more eclectic practices.

The importance of play

Play and work with children and young people were an important part of the early work of community artists, and one of the most symbolic sites for this was the adventure playground. These play structures had been imported from Denmark at the end of the Second World War, when they were promoted as 'the playground of the future' (Kozlovsky 2007: 2). Children were provided with materials and tools and allowed 'the pleasure of experimenting, making and destroying structures and environments' (Kozlovsky 2007: 2). Championed in Britain by urban planner Lady Allen of Hurtwood, they were initially built on post-war bomb sites, and in the 1960s and 1970s, they were still sites that were 'never complete […] makeshift and in a state of constant un-development' (Norman 2005). Gerri Moriarty describes setting up an adventure playground

in Chapter 3, but it is worth noting Lacey's suggestion of a connection between play activity and the ways in which play activities acted as a catalyst for other more social developments:

> In 1974 we ran our own summer playscheme for five weeks in the bottom floor of a tower block in Sandwell [in Birmingham]. We supported a group of local mums who were trying to take it on, using the work as a training opportunity to pass on skills and get it going. We also acted as intermediaries between them and the local authority. At the end of the five weeks we staged a sort of Question Time [political TV debate format] between the council officers and the local mothers. The mothers said that they'd like the playscheme to continue and the officers came back about a week later saying that they were going to invest in it. So they established a play centre in that space and employed some of the mothers to run it on a part-time basis. (Lacey 2012)

This is a good example of some of the ways in which community artists hoped that their work with communities would have a wider impact beyond the arts project itself. Working with children through play was often used as a gateway to the wider community and into more direct action and potential social impact that came from this broader mobilization.

Figure 2.2 In at the deep end

Festivals and processions

Other innovative practices were found around the festival and procession form. Work on festivals and processions was often categorized as 'celebratory work' and was used to create highly visible community activity in, sometimes, unpromising surroundings such as large housing estates. Historically, festival activities continue to be common in many towns and cities, usually as an inheritance from the farming calendar and from the public activities of various Christian denominations. Rush-bearing festivals, for example, take place in the north of England, as do Whit Walks where church congregations take to the streets dressed in white accompanied by elaborate church banners and brass bands as a public testimony of faith every Whitsuntide (traditionally the seventh Sunday after Easter). These festivals and processions were joined throughout the 1960s and 1970s by carnival and other traditions brought by migrants from the Caribbean. Mathew Hypolite was the band leader of Hippo's Mas Band and member of Greater London Arts Association's Community Arts Panel and wrote of his hopes for the 'indigenous community' getting involved in West Indian Carnival (Hypolite 1982: 11). Caribbean artists' street and carnival traditions were often eagerly embraced by community artists looking for a different aesthetic and set of practices that could distinguish a community arts festival from a more traditional Western Christian one. For many years, PRESCAP, a community arts project in Preston actively supported the Caribbean carnival there, said to be the biggest in Britain after the Notting Hill Carnival. Similar arrangements between community arts companies and local festival organizers in places like Bristol and Luton proved fruitful with the skills of the makers, in particular, being used to good effect in making the costumes and floats for the processions.

Processions could also be quietly subverted by including more campaigning messages into the traditional form. Thus, Graham Marsden (2010) describes designing and making floats with a political message:

> One women's group was looking at the difficulties of having to take their kids of similar ages to different local schools. So, we made a huge figure of a woman with a great wedge cleaving her in half with actual children on both arms tugging her in different directions. There was a big campaign in Telford to get a hospital so we had a hospital float that was quite carnival-like. The Shropshire Women's Action group wanted to highlight domestic violence so we made a huge Mr. Punch figure which looked like a traditional jolly festival figure but when you got up close you realised he was beating one of the other figures on the float.

Some artists were cautious about these big celebratory projects, worried that they might become 'sanctioned safety valves' like past festivals such as the Lord of Misrule (Foster 1982: 13). Others were more critical that energy and resources were diverted into celebratory work that would be better spent on more overtly political projects. Nevertheless, festivals of many kinds were a strong part of the annual calendar for many community arts companies at this time. Indeed, some continue and the relationship set up in the mid-1980s between Darnhill Festival in Rochdale and Cartwheel Arts still continues.[1]

Links to the labour movement

For artists like Brian Blumer, there was no point in carrying out community arts unless it was explicitly tied into the labour movement despite the fact that it has had a chequered relationship with arts; and, historically, the Labour Party had proved 'lukewarm' about culture (Blumer 1980). Nevertheless, there have been notable periods of interest (Mulgan and Worpole 1986) and one of these was in 1960 when the Trades Union Congress (TUC) signalled its interest in promoting the arts passing Resolution 42 on the subject of 'Promotion and Encouragement of the Arts' which recognized the importance of the arts in the life of the community. Following this, playwright Arnold Wesker organized a series of festivals on behalf of the trades unions in 1961 and 1962 before setting up Centre 42 at the Roundhouse in Camden. Wesker's 'unswerving faith in the empowering potential of high art' (Holdsworth 2011: 211) relates more closely to the democratization of culture than to cultural democracy which is discussed in more detail later in the text. Whether for this reason or not, Centre 42 never fulfilled its early promise and the programme of work there was short lived. In the late 1970s and early 1980s, there was another spike of trade union interest in the arts exemplified by the TUC's Campaign for Economic and Social Advance's Bread and Roses rally in 1980. An interesting initiative led by the Lancashire Association of Trades Councils aimed to place an arts development officer in the trade union movement and Rick Gwilt became the first artist to work within the trade unions' structure. Although Gwilt's work remained an isolated experiment, 'more like an injection than a course of treatment' there were several notable successes that followed it including the setting up of PRESCAP, a community arts company in Preston in 1986 (Higney 1985).

Less isolated was the relationship between the Community Arts Movement and the communities affected by the Miners' Strike of 1984–1985. Steve Trow, who was a community artist in the Midlands, described the strike as equivalent

to 1968 in its importance and impact on community arts (Trow 2012). Brian Cross, a community artist based in Yorkshire, recalled running mobile printing workshops with miners' wives at Woolley colliery 'working in and out of people's houses' (Cross 2015). For Welsh community artist Phil Cope community arts projects 'generated an extensive and vibrant culture in support of the strike' with community artists running printing workshops which generated posters, T-shirts, and badges for the striking miners (Rothwell 1992: 12). However, once again, this seems to be a story of success in the moment that fails to be sustained and it was not possible to build on these networks as the basis for further creative or political activity. Cope suggests that the end of the Miners' Strike not only delivered a blow to the trade union movement 'it also signalled a failure to build on these positive developments, to make the new networks part of a future notion of political activity' (Rothwell 1992: 13). The impact of the Miners' Strike on community arts in Wales is discussed at length by Nick Clements in Chapter 5.

A cross-art platform

Community artists used their work during the 1970s and early 1980s to forge relationships with many different groups using multiple art forms. The work had originated in the visual arts with print and photography prominent, but drama became another dominant mode of expression with community artists drawing from radical theatre traditions and joining these with new devising techniques. Festivals and processions offered the opportunity to combine the making of large figures, costumes, and banners with music and performance. Community arts projects responded to a social need and built on ways to articulate that need and place it before a larger audience. Developments in technology enabled artists to work with portable sound and video recording, adding to the range of possibilities already open through photography and other documentary techniques, extending opportunities for self-representation beyond the usual imposed structures. Political shades of opinion differed widely across the Community Arts Movement but there was a sense of shared articulation around the idea of supporting people who they felt had limited access to cultural expression and the means by which that expression could be formed and amplified and broadcast to the world beyond. Community artists turned their backs on the traditional modes of making and presenting art and tried to find new ways of working and new language to describe what they were doing. They knew that community arts was not about simply making what already existed or

the work that artists made available to more people – what they were beginning to articulate through their practice was a sense of cultural democracy.

Experiments in cultural democracy

One of the most significant aspects of the experimental nature of the Community Arts Movement lies in its attempts to put cultural democracy into practice. Baldry argued that community arts should be seen as an experiment in cultural democracy – 'of great importance not only for the immediate stimulus and enjoyment it can provide, but because its long-term results – or lack of results – will throw light on the question "arts for whom?" which is vital for the future of our society' (Baldry 1981: 147). One of the main threads running through this book concerns the relationship between ideas about cultural democracy and the democratization of culture; what Evrard calls the democratizing paradigm and the democratic paradigm of culture (Evrard 1997). Mulgan and Worpole describe the democratizing paradigm as the 'distribution model' which defines 'the problem of cultural democracy as being simply the distribution of access to culture' whereas cultural democracy tackles the 'problem of what constitutes that culture' (Mulgan and Worpole 1986: 20). In order to explore what both paradigms might entail, it will be necessary to take a short detour into government arts subsidy in Britain, drawing from initiatives that began during the Second World War. Looking at the Travelling Musicians, one specific aspect of government support for the arts in this period, is enlightening because it illustrates clearly how attitudes towards funding and support for the arts were set up and shaped.

Organized state funding for the arts emerged formally in Britain in the 1940s when the new organization, the Council for the Encouragement of Music and the Arts, or CEMA, transformed into the Arts Council of Great Britain. CEMA had been set up during the war in 1939 using money from American charity, the Pilgrim Trust. Its goal was to take all kinds of art out to towns and cities all over the UK that were suffering as a result of the conflict – the 'distribution model writ large' (Mulgan and Worpole 1986: 19). CEMA's main objective was to relieve the 'tedium and over-work in civilian life under the exceptional war-time conditions' (Evans and Glasgow 1949: 49). The formal terms of reference for the organization are summarized by White:

a) The preservation in wartime of the highest standards in the arts of music, drama and painting;

b) The widespread provision of opportunities for hearing good music and the enjoyment generally of the arts for people, who, on account of wartime conditions, have been cut off from these things;

c) The encouragement of music-making and play-acting by the people themselves;

d) Through the above activities, the rendering of indirect assistance to professional singers and players who may be suffering from a wartime lack of demand for their work. (White 1975: 26)

The work of CEMA, therefore, was based on the assumptions that there must be support for artists to enable them to produce high-quality work; that there should be opportunities for as many people as possible to gain access to this work; and that there must also be opportunities for people to create their own art. Readers who are interested in more detailed accounts of CEMA's wartime work should consult (Minihan 1977; Pick 1980; Baldry 1981; Hutchinson 1982; Witts 1998; Weingartner 2006). However, for the purposes of this study, I will focus on one aspect of CEMA's work, the Travelling Musicians, set up by Walford-Davies and taken over by Ralph Vaughan Williams on Walford-Davies' death in 1941. Tracing this initiative through to the end of the war, when CEMA transformed into the Arts Council of Great Britain (the Arts Council), led by J.M. Keynes, will show how attitudes to support for the arts have swung between the goals summarized by White above. The democratization of culture paradigm places stress on three of these: points a, b, and d from the list above – preservation of 'standards', support for professional artists to produce work, and accessibility for audiences to artists' work. The interests of cultural democracy lie in the third point: support for people to make art themselves.

CEMA had initiated the Travelling Musicians programme in 1940, employing six pioneer Travelling Musicians who, in the first six months of that year, set up thirty-seven new orchestral groups and 244 new choral groups in addition to organizing 254 concerts (White 1975: 30). Despite their success, the Travelling Musicians are largely 'written out of the Arts Council chronicles' (Witts 1998: 60). The first six 'pioneer organisers' of music were recruited from the Rural Musical School Council and their salaries paid by CEMA (Weingartner 2006: 63). All were women and professionally trained musicians and vocalists, and they were given a budget and required, as their title suggests, to travel around the country giving and organizing concerts, running classes, and generally being available to encourage a range of musical activities, both amateur and professional. Walford-Davies called them 'working leaders' and set out what he considered their attributes should be (Sheridan 2007: 123):

a) disinterested – enthusiasts 50/50 philanthropic – and music minded and of course 100 per cent public service actuated
b) outstandingly good players or singers themselves, able to give exemplary readings of fine music
c) able to conduct or community-lead
d) able to steer an evening's programme
e) able to get on with all sorts of people and do non-musical jobs in an emergency
f) able to surmount human difficulties

Setting up a kind of catalytic reaction, they were expected to 'leave behind them others who were able to carry on the work they had begun' (Sheridan 2007: 128): a version of this could have formed the job description of any community artist in the 1970s. By all accounts, they were hugely successful in their work and managed to bridge the amateur/professional divide with intelligence and alacrity.

However, the writer of *The Times* editorial in June 1940 was less impressed:

What has such musical propaganda to do with the war? [...] However excellent it may be in itself it clearly will not help such major institutions as the leading orchestras. [...] Is it, in the case of music, to which [CEMA's] title gives special prominence, to strive to uphold existing institutions of the country by making them serviceable to new audiences, or has it an itch to discover a hitherto dormant musicality among the people, while it leaves the art of the orchestra to languish and die? If the latter, then the support of the Treasury may not have been so well bestowed as to deserve the paean with which it was greeted. (Sheridan 2007: 190)

The writer accurately summarizes the double goals of CEMA – to support work by existing artists and to encourage the development of artistic work by 'the people' themselves. However, in his view the two are not compatible. If a 'dormant musicality' is stirred in the people who make up the audiences then, by implication, professional musicians may be starved of audiences and resources. But there is another assumption lurking here, the un-crossable gulf between 'the people' and 'the professionals'. The writer cannot envisage any way in which professional musicians might emerge from 'the people'. This seems to presume that professional musicians cannot be created, cannot emerge from the audience, but must be born into the sort of circles that 'make' musicians and thus the elitist circle of privilege is perpetuated.

J.M. Keynes, the economist who argued for state intervention to rebalance the economy and one of the 'fathers' of the welfare state (Brown 2001), took over

the leadership of CEMA in 1943. Like many early patrons and officers at CEMA, and later the Arts Council, an enthusiastic patronage of the arts, rather than aptitude or playing an active role in the arts, was seen as sufficient qualification to run either organization (Pick 1980). Keynes was known to be critical of 'amateur work', preferring to focus on 'centres of excellence rather than village halls' as Mary Glasgow, the secretary to CEMA, stated in her memoirs (Sheridan 2007: 184). Once in position at CEMA, one of Keynes' first actions was to begin cutting the funds of the Travelling Musicians and reducing the budget for the factory concerts which had been a central part of CEMA's work (Weingartner 2006: 108). The motto for CEMA had been 'the best for the most' and, as the end of the war loomed, Weingartner suggests that London and the nascent Arts Council seemed to champion the best in terms of professionally produced art, while the regions favoured the second, wider access to participation in the arts (2006: 109). CEMA's central office in London proposed increasing the administrative role of the Travelling Musicians, giving them responsibility for organizing professional concerts, while the regional offices were much less keen on reducing opportunities for direct contact with people. The Travelling Musicians were very unhappy with these developments. Speaking of their shock at their changing roles, Sybl Eaton, who was the first one to have been employed when the scheme was set up, asked in a letter, 'why so sudden and so drastic?' (Sheridan 2007: 194). The 'rather inconvenient voice' of Vaughan Williams advocated strongly for amateur activity and tried to block the proposed changes (Weingartner 2006: 107). Community artist Steve Trow identified this struggle between Keynes and Vaughan Williams over the questions of access to the arts as one of the keys to understanding cultural democracy.

> I think you can start with the debate that happened in the Arts Council in 1948. Vaughan Williams's line was that it was all about the arts, all of the arts, all the ways that people engage with the arts. He said '[The Arts Council] can't support everything but we have a unique responsibility to have that breadth of view. And the true benefit that we're trying to deliver is maximum engagement because we believe the arts have value.' Maynard Keynes was emphatic in saying 'No it's not. It is about the best not the most. The principle is we support professional artists. That's our obligation. And our second obligation is to enable others to appreciate, understand and benefit from that.' And that's the model that we know has forever stuck. (Trow 2012)

As CEMA transformed into the Arts Council for Great Britain at the end of the war and various panels were set up to oversee the different art forms, champion

of the Travelling Musicians Vaughan Williams found himself excluded by Keynes from the newly set up Music Panel. A series of bitter arguments granted the Travelling Musicians a stay of execution; but when three of the women resigned, Keynes took the opportunity to announce that the programme would be terminated. The short-lived experiment in balancing access to all aspects of music-making, including encouraging people to make their own music as well as appreciating work by professionals, gives a good example of the range of approaches to access and some intimation of the difficulties of moving towards a more culturally democratic approach.

Discussions on cultural democracy were further developed in the 1970s due to 'problems of community life' brought about by increased urbanization and high-density housing, growing mobility and increased complexity in 'the mechanics of living and working' (Berrigan 1978: 3). Part of the UN, the Educational, Scientific and Cultural Organization (UNESCO) had developed from meetings held by European ministers for education during the Second World War with a view to rebuilding educational systems once the war was over. In 1970, Francis Jeanson of UNESCO wrote that cultural democracy

> points to a culture in the process of becoming, as opposed to one that is stagnant, already there, ready-made, a sort of sacred heritage which it is only a matter of conserving and transmitting. It even rejects – or at any rate goes way beyond – the naïve idea of a more just, more 'egalitarian' division of cultural heritage. (qtd. Adams and Goldbard 1982,1996: 3)

In 1978, a publication produced for the Council of Europe symposium 'Animation in New Towns' suggested that

> a cultural democracy is one in which no pre-selection of cultural and artistic forms is made, to be spread thinly throughout the country; what is intended is that cultural forms which arise from, and are based in the community, are encouraged. It does not rely upon local imitation of established national models, but on the creation at the local level of opportunities for participation in cultural and artistic activities relevant to a particular social and physical environment. (Berrigan 1978: 3)

At the Helsinki UNESCO Intergovernmental Conference on Cultural Polices in Europe in 1972, English critic Raymond Williams collaborated with Augustin Girard and V.S. Kruzhkov on a presentation called 'Larger Access to and Participation in Culture'.[2] Girard, Williams, and Kruzhov underlined the importance of the statement in the Universal Declaration of Human Rights that

'everyone has the right freely to participate in the cultural life of the community, to enjoy the arts and to share in scientific advancement and its benefits' (Girard et al. 1972). They were responding to the situation whereby the rising standard of living in Europe, the spread of education, increase in leisure time and the developments in the mass media had proved something of a double-edged sword for the continent. While advantageous to many, these successes had been built on the back of increased industrialization and urbanization, where the 'acceleration of change has transformed notions of value by blowing apart the closed systems of the village, the family, occupations, beliefs etc., more than ever before' (Girard et al. 1972). Girard was mainly responsible for introducing the term 'animation', 'a process in which individuals, small groups or larger communities are activated or animated to create for themselves and their neighbours improved social, physical, cultural or emotional settings' (Berrigan 1978: 3). Challenging living environments could be ameliorated by 'cultural promotion' where *animateurs* acted as 'mediators between people, and between people and works of art, decoders of the mysteries of creation, inciters of interactions, and developers of collective talents' (Girard et al. 1972). The public authorities were seen as the main providers of cultural activities in 'drawing up a cultural policy, in the actual work undertaken and in the management of institutions' whereby 'a true cultural democracy' would institute full democracy (Girard et al. 1972).

At the end of the 1950s, in *Culture and Society 1870–1950*, Williams had set out to investigate culture 'with all of its complexity of idea and reference' as a response to 'new methods of industrial production', as connected with 'new kinds of personal and social relationship', and as a response to 'the new political and social developments' (Williams 1958: 17). He suggested that where, historically, culture had meant a habit or a state of mind, or a 'body of intellectual and moral activities' it had more recently come to mean 'a whole way of life' (Williams 1958: 18). To understand a society, he argued, it is not only important to look into its literature but also to 'history, building, painting, music, philosophy, theology, political and social theory'; but if we are wise, we will also examine 'experience that is otherwise recorded: in institutions, manners, customs, family memories' (Williams 1958: 248). By taking this more anthropological approach to culture, Williams helped artists to see 'culture as a continuous action' rather than as an aesthetic discussion of even a series of artifacts' (Morgan 2003: 139). This made it possible to conceive of 'working-class culture', for example, not as 'proletarian art' but as 'the basic collective idea, the institutions, manners, habits of thought and intentions' seen in 'the collective democratic institution, the trade unions, the cooperative movement, or a political party' (Williams 1958:

313). These ideas may seem commonplace now but, at the time, liberating the idea of culture from its narrow associations with 'the fine arts' was revolutionary. However, older ideas of culture still linger, and even today, it is possible to describe someone as 'cultured' as a residual gesture intended to indicate their knowledge and appreciation of the so-called high arts.

There is evidence of a fruitful relationship built around thinking on cultural democracy between community artists in the UK and their counterparts in the United States. In the 1980s, American community artists visited community arts projects in Britain, including one in Glenrothes, Fife, in Scotland where 'town artist' David Harding was working (Adams and Goldbard 2005: 60). In 1982, Andrew Duncan from Free Form Arts Trust in London was invited to speak at the sixth annual Neighborhood Arts Program National Organizing Committee (NAPNOC)[3] conference in Omaha where he described 'a range of project models that had considerable influence on his American listeners' (Adams and Goldbard 2005: 61). Duncan related his experiences of this visit in an article called 'Voice of America' (Duncan 1983). In 1983, NAPNOC renamed its organization the Alliance for Cultural Democracy, and in 1986, Karen Merkel from Cultural Partnerships, a community arts company in London, remembers speaking at Imaginaction, their tenth annual conference in Boston (Merkel 2015). In the United States, the Alliance for Cultural Democracy wound up in 1994; the British Campaign for Cultural Democracy was to be more short-lived.

In the early 1980s, a group of community artists had begun to discuss the ways in which 'community arts' had been co-opted by funding bodies, government, and other monopolies. They felt that there was a need for cultural democracy to take over from community arts and, in March 1985, a special meeting of the members of the Shelton Trust met to plan a strategy by which to achieve this (Burgess and Cope 1985: 4). By this stage, the community artists involved were of the opinion that democratic government could only be built on a cultural democracy; in the words of artists in Valley and Vale, 'in order to achieve true political democracy it is necessary also to achieve cultural democracy' (Morgan 1995: 19). The aim of cultural democracy 'must be to organize the production of ideas and images in ways, and in amounts, which allow for participation, reaction and response' (Burgess and Cope 1985: 2). Furthermore, in a cultural democracy, 'ideas and images will flow out of communities (which are deemed of equal importance) and are distributed upwards, where necessary, through federated networks' (Burgess and Cope 1985: 2). This shift in emphasis, taking in distribution as much as production, was a key concern of community artists. Ideas about creation and distribution were taken up in four 'On the Road'

seminars organized by the Shelton Trust which attempted to connect with as many community artists as possible across the country. These focused on first principles, legal structures, collective production, and distribution and reception. Focusing on distribution was part of a conscious reaction against the mass market and a growing interest in celebrity. Community artists wrestled with the fact that, while much community arts activity was local in its execution, there was a desire to extend the reach of the work promoting its political messages. The Shelton Trust organized a conference, 'Another Standard '86, Culture and Democracy' for July 1986, the purpose of which was to debate the ideas of cultural democracy, analyse their practical potential and establish a number of campaigning activities to get cultural democracy onto the political agenda (Another Standard 1986).

The conference was held in Sheffield and included speeches from representatives from Ireland, the United States, Chile, and Nicaragua as well as a number of British speakers. Delegates were each given a copy of *Another Standard 86, Culture and Democracy The Manifesto* (Kelly et al. 1986). This was in two sections, the first one outlining 'The State We're In' and the second part called 'Another Standard'. The booklet had high production values and had been formally published by Comedia. To many delegates this felt less like a discussion document and more like a *fait accompli* and some struggled with its 'complex style and language used' (Stephens 1986). Discussing the manifesto in an interview for this book, Kelly explained the thinking of the artists who had assembled it:

> We felt 'let's put something out that really excites people'. We didn't want it to be a roneoed document of twelve pages, like a teenager writing poetry. We wanted something that looked like a serious work. We made a big effort to make it look snazzy but that meant that unfortunately some people felt overwhelmed, or felt they couldn't contribute. (Kelly 2013)

For community artist Sally Morgan, it was too far removed from the earlier draft charter for cultural democracy which captured 'the clarity of our aims and the complexity of our modes of action' and which stated:

> Let us tell the story … We believe that people have the right to create their own culture. This means taking part in the telling of the story, not having the story told to them.
>
> This story is ours … We believe that people have the right to put across their own point of view in their own particular way. This means not being told to do this by people who don't understand it.

> Now listen to our story... We believe that people should have the right to reply. This means that people should have equal access to resources to give them an equal voice. (Morgan 1995: 24)

Although it is not clear from Morgan's account exactly when and how the first draft was drawn up, the manifesto as it appeared at the conference in Sheffield in 1986 was a much more obviously left-leaning political document challenging the monopolizing power of the market, capitalism's rapaciousness, and a growing professional class (Kelly et al. 1986) and many delegates felt alienated and disappointed. Following resolutions made at the national conference in Sheffield in 1986, the Shelton Trust renamed itself Another Standard but found that the newly emerging organization 'was in breach of its articles and had to be wound up' (Morgan 1995: 25). For Morgan, the loss of the Shelton Trust/ Association of Community Artists resulted in the loss of a national voice as 'the ideological side of the movement all but disappeared as a cohesive force' (Morgan 1995: 25). This placed the Community Arts Movement in a vulnerable position where artists were less able to stand up to funders and other outside bodies and, in effect, signalled the end of community arts as a coherent movement with national ambitions. Although the Campaign for Cultural Democracy may have stalled in that moment, as a concept cultural democracy continues to play a vital, if often unrecognized, role in thinking about the relationship between art and people.

Many of these ideas will be picked up again in Chapter 7 which introduces Part Two of this book, when we look in more detail at some of the legacies of the Community Arts Movement. The rest of Part One of the book is devoted to accounts of the developments of community arts in specific locations of England, Wales, Scotland, and Northern Ireland. Gerri Moriarty's chapters outline her work as a community artist in different locations in England and her chapter on community arts practice in Northern Ireland concludes the first part of the book. Andrew Crummy from Scotland and Nick Clements from Wales take account of community arts from their particular national perspectives. All accounts are situated within the practices and companies that these artists were most familiar with though they have also tried to give a sense of how the work that they discuss might sit within the wider picture in their location at the time. All writers take up the question of the legacy of this early work in an attempt to show how the work begin in the late 1960s and developed throughout the 1970s and 1980s can be viewed through a contemporary lens.

Notes

1 http://www.cartwheelarts.org.uk/ (accessed 1 July 2016).
2 This symposium was also attended by Graham Woodruff who went on to set up Telford Community Arts and Helen Crummy who developed Craigmillar Festival Society as described by Andrew Crummy in Chapter 4.
3 NAPNOC is the American equivalent of the Association for Community Artists (ACA).

References

Adams, Don, and Arlene Goldbard. 2005. *Creative Community. The Art of Cultural Development* (Rockefeller Foundation: California).

Adams, Don, and Arlene Goldbard. 1982, 1996. *Animation: What's in a Name?* http://www.wwcd.org/action/action.html (accessed 19 July 2016).

Another Standard. 1982. *The Arts Council after Devolution* (The Shelton Trust: London).

Another Standard. 1983. *A Nasty Case of the Hierarchies* (The Shelton Trust: London).

Another Standard. 1986. *Surfing on the Tidal Wave of History* (The Shelton Trust: London).

Baldry, Harold. 1981. *The Case for the Arts* (Secker and Warburg: London).

Baynes, Cilla. 2010. Interview with Alison Jeffers and Gerri Moriarty.

Beck, Antony. 1989. 'The Impact of Thatcherism on the Arts Council', *Parliamentary Affairs*, 42: 362–79.

Berrigan, Frances. 1978. *Animation' Projects in the UK Aspects of Socio-Cultural Community Development* (Council of Europe: Leicester).

Bishop, Claire. 2012. *Artificial Hells. Participatory Art and the Politics of Spectatorship* (Verso: London and New York).

Blumer, Brian. 1980. 'Community Arts and the Labour Movement', in Bernard Ross, Sally Brown and Sue Kennedy (eds.), *Community Arts Principles and Practices*, 18–19 (The Shelton Trust: London).

Brown, Derek. 2001. '1945–1951: Labour and the Creation of the Welfare State', *The Guardian*, March.

Burgess, Sybil, and Phil Cope. 1985. 'The Shelton Trust Annual Report 1984–1985', in *Another Standard*, 1–4 (The Shelton Trust: London).

Crehan, Kate. 2011. *Community Art. An Anthropological Perspective* (Berg: London and New York).

Cross, Brian. 2015. Interview with Alison Jeffers.

Duncan, Andrew. 1983. 'Voice of America', in *Another Standard*, 16–17 (The Shelton Trust: London).

Evans, Ifor B., and Mary Glasgow. 1949. *The Arts in England* (The Falcon Press: London).

Evrard, Yves. 1997. 'Democratizing Culture or Cultural Democracy?', *The Journal of Arts Management, Law and Society*, 27: 167–75.

Foster, Chris. 1982. 'Lord of Misrule', in *Another Standard*, 12–13 (The Shelton Trust: London).

Freeman, Jo, and Victoria Johnson. 1999. *Waves of Protest. Social Movements since the Sixties* (Rowman and Littlefield Publishers Inc.: Lanham, Boulder, New York and Oxford).

Girard, Augustin, K.S. Kruzhkov, and R. Williams. 1972. 'Larger Access to and Participation in Culture', in *Intergovernmental Conference on Cultural Policies in Europe* (UNESCO: Helsinki, Finland).

GLC Arts and Recreation Committee. 1986. 'Campaign for a Popular Culture' (Greater London Council: London).

Gorney, Carry. 2014. *Send Me a Parcel with a Hundred Lovely Things* (Ragged Clown Publishing: London).

Hewison, Robert. 1986. *Too Much. Art and Society in the Sixties 1960–1975* (Methuen: London).

Higgins, Lee. 2012. *Community Music in Theory and in Practice* (Oxford University Press: Oxford).

Higney, Clare. 1985. *Not a Bed of Roses. Arts Development Officer in the Trade Union Movement* (The Gulbenkian Foundation: London).

Holdsworth, Nadine. 2011. *Joan Littlewood's Theatre* (Cambridge University Press: Cambridge).

Hutchinson, Robert. 1982. *The Politics of the Arts Council* (Sinclair Brown: London).

Hypolite, Mathew. 1982. 'MAS!' in *Another Standard*, 11 (The Shelton Trust: London).

Itzin, Catherine. 1980. *Stages in the Revolution. Political Theatre in Britain since 1968* (Methuen: London).

Kelly, Owen. 1984. *Community, Art and the State: Storming the Citadels* (Comedia: London).

Kelly, Owen. 2013. Interview with Alison Jeffers and Gerri Moriarty.

Kelly, Owen. 2016. Personal Communication.

Kelly, Owen, John Lock, and Karen Merkel. 1986. *Culture and Democracy. The Manifesto* (Comedia: London).

Kosecik, Muhammet, and Naim Kapucu. 2003. 'Conservative Reform of Metropolitan Counties: Abolition of the GLC and MCCs in Retrospect', *Contemporary British History*, 17: 71–94.

Kozlovsky, Roy. 2007. 'Adventure Playgrounds and Postwar Reconstruction', in Marta Gutman and Ning de Coninck-Smith (eds.), *Designing Modern Childhoods: History, Space and the Material Culture of Children. An International Reader* (Rutgers University Press).

Lacey, Stephen. 2012. Interview with Alison Jeffers and Gerri Moriarty.

Landry, Charles, Paul Morley, Russell Southwood, and Patrick Wright. 1985. *What a Way to Run a Railroad. An Analysis of Radical Failure* (Comedia: London).

Leach, Nigel. 2010. Interview with Alison Jeffers and Gerri Moriarty.

Mackerras, Cathy. 2015. Interview with Gerri Moriarty.

Marsden, Graham. 2010. Interview with Alison Jeffers and Gerri Moriarty.

Marwick, Arthur. 1998. *The Sixties* (Oxford University Press: Oxford).

Merkel, Karen. 2012. Interview with Alison Jeffers and Gerri Moriarty.

Merkel, Karen. 2015. Personal Communication with Alison Jeffers.

Minihan, Janet. 1977. *The Nationalization of Culture. The Development of State Subsidies in the Arts in Great Britain* (New York University Press: New York).

Moore-Gilbert, Bart, and John Seed. 1992. *Cultural Revolution? The Challenge of the Arts in the 1960s* (Routledge: London).

Morgan, Sally. 1995. 'Looking Back Over 25 Years', in Malcolm Dickson (ed.), *Art with People* (AN Publications: Sunderland).

Morgan, Sally. 2003. 'Beautiful Impurity: British Contextualism as Processual Postmodern Practice', *Journal of Visual Arts Practice*, 2 (3): 135–44.

Mulgan, Geoff, and Ken Worpole. 1986. *Saturday Night or Sunday Morning? From Arts to Industry – New Forms of Cultural Policy* (Comedia Publishing Group: London).

Norman, Nils. 2005. *Pockets of Disorder. The History of Adventure Play*, http://www.cityprojects.org/cityprojects_content.php?id=167&i=11 (accessed 19 July 2016).

O'Gorman, Siobhan, and Charlotte McIvor (eds.). 2015. *Devised Performance in Irish Theatre: History and Contemporary Practices* (Carysfort Press: Dublin).

Phillips, John. 1983. 'Barriers and Gateways', in Cilla Baynes, Phil Cope, Chris Humphrey, Owen Kelly, and Karen Merkel (eds.), *Friend and Allies* (The Shelton Trust: Salisbury).

Pick, John. 1980. *The State and the Arts* (City University, Centre for the Arts: London).

Pinhorn, Maggie. 2014. Interview with Alison Jeffers and Gerri Moriarty.

Rigby, Ross. 1982. *Community Arts Information Pack* (The Shelton Trust: London).

Rittner, Luke. 1986. *41st Annual Report and Accounts 1985/1986* (Arts Council of Great Britian: London).

Ross, Bernard, Sally Brown, and Sue Kennedy. 1980. 'Community Arts Principles and Practices', The Shelton Trust: London.

Rothwell, Jerry. 1992. *Creating Meaning. A Book about Culture and Democracy* (Barry: Valley and Vale).

Sheridan, David Allen. 2007. '"Give Us More Music": Women, Musical Culture and Work in Wartime Britain, 1939–1946', PhD thesis, University of Southern California.

Stephens, Jenny. 1986. 'A Weekend in the Life of a Cultural Activist: Another Standard' '86 Culture and Democracy', *Mailout,* September.

Trow, Steve. 2012. Interview with Alison Jeffers and Gerri Moriarty.

Turner, Mary. 2012. *Action Space Extended* (Action Space Mobile).

Weingartner, Jorn. 2006. *The Arts as a Weapon of War. Britain and the Shaping of National Morale in the Second World War* (Tauris Academic Studies: London).

White, Eric W. 1975. *The Arts Council of Great Britain* (Davis-Poynter: London).

Williams, Raymond. 1958. *Culture and Society 1780–1950* (Penguin: London).

Witts, Richard. 1998. *Artist Unknown. An Alternative History of the Arts Council* (Warner Books: London).

Community Arts – a Forty-Year Apprenticeship: A View from England

Gerri Moriarty

Training is not limited in time, it is permanent.

Jean Hurstel, Montbéliard[1]

First stages: Learning to build a framework

On the day in 1974 that I walked round the Gorwell estate in Barnstaple in North Devon for the first time, the rows of council houses perched on the hillside overlooking the town were being rattled by a vicious wind and lashed by driving rain. This was a great piece of good luck because it was difficult for people to shut the door on a drenched human being, even if she was introducing herself as a 'community artist'. It is arguable that I owe the whole of my working life to the generosity of the women who invited me into their houses to have a cup of tea and listened, with some amusement, to what I had to say for myself. At the age of twenty-two I had been offered my first full-time job by the Beaford Centre, a rural arts centre, which was based in the small village of Beaford and had been founded by John Lane, the author of *Arts Centres: Every Town Should Have One* (Lane 1978). I had impressed the recruitment panel by my ability to lead an entire North Devon pub in community singing on the evening before my formal interview – although this owed far more to my injudicious consumption of local scrumpy than my powers of communication. Working alongside Ros Rigby, who had founded the Beaford Centre Community Arts Project, I was expected to be the 'urban wing' of the organisation, working with the residents of the Frankmarsh and Gorwell estates.[2] And my first discovery had been that there was no easy way to get in touch with these residents; there was no youth

club, no community centre, no playgroup, no church hall, no place for residents to meet, socialise, and organize. I was out on the streets, knocking on doors, as that appeared to be my only option.

For someone as inexperienced as I was at the time, it was a daunting place to start but it was critical to my development as a community arts practitioner. I talked very little and I listened a lot. My work became informed by the everyday difficulties and concerns of local people; I did not try to create a plethora of arts activities and expect people to turn up to take part in them. I tried to engage with and contribute my skills to the existing cultural life of the community; I did not try to drag an unwilling and disinterested community into 'my' version of culture. Listening to the women living on the two estates, it became apparent that the lack of communal meeting facilities – and especially play facilities – was a major problem for them. I began with what I already knew from working on Balsall Heath Adventure Playground and with Telford Community Arts in Birmingham; we built an adventure playground on the estate and then ran summers of arts-based activities for children and young people, transforming the recycled structures we had created into ships, rockets, castles, and caves. The 1977 Beaford Centre Community Arts Project Annual Report describes one event as having an 'emphasis on fun for all. On Frankmarsh/Gorwell playground last year, St. George's Day went space-age. The huge junk dragon built by the kids was chased across space by St. George and his spaceman army and finally slaughtered after a bloody battle'.[3]

My use of the pronoun 'we' is significant; I did not build the adventure playground, nor did the staff of the Beaford Centre. I co-ordinated a large-scale collective endeavour on both estates. A father created a design for the playground, local builders and carpenters volunteered their time to construct it, local businesses donated materials, and the probation service organized ex-prisoners to help out with some of the tasks. What I contributed was my experience of creating drama outdoors and collaborating with other artists, such as musicians and puppeteers, to support a programme of arts workshops and events. These activities were supplemented by local residents who organized treasure hunts, picnics, competitions, and obstacle races. It turned out to be an important lesson for me in how to create the conditions for community involvement. This was a theme that was to run right through my practice, whether I was devising a community play or building an organization; I would try to find frameworks that encouraged as many people as possible to make creative contributions to the process. I had learned very quickly that, although it is fine to be an expert in some things, if you try to be expert in all there is no room for anyone's creativity to flourish but your own.

At the same time as I was developing my practice and finding a range of ways of working in and with communities, I was receiving my first lesson in the politics of cultural development. Once every few months, I travelled to London, to national meetings of the Association of Community Artists (ACA), which was involved in a long-running campaign to gain recognition and funding for community arts from the Arts Council of Great Britain (ACGB). The then Secretary-General of the Council Roy Shaw, described as 'the arch enemy of community arts',[4] commented that for ACGB to agree to our proposals would be for it to play the part of the householder in Max Frisch's play *Biedermann und die Brandstifter*, who invites arsonists to set up home in his attic, with dreadful but inevitable consequences. Shaw was vigorously attacked for this view in an article in *The Spectator*:

> Why would Sir Roy be currently intimidating community artists by complaining that they 'consistently bite the hand that feeds them' and that because of this the Council will soon be considering whether it can continue to subsidise artists in order to have them critical of itself or of the state. The analogy Sir Roy provides for this situation comes from a play in which a middle-class muddler goes on being polite and helpful to two arsonists who have designs on his house. While I can heartily endorse Sir Roy's vision of himself at the Arts Council as a middle-class bungler (if not a very helpful one), the flaw in casting Community artists as arsonists is that they at least part-own 'his' house, whilst having positively no assurance on it.[5]

But there was truth in Shaw's warning. Community artists *were* engaged in trying to subvert establishment notions of what the term 'culture' signified, what forms of art should receive public funding, where arts activities should take place, who should have the opportunity to take part in the process of creation and whose voices, stories, and ideas should have a platform for expression.

One of our major arguments was that the ACGB, and the organizations it funded, was not fulfilling the terms of the Council's Charter of Incorporation, as revised in 1967. It was not, we believed, increasing 'the accessibility of the arts to the public throughout Great Britain'.[6] It was serving the needs of a section of society that was largely white, middle-class, and London-centric. We wrote lengthy submissions and hosted visits for the Community Arts Working Group set up in 1974 under the chairmanship of Professor Harold Baldry to consider whether or not the Arts Council should fund the kind of work we were doing. Professor Baldry was impressed, commenting in a meeting with ACA that I attended that community arts practice reminded him of the construction

processes used to build medieval cathedrals; buildings that were created not by one artist, or even by a group of artists, but by hundreds of people with different skills working together collaboratively and purposefully.

Political campaigns are won as much by powerful images and metaphors as by logical arguments. One of the best visual images of that time was co-ordinated by Martin Goodrich of Free Form Arts Trust, who drilled a number of ACA members and supporters in a Chinese Placard demonstration on the pavement opposite 105 Piccadilly Gardens, the offices of ACGB.[7] Each of us carried an individual placard, which fitted together to make a huge image; on one side, there was a profusion of golden dandelions surrounding a single rose, dripping poison and covered in thorns. On the other side a slogan read 'Never Mind the Roses, Fund the Dandelions'; perhaps an oblique reference to the proposal, in 1951, by ACGB's the then Secretary-General William Emrys Williams that the Council should fund 'few, but roses' (Harvie 2005: 18). In 1975, ACGB, somewhat reluctantly, set up a Community Arts Panel with Professor Baldry as its Chair, for an experimental two-year period and Graham Woodruff from Telford Community Arts, Nigel Leach from Bath Printshop, and Maggie Pinhorn from the Association of Community Artists were among its first members. The attic had been successfully infiltrated.

Figure 3.1 Fund the dandelions

Meanwhile, back in North Devon, we had moved from our small Barnstaple office, shared with another voluntary sector organization, North Devon Community Action, to a much bigger building, a disused sub-post office. I had been joined by visual artist Diana Murray, whose skills and experience complemented my performing arts background and thanks to her and to volunteer Philip Trick, who built a dark room and a range of silk-screen equipment for the project, we were able to add printing, photography, and video to the range of art forms we were able to offer community groups and individuals. The 'video' section in the 1977 Annual Report gives a useful insight into our priorities and preoccupations. We had borrowed video equipment for a month in the summer of 1976 and had made five short films, described thus:

- An information film made for North Devon Play Association outlining the activities offered by the nine member playschemes.
- A film scripted by and filmed with adult residents living on the Chivenor estate to communicate the problems of the estate and outline the solutions they proposed to outsiders and local authorities.
- A film made by sixteen- and seventeen-year-olds in the small town of North Tawton. This experimented with sound and visual images to highlight the lack of provision for young people.
- Younger children in Frankmarsh/Gorwell performing an impromptu circus
- A film showing professional arts company Major Mustard performing on the Frankmarsh/Gorwell playground.[8]

We announced in the report that we had just received a grant from South West Arts to buy our own video and Super 8 film equipment and say that this will help us to work with groups 'to make films of an archival nature, to explore the creative potential of video and to communicate information'.

The 1977 Annual Report is also revealing in what it has to say about income and expenditure. I suspect that, in those early years, my only reference point in terms of financial management was that offered by Charles Dickens' Mr. Micawber in *David Copperfield*: 'Annual income twenty pounds, annual expenditure nineteen pounds nineteen and six, result happiness. Annual income twenty pounds, annual expenditure twenty pounds nought and six, result misery.' The organization's income for the year was £9,827 and its expenditure was £9,826 (roughly the equivalent of £53,000 in 2016). We had, however, already understood the necessity of developing an income from different kinds of funding sources; ACGB were providing 36.5 per cent of our income, local authorities 36.5 per cent and the Elmhirst Trust 20 per cent. We were generating 6 per cent through sales of our services and 1.5 per cent had been donated by local industry.

In those first four years of my working life, I had a freedom to experiment and a freedom to fail, that would be unimaginable to many contemporary practitioners. My remit was broad and vague and nobody told me how I should be fulfilling it – because nobody really knew, including me. On summer evenings, for example, we thought nothing of piling the members of the young people's drama group into our van and driving to Ilfracombe beach to play drama games. No one asked us how exactly this met ACGB's strategic goals, whether we had carried out adequate risk assessments or even who was actually participating in our projects and programmes. We organized opportunities for local people to attend performances and workshops by professional performers like the mime artist Nola Rae and former Ballet Rambert dancer Peter Curtis and arts organizations such as Northern Black Light and London Contemporary Dance. We turned Chivenor Community Centre into a Haunted House for Hallowe'en; we used the government's Manpower Services Commission Youth Training Scheme to employ four young people to act as an arts support group to tour playschemes; we helped design and print campaign materials; we worked with local activists and an energetic local councillor to establish a community centre for Frankmarsh and Gorwell, and we helped Swimbridge Youth Club develop their own pantomime. We were close to our local communities and highly responsive to their needs.

In those years, I learned other lessons that would have a major influence on how my work developed. I began to understand that it was not enough to work at the grass roots; it was also necessary to identify the sources of power and holders of resources in order to be able to challenge or influence their policies. I would go on to work in a range of ways with Arts Councils, Regional Arts Associations, local authorities, and trusts and foundations as external consultant, facilitator, board member, and agent provocateur, as part of my contribution to the long-term development of community arts practice in the UK.

In the 1970s, we did feel that we were part of something bigger than just a tiny organization working on the western edge of England. We attended national community arts conferences in Newcastle, Sheffield, and Liverpool – the Beaford Centre Community Arts Project hosted one in Barnstaple in 1980 – and we met up regularly with other regional arts practitioners as members of South West ACA. Were we part of a movement? If the definition of a movement is that it has a common philosophy or goal, I am uncertain. We certainly shared a desire to change the established order, but there were major differences of view about how it might be changed and about what the future could or should look like. Sometimes, it felt more like being a member of a nomadic and anarchic tribe

that lived for most of the time in small groups in landscapes as varied as the desert and the sea, the forest and the city, coming together on ritual occasions to renew our vows, plot against our enemies and tolerate, to a greater or lesser extent, each other's various eccentricities. In the South West, for example, as well as the Beaford Centre, our members included Medium Fair (a rural touring theatre company), Staverton Bridge (a folk music trio), and Bath Printshop, which hosted a truant school and acted as what founder Nigel Leach describes as 'a community centre, quite a lot of the time for the black community in the area, who had no community centre at all' (Leach 2010). We were an eclectic mix of practitioners who had an instinctive sense of affinity for each other's work.

Practising my craft

In 1979, I left North Devon to become the first worker for a new organization, High Peak Community Arts (HPCA), located in an area on the outskirts of Greater Manchester, in northwest Derbyshire. I was attracted by the idea of being involved right at the start of something, with everything that it implied in terms of building core principles and ways of working and by the fact that the idea for HPCA had come from local people encouraged by Oliver Bennett, who was the first of North West Arts Association's Community Arts Officers.[9] I also had a sense of being in the middle of an apprenticeship to community arts – I needed to both practise my craft and extend my experience. HPCA offered me other tangible attractions, over and beyond that of a welcome pay rise. North West Arts Association and its Director Rafe Gonley had the reputation of being sympathetic to community arts (not something that could be said of the equivalent regional body in the south west of England) and the High Peak area, which was made up of post-industrial mill towns and rural villages, had a stronger community development infrastructure, as evidenced by the composition of HPCA's first management committee, which included senior youth workers, adult education co-ordinators, teachers, and local artists.

From those early years at High Peak Community Arts, three projects stand out in my memory as illustrations of the kind of work we were doing. *Kick One and They All Limp*, which we produced in 1982, began as a creative response to an issue in one of the larger towns in the area, New Mills. The youth club, which was located on the edge of the town, had an uneasy relationship with the rest of the community; the young people who attended it were regarded as 'troublemakers' by most residents, while the young people felt alienated from their wider social

environment. With the support and encouragement of the senior youth worker, we proposed a community play, which would involve young people and adults in researching, devising, and performing an epic narrative based on the working-class history of this former mill town. This would not be a play presented by professional actors with a community chorus. The performers were all local people, young and old, although we worked with two excellent professional folk musicians, Steve Ellis and Dave Praties, to write a set of songs for inclusion in the play. This was the first community play I would direct – there were to be many more – and it consolidated my understanding of the power of creating a basic artistic scaffolding which offers the space for people to contribute ideas, develop content, and use their expertise, knowledge, and skills to bring a concept into reality. The residents of New Mills authored the play through research and practical workshops; I brought my knowledge and expertise to help shape the piece and bring it to audiences. It was a work that today would be described as co-created and co-produced.

This was also an example of intergenerational arts practice, long before I had ever heard people use the term. I remember, for example, Stephen Evans, owner of the local printing firm Kinder Press, who was then in his nineties, telling a small group of youth club members of seeing people having to enter the workhouse. His description of the reality of this appalling social policy taught us all far more than any history teacher ever did. We also used the many challenges of producing the play to encourage adult residents of the town into the youth centre, which few had visited before. For example, a key scene in the play involved the controversial decision of the nineteenth-century town council to build an expensive bridge across the River Torr; we persuaded the then town council to play the parts of their predecessors. I like to think that Brecht might have appreciated our attempt at a *verfremdungseffekt* or alienation effect; our audiences certainly appreciated the tongue-in-cheek invitation to compare and contrast the behaviour of nineteenth- and twentieth-century politicians. The youth club members, on the other hand, got considerable enjoyment from listening to me berating adult politicians for not learning their lines.

Our 'Suitcase Circus' programme, which we ran for several summers in different parts of the High Peak, also made as much use as possible of the skills and talents of adults, although it was aimed primarily at young people. Liz Mayne, who had succeeded Oliver Bennett as North West Arts Association's Community Arts Officer, approached HPCA in 1980 to ask whether we would be prepared to host a visit from Reg Bolton, a pioneer of circus for young people, who was then based in Edinburgh. We spent one summer learning from Reg's

inspiring philosophy and practice; it was immediately clear that young people loved the circus genre which is physical and placed them at the centre of the action and in control, rather than unempowered and marginal. When Reg left us, we decided we would create our own High Peak Suitcase Circus. We trained a core group of young people as performers, with skills in unicycling, juggling, stilt-walking, and clowning, and some of these young people quickly became assistant workshop leaders. Their primary purpose was to begin our summer 'residency' in a village or town with a show, giving a dazzling display of what it was possible to achieve. We would then begin work with children and young people of all ages, with the aim of helping them produce their own mini-circus at the end of a fortnight or three weeks. Parents and adult friends were encouraged to get fully involved – designing and making costumes, making stilts and bean bags for juggling, printing posters, or helping prop up novice unicyclists until they found their balance. The residency would culminate, not just in a community circus event, but in a celebration of community; it was a worked example of what could be achieved when children, young people, and adults collaborated with a common goal. The *Buxton Advertiser*, writing about a performance at Chinley Youth Club describes it as an *experiment turned into a victory*[10] and in a revealing reference to the prevailing adult view of young people in the 1970s and 1980s added that 'it was hard work; but the end result getting applause instead of a clip round the ear for messing about – was well worth it.'[11]

In Reg Bolton's obituary, community artist Tina Glover wrote of him:

> Following a short time studying at l'École Nationale du Cirque in 1977, he wrote 'It was clear I was not cut out to be a great circus star [...] my orang-utan arms would never straighten into an elegant handstand' and decided to create his own circus school 'where elegance and perfection would not be the only criteria'. (Glover 2006)

One of the most joyous aspects of High Peak Suitcase Circus' work was that everyone who wanted to be included *was* included, even if this meant working out an acrobatic routine for twenty under-eight-year-olds or finding a way to make someone who could barely totter on their stilts look like an accomplished clown. Although some of our participants were indeed elegantly skilled, many were not. In his PhD thesis, 'Why Circus Works,'[12] Reg outlines the developmental elements necessary for positive childhood and adolescent experiences – self-invention, self-design, and individuation; fun, play, laughter, and happiness; risk and adventure; dreaming and aspiration; trust, touch, and confidence; hard work, application, and ingenuity – and explains how circus can help provide

these developmental elements. It was our experience that this is exactly how creating circus benefitted not just our young people but also their communities, helping adults to see young people with fresh eyes and fully appreciate the scale of their creative potential.

The final HPCA project I want to discuss is *Firefox*, a site-specific event, which took place in 1983, towards the end of my time with High Peak Community Arts. I had persuaded two visual artists who specialized in pyrotechnics, Neil Canham and Tom Thompson, to help us produce a fire show for New Mills for Bonfire Night. Once again, we used the principle of a strong aesthetic framework – in this case, a torch-lit lantern procession which culminated in an outdoor performance using giant puppets, shadow puppets, the construction of a large-scale stage set which was eventually set on fire and fireworks – to invite involvement by local people. Many of the young people and the adults who had taken part in the Youth Club productions got involved and young local bands composed music and played a live score for the event. The workshops also attracted a high percentage of men, young and old, who had not previously participated in any of HPCA's activities. For generations, workers in this area had worked with their hands; 'making' was in their DNA and the outdoor nature of the event meant that people could casually drop in and out in a way that is not always easy to encourage in indoor venues. *Firefox* was an amazing theatrical spectacle, attracting an audience of over 2,000, but its most valuable long-term achievement was entirely unforeseen. Our processional route took our cast and several hundred local people through the Torrs area of New Mills, which was then a rather forgotten part of the town. Situated at the bottom of a deep ravine and site of the derelict mills that had given the town its name, it provided a wonderful Gothic gift for theatrical purposes. Since then, local councils have worked together to build a Millenium walkway over the river and to open up pathways through the Torrs for walkers; local residents continue to use it for community-based cultural events, including lantern processions.

The 'journeyman' phase: Spreading principles and practice further afield

In 1984, I left High Peak Community Arts to work as a freelance community arts practitioner. At the time I made the decision, I think I saw myself as rather like a journeyman; I had completed an apprenticeship in my chosen craft but was far from being a master of it. In some craft traditions, particularly in Germany,

a journeyman is expected to spend a few years going from town to town to gain experience of different ways of working, which was exactly what I was about to do. North West Arts Association had embarked on a programme of encouraging local authorities to consider funding for community arts work in their areas; I was asked to help establish a new organization in Rochdale Metropolitan Borough, in the north of the Greater Manchester conurbation. At around the same time, similar organizations were being set up in Preston (PRESCAP) and in Crewe (the Whole Works); these new cultural organizations were being established at an apparently unlikely moment, just when Thatcher's policies were beginning to have a serious impact on arts funding in the UK. In Rochdale, the factors which influenced the establishment of what became Cartwheel Community Arts included the Regional Arts Association's ongoing interest in supporting community arts practice, the personal influence and commitment of Rochdale Council's Head of Libraries and the willingness of a number of local activists to serve on the organization's embryonic management committee. The organization was also fortunate to appoint two dynamic community arts workers, Dave Chadwick, who would go on to found pa-BOOM, a workers' co-operative specializing in sculpture, theatre, and pyrotechnics, and the co-editor of this book, Alison Jeffers. They would build a solid base for community-based cultural work which would grow and develop over the following three decades; the organization continues to thrive under the new name of Cartwheel Arts.

During those decades, several of my community artist colleagues, like Cilla Baynes of Community Arts North West and Julian Dunn of Action Factory, remained with, and built up, the community arts organizations they had helped to found. Cilla, Julian, and others worked to create an infrastructure and networks at local and regional level; I worked more as a pollinator, seeding ideas and nurturing action across sectors, countries, geographical areas, and generations. As a freelance practitioner, I directed community theatre in Manchester and Addis Ababa, trained creative professionals in Liverpool and Oman, facilitated strategic planning in Uganda and Wales, and worked with community activists in Belfast and Knowsley.

Propagation and the barriers to propagation

The dandelion metaphor we had used on that early protest march proved to be prophetic. Community arts principles and practices blew across the cultural landscape of the UK, finding nooks and crannies where they could flourish,

burying invisible roots into the subsoil, sometimes apparently dying away, only to re-emerge when hostile conditions changed. Some seeds adapted well to the new ecologies in which they found themselves, creating hybrids and new varieties. In the early decades of the twenty-first century, it is possible to find campaigning groups, housing associations and health trusts, creative enterprises and 'mainstream' cultural organizations working in ways that have their origins in the experiments initiated by the community arts movement, whilst building-based organizations such as the Ovalhouse in Lambeth often provide a hub for long-term, geographically based community involvement. The propagation of community arts has been so widespread that casual references can be made to it in popular fiction; the ability of a character in a detective novel set in the Shetland Islands to get money out of the local Arts Trust for a community theatre project is casually alluded to as evidence of her intelligence, without any concern that the reader might not understand what is being referenced (Cleeves 2015).

In terms of what has been achieved, however, we (or perhaps I) were culpably naïve. In those early years, I certainly did not understand how easy and commonplace it is for the dominant cultural mainstream to capture innovations from the margin and adapt them for its own purposes, without concerning itself unduly about the politics and principles that initially under-pinned them. Therefore, it is now possible to watch professional theatre productions that 'engage' community members and wonder if the motivating factor has been the director's desire for a larger cast, most of whom will not need to be paid at Equity rates, rather than a desire to make collaborative work which expresses the concerns and aspirations of local communities or communities of interest. Or to attend a visual arts exhibition or event where people appear to have been used by artists as little more than a type of malleable clay. These kinds of projects can be very enjoyable for the people who take part in them and offer all kinds of benefits, from making social connections to developing skills, but they are not about exploring collective methods of making art through a sharing of professional and non-professional expertise nor about enabling those who do not have power to challenge the status quo. These are examples that could lead to increased cultural marginalization not to cultural empowerment.

I also had little understanding of the relationship of consumerism to neo-liberal capitalism which has been in the ascendancy during this period of history. Richard D. Wolff, the American Marxist economist, describes the situation of workers in the United States – which is not greatly different to that in the UK – thus:

They had to be called to think of (identify) themselves and everyone else as free market participants striving to maximize the consumption they could achieve from work. They had to define themselves as above all 'consumers' who willingly suffered the 'disutility' of labor to acquire the 'utilities' embodied in consumption [...] Workers in the US have been systematically subjected to/by an ideology that defined and celebrated them as consumers first and positively (and workers as secondary and negatively). (Wolff 2004–2007)

The motto of this world order, as the artist Barbara Kruger so brilliantly identified it in 1987, has been 'I shop, therefore I am'.[13] In contrast, community artists were inviting the people they worked with to define and celebrate themselves as creators rather than consumers of culture; this was – and continues to be – a radical proposition, presenting a subversive challenge to capitalist ideology. It was always going to be a long, tough struggle.

At the micro-level, I think that few of us fully understood the impact that our personal circumstances would have on the trajectory of community arts. In the early years, it had a workforce of largely young people, ready and willing to work for little money, in difficult conditions and for long hours. Over time, many of them wanted to start families or find more secure living accommodation, or became exhausted; there was a growing need to find ways of sustaining passion and action that would not lead to collapse and burnout. In my own case, many of my decisions had to be shaped by having to learn how to manage a chronic health condition and by caring responsibilities for older relatives.

I have never been overly sentimental about the specific forms community arts practice took in the 1970s and early 1980s. We had limited access to financial resources, we were learning by doing and there was no road map for us to follow; as Alison Jeffers has commented elsewhere, there were 'rough edges' (Jeffers 2010). Sometimes our collaborative work was strong and effective and sometimes it was poor and incomprehensible; as indeed can be the case with all forms of art. But I have never abandoned my commitment to or belief in the ideals which lay behind the development of 'community arts'. If I need protection from such recidivist tendencies, I reread the work of Paolo Freire who argues

To exist, humanly, is to name the world, to change it. Once named, the world in its turn reappears to the namers as a problem and requires of them a new naming. Human beings are not built in silence, but in word, in work, in action-reflection [...] saying that word is not the privilege of some few persons, but the right of everyone. Consequently, no one can say a true word alone – nor can she say it for another, in a prescriptive act which robs others of their words. (1996 [1970]: 69)

If we accept that naming the world is not the preserve of a few but the right of all, as is proposed in Article 27 of the Universal Declaration of Human Rights, which states that everyone has the right to freely participate in the cultural life of the community, how do artists and activists develop propositions that speak to the context of the twenty-first, rather than the mid-twentieth century?[14]

Access, participation, authorship, and ownership in the twenty-first century: Answering the challenge

The Community Arts Forum, which was based in Belfast between 1994 and 2011, suggested that there were four important elements that characterized community arts work: access, participation, authorship, and ownership (Lynch 2004: 18). It should be noted that these elements cannot be separated from each other. There are twenty-first-century arts organizations that offer 'participation' in arts activities while paying little or no attention to issues of authorship; I would suggest that art practices operating in this way cannot be regarded as being aligned with community arts practice.

What do these elements actually look like within contemporary cultural practice? Access means access to both the means of cultural production and access to the development of technical skills and skills in generating, analysing, and developing ideas. A contemporary example is the Vale, which opened in Mossley in Greater Manchester in the summer of 2015, with this fanfare: 'Mossley will have its own dedicated community arts resource despite the challenges the creative economy faces today. Community led and self funded through social enterprise'.[15] The Vale houses a small cinema, a hub for creative and digital businesses, and a live music venue; it runs a fifty-piece music ensemble for young people and workshops in screen-printing and carnival and sells ukuleles and accessories. It's a contemporary initiative that would be absolutely recognizable to many of us who were involved in the early years of community arts.

A different kind of example can be found in the work of Common Wealth Theatre that would not describe itself as a 'community arts' organization but writes about itself in terms that, again, would resonate with artists and activists from an earlier era. 'We aim to make theatre for people who don't usually think it's for them, we're bored of theatre being for the middle classes and those that can afford it – we genuinely believe in theatre as an art form and the power it has. We think this should belong to everyone – as audience, participants and as

protagonists.'[16] One of their productions, *No Guts, No Heart, No Glory* (2015), was based on interviews with young Muslim female boxers. A cast of five, most of whom had never performed before an audience before, was recruited from Bradford schools and the show was taken to the Edinburgh Festival in 2014. Common Wealth Theatre's artists explain that

> the cast of five shaped the play based on their experiences, their insight and what felt right, what we all wanted to say [...] Muslim young women are rarely represented in the media, *No Guts, No Heart, No Glory* is a chance for Muslim young women to represent themselves, to dance, to box, to swear, to get angry, to enjoy it, to be champions.[17]

This is authorship – 'what we all want to say' – and ownership 'a chance for Muslim young women to represent themselves' in a contemporary form.

Finally, there are those organizations that began in the 1970s and 1980s and are still alive and kicking all these decades later – organizations like High Peak Community Arts in New Mills, Community Arts North West in Manchester, and Cartwheel Arts based in Heywood, Lancashire. In that time, they have developed to meet new challenges, from the financial to the technological, from the cultural to the aesthetic. A recent Cartwheel Arts' publication, for example, is a graphic novel entitled *Blackwheel*. Developed by artists working with young people from the Belfield area of Rochdale, it aims to 'present an alternative view of the types of characters, stories and environments that popular comics and graphic novels often portray'.[18] Community Arts North West, who co-ordinated Exodus a significant programme of work with refugees and host communities across Greater Manchester, recently collaborated with the Royal Northern College of Music to set up Manchester International Roots Orchestra. This is

> a unique ensemble of musicians with roots from across the world including students from the RNCM. Its repertoire skilfully combines diverse musical influences from haunting Eastern European melodies, to the delicate textures of Middle Eastern percussion and vocals; through to soulful Sufi chants of South Asia, joyful African gospel – embracing rap, hip-hop, classical and jazz along the way.[19]

The publications produced by Cartwheel Arts, and the work carried out by Community Arts North West through the Exodus refugee arts programme, demonstrate access, participation, authorship and ownership and address how perceptions and perspectives can be renamed and changed through the arts.

I have stopped often in writing this chapter wanting to remember and record the people who have taken part in this struggle, to find a way to acknowledge all the people who worked alongside me, particularly in those early years. Fay Webber, the Barnstaple town councillor, who fought with us to get communal meeting facilities for the residents of Frankmarsh and Gorwell. Chris Watson and Doug Agnew, who helped set up High Peak Community Arts. Mic Smith, a community artist with Community Arts North West, who worked with me to set up Cartwheel Community Arts. Nidge Gregory, unicyclist, wonderful clown and young actor, who tragically died just as I was writing about our time together in the High Peak. Eventually, I gave up because the list would have been impossibly long.

As I finish writing, however, I consider again the bright yellow dandelions from our demonstration in the 1970s. Dandelions have both nutritional and medicinal properties and can survive anywhere from sea level to an altitude of 12,000 feet, in almost any climate. My 'permanent' apprenticeship in the cultivation of dandelions may last, I think, for a little while longer.

Notes

1 Hurstel (1975).

2 Ros Rigby went on to found Folkworks, which is based at Sage Gateshead and aims to develop interest and practical involvement in traditional music, song and dance. She compiled the community arts directory discussed in Chapter 2.

3 Beaford Centre Community Arts Project. 1977. *Annual Report* [author's private archive].

4 Harding (2005).

5 Gilmour (1979).

6 Victoria and Albert Museum (2013).

7 For another account of this event, see Crehan (2011).

8 Beaford Centre Community Arts Project. 1977. *Annual Report* [author's private archive].

9 Oliver Bennett writes about this role in Chapter 8.

10 Buxton Advertiser. 1980. *The Little Big Top*, 28 August [author's private archive].

11 Ibid.

12 Bolton (2004).

13 Kruger (1987).

14 United Nations (1948).

15 The Vale. 22 August 2015. *Nearly Ready for Lift Off* (The Vale). Available at: http://www.the-vale.co.uk/nearly-ready-for-lift-off/ (accessed 5 April 2016).

16 Common Wealth Theatre. (Common Wealth Theatre). Available at: http:// commonwealththeatre.co.uk/about/ (accessed 5 April 2016).

17 Ibid.

18 Cartwheel Arts. 2016. (Cartwheel Arts). Available at: http://www.cartwheelarts.org .uk/images/publications/Blackwheel%20TUAO%20Written%20by%20Yussuf%20 Mrabty%20and%20Ali%20Gadema%20Illustration%20and%20Art%20and%20 design%20by%20Krik%20Six.compressed.pdf (accessed 6 April 2016).

19 Ibid.

References

Bolton, R. 2004. 'Why Circus Works.' PhD thesis, Murdoch University, Perth. Available at http://www.regbolton.org/images/pdf/Why_Circus_Works-Reg_Bolton-PhD.pdf (pp. 184–95) (accessed 12 April 2015).

Cleeves, A. 2015. *Red Bones* (Pan Books: London).

Crehen, K. 2011. *Community Art: An Anthropological Perspective* (Bloomsbury Publishing: London).

Freire, Paulo. 1996 [1970]. *Pedagogy of the Oppressed* (Penguin Books: London).

Gilmour, P. 1979. 'What about the Heritage', *The Spectator*. Available at: http://archive .spectator.co.uk/article/10th-november-1979/24/what-about-the-heritage (accessed 12 April 2015).

Glover, Tina. 2006. 'Reg Bolton', *The Guardian,* 26 July.

Harding, D. 2005. 'Memories and Vagaries: The Development of Social Arts Practices in Scotland', *Community Arts* (David Harding). Available at: http://.davidharding.net /article05/article0502.php (accessed 29 November 2016).

Harvie, Jen. 2005. *Staging the UK* (Manchester University Press: Manchester).

Hurstel, J. 1975. *The Training of Animateurs*, paper held in File ACGB/113/3, Training of Community Artists (National Arts Library Victoria and Albert Museum: London) (accessed 29 April 2016).

Jeffers, Alison. 2010. 'The Rough Edges: Community, Art and History', *RiDE: The Journal of Applied Theatre and Performance*, 15: 25–37.

Kruger, B. 1987. Untitled *(I shop therefore I am)* Photographic silk screen/vinyl (Mary Boone Gallery: New York).

Lane, John. 1978. *Arts Centres. Every Town Should Have One* (Paul Elek: London).

Leach, Nigel. 2010. Interview with Alison Jeffers and Gerri Moriarty.

Lynch, Martin. 2004. 'The History of Community Arts in Northern Ireland: According to Martin Lynch', in Sandy Fitzgerald (ed.), *An Outburst of Frankness: Community Arts in Ireland. A Reader* (tasc at New Island: Dublin).

United Nations. 1948. *Universal Declaration of Human Rights.* Paris: United Nations General Assembly. Available at http://www.un.org/en/universal-declaration-human -rights/ (accessed 11 April 2016).

Victoria and Albert Museum. 2013. *Arts Council of Great Britain: Records, 1928–1997*. Available at: http://media.vam.ac.uk/media/website/acgb/ (accessed 4 July 2016).

Wolff, R.D. 2004–2007. *Ideological State Apparatuses, Consumerism, and U.S. Capitalism: Lessons for the Left'*, Working Paper (University of Massachusetts: Amherst).

Craigmillar Festival, the Scottish Community Arts Movement of the 1970s and 1980s and its Impact: A View from Scotland

Andrew Crummy

The creation of art in any of its forms is perhaps the most profound and powerful affirmation of life against death that we humans can make, of harnessing the constructive and destructive forces. The cultivation of the imagination develops a resourcefulness which enables reality, however grim, to be contended with more innovatively. The Craigmillar folk had not much else than their imagination to fall back on. Their imagination was their road to greater self-reliance.

Trist 1979: 447

Introduction

The history of the community arts in Scotland in the 1960s, 1970s, and early 1980s was of a grass-roots arts movement that attempted to use 'art as a catalyst' to address wider issues in society, in particular, poverty. Community arts groups wanted not only to highlight these issues but to tackle them in a positive, direct, and pragmatic manner. These community art groups were mostly based in housing schemes on the edges of Edinburgh, Glasgow, and other conurbations. In these areas, such groups as the Craigmillar Festival Society, Easterhouse Festival Society, Cranhill Arts Project, Pilton Video Workshop, and many others flourished.

The groups tended to be organized by women and their starting point was that they were seeking a better life for their children and family. The production of art was not the end of the process but often only the beginning of self-help

that promoted a 'sharing and caring' attitude that would have an impact on the local community. Often campaigning for a better quality of life, people would not only protest but use the arts to tell their story and communicate their vision. They used the full range of arts, but in particular street theatre, murals, sculptures, photography, video, song, and dance. Those in government or in local councils at the time would not be expecting this more creative approach, and they would often go back to their offices and revise the decisions they had made. Community arts groups won many victories and gained many new local amenities and services through this innovative and creative form of protest.

The primary aim of these groups was about reflecting the creativity and artistic skill of those living in the housing schemes but also of improving their way of living. The very act of being creative was seen as a simple positive tool. The assumption was that everyone is creative to some degree, we can all sing, dance, paint, write, make movies, take photos – the list goes on and on. It was this natural creativity that lies within us all, that was the thread that pulled the community together. Within this process, it could be transformative for individuals to develop their creativity, confidence, skills, and intellect. It is these countless individual positive stories of these communities, families, and

Figure 4.1 Festival

friends that have carried the idea forward not only in the UK but in many other countries. In particular, many of the children and young adults that grew up in this era, and benefited from it, have taken this concept forward. As a professional artist, I am one such 'child of community arts'.

Craigmillar Festival Society

One of the key statements of the Scottish community arts movement was it used 'art as a catalyst' but what was it used as a catalyst for and how did this work? How can an artwork have a direct relationship with other community activities which are not artistic? To further examine how these groups worked, it is best to take one example and explore this relationship and history and, because I know the Craigmillar Festival Society best, that will be my main focus. However, the roots of the Craigmillar Festival Society are very similar to those of so many communities and community arts projects across Scotland. This helps explain why these groups flourished in the 1960s, 1970s, and 1980s at a time when many were facing the same issues of frustration over exclusion and poverty in the housing schemes across Scotland.

It is generally agreed that one of the key starting points of the Craigmillar Festival Society and, therefore, of the Scottish Community Arts Movement was in the early 1960s after a mother, Helen Crummy, asked the headmaster of Peffermill School if her eldest son could learn to play the violin. The headmaster, Mr Lyall, refused her on the grounds that 'it takes all our time to teach these children the three R's'.[1] Helen went back to the mothers' group, who were very angry at first and could have made the usual response and gone back to complain to Mr Lyall. Instead, over a period of time, they decided to take the unusual and bold step of organizing their own festival to showcase the talent of local children. The mothers knew the area was full of talent because of the tradition of the local impromptu 'back green' concerts.[2] On hearing this Mr Lyall said, 'I will not do it for you, but I will help you' and the Craigmillar Festival was born (Crummy 1992: 39). Helen Crummy passed away in 2011, but in 2014, a statue was unveiled in front of the new library in Craigmillar that tells this legendary violin story. Helen would not have approved of a statue of her, but to many in Craigmillar to this day, this is a story they are proud to be associated with.

'The Festival', as it became known locally, grew very quickly, showcasing not only the children of the area but anyone who had a creative talent. The violin story was in fact a historical step that would start an annual festival that has lasted

up to the present day and also powerfully demonstrated an attitude of self-help that would start the regeneration of Craigmillar. After the first festival, those involved realized they had little access to the existing amenities in the area, so the Society turned into a campaigning group with a creative edge. In 1969, the Society formally constituted itself as the Craigmillar Festival Society (CFS) and in that year held a Festival Fair in Craigmillar Castle that attracted thousands, many of them participating. In 1970, the CFS gained an Urban Aid grant and appointed a small group of local people – Muriel Wilkinson, Clare Elder, Alice Henderson, Paul Nolan, and Nora Smith – as part-time neighbourhood workers, and Helen Crummy became the full-time organizing secretary. Their aim was to help neighbours with social issues and they were soon inundated with a whole range of housing and social problems. But they were also expected to be involved in the arts, in particular the annual festival, and this was written into their contract. This entwining of art and social action was at the heart of the CFS. The festival showcased the creativity of the people but 'became more than a vivid and colourful demonstration of the artistic talents of the area: it developed as a focus for social change in Craigmillar as local people increasingly found their intentions thwarted by the lack of facilities for the festival' (McRobie 1981: 118). In 1975, the group received funds from the EEC Programme of Pilot Schemes and Studies to Combat Poverty, which proved so successful that new funding became available in 1980 – even though many people in Craigmillar resented being called poor.

From 1972, the CFS began a series of community musicals that would highlight issues of the day and provide possible solutions in the form of song and dance. These large-scale productions would be the cornerstone of the annual festival for many years. The shows were written and performed by the local people with support from young actors, such as Bill Paterson, Kenny Ireland, Billy Riddoch, John Murtagh, Jimmy Chisholm, Victor Cairn, Eileen McCallum, Sandy Neilson, and Ian Woolridge. They performed in the local Richmond Church, where the altar was the stage and the lights were in the aisles. These sell-out shows would deal with issues of the day with song and dance; for example, *The Time Machine* (1973) opposed the building of a motorway, *Castle, Cooncil and Curse* (1974) dealt with the issue of empty houses on Craigmillar, and *Willie Wynn* (1976) dealt with child poverty.

The aspiration of 'The Festival' was captured in many of the songs written for these community musicals and the list included songs like 'Craigmillar Now – Fine Place to Be', 'Rehabilitation', 'More of Us Than You', 'The Plenty', and many more. But one song illustrated the vision of the CFS most clearly and that was 'When the People Play Their Part' by Douglas Galbraith from the first

community musical in 1972. It is worth quoting this in full to give a sense of the ethos and beliefs of the CFS and other community arts groups like them.

> We thought the day had come
> when we'd win through at last,
> when all would walk with dignity
> in their own cities, proud and free –
> but now the moment's passed.
>
> (Chorus) *The Powerful in the land,*
> Can't bring a change of heart,
> But history will be made,
> When the people play their part.
>
> You ask me why I'm sad:
> Have you been on a trip!
> The headlines stare you in the face,
> And kidnap, killings, riot, race
> Hold us in their grip.
>
> But some say that they've heard,
> A whisper in the wind;
> Communities are on the move,
> Their way of living to improve –
> And festivals you find!
>
> (Galbraith and Crummy 2003)

This song was sung by a blind singer, Janet Howie, and the image of Janet singing was used to attract attention at the beginning of many community events. Janet became a symbol because she was a woman who believed in the Festival and she knew the community cared about her and her creativity. This was a belief shared by many in Craigmillar – that the Festival was there for them, they were running it and being employed, it was well organized and structured, it was fun, it was creative, and it was caring. It was this direct link between creativity and 'sharing and caring' that has produced its most enduring legacy, with many individual stories of how 'The Festival' cared for and nurtured many.[3]

The CFS grew from being simply a Festival Society 'to being an all-round community development organization' and they published what now is regarded as a pioneering planning document 'The Comprehensive Plan for Action for Caring and Sharing' (CPA) in 1978 (Trist 1979: 447). The front cover featured an image of 'The Gentle Giant Sculpture', a huge 'Gulliver' play structure that was commissioned

by the CFS in 1974. It was designed by Jimmy Boyle, while he was in Barlinnie Prison and was influenced by the desire of the Craigmillar community to create not only a play structure but one that was an artistic symbol of a caring community. The process of working with an artist who was in prison was supported by Richard Demarco and American artists Beth Shadur and Ken Wolverton. The sculpture represented the community as 'the gentle giant who shares and cares'. It was unveiled by Billy Connelly in 1976 and was later said to be so large that it could be seen by satellite.

The introduction to the CPA states:

> This Plan is basically a working document, a kind of green paper, which requires shared government, partnership between the people of Craigmillar and the local and wider authorities and agencies. It contains a vision of Life in the years ahead. The vision is the achievement of a viable community with all the necessary ingredients of amenities, facilities and services. But the action plan includes a very large plus. It is the taking of responsibility by the people of the area themselves in a joint fulfilment of the vision with the outside authorities and wider community. In such a sharing of developing and governing there is revealed a new way which has great relevance for all other similar areas as well as those from which many of the people of the housing estates come, the inner urban areas.
>
> Its basic importance lies in the fact that it advocates and signifies a change in politics and economics to yield a more fulfilling society. It is highly relevant. It proposes, by engaging and activating local people, such as the planning and carrying out in partnership with outside agent's projects which improve the quality of Life to do more with the limited public funds and other resources. (Craigmillar Festival Society 1978)

Throughout the 1970s 'The Festival' was developing a structure that was open and accessible and producing the CPA itself was a democratic process. Described as 'an action plan to break the cycle of deprivation by those who have produced it' (Trist 1979: 447), the structure of the CFS was based on involving as many as possible in the decision making. This was enabled through the democratic structures of the organization itself. Everyone who lived in the area could be a member of the CFS if they wished to be. It had an executive committee under which sat nine working parties – planning, housing, environmental improvements, social welfare, education, employment, communications, arts, and finance/administration. The working parties were made up of local people, their advisors, elected representatives, local authority, central government officials, trade unions, and other agencies. Through these working parties, the CFS organized over eighty groups and events that covered activities from the annual festival and many arts events, after-school

clubs, holidays and play schemes for children, youth activities including clubs, unemployed clubs, disabled clubs, sports clubs, old age pensioner clubs, lunch clubs, and community transport. It was through this complex structure that CFS could organize and articulate a vision for the community, demonstrate the ethos of 'sharing and caring' for the community, *and* have a thriving community arts scene, which gave the arts a central and valid role in the Craigmillar community.

The impact of this structure and the Comprehensive Plan for Action document was far-reaching. The CPA gained attention in both academic and political circles. George McRobie said that the work that came out of the plan demonstrated 'innovative experiments in local responsibility' and wrote that copies of the CPA were distributed in China, the USA, Russia, Israel, Canada, India, and throughout Europe (McRobie 1981: 119). He added that 'the imagination, vivacity and local creativity that has blossomed from a community arts festival in 1962 is seen as an example with worldwide significance' (McRobie 1981: 119). Sociologist Eric Trist claimed that the Craigmillar Community was 'at the leading edge of post-industrial innovation and has greatly influenced my search for alternatives' (Trist 1979: 447). Professor Albert Cherns, in a letter to the government, said that the CFS

> represents a most useful model for the containment, if not the solution, of many of the social problems that crowd upon us. I believe that a thousand such associations throughout Britain would not only relieve the so-called public sector of a great deal of its social work (broadly defined), but also enlist communities in the containment of deviance as well as of other problems. Furthermore, it would give much meaning to the notion of grassroots democracy. (Letter to Michael Young, Rt. Hon. Lord Young of Dartington, 2 August 1982)

Academic Helen Wood claimed that it was no coincidence 'that the model of the Craigmillar society has become a legend and inspiration to other community groups seeking ways of resisting social dereliction' (Wood 1982).

After the experience of the first festivals, the organizers knew that by creating a stage for children and adults to share their artistic skills and thoughts, they would be willing to be part of a group to get involved in more arts events. And if they did this then they would be willing to help and volunteer with other activities too. It was the communal acceptance and sharing of their individual creative skills that proved to be the powerful tool to bind the community together. Many saw that by working creatively together new possibilities opened up. Therefore, the saying 'We can either react in fear or anger to the state of our world thus becoming part of the problem or respond creatively and become part of the

solution' (Crummy 1992: 6) became a mantra used extensively by the Festival and illuminates what the aim of the movement was. Therefore, the Festival, the artistic or creative side of the CFS, was the glue that attracted a broad range of people to join in.

The importance of the Craigmillar Festival Society was that it not only recorded and documented what they were doing, but also they were thinking through the process and producing structures and theories that explained what they were doing. Words and phrases such as 'communiversity', 'creative shared government', 'the poor looking at the poor', or 'art as the catalyst, education the tool' are regularly found in its documentation and all allude to a group of people who were trying to work out a way of thinking and action. The Festival had developed a structure within Craigmillar that involved thousands of people. As artist David Harding states, 'What is astonishing about the Craigmillar story is that, while incisive, creative thinkers like Augusto Boal, Paolo Freire and Ivan Illich, among others, were publishing their ideas on approaches to the issues of the poor and excluded, intuitively the Festival Society was actually carrying them out' (Harding 2004: 31). It was the academic Steve Burgess, who for many years worked with the Festival, who would become fascinated by this structure. In his appraisal of the Festival, he links its way of working to a biological term as 'a series of directive correlations' pointing to the underlying structure and using the language of 'linkage', 'collaboration', 'co-producers', and 'co-determination' (Burgess and Trist 1980). As academics both Trist and Burgess were interested in how the Festival could develop a structure that promoted a healthy and growing community. Could this 'sharing and caring' structure provide solutions to poverty and exclusion?

Untapped creativity

To tell this story of the development of community arts across Scotland involves thousands of people, many groups, and projects and is a difficult story to tell, mainly because the archive of this history has not been systematically collated. There is no straightforward timeline to tell the story of how community arts developed in Scotland, rather a series of artworks, projects, and events that had a cross-fertilization with other groups and like-minded individuals. Scottish community arts became a national movement because of this cross-fertilization, not only in Scotland and the rest of the UK but also in other countries. As with all forms of art, there was a lot of trying to find new ways, experimenting and

learning. To a more discerning traditional eye and ear, the Community Arts Movement at times could be brash, loud, anarchic, and rough around the edges. The enduring image of community art is of a badly painted mural in a housing scheme. This simple representation failed to take into account the wider social impact that these artworks were attempting to make.

The production of this grass-roots, bottom-up approach in making art had certain characteristics, the most important being that it was about people working together in a creative manner to produce artwork. Sometimes these groups could be just a few people, other times a 'cast of thousands'. The group or project may be very short lived or it could develop over many years. These groups could vary in content from being a very small group which was about developing individual skills and confidence to a big brash community project full of colour, vision, and hope. Most of those involved were untrained, while others would bring their professional training, knowledge, and craft to support and nurture. In places like Easterhouse or Glenrothes, to the astonishment of people who did not live in these areas, the authorities would be amazed how so many 'poor' people could work together to produce art that had such an impact. The reality was these housing schemes were teeming with untapped creative ideas and vision.

The public space was a common venue for these groups. The main reason for this was that there were few amenities in these areas that would cater for these ideas and vision and, even if amenities existed, they were often not accessible, something which further illustrated the feeling of exclusion from society that these groups experienced. The housing schemes in the major Scottish cities had no cultural venues such as theatres, exhibitions space, or workshops so they would try to use other public venues such as churches or schools. But it would be on the streets of these cities that these groups would make a bigger impact. So, a mural or a sculpture would brighten up the housing scheme, or events such as street theatre, parades, and festivals were common place. These groups would use all sorts of public spaces from the housing schemes to medieval castles, bus stops to the front of national galleries. This street theatre would bring colour, song, laughter, and protest through a range of events such as re-enactments of famous scenes and figures from Scottish history. Unwittingly, this exclusion from local amenities and traditional art venues gave the people from the estates a greater audience, and they were able to engage with many more thousands of people. These groups learned an important lesson: that this direct approach gave them an impact that you would not get if you were hidden away in an art gallery or theatre.

A key moment in this history was when many of these pioneering groups came together, and over 400 people from around Scotland in 1982 gathered for a national conference organized by the Easterhouse Festival Society. Helen Crummy describes the event:

> It was a conference with a difference or two. One was that there were very few professionals there. Another was that it was not so much a talking conference; it was more action all the way. Instead of presenting papers on action in their community, delegates presented 'their punters', the ordinary folk who came to give a demonstration of community arts going on in their own backyard. In every room each group showed their mettle. There was music, drama, crafts, visual arts, video, photography, puppets, printmaking – you name it, it was there. And all at an impressively high standard. People were of course getting to know one another and learning from each other. I was not the only one to leave that day with a feeling of well being and comradeship, knowing we were part of a community arts movement which was fast gathering momentum as it moved through urban and rural Scotland. (Crummy 1992: 196)

New towns were being built in Scotland to house the people being displaced by the slum clearances of the 1970s. The concept of the new town artists was developed and people like Brian Miller in Cumbernauld and David Harding in Glenrothes helped local councils pioneer a way of working in a community setting which had not been seen before. These were artists who were employed by the local council, usually through the planning and architectural services. In Glenrothes, some of these artworks have now been listed by Historic Environment Scotland and these include David Harding's 'Henge' and an underpass wall relief titled 'Industry'. There are many artworks throughout Glenrothes including the iconic concrete 'Hippos' by Stan Bonnar. Many of these artists worked through community involvement and certain key artworks represent what these community groups and artists stood for. The 'Gentle Giant' in Cragimillar has already been mentioned and another iconic artwork was the Easterhouse Mosaic designed in 1984, Britain's biggest hand-built mural at a length of 240 feet. This was commissioned by the Easterhouse Festival Society and involved many artists working with community groups over a three-year period. David Harding remembers, 'It quickly became so well known that, on a visit to Chicago in 1984, I was asked by some artists if I had seen the Easterhouse Mosaic and did I have slides of it? Easterhouse to many people in Scotland meant crime, vandalism and poverty while in Chicago they had only heard of its art' (Harding 1995: 33). The Easterhouse mural was replaced in 2012 with a

new mosaic by Alex Frost. The second one in Craigmillar was a giant mermaid sculpture, organized by Rosie Gibson and designed by New York artist Pedro Da Silva in 1979. It was built as a creative protest to stop a proposed motorway through the heart of Craigmillar. The motorway would have split the community into two and the sculpture was built on the proposed route. The motorway was never built!

Visual arts theatre and performance played a vital role in the overall development of community arts in Scotland at that time. Theatre companies like 7:84 and Borderline were taking political theatre out of the traditional theatres and performing in small community venues all over Scotland and 7:84's production of *The Cheviot, The Stag, and the Black, Black Oil* by John McGrath has a particular resonance. Within the community arts groups, theatre was a popular way to involve as many people as possible and Craigmillar's series of successful community musicals tackling issues of the day showed how it was possible to embed social commentaries within an entertaining format. The Theatre Workshop tradition provided another link through Bill Douglas who started off in Joan Littlewood's Theatre Workshop in London in the 1950s. Born in Newcraighall, Edinburgh, Douglas would go on to create the innovative *My Childhood* (1972), a film which told of his life in the mining village of Newcraighall where the film was shot. Many members of the Craigmillar Festival Society got involved and the two main actors were Stephen Archibald and Hughie Restorick, the then unknown actors from Craigmillar.

In addition to performing, many of the young actors from 7:84 and Borderline would work within the housing schemes, running drama workshops with the young people and helping with the big community shows.[4] The Theatre Workshop in Edinburgh brought theatre and circus skills out into the streets of Edinburgh but the performers would also work in the areas such as Pilton, Wester Hailes, and Craigmillar. Theatre Workshop introduced street theatre to the Edinburgh Festival Fringe in 1971 with a juggler performing at the bottom of the Mound in front of the National Gallery of Scotland. Today, Edinburgh is awash with street performers and crowds in August during the Edinburgh Festival but few realize that the roots of these street performances lie within the community arts movement. Reg Bolton was the first director of the Edinburgh Theatre Workshop and brought together a series of key individuals including Ken Wolverton, Neil Cameron, and Mike Rowan to name a few. They could be often seen in the streets of Edinburgh by a bemused but entertained public. Such was the influence of Reg Bolton, when he died in 2007 his ashes were split into four and taken to New York, Australia, Edinburgh, and his hometown in England.[5]

Learning from our history

Scotland has a long tradition of community celebration that is well established and these community celebrations have many names like the Gala, the Riding, the Gathering, and Highland Games. They are often found in rural, fishing, or industrial communities such as mining, textiles, and shipbuilding and, usually organized by women, tend to celebrate children in those communities. This cultural grass-roots celebration, which to this day continues across much of Scotland, is traditionally organized within the community and self-funded. In some of the fishing communities, 'the Box Meeting' is a parade that would go around the village, a celebration which could take many hours of fun and entertainment while encouraging everyone to donate money into 'the box' which would be used to help the widows of fishermen lost at sea.

Another important root of the movement is the Scottish education system. The liberal approach of 'a school in every parish' can be traced back to John Knox and the sixteenth-century Reformation, developed through the Scottish Enlightenment, the 'Democratic Intellect' and the 'lad o'pairts'.[6] Certainly, systems of education played a direct impact in Craigmillar. When the housing scheme was originally being built in the 1920s, Edinburgh University built the Craigmillar College Settlement where they ran 'penny classes' in the 1930s. In the industrial communities, the labour and trade union movements would see education as an important route out of poverty, so these penny classes would be welcome. This initiative would later play a direct role in educating those people who would set up and run the Craigmillar Festival Society in the 1960s. Also, while growing up in these new housing schemes built across Scotland in the 1930s, the children would come in contact with murals and sculptures that illustrated the new visions of Scotland. Usually, these artworks would be in the local primary school; for example, in Craigmillar Primary School there was one such mural by John Maxwell.

As one of the many 'children of community arts', I have been lucky enough to spend most of my life working as an artist being able to draw upon my childhood experiences in Craigmillar in my professional life. Between 2009 and 2014, I drew and designed three large-scale tapestries – the Battle of Prestonpans Tapestry, the Great Tapestry of Scotland, and the Scottish Diaspora Tapestry. The Great Tapestry of Scotland is a community arts project that involved over 1,000 stitchers and is 143 metres long. It tells the story of Scotland from the geological formation of the rocks of Scotland to the time when it was launched on 7 September 2013 in the Scottish Parliament. When novelist Alexander

McCall Smith (co-chairman of the Great Tapestry of Scotland project) asked me in 2010 if I was interested in doing a tapestry about the history of Scotland, I knew my own childhood experience would help. I could take the elements of the Scottish community arts model of the 1960s and 1970s and build on the knowledge gathered. To me these tapestries are not a celebration of just of those involved in the project but of the whole community arts tradition. On the week of its launch, 5,000 visitors a day were queuing around the Scottish Parliament building, often waiting for up to two hours to view the artwork. Since its launch, it has toured Scotland with all venues recording very high-viewing figures and it is planned to house it in a new building in the Scottish Borders.

The term 'community art' has been contested over many years in the art world, often derided, ignored, challenged, changed, and redefined. But I have found that by defining these tapestries as community arts projects, within the wider public, the term is not contested at all. In fact, it is a starting point to explain how these communal artworks are produced. It is a testament to the original pioneering groups and individuals that not only these tapestries, but so many other art projects that work within social settings, are accepted and funded today, and the term 'community art' has become an accepted part of Scottish society. Although some of the early pioneering groups have disappeared for a variety of reasons, out of their demise have arisen new organizations and projects dealing in similar range of issues. It is quite common today to see many charities, trusts, voluntary associations, and groups using art within a social context, often dealing with poverty, health, disabilities and exclusion, engaging with the full range of society from children and youth to old age. The pioneering community art groups played a part in establishing this now accepted way of using art when they began the very slow process of changing government policy towards arts and its use with regard to poverty linking the arts to issues of community ownership, democracy, and empowerment that are very topical and still developing within contemporary Scotland. Community art is still developing and slowly, over the years, lessons are being learnt and a greater understanding of what these groups and individuals were about is emerging. But in recent years, there has been a growing interest and acknowledgement that this history did exist and has an articulate vision that can help us to understand how to use art in society. Projects include Fablevision, Impact Arts, Out of the Blue, Galgael, and community mural programmes in Invergordon and Prestonpans, with Craigmillar Community Arts still going strong.

Many of the original groups did not document their projects. In addition, the professionals who were involved tended to adhere to the maxim that 'you

should always be at the back of the hall, not at the front telling people what to do', and this further explains why so much community arts to this day remains unknown to a wider public. In Scotland, there has been little real academic study of the impact of community arts on Scottish society or further afield. But, while there is no major archive or even a definitive reading list, the concept of community empowerment that informed of earlier work has developed in Scotland; many of the groups that have developed art practice in health, prisons, housing, and planning owe much to the pioneer community art groups of the 1970s housing schemes. Perhaps too the tide is turning. Alongside the sculpture of Helen Crummy in Craigmillar, her archives are now housed in Edinburgh's Central Library and a new community archive, which was started through the Craigmillar Archive Trust, has been developed by the Thistle Foundation with plans for creating an archive room. In 2005, the Craigmillar Communiversity staged an exhibition at the City Art Centre in Edinburgh which launched a series of books and CDs. They also commissioned a film called 'Art the Catalyst Craigmillar' which went on to win a Saltire Award at the Edinburgh International Film Festival. In 2007, the Craigmillar Communiversity started World Community Arts Day to celebrate the life of Reg Bolton and over the subsequent eight years has shown that there are many groups and individuals around the world who share the same vision.

This essay is only an introduction to a movement that needs and deserves its heritage and archives to be collated and studied so the next generations are not re-inventing the wheel and we can move on quicker and keep developing a process that has a proven valid role to play within society. There are many more stories to discover and tell.

Notes

1 Helen Crummy was my mother and this story is often told about my brother Philip. The 3 Rs that we studied were reading, writing, and 'rithmatic'.

2 Back greens are communal areas usually shared by a number of houses that back onto them. Often used for washing and other domestic tasks, they could also host impromptu gatherings that involved singing, dancing, and other forms of entertainment.

3 Some of the work done at the time can be seen in documentary footage in the short film 'Arts the Catalyst' (Plum films), https://vimeo.com/52005912 (accessed 13 December 2016).

4 Stephen Lacey, who had set up Jubilee Arts in Birmingham, was also involved in Craigmillar's drama projects.
5 Gerri Moriarty also speaks of the influence of Reg Bolton and his Suitcase Circus in Chapter 3.
6 A mythical figure of the young man who can advance himself from lowly origins to a higher level through access to an open education system (see Fox 2002).

References

Burgess, M. Stephen, and Eric Trist. 1980. 'A Giant Step: An Appraisal of the Craigmllar Festival Society's Approach to Community Development. Relative to the Craigmillar European Economic Community Programme of Pilot Schemes and Studies to combat poverty'. Brussels: Directorate General of Social Affairs of the European Commission.

Craigmillar Festival Society. 1978. 'Craigmillar's Comprehensive Plan: For Action', Craigmillar: Craigmillar Festival Society.

Crummy, Helen. 1992. *Let the People Sing. A Story of Craigmillar* (Helen Crummy: Edinburgh).

Fox, Adam. 2002. 'Taking the Higher Road', *The Guardian*.

Galbraith, Douglas, and Helen Crummy. 2003. *Craigmillar Gold: 1973–77. Volume 1. Songs from the Community Musicals* (Craigmillar Communiversity Press).

Harding, David. 1995. 'Another History', in Malcolm Dickson (ed.), *Art with People*, 28-41 (AN Publications: Sunderland).

Harding, David. 2004. *Cultural Democracy – Craigmillar Style*, edited by Craigmillar Festival Project (Craigmillar Communiversity Press).

McRobie, George. 1981. *Small Is Possible* (Johnathan Cape: London).

Trist, Eric. 1979. 'New Directions of Hope: Recent Innovations Interconnecting Organisational, Industrial, Community and Personal Development', *Regional Studies*, 13: 439–51.

Wood, Helen. 1982. 'Festivity and Social Change', in *Leisure in the '80s Research Unit* (Department of Social Sciences: Polytechnic of the South Bank).

The Pioneers and the Welsh Community Arts Movement: A View from Wales

Nick Clements

Community arts was not born fully formed and armed, like Athene from the head of Zeus, neither was it invented by arts funders to place restrictions on artists. It grew gradually and stridently, through trial and error, through the efforts of artists and communities. This was an empirical movement: trying, testing, rejecting and adapting.

Morgan 1995: 16

Revolutionary outsiders

To write about Welsh community arts there is a need to start almost in prehistory. The etymology of the name 'Welsh' is derived from the Anglo-Saxon word 'willisc' meaning 'foreigner' or 'stranger'.[1] The Welsh are strangers in their own land. The speaking of their own language was forbidden for hundreds of years, and within this context, the revolutionary use of language by the Welsh-speaking population connects back to the first bardic competitions in 1176, and the Gwyneddigion Society creating small *eisteddfodau* in taverns in North Wales from 1789 onwards. In 1861, Aberdare hosted the first modern *Eisteddfod*, and they continue to grow through to today, hosted in North Wales one year and in the South the next. In addition, there is the permanently based Llangollen International Music Eisteddfod first held in 1947.

In the 60 years since then it has become one of the world's great music festivals. It began as a way of healing worldwide wounds following the end of the Second World War. Led by local people from Llangollen and Wrexham, planning for the first event began in 1946. There was a fear that no one would come, especially

given the hardships of the post-war years. The public managed to raise an impressive £1,100 with a commitment that every penny would be invested in that year's and any future events.[2]

In addition to these valiant attempts to preserve the language and culture of Wales, its history is dominated by revolution and outsiders. In AD 61, the last stand of the Bardic tradition on Anglesey opposed the invasion of the Romans led by Suetonius Paulinus; in the actions of civil disobedience in 1816, in the miner's strike in Merthyr Tydfil and the 1831 Merthyr Rising, the Welsh raised their voices in defiance. On 4 November 1839, the Newport Rising of the Chartists was the last large-scale armed rebellion against authority in Great Britain. Wales has always been opposed to – and fighting for – something.

In this context, community arts in Wales didn't suddenly sprout into existence in the 1970s. It is a natural continuation of resistance to cyclical, systematically oppressive regimes which have been in existence for thousands of years. The Welsh people are in that sense forged by their battle to resist oppression, which allies them much more with Scotland and Ireland than to England. The uniquely Welsh flavour of this struggle is recorded in the document *The Mabinogion*.

The Mabinogion

The Welsh folklore document, *The Mabinogion*, the earliest prose literature of Britain, contains the oral traditions and magical beliefs of the people, and documents their ongoing struggle to retain autonomy and oppose invasion. Pure storytelling, creative, imaginative, mystical, and magical, *The Mabinogion* combines oral traditions with prose and historical and semi-historical representations. At its best, it enables the Welsh people to joyously celebrate their ancestry. It uses creativity to conjure wonderful images and reflections which are fanciful and also based on real people and events such as Math, a powerful leader and ruler of Gwynedd. 'At that time Math son of Mathonwy could not live unless his feet were in the lap of a virgin, except when the turmoil of war prevented him' (Unknown 2002).

The imagery conjured and the wonderful prose make it ideally suited for large-scale theatre productions and, in 1981, Geoff Moore directed and choreographed a landmark production of *The Mabinogi* at Cardiff Castle. A bilingual production based on the ancient text, it was performed again

in 1983 at Caernarfon Castle. The production was jointly staged by Moving Being, a professional dance and performance company, and Brith Gof theatre company. It was a huge direct experience for the audience as they became enmeshed in the sights, sounds, smells, and tastes of the medieval and magical. It was a truly transformative experience to witness and to participate in, something that was made possible through the inclusion of amateur groups working alongside the professional companies (Milling et al. 2004: 281). Moore described something of its innovative approach: 'The composition of the company reflected a desire for a new language with actors, dancers and musicians in combination with visual arts, not contributing to stage design, but working with the art forms of the twentieth century, projection, film, video, electronics' (Milling et al. 2004: 281). *The Mabinogi* etched its place in the theatrical history of Wales and represented a first confident step towards the development of creativity – cross-disciplinary arts and crafts. It was described as 'a dynamic mix of pageant, dance, music, drama, tale telling and spectacle. Before and during the show the audience joined in a medieval fair, mixing with troubadours, mummers, falconers, craftsmen, cooks, fortune-tellers and an apothecary' (Milling et al. 2004: 281). I can attest to this account because that apothecary was me!

This kind of development of cross art form work by companies in Wales was part of the rich soil from which community arts grew. Being a participant in *The Mabinogi* enabled me to see how much more effective a wide range of arts and crafts can be as opposed to the, until then, restrictive practice of single art form works. Like me, many of the early community artists in Wales participated directly in these productions or took courage from the example being set. This exploration of creativity was ideal for artists wanting to enable local people to become directly involved in the creative process, which we saw happening elsewhere. Many of us looked to the more established community arts organizations in England and Scotland, and wanted to do such things in Wales. However, we didn't really know how to make it happen, so this alternative practice grew in a piecemeal way. But then, in 1984, the landscape and profile of Wales changed. The Miners' Strike took place and it galvanized us all. There was now an easily identified cause and purpose to our work, and this change asked a serious question of us all: how do we support those people whose livelihoods are being threatened? We weren't under threat but we sought to offer solidarity. A clear example of this can be seen in the work of Red Flannel Films. Emma Hedditch wrote of the company:

Disgruntled by their marginalisation and encouraged by the work of other women film-makers outside Wales, a group of women working at Chapter Arts Centre in Cardiff formed their own group in November 1981 called the South Wales Women's Film Group – the first women's film organisation in Wales. The group formed with the intention of sharing skills, supporting ideas and enabling women to play a more active part in film-making. Following the miner's strike in 1985 – when many women were given a taste of political activity – Clare Richardson, Claire Pollak, Carol White, Michelle Ryan, Penny Stempel and Frances Bowyer, joined by Caroline Stone from Open Eye Workshop in Liverpool, Eileen Smith from chapter Video Workshop, and Pearl Berry, a miner's wife, went on to form Red Flannel Films as a Channel Four workshop in 1986. (Hedditch n.d.)

Companies like Red Flannel could be characterized as a 'first wave' of community arts in Wales. Some, like Moving Being (1975–1990), Action Pie (1976–1983), Chapter Film and Video (1978), and Small World Theatre (1979) were products of the 1970s; some still operating, some disbanded or reorganized like Pneygraig Community Project (1977), which became Valleys Kids Project in 1999. The early 1980s saw a rapid growth with companies like Hijinx Theatre (1980), the Pioneers (1981–2004), Valley and Vale Community Arts (1981), Arts for Disabled People (1982), which became Disability Arts Cymru in 1994, Rubicon Dance (1983), North Dyfed Dance Project (1983), West Glamorgan Community Dance (1983), Rhondda Cynon Taff Community Arts (1984), Women's Arts Association (1984), Theatr Iolo Morganwg (1984), Theatr Tales in Wales (1985), Red Flannel Films (1986), and Butetown History and Arts Centre (1986). These initiatives represented the active support of community change and improvement by using the tool of creativity. We had found a cause and enabled people to have a voice: welcome to community arts in Wales.

Revolutionary influences from outside

Wales doesn't exist in a vacuum and we were influenced by the UK and the world beyond these shores. So, in order to understand community arts in Wales, it is also important to step back and see the bigger picture. Having lived and worked in Germany in the 1970s, I bring a particular perspective which reflected my circumstances and influenced my thinking and practice. For a large number of like-minded young people, the very air was laden with the possibility of revolution at this time: we could almost feel it coming. My German

social-worker friend piled sand bags on his balcony and said his machine gun would rest there when the revolution came. The advent of the Baader-Meinhof Red Army Faction heightened our expectation. I remember being in Berlin in 1977, the tension was palpable. Yet nothing really came of it and, in retrospect, I can see why. The idea of revolution was in the embryonic stage, initially just a concept to which we all subscribed. The revolution we sought was the overthrow of establishment, how we did this, or what the consequences of such an action could be, were not clear. We just knew things had to change.

The very fact that a multitude of us wanted revolution to happen and wanted it so badly meant we started to subdivide the initial concept and then subdivide those divisions. Some of us wanted to remain non-violent, others stepped into violent opposition; the embryo fragmented. Many felt the issues around poverty and inequality of opportunity were the main causes of injustice, others argued that issues such as the preservation of bio-diversity and eco-awareness were most important. The subdivided cells divided again. The views of those who prioritized renewable energy, alternative lifestyles and off-the-grid living, as opposed to those who thought the revolution should begin with the psychological and consciousness-raising, the relevance of personal development, and so on, mean that the original embryo has been well and truly divided.

The 1980s: Commodified revolution or pioneering spirit?

As community artists, we were witnesses to the Miners' Strike. None of us were miners, and it became very alluring to represent a voice opposing oppression, when you really had nothing to lose. I remember a wisecrack made during a performance we did in the early 1980s in Mountain Ash: 'We want jobs, we don't want clowns'. When the Strike was over, a large number of miners became double-glazing salesmen and the like, they just wanted and needed employment. Many of the people who had come to show solidarity went back to their well-paid jobs, and 'peace' was restored. Or was it?

The concept of community arts is a dead one; indeed, it may have died a long time ago (Steyn and Sedgemore 1985). In its time, community arts was a useful expression of activism, it was often politically speculative and challenged the notion of the passive consumer. Now, not only has activism given way to professionalism, but the state has appropriated the very art that was meant to 'storm the citadels' as Owen Kelly put it in 1984 (Kelly 1984). As early as 1985, Juliet Steyn and Brain Sedgemore argued that community arts

might even have perpetuated the divisions between elite arts and community arts because 'the very concept of "community arts" [...] has hindered the development of a theoretical socialist base for the arts and displaced the need for a cultural and aesthetic policy' (Steyn and Sedgemore 1985). Their remedy was to suggest that 'rather than trying to resurrect [community arts] we should redefine work, and accept art as part of the process of material production – whilst rejecting the notion of art as a commodity' (Steyn and Sedgemore 1985). This would be done through developing cultural action in workplaces, focusing away from the metropolitan centres, and making art part of the core curriculum in schools up to the age of sixteen. As I write in 2016, having seen very little progress in any of these areas (and a reversal in the case of education), this feels like a double obituary.

In order to respond to the important questions posed by this provocative obituary, I need to point out that Wales was a relatively late participant in the community arts field. The first wave of artists was mainly based in Cardiff and the Valleys, with the Miners' Strike (1984–1985) providing a catalyst for participation. Those of us who had come to these areas of high-social need for the first time found, in the charged atmosphere of demonstrations, confrontation, and the fevered creative process of documenting social inequality and action, a level of excitement and achievement lacking in our previous lives. It was heady, intellectually stimulating, and attractive – we wanted more. Modern-day community arts in Wales was born into a political awareness that such activities were anti-establishment and inherent in that was the understanding you did such work for no pay, out of solidarity with the people you supported.

However, the strike was over, and the revolution was not going to happen any time soon: what was left to be done? Those early artists who had become involved in the movement realized they wanted to continue their work, but in order to do so, they would have to be paid. They had to prove their economic worth to the community, and in order to do this the artists also needed time to develop their ideas. There were two potential sources of funding: Arts Council of Wales (ACW) and the Enterprise Allowance scheme. The Conservative-run Enterprise Allowance scheme, introduced in 1981 under Prime Minister Margaret Thatcher, offered an allowance of £40 per week to people who were out of work, underpinned by an inspiring idea about self-employment as a mode of work for the future. Specifically targeting those wanting to set up their own businesses, the funding came without having to 'sign on' week on week. In other words, you were no longer on the dole, and this reduced the 3 million

claiming dole and benefits dramatically.[3] The downside was that anyone on the scheme could not claim any other benefits for a year but this hidden funding was a fantastic opportunity for emerging community artists, allowing them time and space to try out new ideas, while earning a small living. Artist Chris Partridge remembers:

> The Enterprise Allowance scheme, introduced as a cynical quick-fix to reduce the numbers of unemployed, ironically gave many fledgling community artists a year in which to experiment, get things wrong as well as right. You couldn't join the scheme as an 'artist' [because] this was classified as a hobby, so many of us joined as 'graphic designers', despite the fact we were painters, sculptors and ceramicists. (Partridge 2016)

Community arts took Arts Council of Wales by surprise; they did not know how to react to it. We survived without their funding, and we carried out projects with or without funding. Community arts was outside the ACW's remit and, for a while, this did not seem to matter. We went wild, feral almost, seeking more and more adventurous and un-tried experiences. We didn't fit into existing compartments, we were using creativity and (the way we saw it) were enabling people to create the art, focusing on process rather than product. The arts in Wales was being initiated by artists, not the Arts Council of Wales. It might help to give one example of the confusing situation with regard to funding for community arts in Wales. In 1982, we were seeking funding for a painted mural to be undertaken with teenagers from Willows School in Splott, an inner-city area of Cardiff. When we went to see an officer at the ACW and enthused about the opportunity for young people to grow and express themselves, we were shown the door, and told they didn't fund that sort of 'community stuff', only 'professional art' would be supported. We visited the Allied Steel and Wire company (ASW) a local industry based in Splott at that time and, within 20 minutes of our spiel, given without any great expectations on our part, the officer stopped us and asked how much we wanted. Thrown by this, we recovered sufficiently to ask for £500. Smiling, the employee of ASW told us to 'pick up the cheque as you leave.' Proud to have gained such a fee, we immediately set about the mural. However, two weeks later, the local paper led with the story that ASW had awarded the Welsh National Opera £20,000: we realized we still had a long way to go. Although it barely constituted a living wage, at least we had some money because the previous two murals had been painted in return for fish and chip suppers and some very dodgy office equipment.

Beyond existing boundaries

In those brief untethered years, I remember one workshop in the Rhondda where so many kids turned up we couldn't do any art with them, so we played football with a huge ball made from scrap materials. During the course of the game a boy broke his leg, followed by his dad turning up and carrying him into the back of his car, saying 'No problem, I'll take him to hospital'. I remember nine- and ten-year-olds in goggles and gloves, using a concrete mixer, loading it and then mixing into its mouth with their spades; young children using trowels and other tools to layer the concrete onto structures; artists making huge concrete sculptures alongside teenagers. I remember school children cutting glass and mirrors to make huge murals, all of us working in rooms filled with the suspended tiny particles of glass coming off the broken tiles.

Looking at this picture from a different perspective, community arts in Wales in the late 1970s and early 1980s was characterized not by commodification but by a pioneering spirit that was truly led by the artists. It was a unique event, and a huge privilege to have created work during this time. Artist Richard Berry reflects:

> We were motivated by the sheer joy of exploring things, most of these being beyond our limited previous experience. We didn't know how to do things, but we'd give it a go. We were all equal, there were few directors, administrators or even writers, and all art forms were present. This enabled us to create new languages about creativity, not art form. We made mistakes, but remained inspired. (Berry 2015)

This pioneering spirit was about innocently stepping into the unknown, making mistakes and also having huge triumphs. We were all pushing the limits and boundaries of our practices in a range of ways. We were a movement of young people, recent graduates not established artists, with a few hardened socialists and communists in the mix. Working in a non-hierarchical way, not employing administrators or managers, illustrated the belief that everyone was creative. We were working in geographical areas which had never been exposed to the arts in this way before. Free to follow process rather than be too concerned about the product, we used dynamic and innovative art forms and cross-disciplinary styles, finding the start of 'creativity'. We were making art, which told the stories of communities and the people who lived there.

We were also beginning to work with different kinds of communities, not just those in one town or village, but with people who felt like part of a community based on identities. One example of this was work with groups of

disabled people in projects such as 'A World of Difference – Three Accounts of Disability' in 1989 which involved making a video with three people with physical disabilities, in partnership with community arts company Valley and Vale. This was part of a larger body of work around disability and the rise of 'the political voice of disabled people' in the struggle for 'support and inclusion of those who have been historically devalued by archaic notions of disability' (Davies and Evans 1996: 78).

As the work developed, we were beginning to make applications to formal bodies like Arts Council of Wales and were receiving funding, which meant that we were radically changing our practice. Part-time temporary workers were transformed into full-time practitioners, administrators and managers were employed. The professionalization of the work inevitably led to Arts Council of Wales asserting its control. For example, the Pioneers had been a workers' co-operative. Indeed, many community arts groups were just loose collectives, but the legal status of organizations had to be formalized. This meant the unrestricted innovation and creativity inevitably shrank. Appraisal and evaluation became the key words, the paperwork mounted on our desks. We accepted these restrictions in return for full-time jobs.

Figure 5.1 Hijacking an idea

The 1990s: Rapid growth for what purpose?

The rapid growth and diversification of the work and of organizations throughout the 1990s and 2000s was astonishing. There were community arts groups doing dance, drama, film, murals, photography, as well as combinations of all these art forms. Following on from the companies that emerged in Wales in the 1980s, the next wave saw new companies being set up which included South Wales Intercultural Community Arts (1990–2015), Community Music Wales (1993) and Celf O Gwmpas (1998). A further more recent wave could be characterized by companies like the Gate Arts and Community Centre (2004), Head for Arts (2008), Breaking Barriers Community Arts (2007), and the Romani Cultural and Arts Company (2009).

In another process of the splitting of the embryo, this growth has also spawned a multitude of names for the art being produced – art in the community, participatory art, arts in health, art in education, and residencies. The use of creativity to highlight injustice and to represent solidarity with the working people, which so easily identified the first wave of community artists and organizations, has been replaced by the idea of 'access to the arts' (Arts Council of Wales 2009).[4] Driven by Arts Council of Wales, this proposes that people all over Wales should have access to the arts, leading to some gruesome examples of tokenistic participation. One example of this would be a relatively famous painter who had a very identifiable style 'doing community arts' in local schools. The children copied one of his paintings, and their works were then reproduced on an external hoarding around a building site. The hoarding was a big structure and there must have been at least a hundred copies of *his* painting faithfully stretching around the site. In another example, a silver-ball sculpture in a seaside town in South Wales had been cast with a number of hands etched onto its surface. The artist proudly told me that was the 'participation' of the local people; he'd drawn around a few of their hands in an afternoon and included them in his work. The artist had allowed no consultation, no participation, no pride, and no involvement for local people, and a lot of them were left feeling very disgruntled, which made our jobs more difficult.

This new-founded enthusiasm for 'community arts' does not necessarily reflect a conversion to the concept of community arts; instead, it is mostly financially driven. 'High Art' empires continue to be built, and their allegiance to 'the cause' is questionable. Several of the largest cultural organizations in Wales have obtained grants to fund education officers and community projects. Some

of the existing art and creativity college courses in Wales, which had previously ignored community arts, have now renamed themselves as participatory arts courses, promoting their previously hidden interest in collaboration and access to the arts. The newly fledged artists, dancers, performers, video makers, ceramicists, leaving the colleges realized that there were opportunities to bring their art forms to local or community groups. However, many have done this, not out of a political commitment as with the first wave of community artists, but as a potential way of earning money. Some would argue that this is fair enough as the revolution didn't materialize and new areas of creativity needed to be explored.

As a consequence of professionalization, community arts had to change. The issues of injustice remained, but community artists had to find a new way of operating in an increasingly depoliticized environment. According to Graham Day, 'Communities are developed in order to be more economically effective, to play a larger role in decision making or to exercise greater control over social misbehavior' (Day 2006: 236). For community artists in the 1990s, the painful phrase 'papering over of the cracks' struck many of us as a reminder of our roots. Instead of working towards revolution, some of us felt that we were being employed by the government to suppress revolutions and to keep people quiet.

Over thirty years of persistence: Time for resurrection?

In reality [...] if we're honest, there is little evidence of community arts playing a significant part in any kind of radical social change in this country since the genesis of the movement. How much of an influence can we claim to be having on racism, sexism, nationalism, class or poverty? How far is our work actually promoting equality, freedom... expression even? On the contrary, much that passes for community arts today actually bolsters the status quo, discourages dissent, acts like an acceptable soft police force. (Cope 1984: 27)

In the beginning, community arts was a part of political unrest, seeking the dismantling of the establishment and their repressive society. If that was our only goal, then community arts failed and died a long time ago. It might seem odd now, but in 1994, the Pioneers refused to accept the help of the newly created Lottery Fund, as the artists felt it was a 'tax on poor people', but within two years, the Pioneers were applying to the Lottery like everyone else. The principles of

socialism and revolution were quietly packed away; the role of the artist as an interpreter of social change was forgotten. The work in the early 1980s had been focused on preserving communities, by the 1990s, as Margaret Thatcher and her neo-Conservative government had hoped, community had radically altered if not disappeared, and our job was to try and recreate or invigorate those communities.

That is not to say all changes were negative. Community arts just shifted its emphasis from calling for the downfall of the Western materialistic society, to being of service to people, groups, and communities. Creativity was now being used as a means of developing self-confidence and rebuilding community. We expanded, we adapted, we survived, and we persisted. The politically motivated community arts of the 1970s no longer exists and, in many ways, that is a good thing. Most of the early art was pretty dreadful, emphasizing process rather than product, and despite protestations to the contrary, people make judgements on their work, and want to see a 'good' finish.

We were all making it up from the beginning, we were exploring the unknown and, because of that, we made mistakes; yet, in making those mistakes we learnt and grew – over thirty years of persisting. Most artists involved had no supervision during that time, working with sometimes extreme behaviours of individuals, in areas of poverty and high social need. Unsurprisingly, the burnout rate of community artists has been high, and those of us who have survived changed our work practices for the long term and sought help. Thirty years of persistence has paid dividends, and the work is now recognized as having had many significant impacts. We are creating work in Wales which would have been impossible to have imagined all those years ago. We have diversified, specialized, and conformed. However, that doesn't mean that the joy of working with people has been diminished, it has just shifted.

Legacies

Community arts changed its emphasis from documenting local stories to being of service in other ways to people, groups, and communities. We had to shift our focus, because the social landscape of Wales had changed. The old heavy industry, which spawned workers' rights, political movements, and strikes, has been replaced by the service industries. Nowadays, we even work in harmony with corporations, charities, and governments to improve people's lives. Who would have thought it? At the same time, the ingredients

for revolution are increasingly becoming visible again; there are any number of urgent issues we need to address, not linked to the past, but very much concerns for the future. Consequently, community arts has the chance to resurrect itself, in new ways and forms. The issue of climate change, for instance, gives artists of the twenty-first century an opportunity to assist and show their solidarity to environmental issues. There is a clear path, which didn't exist in the 1970s.

After twenty-three years of operating, the Pioneers closed in 2004; but it was far too early to retire, so I returned to creativity and formed a working alliance with Katja Stiller from Valley and Vale Community Art and Rhys Hughes, a freelance counsellor and former psychiatric nurse, who trained local authority and private sector health and care professionals. The three of us have worked together for over ten years and developed a Person-Centred Creativity programme where we work with care and health workers, as well as directly with their clients. The focus is on wellbeing not illness, and the work enables participants to come up with their own solutions to problems and barriers to personal growth by having fun in a safe environment. 'The facilitators have enabled hundreds of service users, service providers and managers to experience and recognize their own creativity and strength' (Clements et al. 2015: 9).

The revolution – did it happen?

Many professions now expect artists to participate in major public projects but the Pioneers did not achieve this in isolation. We were a significant part of that process along with many other groups and companies in Wales. The revolution did not happen as we imagined it in the early days of community arts – we didn't storm the citadels. Communities were destroyed, many remain fractured, and nothing we did could change that. Maybe change happened in ways we were not expecting, as the idealism of the 1970s was replaced by the entrepreneurial spirit of the 1980s, then the pragmatism of the 1990s and 2000s. However, the call to action, a response to perceived injustice, strongly allied to 'revolution' persists into the twenty-first century and continues to be answered by 'revolutionary outsiders', those of us on the fringe of society, including artists. As with many revolutionary concepts, community arts is constantly changing, being added to, and having parts subtracted.

Long live community arts, community arts is long dead.

Acknowledgements

Thank you to Richard Berry, Alex Bowen, Phil Cope, Richard Cox, Sybil Crouch, Steve Garrett, Rhys Hughes, Chris Partridge, Katja Stiller, and Richie Turner for giving so generously of their time and ideas in preparing this chapter.

Notes

1 http://international-eisteddfod.co.uk/a-bit-of-background/history-of-llangollen
2 Ibid.
3 Under the terms of unemployment legislation, anyone wanting to claim unemployment benefit (go on the dole) had to 'sign on' at the local bureau once a week.
4 In 2015, the Arts Councils produced an Arts in Health and Wellbeing Action Plan which intended to increase understanding of the role of the arts in health and well-being, and support the development of arts and health initiatives through information and guidance. It describes action in five main areas: the Arts and Public Health and Wellbeing, the Arts in Healthcare Settings, Community Arts and Health and Wellbeing, Arts Therapies Professions, Art in Humanities and Healthcare. The plan, which is jointly owned by Arts Council of Wales and Department of Heritage, and Public Health and Health Professions, is intended as the basis for the future development of arts and health in Wales.

References

Arts Council of Wales. 2009. *Arts in Health and Well-being. An Action Plan for Wales*. (Arts Council of Wales: Cardiff).

Berry, Richard. 2015. Interview with Nick Clements.

Clements, Nick, Rhys Hughes, and Katja Stiller. 2015. *Person-Centred Creativity* (Valley and Vale Community Arts: Bridgend).

Cope, Phil. 1984. 'Promises, Promises', in *Another Standard*, 27–29 (The Shelton Trust: London).

Davies, Jeff, and Julie Evans. 1996. 'How Naive Was My Valley? The myth of the caring coalfields', in Phil Cope, Pat Hill, Simon Jones and Jenny Turner (eds.), *Chasing the Dragon. Creative Community Responses to the Crisis in the South Wales Coalfield* (A European Community (ERGO) 2 Coalfields Community Campaign VIAE Report).

Day, Graham. 2006. *Community and Everyday Life* (Routledge: London and New York).

Hedditch, Emma. n.d. 'Red Flannel Films', http://www.screenonline.org.uk/people/id/1403844/ (accessed 10 December 2015).

Kelly, Owen. 1984. *Community, Art and the State. Storming the Citadels* (Comedia: London).

Milling, Jane, Peter Thompson, Baz Kershaw, and Joseph Donohue. 2004. *The Cambridge History of British Theatre* (Cambridge University Press: Cambridge).

Morgan, Sally. 1995. 'Looking Back over 25 Years', in Malcolm Dickson (ed.), *Art with People* (AN Publications: Sunderland).

Partridge, Chris. 2016. Interview with Nick Clements.

Steyn, Juliet, and Brian Sedgemore. 1985. 'A Socialist Policy for the Arts', *The Guardian*, 16 January.

Unknown. 2002. 'The Mabinogion', http://aoda.org/pdf/mbng.pdf (accessed 7 October 2015).

Grown from Shattered Glass: A View from Northern Ireland

Gerri Moriarty

Community art is the process of harnessing the transformative power
of original artistic expression, producing a range of social, cultural and
environmental outcomes. Looked at politically, socially, culturally and/or
economically, community arts aim to establish and maximise inclusive ways
of working, providing an opportunity for communities and their participants
to continue to find ways to develop their own skills as artists and for artists
to explore ways of transferring those skills. Through this process, community
arts aim to maximise the access, participation, authorship and ownership in
collective arts practice.

Arts Council Northern Ireland Art Form and
Specialist Area Policy 2014–2018[1]

Of all the bodies responsible for public funding of the arts in England, Scotland, Wales, and Ireland, only the Arts Council of Northern Ireland (ACNI) promotes a contemporary definition of 'community arts', developed in partnership with the community arts sector.[2] Its policy statement sets out explicitly why it considers community arts should be given public subsidy, seeing it as inclusive, democratic, and transformative. It has a clearly identified set of policy objectives, which it believes will contribute to the long-term development of community arts organizations, practitioners, and projects. If it were possible to travel back in time and share this news with those groups and individuals involved in community arts activity in the 1970s, 1980s, and even those with whom I worked in the 1990s in Northern Ireland, it would have been regarded as a notion as difficult to comprehend and as unlikely to become a reality as the eradication of smallpox would have been to individuals

living in the nineteenth century. This chapter aims to unravel and examine a few of the strands that have woven together to make this unlikely state of affairs possible.

Grown from shattered glass: The role of the outside catalyst, the alternative proposition, and the response of communities

In every country and region in which the concept of community arts has taken root, its development has been significantly shaped by a specific political and cultural context; community arts in Northern Ireland has been no exception and in some ways, may provide the most powerful illustration of this. Its story begins in Belfast in the last years of the 1960s and the early years of the 1970s. Cultural activist and community media and arts practitioner Marilyn Hyndman describes

> a society that in many ways was closer to the 1890s than the 1960s – in terms of architecture, for example. It was grim. I remember going into a little house in the Markets [a working-class Catholic area on the edge of Belfast City Centre]. It wasn't even a one up, one down. It hit you, the incredible poverty, it was quite startling, how poor people were, the atrocious housing conditions. It was third world, but not in the third world. (Hyndman 2014b)

In 1967, the Northern Ireland Civil Rights movement was established to campaign, non-violently, for equal rights in terms of votes, jobs, and services for the minority Catholic population. The events of the subsequent three decades have been summarized thus:

> When it became obvious that those unionists who were in power were not willing, or able, to address quickly enough the demands of Catholics for civil rights, the campaign gradually developed on the part of some people into a violent campaign which claimed that equality was impossible within the existing state structures. This campaign of violence and counter violence by the Loyalist paramilitaries, with attempts at containment by both the police and [the British] army, lasted until the cease-fires of 1994.[3]

This cool academic language cloaks a harsher reality. Between 1966 and 1998, 3,600 people lost their lives as a result of the conflict (McKittrick et al. 2012). Countless other people were seriously injured, traumatized, or forced to leave their

homes and many more lost close relatives or friends. In a small place, there were very few families – including mine – that were not affected in some way. This was the political, social, and cultural context within which community arts developed and grew.

Grown from shattered glass: The role of the outside catalyst

Doff Pollard, a young student from Bretton Hall College in Yorkshire, remembers arriving in Belfast in 1970 as a volunteer for the Voluntary Services Bureau (VSB) summer playschemes. She travelled 'overnight on the ferry, walking into Belfast and people were out brushing the glass off the streets – it was the 13th July, the day after the 12th of July marches' (Pollard 2015). She set to work devising projects based on theatre games that the volunteers then took into the Catholic Divis Flats and the Protestant Shankill Road. Returning to work on a longer-term basis in 1972, she took part in a project instigated by two other outsiders: Patrick O'Connor, from Wexford and London, supported by Jude Wilde and Nancy McKeithe, an American. The Department of Education for Northern Ireland (DENI) had been persuaded by O'Connor to provide two salaries and a base in a former church in Sandy Row to set up what became Hope Street Community Arts Centre. Hope Street ran arts activities for children – 'using paint and clay, making costumes, doing plays' from a double-decker bus, working with international volunteers and students from Queens University Belfast (Pollard 2015).

In this period, 'there were always weird and wonderful people weaving in and out – Belfast attracted outsiders' (Hyndman 2014a); thereafter, the influence of the 'outside catalyst' becomes a recurrent theme in the narrative of community arts in Northern Ireland. Other influential community arts organizations were founded by 'outsiders', two of whom – Englishman Mowbray Bates and Australian Mike Maloney – had also been volunteers on those early VSB playschemes and would go on to set up Neighbourhood Open Workshops (1978) and Belfast Community Circus (1985),[4] respectively. Others, like Chrissie Poulter, who co-founded Jubilee Arts in Sandwell in the West Midlands in 1974, Dan Baron-Cohen of Manchester Frontline, who came to Derry in 1988 to set up a Manchester-Derry collaboration, and Jo Egan, a Dublin-based community arts practitioner, came to live and work in Northern Ireland, bringing philosophies, skills, and approaches to share with local community artists and activists. There were visits that were more fleeting –

Figure 6.1 Forging ahead

for example, John Arden and Margaretta d'Arcy in the 1970s, Augusto Boal in the 1990s, and Galway-based company Macnas – but all were significant in providing both expressions of solidarity in the hardest of times and injections of ideas and expertise.

Grown from shattered glass: The alternative proposition

Two of the other important influences on the development of community arts in Northern Ireland were, however, home-grown and relate to what might be called 'the alternative proposition' and the 'response of communities'. The kind of repressive society that was being challenged was one where

> no-one was entitled to speak, there was tight control of the media. There were well-meaning economists and sociologists, but very little of people telling their own stories, not until the eighties and not even then. There was blanket British propaganda. You'd have interviewers saying to artists 'That's a marvellous painting, now would you like to say a few words against the terrorists?' (Hyndman 2014a)

In 1971, Dave and Marilyn Hyndman were members of 'a collective of idealistic young people, doing alternative publications – magazines, graphic design, screen printing' (Hyndman 2014a) who set up the Belfast Arts Lab.[5] Activities included organizing a community festival in East Belfast, bringing children and young people from the New Lodge area of North Belfast into the Arts Lab for drama workshops, exhibiting films, teaching community groups to design and print publicity material, as well as printing for civil rights groups, community groups, and political groups. There was 'a huge ideology of collectivism – libertarian, anarchist politics, feminism with groups such as the Women's Group which was a sexual liberation group, the Socialists Women's Group, the Belfast Women's Collective and Women against Imperialism being established' (Hyndman 2014b). At this point, 'video made a big difference, it was a technological revolution. Sony developed the portacam – for the first time it was a camera you could carry and video was accessible in a way that film wasn't – it was a way to communicate' (Hyndman 2014b). Dave and Marilyn Hyndman went on to establish Northern Visions in 1986; this is an organization that continues to have a strong community arts ethos, with a 'vision of a democratised form of media, where new technologies are utilised as a tool for expression and creativity, to effect social change and combat poverty, social exclusion and isolation' (Northern Visions Corporate Plan 2016).[6] Significantly, Northern Visions have made several documentary films about different kinds of community arts work in Northern Ireland and placed them in their online archive representing an important resource for both researchers and practitioners.[7]

There were other kinds of approaches to establishing an 'alternative proposition.' In 1988, members of the North West Musicians Collective approached Derry City Council for support for a building that they could use to store equipment, make recordings, and play gigs. In 1990, they helped establish the Nerve Centre in Derry; this initially prioritized work with young people, using popular music, film, video, animation, and interactive multimedia. It has since developed into a major multimedia arts centre and social economy enterprise, working across Northern Ireland with a programme of arts events, creative learning centres, training opportunities, and state-of-the-art production facilities.

In 1993, David Boyd, who was at that time a youth worker based in East Belfast, invited Manchester-based Inner Sense to lead a series of workshops which led to the formation of a Belfast samba band. This gradually evolved into the Beat Initiative, which had as its aim to 'initiate alternative and accessible forms of community cultural expression and to directly provide creative arts

opportunities for young people in and around East Belfast' (Moriarty 1997: 9). The Beat Initiative has since developed into Beat Carnival, an organization which specializes in carnival arts, offering spectacular performances, training both artists and community members and aiming to encourage collaborative, creative skills at grass-roots level.

Growing from shattered glass: The response of communities

The third important influence on community arts development in Northern Ireland was the cultural response to the worsening conflict that emerged from within working-class communities. This was visibly expressed firstly in murals, which were largely created by individual artists working with the explicit or tacit permission of local communities and secondly through community theatre.[8] Community theatre had two functions, one of which was primarily social. In a society where the centres of cities like Belfast and Derry were seen as potentially dangerous places to socialize and few people wanted to stray far from their own enclaves after dark, community theatre groups offered a valued locally based cultural experience. For example, one of the most well established of these groups, explained that they had identified

> the need to perform in their own area rather than a city centre venue like the
> Group Theatre. The local community centre where they rehearse and perform
> is far from ideal as a performance space. It is in heavy demand by other groups.
> But they feel that there is still a substantial number of local residents who would
> be reluctant to go into the city centre to see a show. (Grant 1993: 20)

Two such groups were Tongue in Cheek, based in Ardoyne, a predominantly Catholic district of North Belfast, and Ballybeen Community Theatre, based in a predominantly Protestant housing estate in Dundonald, on the eastern edges of Belfast. Tongue in Cheek's work was characterized by comedy sketches based on aspects of their own lives, which were devised by the group or written by local writer Kate Muldoon. Ballybeen Community Theatre performed plays by local writers, commissioning at one point a play from professional playwright Gary Mitchell (Grant 1993). In general, the work of these kinds of groups was aimed to entertain and was not seen as particularly politically contentious.

Some community theatre groups, however, addressed the political and social situation with uncompromising directness. Early examples are associated with the People's Theatre in Springhill in Ballymurphy, which performed plays by

Father Des Wilson. Playwright Martin Lynch, who would later become heavily involved in the development of community arts in Northern Ireland, recalls seeing one of their performances:

> I had seen a hand-written poster on a wall in a social club advertising a play. I can't remember the title of the play, but when I went along it was packed. It turned out to be a play written by Fr. Des Wilson and it was all about the injustices of internment without trial. Local people acted in it. I remember a scene where a group of women were banging bin lids [bin lids were used to warn local communities that British soldiers were approaching] on the floor. It was quite good, certainly authentic, and I enjoyed it. (Lynch 2004)

In 1992, *Conor's Story*, written by Paddy McCoey as a response to months of drama workshops with the Dock Ward Community Theatre Group led by myself, was inspired by

> a particular bomb planted by Protestant paramilitaries in the New Lodge [a predominantly Republican area in North Belfast] in the 1960s that killed fifteen local people... it was set in the moment when the bomb went off, in a kind of emotional limbo or purgatory. It was quite controversial at the time because it was saying, 'Is this ever going to stop?' And actually to be saying that in the heart of republican New Lodge – some people didn't think we should be saying it [as it could be perceived as undermining the aim of achieving a United Ireland], so it caused quite a dialogue and a discussion within the community. (Moriarty 2005)

In 1997 *Bin Lids*, a collaboration between professional theatre company DubbelJoint and Justus community theatre group, directed by Pam Brighton, told the story of West Belfast from the introduction of internment in 1971 to the founding of *Feile na Phobail*, the West Belfast Festival, in 1988. Underlining the importance of direct artistic responses from working-class communities, Brighton commented, 'So much has been written about West Belfast, but by people from outside. Everybody thinks they know how people here think. The women have gained so much by being able to say in their own words the way they feel about their lives and the events that shaped them' (Brighton 1997).

Individual Protestants and Catholics crossed territorial and psychological barriers to take part in drama projects and attend theatre performances throughout the course of the conflict. However, in 1999 *The Wedding* community play deliberately set out to make a collaborative theatre piece with community theatre groups from across the political divide. The premise of the play involved taking audiences on a short bus journey from a house in a Loyalist

Protestant area of East Belfast to a house two streets away in the Nationalist Catholic area of Short Strand. This site-specific production, which also used a city centre church and a riverside pub as performance locations, was a concept proposed by playwright Martin Lynch and community arts practitioner Jo Egan and the project was supported by Community Arts Forum, the community arts development agency for Northern Ireland. It was an ambitious project that had a deep political and cultural significance for many of those who participated in it. As an unknown cast member commented during rehearsals, 'I would love the play, at the end of the day whatever way we finish it, that people from Belfast come and see it, and walk out saying "They have gone past the peace process"'.[9]

These indirect and direct responses to political and social conditions in Northern Ireland could, and still can, be observed side by side in the kinds of community performances which are showcased at community-based festivals. Festivals also showcase professional mainstream arts practice and popular commercial culture, encouraging new and unexpected connections and resonances for audiences and artists. The best known of these, mentioned above, is *Féile an Phobail*, which began in West Belfast in 1988. Speaking about the festival in 1997, its Artistic Director Caitríona Ruane said that its aim 'was to allow the local community to take control of its own image-making, and to create a showcase of creativity, talent and energy. It was also designed to bring people into an area that was "closed off economically, politically and culturally"' (qtd. Brighton 1997). More recent community-based festivals, such as the East Belfast Arts Festival and the Earhart Community Arts festival in Derry, followed a similar pattern. All of these festivals are shaped to draw on the assets and aspirations of the communities they serve.

Making the most of poor soil: The policy context

In the 1970s and 1980s, community arts managed to establish roots in the cultural life of Northern Ireland in spite of the Arts Council of Northern Ireland (ACNI), rather than because of it. Dave Hyndman remembers that 'there was no interface with the Arts Council – they were quite removed and distant' (Hyndman 2014a). Community arts organizations and projects were largely initially funded by other bodies like the Department of Education, the Community Relations Commission and the Quakers, and later by regeneration agencies such as Making Belfast Work. As late as 1993, it was argued in a review of theatre commissioned by the Community Relations Council that

The pursuit of excellence is rightly a deep-rooted concern of the Arts Council, but it is too often confused with support for 'centres of excellence' (the main theatrical institutions) in a way that is for the large part seldom critically reviewed. Running alongside this acceptance of precedent, is the fact that arts policy has been governed historically by a predominantly middle-class and middle-aged aesthetic. These values have their place, but they should form only part of the complete policy equation. (Grant 1993: 3)

In order to find the first signs of what would eventually turn out to be a much-contested shift in cultural policy, it is necessary to look back to 1978 to a period when Northern Ireland was directly administered from Westminster. Lord Melchett, a Labour minister, decided to give £100,000 to ACNI to enable the setting up of a community arts fund, with the aim of encouraging both cultural democratization and cultural democracy. Melchett considered that this fund, which ACNI was not allowed to use for other purposes, would

First [...] encourage existing artistic activity, exhibitions of the visual arts, concerts, plays and so on, to expand into the more deprived and isolated areas of Northern Ireland where they would not normally be available and to do so in a way which encourages people who would not normally go and see or listen to, to start doing so. Second I believe the need to do more to encourage the artistic efforts of people living in deprived areas, particularly where the artistic activity, where ever it is, is especially relevant or linked to the lives and experiences of local people. (Coppock 2003)

The fund privileged work happening in the conurbations of Belfast and Derry, leading to an imbalance in community arts development in smaller cities, towns, and rural areas, a picture that would persist for some decades.

In 1983, fifteen organizations from across the island of Ireland met together for the first time and agreed to form a collective body called CAFÉ (Creative Activities for Everyone).[10] Although it had been hoped that CAFÉ might be an all-Ireland organization, it was felt that there were too few organizations working at that time in the North for this to be possible. It was not until a decade later, in 1993, that community theatre activists came together to create Community Arts Forum (CAF), an organization that aimed to encourage the development of community arts work across Northern Ireland and to lobby funders and decision makers for financial support. Martin Lynch, who was one of the first development workers for the organization, regarded the establishment of CAF as an expression of an important moment in the cultural history of the North.

> The emergence of CAF was not an accident and the organisation did not come
> about because of the work of one or two people. CAF was a product of its time.
> It couldn't have happened 20 years before, it certainly couldn't have come about
> fifty years ago – it's an accumulation of a change in society's behaviour and that
> is that the arts were becoming more acceptable in areas that previously they were
> not accepted – that is working class areas and areas with high levels of social
> deprivation.[11]

Northern Ireland is a highly politicized society within which many groups
and individuals have a well-developed sense of how power is distributed and
how it can be challenged. CAF was one such organization, committed to both
leading and contributing to the development of cultural policy; it saw this work
as a necessary part of developing and sustaining practice. This endeavour has
been taken up by Community Arts Partnership (CAP), an organization which
represented a merger of New Belfast Community Arts Initiative and Community
Arts Forum and succeeded CAF in 2011.

In 1998, with funding from Making Belfast Work, and practical advice and
support from Community Arts Forum, the community arts sector in the city
was mapped by independent consultants, Comedia. The resulting report showed
that there were fifty-three groups in the city who saw themselves as involved in
community arts, with drama the most popular art form, accounting for 40 per
cent of baseline activity. Visual arts, music, and multi-art form practice were also
strongly represented. Arguments for support for community arts from public
finances were made on grounds which were particularly resonant in a society
trying to find ways of emerging from conflict. The authors of 'Vital Signs', the
report based on this research, were convinced of the value of community arts
activities in Northern Ireland.

> Very often, these brief descriptions [individual responses to survey questions]
> are frankly moving, personal testimonies to the way in which creative work has
> changed people's feelings about themselves, their community and their city [...]
> People felt more optimistic, more tolerant, more informed [...]. [Community
> arts] offers opportunities for cross-community cooperation of all kinds and
> positive celebration of local concerns and identities. (Matarasso and Chell 1998)

In 2007, CAF produced a report on a major programme of work which had
explored the part community arts could play in tackling conflict, exclusion,
and intolerance; this programme included two international conferences:
'Arts: Towards an Inclusive Society' (2005) and 'Cultures and Conflicts' (2006).
In addition to supporting research and building policy arguments for financial

support for community arts, CAF lobbied politicians directly, organizing events at Stormont which was by this time the seat of the Northern Ireland Assembly, demonstrating at the offices of the Department of Culture, Arts and Leisure and campaigning alongside ACNI and the wider arts sector in 2006 and 2007 to make the case for funding for all the arts, under the banner 'Invest in Inspiration'. This research and advocacy work was effective, with recognition for community arts and funding gradually increasing from a range of sources such as the European Union's PEACE programme,[12] the International Fund for Ireland, from district councils right across Northern Ireland and, increasingly, from ACNI. Partly as a consequence of the Good Friday Peace Agreement in 1998, public bodies in Northern Ireland began to develop more transparent governance procedures and a number of experienced community arts practitioners applied successfully to be members of ACNI's governing Council and began to more fully address the unbalanced 'policy equation' that had earlier been identified by David Grant (Grant 1993).

By the early years of the twenty-first century, therefore, several factors combined to place the practice of community arts in a more visible, and arguably, more coherent position in Northern Ireland than was the case in England, Scotland, or Wales. The first factor relates to size and scale; Northern Ireland has a population of circa 1.8 million, compared to the population of Yorkshire and the Humber, for example, which is circa 5.3 million. Community arts activities, even when delivered with limited resources, were able to make a considerable impact on communities, in the media and on decision makers. The second factor was that, although funders in Northern Ireland also use terms such as 'participatory arts' and 'socially engaged' arts, neither the community arts sector nor its major funders abandoned the term 'community arts', as has happened elsewhere. This was greatly assisted by CAF's assertion that there were four distinctive and indivisible characteristics of community arts practice: access, participation, authorship, and ownership, which did not necessarily apply in quite the same measure to either participatory or socially engaged art.[13] As someone who was deeply engaged with CAF's work at this period, I would describe these as increasing the right of everyone to make use of all the resources required to make and enjoy the arts, increasing the right to actively share in the benefits of involvement in the arts, increasing the right of everyone involved to originate ideas and material, and increasing the right of participants as well as artists to make decisions and exercise power.

Third, as outlined above, artists, community arts organizations, and community arts participants engaged directly in influencing and shaping

cultural policy in ways that became much less common in other jurisdictions from the mid-1980s onwards. It is also possible that the very expression 'community arts' has a particular kind of significance in a society where geographical communities have been and can still be deeply divided; the sides in many conflicts are often labelled as 'this community' or 'that community'. Community arts in Northern Ireland bore witness to the value and potential of a different kind of 'community' – one in which difference could be respected and enabled as a positive creative force. A current example of this is the Playhouse in Derry, which describes one of its core values as working 'as a community, for the community – by creating safe spaces where people of diversity can mingle and thrive.'[14]

Setting the agenda: Facing up to new challenges

In the twenty-first century ACNI and the community arts sector have shifted ground, coming together on occasions to lobby Northern Ireland's politicians to maintain and expand resources for all the arts, and not just for community arts. CAP played an influential role in the development and implementation of ACNI's Intercultural Arts Strategy (2011–2016) which aimed 'to create many avenues for minority ethnic communities to access and participate in the arts in Northern Ireland and further afield'[15] (ACNI, 2011) through its PICAS programme (Programme for Intercultural Arts Support). In 2015, CAP's chief executive Conor Shields participated in Ministerial Arts Advisory Forum to develop the Department of Culture and Leisure's ten-year strategy for the arts, arguing that

> arts bring people together. We celebrate who we are; what we can contribute, what we enjoy, what entertains, and what enables our shared celebration of people and place. The arts reflect our cultural selves and the local offering of carnivals, theatre, public art, street art and galleries, books, comics, films, workshops and masterclasses, community plays and fashion design shows, poetry slams, concertos and gigs and a myriad of other events and happenings, highlight the best of our achievements and point to the depth of our collective potential.[16]

In Northern Ireland, community arts organizations, individual practitioners, and participants have always aimed to articulate their arguments, to identify friends and allies and struggled hard to set agendas, rather than to wait passively

to be told what the future will hold. As African American civil rights activist Florynce Kennedy said, 'Don't agonise, organise' (Busby 2001).

In the twenty-first century, practice has also developed to take account of new priorities in communities, new technologies, and new ways of creating and presenting artistic work. As an example, Northern Ireland has the highest rate of suicide per head of population in the UK; this has been linked to both high levels of deprivation in economically-deprived communities and to the ongoing legacy of the conflict.[17] In 2014, Colin Neighbourhood Partnership in West Belfast and Partisan Productions, a professional theatre and film production company, worked collaboratively to research the impact of suicide with individuals, families, and community groups locally and elsewhere in Northern Ireland. They produced a play called *I Never See the Prettiest Thing* with and for the communities who have been most deeply affected. Artistic Director Fintan Brady explains, 'We attempt to construct productions which allow our audiences to experience and re-imagine complex situations in ways that require a complex response. The theatricality, the aesthetic, of the work is key'. Local youth worker Tony Silcock, commenting on the positive responses of young people to the production, confirmed that the play provided 'a fantastic opportunity to engage in conversation with young people about suicide. Another example of a different kind is Down Community Arts that work in a rural community with a wide range of people, using animation, film, and new media; their work bears witness to the fact that for many years now, community arts practice has developed well beyond the narrow confines of Belfast and Derry. Another type of contemporary example is the Duncairn Centre for Culture and Arts, which is based on the interface between Catholic and Protestant working-class neighbourhoods in North Belfast; this blurs the lines between different forms of arts practice, presenting a programme of contemporary folk music, traditional Irish music, workshops for local people in all art-forms and exhibitions, some of which are community-based and some of which feature the work of individual artists.

This combination of involvement in the evolution of cultural policy and development of artistic practice has served community arts in Northern Ireland well. At the time of writing, however, there are major uncertainties, particularly concerning levels of public funding. For example, how will community arts be affected by the recent transfer of the functions of the Department of Culture, Arts and Leisure to the newly established and multifaceted Department for Communities? At first sight, it might appear that this change could only be of benefit, but the reality may be that community arts, and indeed all the arts, will move towards the bottom of a very long list of

social and economic priorities, with little attention and less money being given to them. The European Peace Programme, PEACE IV, which has contributed a great deal to community arts activity will finish in 2020; will Northern Ireland continue to be seen as a priority, more than twenty years after the signing of the Good Friday Agreement and given the results of the 2016 UK referendum on leaving the European Union? And in general, the cuts to public funding caused by austerity measures, which have had a huge impact across the UK, are even more difficult for Northern Ireland, where public sector expenditure has traditionally been high; how will the aftermath of these cuts affect community arts practitioners and organizations?

It may be necessary to recall that, as I have suggested above, community arts in Northern Ireland is a resourceful practice that grew from shattered glass and poor soil; the hope must be that, at a deep level, it will somehow be able to find a way, or several ways, forward.

Notes

1 Arts Council of Northern Ireland, *Art Form and Specialist Area Policy 2014–2018*. Available at http://www.artscouncil-ni.org/images/uploads/artform-documents/ Community_Arts_May_2014.pdf (accessed 13 April 2016).
2 This chapter refers to the development of community arts in the Republic of Ireland but does not attempt to document its rich history. An insight into this can be found in Fitzgerald (2004).
3 Fitzduff and O'Hagan (2009).
4 Members of Neighbourhood Open Workshops went on to become involved in setting up the Crescent Arts Centre (circa 1981). Crescent Arts Centre hosted organizations like Belfast Community Circus and developed an outreach arts programmes in communities.
5 In common with Jim Haynes Drury Lane ArtLab and other Artslabs set up around the UK, Belfast Arts Lab advertised in the London alternative information centre BIT
6 Mission Statement included in Corporate Plan, made available by the organization, 2016.
7 The Northern Visions archive can be found at http://archive.northernvisions.org/ tag/community-arts. The film 'In Our Time' sets the development of community arts in Belfast against the background of the conflict (accessed 4 May 2016).
8 A comprehensive account of murals in the North of Ireland can be available at http://cain.ulst.ac.uk/bibdbs/murals/rolston1.htm (accessed 4 May 2016).

9 Author unknown (1999). For a more detailed account of *The Wedding* community
 play, see Moriarty (2004).

10 CAFÉ was one of the organizations that spoke at the Conference for Cultural
 Democracy in Sheffield that is discussed in Chapter 2.

11 Lynch qtd. in Floyd et al. (2016). This report contains many more examples of
 community arts organizations and projects.

12 The European Union PEACE programme was first established in 1995 to make a
 positive response to the paramilitary ceasefires of 1994. It has directly or indirectly
 supported several community arts initiatives.

13 Floyd et al. (2016).

14 Derry Playhouse (n.d.).

15 ACNI (2011).

16 Community Arts Partnership (CAP) (2015).

17 BBC (2016).

References

ACNI. 2011. *Intercultural Arts Strategy Executive Summary*, 5. Available at http://www
 .artscouncil-ni.org/images/uploads/publications-documents/Exec_Summary_(2)
 .pdf (accessed 5 May 2016).

Author unknown. 1999. Transcripts of interviews with participants. Available at http://
 www.bbc.co.uk/northernireland/learning/eyewitness/better/wedding/transcript2
 .shtml (accessed 4 May 2016).

BBC. 2016. 'Suicide: Northern Ireland Has UK's Highest Rate for Second Year in Row'
 4 February. Available at http://www.bbc.co.uk/news/uk-northern-ireland-35491402
 (accessed 16 June 2016).

Brighton, P. 1997. 'The Lid of Me Granny's Bin', *Irish Times*.

Busby, Margaret. 2001. 'Florynce Kennedy', *The Guardian,* 10 January.

Community Arts Partnership (CAP). 2015. *Response to the Consultation Document
 Strategy for Culture & Arts 2016–2026 DCAL November 2015, January 2016.*
 Available at http://comartspartner.org/wp-content/uploads/2016/02/Community
 -Arts-Partnership-Response-DCAL-16-FINAL-version.pdf (accessed 16 June 2016).

Coppock, Chris. 2003. 'A.R.E. Acronyms, Community Arts and Stiff Little Fingers',
 in *The Vacuum* (Factotum: Belfast).

Derry Playhouse. n.d. *About the Playhouse: Vision, Mission and Core Values'.* Available
 at http://www.derryplayhouse.co.uk/content/vision-mission-amp-core-values/50
 (accessed 20 June 2016).

Fitzduff, M., and L. O'Hagan. 2009. *The Northern Ireland Troubles: INCORE Background
 Paper.* Available at http://cain.ulst.ac.uk/othelem/incorepaper.htm (accessed
 13 April 2016).

Floyd H., C. O'Donnell, R. O'Reilly, L. Cochrane, and C. Shields (eds.). 2016. *A Coming of Age* (New Belfast Community Arts Initiative as Community Arts Partnership: Belfast). Available at http://comartspartner.org/wp-content/uploads/2013/12/a _coming_of_age.pdf (accessed 4 May 2016).

Grant, David. 1993. *Playing the Wild Card. A Survey of Community Drama and Smaller-Scale Theatre from a Community Relations Perspective* (Community Relations Council: Belfast).

Hyndman, Dave. 2014a. Interview with Gerri Moriarty.

Hyndman, Marilyn. 2014b. Interview with Gerri Moriarty.

Lynch, Martin. 2004. 'The History of Community Arts in Northern Ireland: According to Martin Lynch', in Sandy Fitzgerald (ed.), *An Outburst of Frankness: Community Arts in Ireland. A Reader* (tasc at New Island: Dublin).

Matarasso, François, and John Chell. 1998. *Vital Signs. Mapping Community Arts in Belfast* (Comedia: London).

McKittrick, David, Seamus Kelters, Brian Feeney, Chris Thornton, and David McVea. 2012. *Lost Lives. The Stories of the Men, Women and Children Who Died as a Result of the Northern Ireland Troubles* (Mainstream Publishing: Edinburgh).

Moriarty, Gerri. 1997. *Walking New Roads, Stepping in New Shoes: A Community Arts Audit for Greater East Belfast* (Community Arts Partnerships Community Arts Library).

Moriarty, Gerri. 2004. 'The Wedding Community Play Project: A Cross-Community Production in Northern Ireland', in R. Boon and J. Plastow (eds.), *Theatre and Empowerment: Community Drama on the World Stage*, 13–32 (Cambridge University Press: Cambridge).

Moriarty, Gerri. 2005. Interview with Alison Jeffers.

Pollard, Doff. 2015. Interview with Gerri Moriarty.

Part Two

Cultural Democracy: Practices and Politics

Then and Now: Reflections on the Influence of the Community Arts Movement on Contemporary Community and Participatory Arts

Alison Jeffers

The past is always much less complicated than the present; memory smooths down the awkward edges and turns the jagged rocks into polished stones.

Mulgan and Worpole 1986: 91

Introduction

The function of this chapter is twofold. It is intended to bridge the gap between the 1980s and the present day by accounting for the major changes in community arts between then and now. Although the contributors in Part One brought their nationally focused narratives up to date, this section offers the opportunity to investigate specific aspects of community arts in more detail. The second function is to account for the differences and similarities between the kinds of community arts represented by the Community Arts Movement of the 1970s and early 1980s and contemporary practices which concern themselves with participation and co-production in the making of art. There are four main elements in this chapter: first, I show how one of the major differences between then and now is the fragmentation of community arts during the 1990s and into the new millennium; second, I will examine how the struggle for a coherent theoretical base has been very similar across the years, even though it may be differently expressed. Third, I consider the economics of supporting community arts which was an urgent question for the Community Arts Movement and continues to be so today.

Finally, and closely connected to that, is the question of what happens when economic support becomes available for community arts, as it did in the late 1990s and early 2000s in amounts unimaginable for artists in the Community Arts Movement and tied to agendas beyond those of community arts and community artists.

It is tempting to convince oneself that the debates and struggles of the early years of community arts were clearer somehow, better delineated, and articulated. Anyone who was involved with community arts knows this to be a false memory but time has made it possible to create certain narratives that make it seem so. Today, by contrast, feels messier and more complicated, harder to articulate or clarify: in the words of Mulgan and Warpole above – awkward and jagged. In Part One, we traced the beginnings of the Community Arts Movement from the radical art and political movements of the late 1960s and accounted for the expansion of community arts activity in the UK throughout the 1970s and early 1980s. Part Two of this book is intended to reflect on some of the traces left by the work of the early 'pioneer' community artists and how these have been adapted. In this task, we find ourselves creating certain narrative trajectories one of which is the desire for recognition of community arts and what the artists who pursue it believed it could achieve. This has been a constant element of community arts going back to the early 1970s and, although it may be articulated in different ways, it still pertains today.

One of the methodological challenges in creating this collection has been the strain of looking back to a time and a set of activities that many contributors to this volume lived through and experienced directly. Moreover, our informants were activists with a passionate commitment to the politics and methodology of an art practice which they initiated and developed. As researchers, it is important to be alert to canonical stories based on possibly romanticized accounts or nostalgic recollections. Fragmented archives, and the lack of contemporaneous critical literature, make it very difficult to test memory and anecdote. Triangulation methods, often used in historical research, of moving between archival, personal, and critical sources are limited because there is so little account, critical or otherwise, of the work carried out. In addition to our interviews, the community arts magazine *Mailout* has provided one way to navigate the changes between 1986 and the present day. Started as a newsletter for community arts in the East Midlands in 1986, it began to cover other regions in 1988 before becoming a fully independent national magazine at the end of 1991. It ceased paper publication in 2010 but can be found online.[1] Its

strapline has alternated between 'Arts Work with People' and 'The National Magazine for Developing Participation in the Arts' and it has provided a focus for a wide range of practice in the UK that places questions of participation, access, and equality at their core. In many ways, although it is a very different publication, it took over from *Another Standard* as the national voice of what had become an even more disparate set of practices to that of the Community Arts Movement. Despite an update from the 4th AGM of the Shelton Trust (placed as an advert in *Mailout* in 1987) which proposed a revamped magazine, in 1988 *Mailout* claimed that the Shelton Trust and *Another Standard* had ceased to exist, explicitly taking on the mantle of becoming the national voice of community arts.[2]

Community artist Frances King comments that 'community arts, or *whatever we are not going to call it*, is in need of an urgent overhaul' (1994: 14, emphasis added). Confusingly, despite artists wanting to distance the *activity* of community arts from the *term* 'community arts' in the 1990s, a single alternative name has never quite emerged meaning that terminology for this activity post-1986 presents something of a challenge here. It is useful to revisit the 'umbrella' image from the Introduction in the sense of needing a generic term to cover the activities discussed. However, in creating one, I am forced to make a set of value judgements because naming the generic, or overarching, term sets the terms of debate. It seems impossible, in the face of changes such as those suggested above, to keep calling all of this activity 'community arts' as it provides an inadequate umbrella. Therefore, I will use the term 'community and participatory arts' as a generic marker covering all the activities discussed. At the same time, it is worth adding that 'participatory arts' is a marked term for many community artists, often signifying work that is less politically driven or that does not place ideas of change at its centre. Sometimes used by larger cultural institutions that began to offer access programmes and audience development initiatives in the early 1990s, it is thought to be more often associated with the democratization of culture model discussed in the Introduction and in Chapter 2. Activities labelled participatory arts are more likely to be interested in questions of access to the *existing* arts for participants as opposed to community arts where the stress lies on the cultural democracy model of offering opportunities to *produce* art. However, coupling participatory with community arts provides a necessary umbrella term here and using both terms provides an ongoing reminder of the struggle between the differing modes of operation as they emerged in the 1990s.

Fragmentation of community arts in the 1990s

The challenge of creating a coherent, critically informed narrative for community arts after the mid-1980s is compounded by the fragmentation of community arts practices. What had been a fairly coherent, if disparate, body of practice in the 1970s started to become much more diverse in terms of the numbers of projects and range of interests of the artists working in the area, the groups with whom they worked and the techniques available to artists. During the 1990s the number of community arts projects and organizations expanded and, although it is impossible to quantify, it can be said with some confidence that every major city would have had at least one community arts company, with companies and smaller projects also attached to most large towns throughout Britain, to which can be added considerable activity in what was called 'rural arts' in more remote locations. At the same time, as new companies and projects were beginning, some of the older companies who had been established in the 1970s and 1980s were disbanded by the artists who had set them up. For example, as discussed by Owen Kelly in Chapter 11, he and Dermott Killip at Mediumwave told their funders, the Greater London Arts Association, in 1990 that they would not be applying for further support (Kelly 2016). *Mailout* announced in 1989 that in the West Midlands 'some noble giants from the early days of the community arts movement' had disbanded, mentioning particularly Saltley Print and Media, Trinity Arts, and Telford Community Arts (TCA) (Maguire 1990). Cathy Mackerras discussed what was behind this for the artists at TCA:

> We were having to jump through more and more hoops to get the money. That was one of the main reasons for us closing down. We could see the writing on the wall I think, in terms of funding and the difficulty in carrying on doing the kind of work that we wanted to do. We thought it would be better to stop it ourselves rather than be stopped – that it would be better to be in control of the end than just be victims of it. (Mackerras 2015)

Many artists also began to leave the older community arts companies to become 'freelancers' or self-employed artists which allowed them some degree of autonomy that may have been lacking in being part of a company. They could be less tied to specific neighbourhoods and could operate alone or work with other artists on a project-by-project basis. Crucially, they freed themselves from much of the daily grind of increasingly operating to the funders' agendas and trying to keep a company going, particularly in the testing circumstances of the

early 1990s when companies often found successive Conservative governments less than enthusiastic about funding the arts in general; this will be discussed in more detail below.

These shifting patterns of work had implications for the local nature of much of the work carried out by the Community Arts Movement with their traditionally close ties to specific neighbourhoods and communities meaning that artists were increasingly unlikely to be locally based. Scanning *Mailout* between 1986 and the present day shows that some community arts projects associated with the Community Arts Movement, which were grounded in geographically, socially, and economically defined areas of towns, cities, and villages through out the UK, have continued. However, since the late 1980s the nature of many of the groups that worked with community artists has changed. Although there are still many locality-oriented projects, from the late 1980s they were increasingly joined by a myriad of other constituencies that were beginning to emerge – from theatre in prisons, oral history groups, disability activist projects, unemployed groups, black arts projects, peace groups, ecology projects, mental health groups, and many others. *Mailout* describes the work of the Community Arts Movement of the first stage of community arts, to be characterized as 'mainstream neighbourhood-based community arts' (*Mailout* 1988). In the next stage, they add 'Arts with young people, creative work with special needs groups, art-based community development and education or issue and interest driven campaigning' (*Mailout* 1988: 3). Janet Sisson stated that by the late 1990s, community and participatory arts had become 'too broad, too eclectic and allied to too many other areas of work – community development, health, regeneration youth work and so on, for it to be encompassed in one glib funder-friendly definition' (Sisson 1999/2000: 21). This represents not only a rise in community and participatory arts activities generally but also a challenge to the class-based social analysis of the early community artists which was diminishing in popularity.

By the early 1990s, many community artists and companies took the pragmatic decision to call what they were doing participatory arts rather than community arts (Matarasso 2013: 215). At 'Challenges for the Nineties', a national conference held in 1990, some delegates felt that it was time to 'dump the ideological exclusivity and moral superiority that characterised much of what is still called community arts' (*Mailout* 1990: 16). Frances King suggested that 'the pre-fix community has been surreptitiously dropped and replaced by "participatory"'. Not only did the term 'community arts' 'have a dubious reputation and appear dated, reminding people of those apparently oh-so-embarrassing values of

the 60s and 70s', the term 'community' had been 'overused and abused' (King 1994: 14). This seems typical of a desire from the beginning of the 1990s to distance arts activities grounded in participation from the earlier work of the Community Arts Movement of the 1970s and early 1980s. This is picked up by Sophie Hope in Chapter 10 when she discusses the move from community arts to socially engaged practice.

This seems to have been partly a way of distancing their work from forms that had begun to feel dated and out of touch as discussed above. 'Participatory arts' had proved a more *useful* term that came without the accompanying ideological 'baggage' of community arts. It was also useful because the model of community arts companies located within specific communities had started to disappear and many companies were looking for a new name that reflected this. Helix Arts, for example, define participatory art in a way that is very close to community arts but they do not want to term it so because it is not located in communities and could take place with individuals and with groups who do not define themselves as a community (Lowe 2011). Less positively, François Matarasso argues that the move from community to participatory arts marks 'a transition from the politicised and collectivist action of the seventies towards the depoliticised, individual-focused arts programmes' which encompass the journey from 'radicalism to remedialism' (Matarasso 2013: 216). For Matarasso, it reflected wider trends and changing ideas about individuals and communities which saw the fall of socially based systems of working and living and the turn to the individuality of the coming neoliberal age. For community arts, 'the techniques of cultural democracy were conscripted to the cause of the democratisation of culture' (Matarasso 2013: 226) and the transition marked the end of thinking about community arts as part of community development and activism.

The theoretical base for community arts

Community artist and researcher Jennie Hayes suggests that thinking about community arts through Dwight Conquergood's 'creativity, critique and citizenship' ideas in relation to practice and research are revealing because they show that 'we're not so afraid of dealing with the creativity and citizenship strands' but 'we've abandoned critique in any public sense' (Hayes 2003/2004: 11). In developing community and participatory arts, artists have taken ideas and approaches from a wide range of political and social theorists, been drawn

to discourses in feminism, gender politics, community development, racial politics, cultural theory, and many others, but have seldom explicitly discussed these influences in a public arena. One of the big shifts that has taken place between community arts in the 1970s and the work from the 1990s onwards has been the move from the politics of class to the politics of identity; yet, to agree with Hayes, there is very little obvious analysis of this. The focus of community artists has been most often on action and practice with less emphasis being placed on reflection and theorizing. The emphasis on the pragmatics needed to 'get the job done' often dominated in the past, and continues to do so, and reflecting on and theorizing the work were and are not prioritized to the same extent.

For Dermott Killip, who started Mediumwave with Owen Kelly in the early 1980s, contemporary community and participatory arts have lost their radical edge and one of the reasons that he offers for this is that community arts is 'stuck in the theoretical trenches it dug for itself in the seventies' and 'hasn't advanced its theoretical base sufficiently in recent years. Although the work it produces is often innovative and first rate, little energy has gone into refining and developing the philosophy or concepts behind community arts' (Killip 1991: 16). Yet, even during the 1970s, community artists found it hard to marshal the resources available to create a sound theoretical underpinning for community arts to any great extent. For example, looking back on his time as a community artist Stephen Lacey regrets not having paid more attention to the cultural theories that were emanating from the Centre for Contemporary Cultural Studies in Birmingham. Set up by Richard Hoggart in 1962, the centre 'operated at the intersections of literary criticism, sociology, history and anthropology' focusing in particular on popular culture.[3] As a postgraduate student studying there, Lacey felt that he had missed an opportunity to more actively link the work he was doing as a community artist with cultural theory. He identified

> the potential to use the cultural studies experience to theorize community arts practice in a very grounded way. I don't mean simply to impose a theory on it but to find a way of articulating a political coherence for community arts practice. This was at the time when the Centre was talking about Gramsci and hegemony and the importance of the cultural field as a site of resistance. Paying attention to the interconnections between different kinds of practice – arts practice, political practice, community action might have helped to make more sense of what was going on in community arts practice. (Lacey 2012)

Some companies such as Valley and Vale in South Wales did produce theoretically and politically informed books which examined cultural democracy (Rothwell 1992) and the 'creative community responses to the crisis in the South Wales coalfield' (Cope et al. 1996). Also, since its inception, the editors and many of the contributors to *Another Standard* displayed the desire to connect more closely to theory, even though the readership seemed not always to appreciate this. After an article in 1983 about United Mime Workers, a political theatre group in Illinois, a reader in a letter to the next edition asked, 'What precisely has the almost incomprehensible philosophy of a "radical" mime troupe from Illinois got to do with the work of the average community artist, struggling to get their work recognised as a contribution to the area in which they work?' (Another Standard 1983). This example illustrates a divergence in the Community Arts Movement with some artists, possibly the majority, having taken a more pragmatic approach, while a smaller group saw 'theory' of whatever kind as potentially useful and something that could help to consolidate and extend their practice.

This apparent gap between what was seen as 'theory' and practice can be seen as far back as the early 1980s when the Shelton Trust conference 'Friends and Allies' in Salisbury (1983) crystalized this tension. The Community Arts Movement was reported as taking a binary position between those who 'seem to do nothing but theorise and analyse with little practice to show for it' and those who 'practice community arts with practically no energy going into theory or analysis' (Brooks 1983). The editors of *Another Standard* warned against ignoring theory, while acknowledging that many readers might find it intimidating, or mistrust it as inherently bourgeois and male (Another Standard 1983: 3). However, they suggested that it was imperative that the community arts movement construct theories to provide a framework for their work because the 'lack of a theoretical perspective within our movement is a vacuum waiting to be filled' (Another Standard 1983: 3): if community artists did not fill the gap, others would. This was the thesis of Owen Kelly's book *Community Art and the State* and he picks up this thread in Chapter 11.

Chapter 2, the introduction to Part One of this book, concluded with 'The Manifesto for Cultural Democracy' produced by the Shelton Trust in 1986. In 2010, a 'Manifesto for Participation in the Arts and Crafts' was launched at the National and Local Government Arts Officers (NALGAO) conference which had been developed by 'representatives from national organisations with support from Government departments and Arts Council England'.[4] These two manifestos create a useful way to conclude this section providing insight into

some of the differences in thinking about the relationship between people and the arts in the early days of community arts and the present day. The 1986 Manifesto for Cultural Democracy presented a radical vision of the central role of cultural production in social and political change. It framed the arts as 'a particular set of creative acts [which identified] a small range of activity which has been chosen from an infinitely larger range' and suggested that this choice was 'the operation of an oppressive culture' which 'represents the values of one particular class' (Kelly et al. 1986: 44). It offered an analysis of what its writers saw as the dominant systems and a 'tool for action' to challenge those systems (Kelly et al. 1986: 8). It is confident, if not even strident, in its tone providing a rallying call to action.

The 'Manifesto for Participation in the Arts and Crafts' in 2010 covers ten brief points and is 'intended for consultation, with an encouragement to embody its main principles into the policy framework of arts organisations' (*Mailout* 2009/2010: 10). Compared to the 1986 Manifesto it seems rather bland, calling for 'a strong coalition and joined-up approach to participation' and 'raising the status of leaders and facilitators of participation in the arts', for example (*Mailout* 2009/2010: 11). It calls for the increase and development of the 'role of the participant in setting the agenda, defining the language and being actively involved in the entire process' (*Mailout* 2009/2010: 11) which stands in marked distinction to the approach of the writers of the 1986 manifesto and their insistence on the central role of all groups oppressed by the capitalist system and the dominant classes. However, another way to look at this would acknowledge that the politics of community arts will necessarily reflect the general political discourses of the time. In the 1970s, when trade unionism was still strong and workers' collectives were the norm, before the fall of the Berlin Wall signified the end of 'communism', the political climate and ways of expressing political opinions were very different. Today, the emphasis lies more in the language of values rather than commitment and the 2010 Manifesto is possibly mistitled being closer to Hayes's 'Values of Participatory Artists' which stresses an ethical dimension in laying out a series of points of belief, what participatory artists respect, and what they endeavour to do (Hayes 2003/2004: 12).

The theoretical base for community and participatory arts remains under-explored and we intend for this book to make some contribution to this lack. The writers in Part Two are concerned with the ways that thinking about the practice inflects that practice in many and various ways. Their concerns to imbricate theory and practice suggest ways in which praxis could be further developed in

this field. *Praxis* was first defined by Aristotle as knowledge produced through action, one of three types of human activity, the other two being *poiesis* (goal-oriented action) and *theoria* (the production of truth) (Given 2008: 676). Twenty-first-century thinkers embraced ideas of praxis, with Marx famously stating early in his career that 'philosophers have only interpreted the world in various ways: the point is to change it' (Given 2008: 676). We can also trace concerns with praxis to two influential figures for community artists in the 1970s, Antonio Gramsci and Paulo Freire. Gramsci's philosophy of praxis is concerned with the effort of people to gain a critical perspective on their world. Citing Gramsci in their call for a socialist policy for the arts, Steyn and Sedgemore suggest that 'doing things consciously is more likely to help us achieve our goals than doing things spontaneously' (Steyn and Sedgemore 1985). This kind of thinking can also be seen in the work of Freire who defined praxis as 'reflection and action upon the world in order to transform it' in his concern for the value of praxis in challenging oppression (Freire 1996 [1970]). However, before these ideas can be picked up in Part Two, it is necessary to put the final two elements of this account into place: one describes the constant battle for resources to carry out community arts and the other looks at what happens when community arts appears to coincide with government policy and monies for the work become available.

Dead dogs and rising stars: The 'economic turn' in the arts

This section examines the emphasis on the economics of the arts, paying particular attention to its impact on community arts. During the research for this collection, community artist Rick Walker offered an account of a business consultancy in the printshop at the Greenwich Mural Workshop in the late 1980s when a matrix was applied to uncover the commercial potential of the work carried out there. In opposite corners of the matrix were dead dogs (where there was very little potential for commercial income but which had a high social impact) and rising stars (which managed to provide both income and social value).[5] This story acts as a useful indicator of shifts in policy and practice in the arts sector generally towards an emphasis on the more commercial aspects of the arts from the late 1980s onwards; moving away from previous thinking about subsidy for the arts to asking what could be provided following 'investment in the arts'.

The financial position of community arts has always been precarious but changes in the way that financial support for the arts was conceptualized,

shifting from the language of subsidy to that of investment from the late 1980s onwards, has placed the economics of community arts at its centre. In 1995, community artist Karen Merkel suggested, somewhat tongue-in-cheek, that the pursuit of finance had become so dominant in community and participatory arts that it could be considered 'a new cultural form' (Merkel 1995: 8). I will use Bloomfield and Bianchini's idea of the 'economic turn' in cultural policy to shape this discussion, considering changes in national and local government funding policies including the beginnings of the cultural industries, the influence of charitable giving, and the impact of the National Lottery. Bloomfield and Bianchini suggest three phases of cultural policy in a great number of western states in the late twentieth century. Social citizenship was the prevalent model from the end of the Second World War until the late 1960s, which then moved on to more radical emancipatory tendencies from the late 1960s until the mid-1980s. In the third phase, from the mid-1980s to the present day, both social and emancipatory models have given way to the 'economic turn' in which 'decision makers perceived cultural policy as a valuable tool in attempting to diversify the local economic base, in response to the process of economic restructuring, the most spectacular manifestation of which was the crisis of traditional forms of manufacturing industry' (Bloomfield and Bianchini 2001: 115). The strengthening hold of commercial models of support for the arts can be seen in the growing importance of a cultural industries model and the increased pressure on the arts to adopt a 'mixed economy' model of support, which saw the arts looking increasingly to local government, charitable giving, and business sponsorship: Hewison notes, for example, that the late 1980s and early 1990s saw an increase in business sponsorship to the value of £65 million by 1993 (Hewison 1995: 256). The impact of the 'economic turn' had a huge impact on the arts in general but, given its scale, its work with less-than-fashionable constituencies and, often, lack of tangible product, the impact of the economic turn has been responsible for much of the change in community arts between the mid-1980s and the present day.

During the mid- to late 1980s, a number of documents, speeches, initiatives, and policies emerged from the Arts Council and from national and local government. The Arts Council began to stress the importance of generating income in the arts or at least of increasing the balance of the 'mixed economy' model, promoted by the Conservative government of the time, away from public funding. Initiatives were often tied to an increasing drive for self-sufficiency (economic and otherwise) or into projects that generated and maintained service industry outlets such as tourism and the growing heritage industry. In 1985, the

Arts Council published *A Great British Success Story* couched in a language that staff at the Arts Council thought the government would understand, presented to look like a business prospectus which 'issued an invitation to the nation to invest in the arts' using the language of product and customers rather than art and audiences (Hewison 1995: 258). The writers from the Arts Council argued that 'money spent from the public purse on the arts is a first rate investment' (Mulgan and Worpole 1986: 24) rather than a subsidy, which is the term that would have been used previously, and 'investment' is the term that continues to be used.[6]

The rise of cultural industries

A Great British Success Story was followed in 1986 by the Arts Council's *Partnership: Making Arts Money Work Harder*. Targeted at local authorities, it suggested that the arts could, among other things, 'bring new life to inner cities/ expand and develop the cultural industries' and bring employment to Britain's decaying cities (Hewison 1995: 258). This was followed by Myerscough's influential 1988 report *The Economic Impact of the Arts in Britain* which introduced the idea of 'multipliers' and the indirect economic impact of the arts based on the 'growing belief that the arts can bring a competitive edge to a city, a region and a country as a source of creativity' (Myerscough 1988: 3). This continued the impulse to highlight the potential economic impact of the arts and cemented the move towards a cultural industries approach which was beginning to take hold.

The 'cultural industries' strategy was favoured by local and central government as a way to deal with the growing problems of industrial decline, unemployment, and urban decay that blighted Britain's cities in the late 1980s (Hewison 1995: 298). The concept of cultural industry has no simple agreed definition.[7] The term was first used by Adorno and Horkheimer in *Dialectic of Enlightenment* (1944) to denote the commodification of culture and particularly the enforced passivity that they considered to be produced by popular culture. When used by national and local government in the 1980s there is no recognition of its earlier use and 'cultural industries' provided a useful portmanteau term to denote the use of culture as an 'agent of urban regeneration' (Moss 2002: 214). In contrast to more traditional modes of subsidy in arts funding, the cultural industries model was 'business-friendly', linked to growth, employment, and economic development. Sheffield was one of the first cities to embrace a cultural industries approach as far back as 1981 when the local authority developed a 'Cultural Industry Quarter' designed as a 'centrifugal force [to draw] more of the arts into the new

centre and [give] them a higher profile' (Caudrey 1988). A very early initiative with the emphasis on job creation, it housed the Leadmill, Yorkshire Artspace Society, Red Tape Studios, and studio spaces for artists of all kinds in the many disused industrial buildings in that part of the city (Moss 2002: 214).

The cultural industries model was further promoted by the New Labour administration in 1997. Early in his government, Prime Minister Tony Blair returned from Australia enthused by their 'Creative Nation' initiative which drew the arts, film, fashion, and computer games together under the banner of 'creative commodity' (Protherough and Pick 2003: 106). He appointed Chris Smith to initiate a British version of these policies and the Department of Heritage became the Department of Culture, Media and Sport (DCMS). Smith set up the Creative Industries Task Force which produced a mapping document in 1998 showing that the sector was worth nearly £100 billion (Protherough and Pick 2003: 111). For this exercise, the creative industries covered advertising, architecture, art and antiques, computer games, crafts, design, designer fashion, film, music, performing arts, software, television, and radio (Smith 1998). Although community arts was not visible in this list of creative industries, Smith assured audiences in a speech in 1997 that he believed that experiencing the arts at local and community level 'has a real impact on people's lives' (Smith 1998: 44). The role of Chris Smith and the DCMS in shaping participatory arts activities in the 1990s and into the new millennium will be discussed in more detail below.

Some parts of community arts practice potentially suited a cultural industries model but these tended to be ones with an obvious product, most notably film, video, and music. Even then, these were usually too small scale to benefit greatly from this approach and their lack of resources and uneven quality did not often lend community arts to being considered as a cultural industry, something compounded by a lack of access to distribution networks. Indeed, the scale of the cultural industries model often rendered small organizations like community arts companies invisible in what Nicholas Garnham calls the 'hierarchy of cultural industries' (Garnham 1987: 32). He places the large multinational producers and distributors and multimedia conglomerates as the 'centres of power' around which cluster smaller 'satellites' like independent production companies. For Garnham, anything below this level in the hierarchy exists only as the audience (Garnham 1987: 34). The early community artists had set out with great zeal to battle just this hierarchical model by placing the emphasis on enabling communities to make and distribute their own cultural products. However, the scale of their 'David' to the 'Goliaths' of the cultural

industries became apparent in the 1990s as the debates on cultural industries matured (Moss 2002: 214): there was no competition.

The National Lottery and charitable bodies

Another important part of this focus on economic changes between the mid-1980s and the present day proved more optimistic and in 1994 the National Lottery was introduced. Described as 'the most significant change in the funding of Britain's arts and cultural sector since the establishment of the Arts Council', it was expected to raise £1.8 billion per year for 'good causes' (Creigh-Tyte and Gallimore 2000: 21). Lottery money for the arts was distributed by the Arts Council, changing its role dramatically from being 'a distributor of a relatively small amount of money from a single source (the Treasury) to a limited number of beneficiaries, into a distributor of much more money (from the Treasury and Lottery combined) to a much larger number and wider range, of organisations and individuals' (Shaw 2009: 11). The fact that money was available only for capital funds and not for revenue was challenging in the early days of the Lottery; but in 1996, the Arts for Everyone (A4E) scheme was one of the first to promote revenue spending. This was advantageous for participatory arts because the aims of this scheme were to encourage new audiences, develop participation in the arts, actively engage young people in cultural activities, support new work, and encourage training and professional development (Creigh-Tyte and Gallimore 2000: 27). Funds from the Lottery proved invaluable for community arts though their impact could be inconsistent. In 2006, *Mailout* reported that there had been 'nothing but growth for 8 years', while suggesting that the looming Olympic Games set for 2012 would inevitably soak up Lottery funds (Champion 2006: 14). Champion's prediction proved correct and 2007 saw a cut of 35 per cent to G4A (Grants for the Arts) when available funds dropped from £83 million to £54 million as the government announced that funds previously available for arts funding would indeed be diverted to the Olympic Games project (*Mailout* 2007).

Just as the private and charitable support from organizations like Calouste Gulbenkian had been so important to the development of community arts in the 1970s and 1980s, charities like the Baring Foundation and the Paul Hamlyn Foundation (PHF) in particular started to give vital support to community and participatory arts in the 1990s. Set up in 1987, PHF aims to 'help people overcome disadvantage and lack of opportunity so that they can realise their potential and enjoy fulfilling and creative lives'.[8] Their Arts Access and Participation Scheme,

for example, which supports projects which improve 'access to the arts as a social good in itself' aligns very well with the work of many community and participatory arts activities and their research initiatives on training for artists working in participatory settings has proved influential; some of this work is discussed by Janet Hetherington and Mark Webster in Chapter 9. The Baring Foundation describe their organization as 'an independent foundation working to improve the quality of life of people experiencing disadvantage and discrimination' and they have supported participatory arts projects since 2010 offering considerable resources to developing arts projects with refugee and asylum seekers in particular.[9] Both charities collaborated with the Arts Council on a major study of arts work with refugees and asylum seekers, for example, producing *Arts and Refugees*, an influential report (Kidd et al. 2008) which played a role in generating much work with refugees and asylum seekers.

The role of funding and support has always been an important part of the community arts agenda. In the 1970s and early 1980s, artists looked to the Arts Council to fulfil what they saw as its obligation to broaden support beyond the large metropolitan institutions and elite art forms and to pay attention to

Figure 7.1 Playing them at their own game

work being made at a more grass-roots level. The introduction of the concept of investment rather than subsidy implied that some kind of return was necessary for the funds offered. For large arts organizations, this could be measured in terms of bigger audiences, the contribution to the cultural heritage of an area, to increased tourism, to employment, and economic development. For community arts, the return on funders' investments was much harder to quantify, or sometimes even to see, and this more restrictive financial environment represents a considerable difference between contemporary community and participatory arts in the 1970s and the present day.

Being listened to: Community arts and the social inclusion agenda

In 1986, writing with some urgency and excitement, Mulgan and Warpole speculated on what would happen to arts and cultural policies if Labour came to power within the next two years, something they saw as a distinct possibility (Mulgan and Worpole 1986: 119). As we now know, this hope went unfulfilled and by 1992, Labour had lost its fourth consecutive national election. After rebranding as New Labour with Tony Blair at the helm, it was not until 1997 that Labour saw general election victory, winning by a landslide of 179 seats. A second conclusive election result in 2001 saw Labour consolidate its hold on power, though many commentators saw the terms on which these elections were won as moving away from reform and towards remedialism and resignation (Wickham-Jones 2003). Nevertheless, in the heady optimism after the election victory of 1997, community artists hoped for a more beneficent governmental approach to policies and support for the arts and culture, perhaps pinning their hopes on the possibilities seen in the 1980s before the abolition of the GLC and the Metropolitan County Councils. Many community arts companies, especially in the north of England which was badly hit by deindustrialization, had forged good relationships with predominately Labour local authorities. Their hope was that a Labour victory at a national level might help them to expand the work they had managed to keep going during the challenging years of Conservative rule. This was despite the fact that the Chancellor Gordon Brown, in the run-up to the 1997 election, had pledged not to increase personal taxation for up to two years after the election and to use the public spending guidelines previously set by the Conservative government (Wickham-Jones 2003: 30). Tony Blair had also begun to emphasize a new era of 'responsibility' where entitlements

were to be matched by obligations as a way to end the 'something-for-nothing approach' that they felt had characterized previous administrations (Wickham-Jones 2003: 33). These were early presentiments of things to come with the hardening of attitudes to the old welfare state model in the first years of the New Labour administration, but they could not dampen the enthusiasm felt by many community artists who harboured great hopes for the arts under a new centre-left administration.

In 1997, New Labour set up the Social Exclusion Unit that produced a series of seventeen reports on different aspects of what had come to be called 'social exclusion' and how to tackle it. The term 'social exclusion' represented 'a shift from the previously dominant concept of "poverty"' and was initially applied to the 5 million people living in households with no one in paid work and the 3 million people who lived in the 1,300 worst housing estates in Britain (Fairclough 2000: 51). A series of Policy Action Teams were set up to develop strategies for alleviating social exclusion and Policy Action Team 10 (or PAT 10 as it became known) produced a report on the role of arts and sport in combatting social exclusion. PAT 10 affected community artists directly because the areas in which they worked were usually those 'poor neighbourhoods' identified by DCMS as needing support (Policy Action Team 10 1999: 5). The DCMS secretary, MP Chris Smith, wrote in the Foreword to the PAT 10 report that 'art and sport can not only make a valuable contribution to delivering key outcomes of longer-term employment, less crime, better health and better qualifications, but can help to develop individual pride, community spirit and capacity for responsibility that enables communities to run regeneration programmes themselves' (Policy Action Team 10 1999: 2). Getting involved in art and sport, it was felt, would increase participants' sense of 'community involvement and ownership' thus improving social cohesion and making it less likely that longer-term funding and support would be necessary (Policy Action Team 10 1999: 6).

These ideas can be read politically in two main ways, neither of them without complication for community arts: as an echo of Blair's emphasis on the aim of the Labour government to challenge conceptions of automatic rights to government support mentioned above; or as a vision for active citizenship predicated on engagement and a sense of ownership. Given the history of their belief in the role of active engagement in the arts in building communities, most community artists preferred the latter reading and saw these initiatives as a way to progress their work with the 'disadvantaged' communities that were under scrutiny in the social inclusion agenda. These were largely the communities that artists were already working within anyway and the opportunity to expand and develop this

work was attractive. For the editors of *Mailout*, the publication of the PAT 10 report represented the possibility of

> Opening up sensible dialogue with significant partners, which requires patience, imagination and persistence, as well as help from wherever it can come […] respecting the skills and perspectives of [our] partners, and sharing experience and best practice. Most of all, it means delivering well-planned and excellent quality work, genuinely rooted in the communities where it happens, and demonstrating over and over again the value of this work. (*Mailout* 1999: 18)

In preparing the PAT 10 report, community arts organizations around Britain had been consulted on these new policy initiatives and the PAT 10 committee included a number of community artists. Community artist Tina Glover, who was on the committee, describes how 'as a mouthy worker, it was almost sad to see my excitement at firstly BEING ASKED to talk about the work we do and then BEING LISTENED TO! […] Not only have we had few chances to talk about strategic, measurable benefits of arts and community work over the past ten years … but we've never really been questioned about what we do either' (*Mailout* 1999: 19). This captures something of the sense of excitement for what seemed to be a genuine opportunity for community artists to influence policy in the direction that their work had been developing since the 1970s. According to Gerri Moriarty, another of the artists involved, Smith proved 'a breath of fresh air, that rare thing – a Culture Secretary that actually knew about the arts! He had a heart for the work and a broad understanding of diversity' (Moriarty 2016). Smith was committed to the idea that, in his own words, 'art and sport can have a profoundly regenerative effect on local communities' but stressed the importance of 'getting this realization running through the rest of government as well' (Smith 2000: 7). His task was partly to convince the Treasury of the need for money for the arts in general, which he could achieve by linking it to social policy, but, once gained, to make sure that enough went to community arts and he fought hard for more equitable shares among the different art forms, including community arts (Moriarty 2016). This was necessary because by this point many large organizations, such as theatres, galleries, and museums, had developed participation and education programmes, realizing that government money was available for these activities. Their larger, better resourced structures and staffing, and their easy access to impressive public buildings often made supporting them a more attractive option for 'investment'.

A number of dissenting voices have critiqued the discourses of 'social inclusion', the term that emerged to describe the programmes generated as a result of the deliberations on social exclusion. The Cultural Policy Collective, an anonymous group of 'educators, curators and cultural workers in the arts and media', rejected the agenda entirely, challenging its 'corporatist visions of "governing by culture"' as part of a 'dangerous democratic deficit' (Cultural Policy Collective 2004b). For them, the 'top-down instrumentalization of cultural practice and the on-going commercialization of the public sector' remained untouched by social inclusion practices which merely encouraged involvement in the arts in order to create compliant neoliberal citizens (Cultural Policy Collective 2004a: 3). They were critical of those for whom the overt short-term instrumentalization of cultural practice was 'justified in terms of its progressive outcome: a culture and society both more equal and more democratic' (Cultural Policy Collective 2004a: 1). The ends in no way justified the means in this vision and, by implication, community artists' enthusiasm for getting involved in the social inclusion agenda, even taking into account any reservations they may have harboured about its politics, was wrong-headed. Despite the value of the Collective's polemic, the anonymity of these authors makes it difficult to pick up their invitation to 'engage with our critique and to contribute their own ideas on how such a transformation [to cultural democracy] might be won' (Cultural Policy Collective 2004a: 42) which is problematic in continuing debate.

Nevertheless, the Cultural Policy Collective have joined a growing number of artists and critics who have felt compelled to discuss the relationship between art and the state as a result of the operations of the state under the banner of social inclusion. From the perspective of many established artists over-enthusiastic state intervention is seen as an intrusion and the rush of museums and galleries to set up education and engagement programmes seems to have alienated some. In *Art for All?*, Mark Wallinger represents a series of opinions about 'the long ideological strings' attached to arts funding in which 'the language of accessibility has led to an almost unconscious adoption of Reithian values – the mission to educate, entertain and instruct – which have permeated from outreach projects to the galleries and museums' (Wallinger and Warnock 2000: 11). Many community artists found this alarm from more 'mainstream artists' amusing and frustrating at the same time. The editors of *Mailout* asked, somewhat facetiously, in 2001 whether they 'should be thrilled to watch as mainstream arts organisations realise the error of their socially exclusive ways, and rush for refreshment at the well-springs of community activity?' as government funds became available to support the social inclusion agenda (*Mailout* 2001: 6).

It was also frustrating to see large organizations getting extra support for initiatives that community arts companies would have been funded to undertake in the past (Baynes 2010).

From a cultural policy perspective Mrunal Mirza presented a series of essays in 2006 which asked, 'Is UK arts policy damaging the arts?' and which was concerned to 'challenge the increasing instrumentalism of policy-makers' (Mirza 2006: 15). In this collection, Eleanora Belfiore identifies as problematic strategies, such as Chris Smith's discussed above, of convincing the Treasury of the value of the arts by pursuing the argument about their huge potential of their role in social inclusion. It 'represents a strategy that allows a "weak" policy sector [like the arts] with limited political clout to attract enough resources to achieve its policy objectives' by attaching itself to another more powerful agenda, like social inclusion (Belfiore 2006: 21). For Belfiore, the implications of this move are that arts organizations are 'under strenuous pressure to deliver' in those other policy areas and that those expectations might mean that 'the British cultural sector is progressively becoming target, rather than process oriented' (Belfiore 2006: 24). The 'pressure to deliver' can certainly be seen in the rigorous metrics which make up part of the reporting process for National Lottery applications. Yet, even though government policies of the late 1990s and early 2000s on arts and culture have sharpened the debate, concerns around instrumentalism represent 'an ever-present ingredient of public debates and arguments over the role of the arts in society and their relationship to the state' (Belfiore 2010: 6). Wallinger and Warnock tacitly acknowledge this in their volume by presenting a section covering the period 1945–1997 with representations for Keynes, an extract from *The Glory of the Garden* and the report of the Community Arts Working Party of the Arts Council among other significant documents from that period. Far from being a recent phenomenon then, ideas about what has become known as the instrumentalization of the arts in achieving government policy are more like the revisiting of a long debate about the role of the arts in society.

The work of the Community Arts Movement, even though it was often misunderstood, has had an impact on that debate by openly challenging the in-built elitism of the arts, particularly in a British context. Artists in the Community Arts Movement instrumentalized their skills and experience when they moved them outside institutional structures in the late 1960s and began working in Britain's inner cities and housing estates with groups and communities who had been traditionally alienated from formal art structures. Their rationale and political motivations for this varied but their analysis was that the traditional channels of state support for the arts, in particular the Arts

Council, had benefitted only a small and elite group of citizens. In the 1990s, community artists found a government concerned to improve conditions for the groups with whom they worked and this presented an interesting dilemma. The possibility of gaining government support for community arts projects was tempered by a growing understanding of the implications of government attention. In 2001, the editors of *Mailout* asked, 'With a bit more cash coming on stream for arts projects with "excluded groups", should the participatory/ community arts sector just shut up and take the money gratefully? [...] Could we be sliding into "arts as social instrument" too far and too easily?' (*Mailout* 2001: 6). The extra resources to work with 'excluded groups' was welcome; what was more challenging politically was the metamorphosis of a complex set of historically inflected political and social circumstances that became branded as 'social exclusion' into the 'social inclusion' agenda. This became problematic for community artists because this way of thinking was based on expected, measurable social outcomes rather than creative or aesthetic ones. Different artists and companies reconciled these challenges in different ways but there is no doubt that by the late 1990s and early 2000s community arts had become tied into the discourses of social exclusion and inclusion in irrevocable ways, both positive and negative, and which sometimes led to misunderstandings like the one outlined next.

In 1997, Matarasso's report *Use or Ornament? The Social Impact of Participation in the Arts* presented the findings of the first large-scale attempt in the UK to find evidence for the social impact of participating in arts activities. He outlined '50 Social Impacts of Participation in the Arts' grouped under six headings: personal development, social cohesion, community empowerment and self-determination, local image and identity, imagination and vision, and health and well-being. Following a cultural democracy model which was interested in active participation and production, no doubt based on his previous experience of working as a community artist, Matarasso argued that 'participating in the arts, being involved in the making of art rather than being a viewer, observer or visitor', was the most effective way to operate (Matarasso 1997). Unfortunately for Matarasso, this report became something of a lightning rod for the growing number of academics working in cultural policy who criticized Comedia's project, possibly misunderstanding its grounding in community arts and the nature of the research. It was criticized on the grounds of methodology for its inherent bias and lack of detachment by Paola Merli (2002), who seemed to have overlooked the fact that it was an advocacy document aiming at 'policy makers and those working in the arts or social

fields' aimed at 'harnessing the forces of art for social democratic purposes', rather than a piece of academic research which would have had to use other research tools entirely (Matarasso 1997: v). Belfiore suggested that the social impacts put forward were 'remarkably broad-ranging, if not positively vague' (Belfiore 2006: 25). Matarasso wrote back, defending the methodology used and the politics of the research (2003), in particular, the accusation that he was perpetuating an instrumentalist approach to the arts as an important way to 'support personal and community development' (Matarasso 1997: v). He had headed the Best Practice subgroup for PAT 10, and pointed out that his report had been published in 1997, the year that New Labour came to power and so, logically, before the social inclusion agenda had been put into place. Reminding his critics that the research and writing thus predated the later work that they saw as 'instrumentalist', Matarasso suggested that the research behind *Use or Ornament* be seen as a symptom of this approach to the arts rather than a cause, underlying his scepticism of direct links between government instrumentality and the arts (Matarasso 2013: 343). Matarasso was drawing on community arts discourses of the 1970s and 1980s rather than creating a narrowly instrumental vision of the role of the arts in the 1990s. He was responding to and amplifying the agenda of community artists who had been working with socially and economically disadvantaged communities who were suffering the effects of underinvestment, deindustrialization, and unemployment since the early 1970s. New Labour paid attention to these social challenges when they came to power in 1997 and saw the potential of active involvement in the arts and sport as one way to alleviate these. In supporting this work, artists became vulnerable to accusations of instrumentalism when they were simply taking advantage of the attention and resources now being paid to the communities within which they had been working for thirty years.

The authors in this part of the book are all concerned to regard and evaluate the past and the history of community arts work and to discuss its possible legacies, each from a different perspective. Borrowing the motif of memories, dreams, and reflections from Jung, Oliver Bennett reflects on his long engagement with many different aspects of community arts. He proposes that the historic moment of the 1970s and 1980s created a kind of interregnum between the post-war period and the present day – a period in which many things seemed possible. This sense of possibility encouraged community artists to pursue large dreams and grand ambitions which achieved a great deal but which were ultimately unstable because their activities were not grounded on a strong enough intellectual or political foundation. Calling the early community

artists Romantic Marxists, Bennett concludes that community artists actually occupied a large number of positions around both a Romantic and a Marxist approach to arts and culture. The Romantic position was based on the ideas of Shelley and Morris, about connections between art and life, broadly correlating to what he calls 'art in the community', while adherents of cultural democracy followed an approach closer to that of Marx. Drawing on his ideas about 'cultures of optimism', Bennett captures the energy and ambition of the early community arts movement. In his reading of community arts, the reach of community artists in the 1970s really did exceed their grasp and the ambition of the Community Arts Movement outweighed its achievements but this energy was necessary in order to test the possibilities for change.

Janet Hetherington and Mark Webster take up the issue of training for community artists. They reflect back on the various initiatives that were undertaken in the 1970s and 1980s. Questions about the thorny issue of balancing artistic and sociopolitical standards and ideals revolved around questions of aesthetics, the quality of the experience for participants, and the needs of the artists. As educators of contemporary community artists Hetherington and Webster are in a strong position to reflect on these issues. They make the case that, on the one hand, training may have led to the setting of standards from outside community arts (by funders, formal educational bodies and others) and levels of professionalization that have potentially numbed the political intentions of the early community artists. On the other hand, more formal channels of training have potentially opened out the possibility of working in community arts to a much wider field because some routes are more visible to a broader social demographic than the historical models that generally required a certain amount of social or cultural capital to access.

Sophie Hope uses the work of community artists in the 1970s and early 1980s as a way to reflect on contemporary practices of what has come to be known as socially engaged art. Although she recognizes the beginnings of this practice as being located in the United States, and draws on the work of American scholars in this field, it is the work of the Community Arts Movement that maps most clearly onto contemporary British work in socially engaged practice. Focusing on the role of the artist within the commissioning of this work, Hope draws parallels between the growing professionalization of community arts in the UK and the role of the professional artist in contemporary practice. Early concerns involved discussions about artists being 'parachuted' into communities with the attendant implications of power imbalances between artists and communities. If artists were to work closely

with participants, it was felt that there needed to be time to build relationships and mutual understanding in order to create work that was balanced between the needs of the community and the artists involved. These concerns are still very much manifest in contemporary practice particularly when projects are more time-limited and possibly emerging from the needs and desires of the commissioning body as much, if not more than, the communities in which the artists work. Utilizing the notion of the 'aesthetic third' and adding her own thoughts on uncertainty, Hope paints a compelling picture of a contemporary practice still working through many of the ideas, challenges, and propositions of community artists in the 1970s and 1980s.

Owen Kelly is one of the few artists from that period to be publicly attached to the Community Arts Movement, largely as a result of his book *Community, Art and Power: Storming the Citadels,* which was published in 1984. Like Bennett, he sees that many of the problems that community artists set out to alleviate, chiefly access to the means of producing cultural artefacts that expressed communities' realities and ambitions, may have been solved by the digital revolution. Miniaturization and portability, the growth of mobile technologies and the rise of the Internet have the potential to place the means of production in the hands of almost everyone in these early years of the twenty-first century. Using Illich's ideas of radical monopoly, Kelly sets out to show how the period of possibility for the radical use of these technologies is limited. In this revisioning of the period, with the hindsight of forty years, he proposes that the concept of dividuality is closer to what community artists were trying to achieve than the Marxist or socialist programmes that many propounded at the time. Using research from the cognitive sciences Kelly argues that assumed ideas about individuality are geographically and temporally located and that subjects are created only communally by other people, in many ways 'storied' into existence. Arguing for the soundness and continuing relevance of collective creativity, Kelly ends on a note of optimism for the ongoing influence of thinking and practice that emerged from community arts.

It is exciting to have the opportunity to revisit an arts movement and a privilege to be able to see it through the eyes of some of the artists originally involved. It has been fascinating to see what new ideas and propositions emerge when the writers in this part of the book return to the work of their early adulthood as older, possibly wiser, thinkers and practitioners. Equally, the opportunity to have community arts revisioned and returned to use by a new generation of artists and scholars has proved both challenging and invigorating.

Notes

1 *Mailout* can be found at http://mailout.co/ (accessed 13 December 2016).
2 The *Journal of Arts and Communities* was launched in 2009 'to provide a critical examination of the practices known as community or participatory arts' which aspired to 'finding a voice that can include those of participants, artists, academics and individuals whose practice encompasses all these positions' (Fyfe 2009).
3 http://www.birmingham.ac.uk/schools/historycultures/departments/history/research/projects/cccs/about.aspx (accessed 1 July 2016).
4 http://www.artsprofessional.co.uk/news/participation-manifesto (accessed 7 July 2016).
5 It is likely that this was based on the BCG Growth Share matrix developed in the 1970s by the Boston Consulting Group (hence BCG) as a way to evaluate the costs and benefits of an investment. The categories in this are Question Marks, Stars, Dogs, and Cash Cows.
6 http://www.artscouncil.org.uk/about-us/how-and-where-we-invest-public-money (accessed 29 June 2016).
7 Creative and Cultural Industries are terms often used interchangeably as will be done here. There are scholars who are interested in making finer distinctions, for example Garnham (2005) and Miller (2009).
8 http://www.phf.org.uk/about-phf/ (accessed 8 July 2016).
9 http://baringfoundation.org.uk/ (accessed 8 July 2016).

References

Another Standard. 1983. *The Area of Theory* (The Shelton Trust: London).
Another Standard. 1983. *A Nasty Case of the Hierarchies* (The Shelton Trust: London).
Baynes, Cilla. 2010. Interview with Alison Jeffers and Gerri Moriarty.
Belfiore, Eleanora. 2006. 'The Social Impact of the Arts – Myth or Reality?' in M. Mirza (ed.), *Culture Vultures: Is UK Arts Policy Damaging the Arts?*, 20–37 (Policy Exchange Limited: London).
Belfiore, Eleanora. 2010. 'Janet Minihan, The Nationalization of Culture: The Development of State Subsidies to the Arts in Great Britain', *International Journal of Cultural Policy*, 16: 4–6.
Bloomfield, Jude, and Franco Bianchini. 2001. 'Cultural Citizenship and Urban Governance in Western Europe', in Nick Stevenson (ed.), *Culture and Citizenship*, 99–123 (Sage: London).
Brooks, Rod. 1983. 'The Decline of the TIE', in The Shelton Trust (ed.), *Friends and Allies* (The Shelton Trust: London).

Caudrey, Adriana. 1988. 'Talent Corner', *New Society*, 13 May.

Champion, Huw. 2006. 'Scanning Horizons', *Mailout*, 14–19, August/September.

Cope, Phil, Pat Hill, Simon Jones, and Jenny Turner. 1996. *Chasing the Dragon. Creative Community Responses to the Crisis in the South Wales Coalfield* (a European Community (ERGO 2) Coalfields Community Campaign. VIAE report).

Creigh-Tyte, Stephen, and Joanne Gallimore. 2000. 'The UK National Lottery and the Arts: Reflections on the Lottery's Impact and Development', *International Journal of Arts Management*, 3: 19–31.

Cultural Policy Collective. 2004a. *Beyond Social Inclusion. Towards Cultural Democracy* (Cultural Policy Collective: Scotland).

Cultural Policy Collective. 2004b. 'Cultural Provision for the Twenty-first Century', *Variant*, 26.

Fairclough, Norman. 2000. *New Labour, New Language?* (Routledge: London).

Freire, Paulo. 1996 [1970]. *Pedagogy of the Oppressed* (Penguin Books: London).

Fyfe, Hamish. 2009. 'Editorial', *Journal of Arts and Communities*, 1: 3–5.

Garnham, Nicholas. 1987. 'Concepts of Culture: Public Policy and the Cultural Industries', *Cultural Studies*, 1: 23–37.

Garnham, Nicholas. 2005. 'From Cultural to Creative Industries: An Analysis of the Implications of the "Creative industries" Approach to Arts and Media Policy Making in the United Kingdom', *International Journal of Cultural Policy*, 11: 15–29.

Given, Lisa, M. 2008. *The Sage Encyclopedia of Qualitative Research Methods* (SAGE: Thousand Oaks).

Hayes, Jennie. 2003/2004. 'Values Revisited', *Mailout*, 11, 12, December/January.

Hewison, Robert. 1995. *Culture and Consensus. England, Art and Politics since 1970* (Methuen: London).

Kelly, Owen. 2016. Personal Communication.

Kelly, Owen, John Lock, and Karen Merkel. 1986. *Culture and Democracy. The Manifesto* (Comedia: London).

Kidd, Belinda, Samina Zahir, and Sabra Khan. 2008. *Arts and Refugees: History, Impact and Future* (Arts Council England, The Baring Foundation, The Paul Hamlyn Foundation).

Killip, Dermott. 1991. 'Back to the Future', *Mailout*, 16, April/May.

King, Frances. 1994. 'But Is It Art?' *Mailout*, February/March.

Lacey, Stephen. 2012. Interview with Alison Jeffers and Gerri Moriarty.

Lowe, Toby. 2011. 'What Does Participatory Arts Mean?' *Helix Arts*.

Mackerras, Cathy. 2015. Interview with Gerri Moriarty.

Maguire, Maurice. 1990. 'Focus on the West Midlands', *Mailout*, 5, 6, August/September.

Mailout. 1988. 'Arts Work with People', *Mailout*, 3, October/November.

Mailout. 1990. 'Challenges for the Nineties', *Mailout*, 16, 17, April/May.

Mailout. 1999. 'Working Together', *Mailout*, 18, 19, October/November.

Mailout. 2001. 'We Don't Do Social Inclusion ...', *Mailout*, 6, 7, February/March.

Mailout. 2007. 'Where Is Your Next Pay Cheque Coming From?' *Mailout*, 12, 13, October/November.

Mailout. 2009/2010. 'Introducing a Manifesto for Participation in the Arts and Crafts', *Mailout*, 16, 17, December/January/February.

Matarasso, François. 1997. *Use or Ornament. The Social Impact of Participation in the Arts* (Comedia: London).

Matarasso, François. 2003. 'Smoke and Mirrors: A Response to Paola Merli's "Evaluating the Social Impact of Participation in Arts Activities"', *International Journal of Cultural Policy*, 9: 337–46.

Matarasso, François. 2013. '"All in This Together": The Depoliticisation of Community Arts in Britain, 1970–2011', in Eugene Van Erven (ed.), *Community Art Power. Essays from ICAF 2011*, 214–239 (Rotterdams Wijktheater: Rotterdam).

Merkel, Karen. 1995. 'A Culture of Enterprise', *Mailout*, 6–8, August/September.

Merli, Paola. 2002. 'Evaluating the Social Impact of Participation in Arts Activities', *International Journal of Cultural Policy*, 8: 107–18.

Miller, Toby. 2009. 'From Creative to Cultural Industries', *Cultural Studies*, 23: 88–99.

Mirza, Munira. 2006. *Culture Vultures? Is UK Arts Policy Damaging the Arts?* (Policy Exchange: London).

Moriarty, Gerri. 2016. Interview with Alison Jeffers.

Moss, Linda. 2002. 'Sheffield's Cultural Industries Quarter 20 Years On: What Can Be Learned from a Pioneering Example?' *International Journal of Cultural Policy*, 8: 211–19.

Mulgan, Geoff, and Ken Worpole. 1986. *Saturday Night or Sunday Morning? From Arts to Industry – New forms of Cultural Policy* (Comedia Publishing Group: London).

Myerscough, John. 1988. *The Economic Importance of the Arts in Britain* (Policy Studies Institute: London).

Policy Action Team 10. 1999. *Arts and Sport* (DCMS: London).

Protherough, Robert, and John Pick. 2003. *Managing Britannia* (The Bryanmill Press: Exeter).

Rothwell, Jerry. 1992. *Creating Meaning. A Book about Culture and Democracy* (Valley and Vale: Barry).

Shaw, Phyllida. 2009. 'Arts Council Reorganisation. Then and Now', *Mailout*, 10, 11, June/July/August.

Sisson, Janet. 1999/2000. 'Defining the Indefinable', *Mailout*, 21, August/September.

Smith, Chris. 1998. *Creative Britain* (Faber and Faber: London).

Smith, Chris. 2000. 'Moving Margins?' *Mailout*, 6, 7, June/July.

Steyn, Juliet, and Brian Sedgemore. 1985. 'A Socialist Policy for the Arts', *The Guardian*, 16 January.

Wallinger, Mark, and Mary Warnock. 2000. *Art for All? Their Policies and Our Culture* (Peer: London).

Wickham-Jones, Mark. 2003. 'From Reformism to Resignation and Remedialism? Labour's Trajectory through British Politics', *The Journal of Policy History*, 15: 26–44.

Memories, Dreams, Reflections: Community Arts as Cultural Policy – the 1970s

Oliver Bennett

Introduction

The title of this chapter recalls the eponymous autobiography of the Swiss psychoanalyst, Carl Gustav Jung. What distinguishes his autobiography from most others is its focus on the author's interior world, to the almost complete exclusion of references to external circumstances. It might thus seem peculiarly inapposite to link it, however tenuously, with a discussion of community arts, which have often taken as their starting point the material circumstances of those perceived to be disadvantaged or oppressed. Introspective individualism, even in the service of psychoanalytical discovery, seems not only out of place in this world, but antithetical to it.

Yet, seen through another lens, Jung's tripartite formulation adapts well to this analysis of events that took place over forty years ago. Although community arts may have their contemporary manifestations, in their original form they exist only in the memories of those who were there. Artworks, videos, and other records still survive, but like photographs from an earlier age, they are now decontextualized relics that tell us little of lived experience. For that, we can draw only on the recollections of those who were in one way or another involved, a number of whom are contributing to this book. They may not yet be eighty-four years old, as Jung was when he embarked on his autobiography, but they are still (and this includes me) looking back over a long stretch of time. The events in which we were involved now form part of our own interiority and can only be reconstructed imaginatively, subject to all the usual distortions of selective memory and historical dislocation. This is not to cast doubt on the validity of the historical record offered; on the contrary, it serves to remind us that histories

are only ever constructed on what people have chosen to remember and record. But when those histories are also our own, we can find ourselves, like Jung, inhabiting that intensely personal world, which the act of private remembering calls into being.

Dreams also figure prominently in the story of community arts, not dreams in the literal sense, but the conscious dreams of a better world that gave the Community Arts Movement much of its energy and motivation. These dreams were integral to what we might call the cultural policy of community arts: a policy that concerned itself not just with the specific conditions of the arts and the media but with the possibility of far-reaching changes in the wider culture, promoted by radical new forms of democratic politics.

My own involvement in community arts spanned much of the 1970s, first as the director of a fledgling arts centre near Gloucester in England (the Courtyard Arts Trust); then as part of a community development project in West Dunbartonshire, Scotland (known as the Quality of Life Experiment); and finally, as the 'community arts officer' of North West Arts, an organization based in Manchester but charged with supporting and developing the arts throughout the northwest of England. In these various roles, I participated in different modes of community arts work for over a decade, sharing many of the hopes, contradictions, and delusions that were being worked through by a generation of 'cultural workers',[1] who sought in various ways to configure new relationships between art, culture, and society. All of this took place against the backdrop of a turbulent period in British politics, a kind of interregnum when the old post-war consensus was breaking down, but when the contours of what would replace it were not yet clear.

Memories

Art in the community

On the night of Saturday 28 July 1973, in a large marquee erected in a field just outside Tewkesbury, the Courtyard Arts Trust (CAT) presented a four-part extravaganza, billed as 'Cataclysm', as part of its mission of widening community involvement in art. First on the bill was the poet Michael Horovitz, who described himself at the time as 'Troubadour and Underground Poet Extraordinary'. Horovitz had appeared alongside Alan Ginsberg and Alexander Trocchi at the 'International Poetry Incarnation' in the Albert Hall in the summer of 1965 and

then gone on to compile and edit the now classic anthology *Children of Albion: Poetry of the Underground in Britain*. Next on the bill was 'Mr Pugh's Velvet Glove Show', a violent and often filthy puppet show, presented by Ted Milton. Milton was beginning to acquire something of a cult following, presenting the 'Glove Show', along with his semi-pornographic 'Blue Show', as warm-up acts for artists such as Ian Dury and the Blockheads, Eric Clapton, and Split Enz. At Tewkesbury, the 'Glove Show' was to be followed by a performance from the ironically named Filey Hippodrome Theatre Company, presenting its new show, 'Positively the Last Appearance of Ted Bijou This Side of the Trent'. Playing on the expectations set up by the name of both the company (sorry Filey) and the show, the cast presented themselves, with a kind of gentle pathos, as a bunch of misfits required to perform various acts – magic, juggling, and so on – but never being quite able to succeed. The night was scheduled to conclude with a set from Rocky Ricketts and the Jet Pilots of Jive, aka the 1950s spoof rock band put together by Bath's Natural Theatre Company.

The audience for the event grew to around 200 as the evening wore on. It was eclectic in its composition, including regular attendees of the arts trust's events, those with interests in the artists appearing, and many who were just curious, such as local kids, young people with nothing else to do on a Saturday night, and bikers from the town. Horovitz was listened to in more or less silence, but as Milton got into his stride, many in the audience got increasingly animated, fired up by both drink and the provocative nature of his interactive and deliberately bad-tempered show. By the time the Filey Hippodrome Company appeared on stage, they were in no mood for its slow pace and wistful study in human frailty: magic tricks that went wrong and jugglers who couldn't juggle just seemed inept, provoking rude interruptions and jeers of derision. As the cast struggled to get through the final phases of the play, impatient calls for Rocky Ricketts became louder and more frequent.

Tension was thus already building before 'Rocky' was due to appear. This was further heightened by the dynamics of the show itself, which involved a delay in the appearance of the 'star', while members of his 'entourage' attempted to ratchet up a growing sense of anticipation. This was only relieved when 'Rocky' finally appeared with his band, giving a blistering rendition of 'Blue Suede Shoes'. The relief, however, was short lived. Under the terms of the licence issued by Tewkesbury Borough Council, which had provided the site, the marquee and the power for the event, the show was due to finish by 11.00 pm. Due to various delays, not least the interruptions to the preceding acts, 'Rocky' was only into his second song when the scheduled finishing time was reached. Ignoring

protestations from the organizers, the operator of the electricity generator, who was employed by the Borough Council, switched off the power at precisely 11.00 pm, killing the sound and plunging the stage and marquee into darkness. After a few moments of stunned silence, the audience erupted: chairs were thrown, fights broke out, and fires were lit. Power was only restored several minutes later when, fearing the consequences of their actions, council officials allowed the show to resume; but not for long.

The finale to the evening was provided with the assistance of the Gloucestershire Constabulary, who had been summoned to the site by the same Council officials. Midway through Rocky's set, the sirens of police cars could be heard as they drove across the field towards the marquee, lights flashing, and then into the marquee itself. Officers jumped out of the car and on to the stage, physically restraining 'Rocky', offering unexpected opportunities for extemporized performance. As he was dragged away, to a cacophony of protest from an irate audience, he implored his new fans to visit him in prison.[2]

Democratizing television

On the evening of Sunday 16 May 1976, over 1,000 people were estimated to have tuned in to the first programme to be broadcast by Vale TV, a new community television service that had started in the Vale of Leven, West Dunbartonshire. The programme was a documentary, titled 'Stray Dogs'. Its opening sequence consisted of a series of close-up shots, each featuring a dog expelling its steaming faeces into the cold morning air and onto Dunbartonshire pavements. The dogs included both strays, of which there were many at the time, and those out with their owners: terriers, Labradors, poodles, mongrels of all kinds. The sequence was accompanied by a voice-over, providing statistical information about the estimated tonnage and volume of canine faeces and urine deposited each year on Britain's public spaces (there were no bye-laws at this time compelling owners to dispose of their dogs' faeces themselves). This anti-dog documentary, polemical in tone, explored a range of canine hazards, including risks to public health, threats to livestock, and attacks on humans.

Vale TV was a six-week experiment in local television broadcasting, which took place in May and June 1976. This was part of a broader 'Quality of Life Experiment', funded by central and local government, with a brief to explore new ways of improving the quality of life within local communities. Four areas of the country had been chosen for the experiment, all considered to be in

decline and experiencing multiple forms of disadvantage. West Dunbartonshire in Scotland was one of these areas, and the Vale of Leven in particular suffered from high unemployment, poverty, poor facilities, high incidence of alcoholism, and a population that had decreased steadily over the previous decade. The Quality of Life Experiments were not designed to address these problems through full-blown urban regeneration projects but focused more narrowly on the developmental possibilities of greater community involvement in cultural, recreational, and sports activities.[3]

Vale TV offered an almost unprecedented opportunity for members of the community to produce and broadcast their own programmes. This was a time of limited and highly restricted communications: no social media, no YouTube, no Sky or Virgin, no mobile phones, not even PCs. Outside of the BBC/ITV duopoly, which was still firmly in place, access to broadcasting was almost entirely prohibited. But in the spirit of experimentation, the Home Office had been persuaded to grant a temporary licence for a community broadcasting project, which was made technically possible by the existence in the Vale of Leven of a cable relay system linked to 6,000 homes, through which programmes could be distributed.[4]

The project was conceived of as an exercise in the democratization of television. It employed a small group of community arts and media workers as its production team, but their role was neither to commission programmes themselves nor to determine the content of programmes made.[5] Instead, the community itself would be invited to propose and make the programmes, and the production team would function only in an enabling role. Those who proposed programmes were required to be closely involved in all aspects of the programme-making: design and structure; shooting; pre-editing; and editing. This was intended to safeguard their interests, ensuring that the final product came as close as possible to whatever it was they wanted the programme to communicate. In this way, Vale TV would – as its stated aims proclaimed – encourage the local community to talk to itself and to engage more actively in local affairs.

In the course of the project, just under a hundred programmes were made and broadcast. 'Stray Dogs', proposed by a middle-aged woman from Balloch, proved to be one of the most popular. Others in the 'top ten' included a recording of the annual concert by a local choir; a documentary about bowling clubs; a programme about the relevance of Christianity to local life; and a weekly news round-up, presented by journalists from one of the local papers. Around 4,350 people were thought to have watched at least one Vale TV programme.[6]

Inside the citadel

While experiments in 'quality of life' and community television were being conducted in West Dunbartonshire, tensions were building up in London around another 'experiment' concerning community arts, this time related to their funding through the Arts Council of Great Britain. Historically, ever since the Council had been established in 1946 with John Maynard Keynes as its first chairman, its funding had been almost exclusively reserved for what it considered to be professional artistic work of the highest standard. In practice, this meant the so-called nationals, such as the Royal Opera House and the Royal Shakespeare Company, the major symphony orchestras and repertory theatre companies, and a few other 'artistically significant' organizations. Community arts hitherto had had no place in this funding regime, but following representations from various interest groups and a great deal of internal deliberation, the Arts Council had set up a Community Arts Committee for a two-year 'experimental' period, with an initial allocation of £176,000 (equivalent to around £1.4 million today).[7] The main role of the committee would be to assess applications for funding and to advise on how this money should be distributed. It included among its members a number of community artists, most of whom were active in the campaigning organization, the Association of Community Artists (ACA).[8]

In the first year of the 'experiment', the number of grant applications deemed worthy of support by the committee far exceeded the amount of money that had been made available to it. The Arts Council responded in the second year (1976/1977) by raising the allocation to £300,000 (just under £2 million in today's money), an increase in real terms of over 40 per cent but still falling far short of the total needed to meet what the committee considered to be the reasonable demands of its applicants. Protesting that this allocation was simply inadequate, the committee refused to make recommendations on distribution, resolving instead to delay the process and to make 'ideal' awards. This was a tactical move, designed to secure a larger settlement by demonstrating in unequivocal terms the gap between the actual needs of the Community Arts Movement and what the Arts Council was currently prepared to offer. For the ACA members of the committee, this also presented an opportunity to apply further pressure, by claiming publicly that the council was failing in its chartered duties and causing hardship to those it was supposed to be supporting.

The committee's decision to disrupt the grant-making process meant that at the start of the 1976/1977 financial year no payments could be made, with the

result that community arts organizations dependent on Arts Council funding became technically insolvent. At an emergency meeting of the Greater London Branch of the ACA, held on 29 April 1976, members were urged to write to Roy Shaw, the Arts Council's Secretary-General, demanding an immediate release of funds and a 100 per cent increase in the allocation to community arts. They were also urged to lobby their MPs. The ACA members of the committee had themselves already written to Shaw on 20 April, with copies to the minister for the Arts and every member of the Arts Council itself, demanding the 100 per cent increase and stating that community arts represented 'possibly one of the most exciting developments in art in this country'.[9] One member had also sent a letter to Shaw on his own behalf, declaring that the demands to the committee represented the need of '98% of the total population, the people who produce the wealth, and are thus the major contributors to the ACGB public fund'. He went on to warn that 'the working class are no longer content to spend their spare time passively in front of a television' and that the council should not 'play games or experiment with a movement of such social significance'.[10]

The Arts Council was not sympathetic to these representations. The deputy Secretary-General at the time, Angus Stirling, observed in an internal memorandum that it was a much-repeated exaggeration that community arts represented the need of 98 per cent of the population and that it was far more likely that '98% of the population … know nothing of their work and are not interested'. He was also dismissive of the demands for additional funding, predicting that total demands would no doubt rise to £2 million in the next year and that 'certain groups' would always try and 'blackmail' the council on the grounds that inadequate funding threatened their survival.[11] What particularly rankled the council was the ACA's public criticism of the disruption to the grant-making process, when it was the ACA's own members on the Community Arts Committee who had been instrumental in causing the disruption in the first place.[12]

In the end, the council agreed to increase funding for community arts in that year by 16 per cent in real terms and in the following year (1977/1978) by a further 14 per cent. But at the same time it announced the end of its 'experiment'. It concluded that community arts did indeed fall within the chartered duties of the Arts Council, but that it was an activity best assessed and funded locally. Although it would continue its direct support to some organizations for the time being, it would in the coming years seek to 'devolve' responsibility for community arts to Regional Arts Associations and Local Authorities.[13] It was

Figure 8.1 The way. Another way

thus to the regions that the campaigns to subvert and transform established modes of cultural policy subsequently moved.

Dreams

Memories of that July night in Tewkesbury, of those arresting images of dogs in Dunbartonshire, and of conflicts in the Arts Council all capture 'moments' in the history of community arts, which, forty years on, seem to possess an emblematic quality. This is because, far from being random or disconnected memories, these 'moments' were all related in some way to a kind of shared cultural–political dream: a dream that the dominant culture of the time could be transformed or replaced and that community arts could play a part in bringing this new culture into being. The word 'culture' here is used in its both narrower and broader senses: as a set of artistic or creative activities and as a whole way of life. This is not to imply that there was agreement on what might constitute this new culture or on what strategies should be used for establishing it. There was not even agreement on what might legitimately be termed 'community arts'. But all those who became involved were at some level united in their opposition to the

prevailing culture and in their conviction that new kinds of artistic and creative practice could contribute to changing it. The Community Arts Movement could, to borrow a phrase from one of its leading commentators, be aptly described as a 'parliament of dreams'.[14]

One such dream was of emancipation through art, the opening of doorways to new worlds and to different ways of being. If sufficient numbers of people could be liberated in this way, then they would no longer put up with the imaginatively impoverished existence to which modern socio-economic systems had consigned them. But this revolutionary potential of art could never be realized as long as most people never experienced it; and they didn't, because most art didn't speak to them and most venues for the arts alienated them. So what was needed was a new kind of art presented in different places and in new kinds of ways. There was a missionary endeavour behind this, shared by artists, often professing socialist or feminist ideologies, who were interested in taking their work into the community, and by the burgeoning arts centre movement, which wanted to break down the barriers that appeared to exclude the community from traditional arts venues.[15] 'Cataclysm' in Tewkesbury was a product of these ideas. All of the artists taking part were involved in a kind of cultural subversion, parodying or adapting traditional forms and attempting to create a new popular art: Horovitz through his 'poetry of the underground'; Milton with his adult puppet shows; Filey Hippodrome through their parodies of municipal entertainment; and the Natural Theatre Company (unintentionally assisted by the police) with its send-up of rock 'n' roll grandiosity. The whole extravaganza, set in what the organizers perceived to be a 'community-friendly' environment, exemplified this dream of liberation through art.

Vale TV was born of another dream: that community television could function as a powerful instrument of radical and progressive politics. Voices that had hitherto been suppressed or marginalized would now have an influential new platform. Indeed, the initiators of the project anticipated that the opening up of the airwaves to one of Britain's most deprived communities would result in a groundswell of political agitation. They were so sure that this would be one of the project's outcomes that they went to great lengths to construct defences against the repressive measures that they expected the project to provoke. The chief threat was perceived to lie in the terms of the broadcasting licence, which stipulated that 'due impartiality shall be preserved in the content of the programmes as respect matters of political or industrial controversy or relating to current public policy'.[16] If no way could be found of reconciling these conditions with the expected political thrust of Vale TV's output, then the project ran the

risk of 'corrective' intervention from the governing body or, worse, withdrawal of the licence. The defensive strategy adopted was to incorporate the *potential* for balance in programming, rather than insisting on actual balance, which would have had the effect of undermining the open access principles under which Vale TV was to operate. The 'potential for balance' would be secured through publishing in the local press all programme proposals received, thus providing the opportunity for any individual or group to put forward alternative perspectives through programmes of their own.[17] In satisfying the conditions of the licence in this way, or at least in giving the appearance of doing so, the Vale TV production team was able to protect its dream of an invigorated democratic debate leading to new forms of political action.

While 'Cataclysm' and Vale TV, in their different ways, embodied cultural policy in its broadest sense, that is to say, by seeking to bring about change in the general culture, some of those on the Arts Council's Community Arts Committee, who saw themselves as 'representatives' of the wider Community Arts Movement, shared the further dream of changing cultural policy in its narrower sense: the policies of the Arts Council itself.[18] For these members, the Arts Council was an elitist organization, which professed to 'democratise culture', but in reality existed to serve the artistic tastes of only a cultivated minority.[19] Community artists sought a radically different kind of cultural policy, one that would shift the focus of support away from what they saw as 'bourgeois culture' and towards the establishment of what was often referred to as a 'cultural democracy'. In this vision, summed up in one ACA discussion paper as 'not arts for the masses but as masses of art created by masses of people',[20] government funding for the arts would in future be directed away from the opera houses, symphony orchestras, and art galleries and into a multiplicity of community projects. This was a dream shared by some cultural administrators, such as Jim Simpson, advisor to the Council of Europe's Council for Cultural Co-operation, who wrote in a paper for a meeting of European Ministers of Culture in Oslo in 1976 that 'cultural policies will be trivial and marginal unless they help the working class to regain control of their own culture, including the mass media … governments must abandon their traditional cultural policies … as a mere relic of the past, irrelevant to the lives of most people.'[21] The British Arts Council, under the then leadership of Roy Shaw, a former professor of adult education, consistently rejected these ideas, affirming the council's support of 'high' culture and what he saw as its primary duty of increasing access to it.[22] But by persuading the council to set up a new committee, even if only as an 'experiment', advocates for community

arts dreamt of a radical transformation of government cultural policies, for which they could prepare the ground by operating from within as a kind of Trojan Horse.

Reflections

The Community Arts Movement was always a broad church, committed to various forms of social and cultural change but containing within it major divisions over what that change should be, how it might be achieved, and on who should even be admitted into the church. Some saw community arts as subordinate to the more practical concerns of community development, while others emphasized the involvement of artists and the importance of creativity; some admitted only 'participatory' projects, while others included artists practising or performing in community contexts. The idea of 'community' was also contested, with some linking it explicitly to working-class interests, while others applied it more loosely to any 'disadvantaged' neighbourhood. Some rejected the idea of geographical neighbourhoods altogether, opting instead to define communities in terms of other attributes (ethnicity, gender, sexual orientation, disability, etc.). These tensions persisted throughout the 1970s, with many growing weary of even trying to arrive at a common position. A report on a national conference held in Barnstaple in 1980 refers to 'major turmoil' and frequent 'confrontations over principles fundamental to an understanding of community arts'.[23]

No selection of recalled 'moments', however suggestive they may be of bigger themes, is ever going to capture the totality of these conflicting approaches; nor can they convey a definitive version of community arts, because no such version existed at the time. But the 'moments' remembered here do have the virtue of being real – they actually happened – and they do point to assumptions that were held by many artists and 'cultural workers', who sought in various ways to make art relevant to the lives of more people.[24] These 'moments' thus offer a good basis for reflecting further on the cultural policies they embodied, the intellectual foundations of those policies and the extent to which their aims (dreams) were realized.[25]

Presenting new kinds of popular art in community venues, as exemplified by 'Cataclysm' in Tewkesbury, was mostly informed, though often not explicitly, by a kind of Romantic Marxism: Marxist in the conviction that the oppression of the many in the interests of the few was intrinsic to the functioning of capitalism; and Romantic in the belief that art could play a significant role in

social revolution and reform. This was an inversion of more orthodox Marxist positions, which acknowledged that art could play a part in the 'struggle', but held that real change could only come through a transformation of the economic domain.[26] In many respects, this privileging of art in the processes of social change was a reversion to the radical English Romanticism of the nineteenth century, advanced by those such as Percy Shelley and the early William Morris.[27] In his *Defence of Poetry*, which can be read as a kind of manifesto of radical Romanticism, Shelley asked the question (still relevant in the 1970s and even more so today) of how it was that science and economics could bring about such extraordinary increases in material productivity, yet at the same time result in 'the exasperation of the inequality of mankind'. Shelley's answer was a failure of imagination: a failure to imagine what was rationally known and a failure to act on what could be imagined. It was the function of poetry – and by extension all of the arts – to strengthen the faculty of the imagination in much the same way as exercise strengthened a limb.[28] Morris pointed to the 'pitiful existence' to which industrial capitalism had condemned the working class, to the extent that its members now barely knew how to frame the desire for a better life. It was therefore an important function of art to open up new horizons and to manifest 'the true ideal of a full and reasonable life'.[29]

Vale TV exemplified a different strand of community arts, one that reconfigured the role of artists and media workers, so that their skills and talents would no longer be deployed in expressing their own vision, however relevant to their audiences they might think that to be, but would instead be used to enable individuals and community groups to articulate and express *their* vision. Inspiration for this approach could be traced back to Marx himself, who claimed that capitalist societies, through their systems of division of labour, suppressed artistic and cultural expression among the broad mass of the population and concentrated it in the hands of the few.[30] The rise of the mass media, and their accumulations of power, added urgency to this kind of critique, with neo-Marxist cultural theorists, such as Adorno and Horkheimer from the Frankfurt School, contending that the 'culture industry' functioned as a powerful ideological tool, inculcating passivity through its strategies of distraction and effectively undermining any serious challenges to the status quo.[31] These ideas were reflected in projects such as Vale TV, which saw themselves as opening up the means of cultural production to those who were systematically denied access to them. In doing so, they aimed to challenge the domination of the public sphere by mainstream media, rejecting emphatically the authority and control exercised by artistic and media 'professionals'.[32] In a kind of self-denying

ordinance, this would, of course, also involve a refusal to take on the mantle of that authority themselves.

In the light of all this, we can see that the Community Arts Committee's quarrel with the Arts Council of Great Britain – or, to be more precise, the quarrel between the Arts Council and some members of that committee – was not simply over funding priorities or even over the role that the arts should play in society; it was a political quarrel, which had at its heart fundamental disagreements over the nature of democracy in capitalist societies. For many in the Community Arts Movement, the struggle for 'cultural democracy' was part of a broader struggle for the greater democratization of all aspects of political, economic, and institutional life. In this view, the Arts Council was simply an illegitimate body, no more and no less than part of that executive of the modern state which Marx and Engels had memorably described in the *Communist Manifesto* as 'but a committee for managing the affairs of the whole bourgeoisie'.[33] This had been made explicit in Su Braden's book *Artists and People* when she declared that the Arts Council had been established to support 'bourgeois culture' and that it had been the 'great artistic deception of the twentieth century … to insist to *all* people that this was *their* culture'.[34] The Arts Council, through its Secretary-General, Roy Shaw, had dismissed such views as 'politically inspired philistinism' and questioned whether it was the duty of the state actually to subsidize those who were working to overthrow it.[35]

Looking back at the Community Arts Movement in these formative years, it cannot be said that it exhibited a consistent or a coherent politics of culture. This was due, in part, as we have seen, to the disparate practices brought together within the movement, exemplified by the 'moments' recalled here. But it was also due to a disparity between the magnitude of its ambitions and its actual capacity to realize them. In its calls for greater democracy, for a more equal society and for a revolution of the imagination, it allied itself to that diverse (and also divided) constellation of leftist forces seeking political and social change, but the power of art to bring about those changes was greatly overestimated. Community artists were not the first to make this mistake.[36] The organizers and artists of 'Cataclysm', along with the many others who experimented with new kinds of art in the community, were no more able to realize their dreams of a general liberation through art than their 'Romantic' predecessors. Shelley's rousing defence of poetry, for example, culminating in his defiant assertion that poets were 'the unacknowledged legislators of the world', acted as a rallying cry for poets and artists in both his own and subsequent generations.[37] But it proved no more than a seductive fantasy: poets were unacknowledged, not because

their far-reaching powers remained unrecognized, but because they could not, in practice, fulfil the role that he had prescribed for them. William Morris learnt this lesson early on, as E.P. Thompson showed in his aptly sub-titled biography, *From Romantic to Revolutionary*. Turning his back on the 'Romantic' dream, Morris more or less abandoned his early attempts to integrate art into everyday life, devoting himself instead to political organization and public speaking. Looking back on his long life, two years before his death, he observed that he had been 'luckier than many others of artistic perceptions', in that he had not 'wasted too much time and energy on any of the numerous schemes by which the quasi-artistic of the middle classes hope to make art grow when it has no longer any root'.[38] This referred to his adoption of a more 'materialist' position, in which changes in art and culture were seen as being primarily driven by changes in the economic and political system rather than the other way round.

If the forcible removal of Rocky Ricketts by the police from the stage that night in Tewkesbury might be said to have produced a striking metaphor of the limits to art's transforming power, then Vale TV's 'Stray Dogs' produced another: of the disparity between the political energies that community arts projects were often expected to release and the actual outcomes that could be observed. As we saw, the initiators of Vale TV were so sure that the project would tap into a reservoir of community discontent, resulting in highly politicized programme content, that they expended much effort on taking precautionary measures to protect the project against anticipated attempts to have it censored or closed down. In this respect, they might be said to have placed undue faith in Marx's 'law of increasing misery', which postulated that under the conditions of capitalism the well-being of working people would become progressively worse (regardless of wage increases), leading to increased politicization and radical social change.[39] The Vale of Leven in 1976 could certainly have been considered one of Britain's most disadvantaged communities, but like many other such communities that community arts projects sought to 'empower', it showed little sign of wanting to mobilize in the ways that activists envisaged. In the case of Vale TV, 'Stray Dogs' was as political as it got, with people queuing up to make broadly 'affirmative' programmes about amateur sports clubs, hobbies, and voluntary organizations.[40] The project may have reflected Frankfurt School critiques of the ideological function of the mainstream media, but, in expecting a community television project to result in a politically challenging alternative, it appeared not to have taken on board the school's more pessimistic conclusions about capitalism's power, through its 'culture industry', to induce conformity;[41] and, of course, in their commitment to helping communities express *their* voice, which

prohibited through self-denying ordinance an imposition of their own voice, cultural workers on projects such as Vale TV could find themselves perpetuating the very conformities that they wanted to resist.

None of this is to suggest that community arts, in all their variations, were without value; or that they did not in many cases enhance the lives of individuals and communities: only that there was a gap between rhetoric and reality; between ambition and achievement. The ACA's attempt to 'storm the citadel' of the Arts Council of Great Britain, demanding a 100 per cent increase in funding just months before the British government was forced to ask the IMF for the biggest loan it had ever granted, was one more example of the delusional ambition that the Community Arts Movement often displayed. It never received the funding it demanded, the citadel remained intact and, to this day, despite periodic expressions of commitment to 'social inclusion' and 'new audiences', the artistic and financial priorities of the Arts Council remain much the same as they have always been.

Ironically, the dreams of 'cultural democracy' – if this is understood in terms of access to the means of cultural production – have been realized not by state-subsidized community artists but by the digital revolution: in other words, by the techno-scientific achievements of precisely those capitalist economic forces to which the Community Arts Movement was historically opposed. Access to the public sphere is now theoretically open to all (at least, to anyone with access to a computer or mobile phone) and it is now no longer possible to claim that any community in the UK is denied a voice. Of course, whether that voice is heard is a different matter: a tightly controlled public sphere has been replaced by an open virtual arena in which a multitude of voices compete for attention in a boundless, cacophonous space. Even when voices do succeed in rising above the mêlée, they are as likely to oppose as to share the leftist values traditionally associated with a 'cultural democracy', as the growth in right-wing populism throughout Europe has recently demonstrated; and even if they do share those values, can it really be said that cultural expression is actually effective in resisting the dominant structures of power they seek to dismantle? If the digital age has produced a kind of 'cultural democracy', might it not also be said that it co-exists with even more entrenched forms of inequality, sustained by concentrations of economic power that can appear almost unassailable?

This is not to imply that within the world of artistic and cultural production the Community Arts Movement has been alone in harbouring an inflated sense of its own significance and efficacy. Such inflation is an occupational hazard – sometimes a psychological necessity – for those engaged in most forms of artistic,

intellectual, or cultural work. As we have seen, it was evident in Romanticism; it was prevalent in what we now refer to as Modernism;[42] and we see it today not only in artistic circles but also in areas of the academic world, such as cultural, communication, and media studies, which typically represent themselves as being in the vanguard of 'resistance' and a generally progressive politics.[43] It is a perennial weakness of the 'culturalist's' position.

But this should not be taken as justification, much less as advocacy, of conservative pessimism. Not only are 'cultures of optimism' essential requisites for both individual and collective living, as I have argued elsewhere,[44] but they have sustained people in their struggles for freedoms and rights that we now take for granted; to cite William Blake, another icon of radical English Romanticism, 'what is now proved was once only imagined'.[45] So in recalling those experiments in community arts from forty years ago, we should not allow ourselves, as Raymond Williams once said of Romanticism itself, 'to be betrayed into the irritability of prosecution'.[46] It was a different time, when the futures dreamt of by the Community Arts Movement could appear more understandable than they perhaps do today. Thatcher had still to win an election (let alone three), the miners were as yet undefeated, and the orthodoxies of global capitalism were still to take root. The 'People's Democracies' of the Soviet Bloc had not yet left the stage. The stabilities of the old post-war consensus, certainly, were breaking down, but it was not yet clear what would take its place. At this juncture, those very instabilities were conducive to the imagining of alternatives. At least, that's how I remember it.

Notes

1 I use the generic term 'cultural worker' here, rather than the more specific term 'community artist'. There were many such workers at the time, who shared the aims of the 'Community Arts Movement', broadly defined, but did not describe themselves as 'community artists'. They could be found in arts centres, community media projects, theatre companies, community education, regional arts associations, and so on. The multiple streams that fed into the 'Community Arts Movement' are discussed further later in the chapter.

2 An account of 'Cataclysm' appears in the *Gloucester Citizen*, 1 August 1973, 5. As director of the Courtyard Arts Trust, I had been largely responsible for conceiving and organizing 'Cataclysm': choosing the location, programming it, getting an audience, and overseeing events on the night.

3 For a full account of the Quality of Life Experiments, see HMSO (1977).

4 The licence was awarded to the Dumbarton District Community Development
 Advisory Board, which was the governing body of the Quality of Life Experiment in
 West Dunbartonshire. It brought together representatives from the then Dumbarton
 District Council, Strathclyde Regional Council, the Scottish Education Department,
 the Scottish Sports and Arts Councils and some co-opted members of the public.

5 As one of the three 'area co-ordinators' appointed to the West Dunbartonshire
 Quality of Life Experiment, my job had been to support and develop arts activities
 within the locality. In this capacity, I joined the Vale TV production team and
 played an active role both in developing the project's aims, policies, and procedures
 and in facilitating the filming, production, and editing of specific programmes.

6 See Oliver Bennett, 'An Experiment in Local Television Broadcasting in the Vale
 of Leven, Dunbartonshire', Report to the Scottish Film Council, Edinburgh, 1976;
 John Cassidy, 'Paper 7: Community Television Project, Dumbarton', in HMSO
 (1977), 231–46.

7 Figures based on the Retail Price Index (RPI) as at June 2015. Source: Hargreaves
 Lansdowne Inflation Calculator at http://www.hl.co.uk/tools/calculators/inflation
 -calculator (accessed 15 June 2015).

8 As the 'Community Arts Officer' of North West Arts, I was invited to attend
 meetings of the Arts Council's Community Arts Committee as an observer and
 to comment on grant applications from artists and organizations working in the
 North West region (this encompassed Greater Manchester, Lancashire, Cheshire,
 and the High Peak District of Derbyshire). A key aspect of my job was to support
 and encourage the development of new community arts activities in the region
 and to ensure that the North West received a fair share of the Arts Council funding
 allocated for community arts.

9 Martin Goodrich, Peter Blackman and Maggie Pinhorn, Circular Letter,
 20 April 1976 (held in the V & A Theatre and Performance Archives, 'Arts Council
 of Great Britain Records, 1928–1997', ACGB/113/71).

10 Peter Blackman, Letter to Roy Shaw, 10 March 1976 (held in the V & A Theatre
 and Performance Archives, 'Arts Council of Great Britain Records, 1928–1997',
 ACGB/113/68).

11 Angus Stirling (ACGB deputy Secretary-General), 'Steel & Skin: My comments
 on the letter of 10 March from P. Blackman', Memorandum to Roy Shaw (ACGB
 Secretary-General), 14 April 1976 (held in the V & A Theatre and Performance
 Archives, 'Arts Council of Great Britain Records, 1928–1997', ACGB/113/68).

12 See John Buston (ACGB Regional Officer), 'Community Arts: Draft Letter to
 Martin Goodrich, Maggie Pinhorn and Peter Blackman', Memorandum to Roy
 Shaw (ACGB Secretary-General), 26 April 1976 (held in the V & A Theatre
 and Performance Archives, 'Arts Council of Great Britain Records, 1928–1997',
 ACGB/113/71).

13 Arts Council of Great Britain, 'Community Arts: A Report by the Arts Council's Community Arts Evaluation Working Group' (London: Arts Council of Great Britain), 1978, 1.

14 See François Mattarasso's blog, 'Parliament of Dreams', at: http:// parliamentofdreams.com/about/francois-matarasso/ (accessed 1 September 2015).

15 In this context, the word 'community' was often used as a euphemism for working-class people or for those perceived to be experiencing some form of economic or social disadvantage.

16 Jenkins (under Post Office Act 1969) for Experimental Service of Local Television by Wire', para 5 (f), Reproduced as Appendix 1, in Bennett, 'An Experiment in Local Television Broadcasting in the Vale of Leven, Dunbartonshire'.

17 Bennett, 'An Experiment in Local Television Broadcasting in the Vale of Leven, Dunbartonshire', 8, 9.

18 For a brief résumé of different understandings of cultural policy, see Bennett (2009), 155–57.

19 For an elaboration of this view, see Braden (1978), 153–55.

20 Association of Community Artists, 'Draft Discussion Paper: Community Arts' (n.d.), 1 (held in the V & A Theatre and Performance Archives, 'Arts Council of Great Britain Records, 1928–1997', ACGB/113/58).

21 Simpson (1976), 35, 36.

22 See, for example, Shaw (1979), 5–9.

23 See the report of the plenary session in Ross et al. (1980), 40.

24 The ACA discussion paper, referred to in Note 16, defined the aim of community arts as 'to make art relevant, useful and available to the great majority in our society and to give everyone equal opportunity to express themselves creatively'. This is not dissimilar to the Arts Council of Great Britain's own description of the aims of community arts as 'to give people the opportunity to enjoy and participate in creative activity, to take an active as well as passive role in the arts, to make the arts more accessible to all members of the community, and more relevant to the creative development of society'. See Arts Council of Great Britain, 'Community Arts: A Report by the Arts Council's Community Arts Evaluation Working Group'.

25 The term 'cultural policy' is used here in its broadest sense, denoting any course of action that is deliberately designed to shape attitudes, values and behaviours. See note 15.

26 For a useful discussion of Marxist theories of art, see Williams (1958), 258–75.

27 For an extended discussion of the relationship of Romanticism to modern forms of cultural policy, see Bennett (2006), 117–34.

28 Shelley (1821), 293.

29 Morris (1894), 244.

30 Marx and Engels (1846), 109.

31 See Adorno (1991).

32 A later report from the Shelton Trust, a successor body to the Association of
 Community Artists, describes itself as 'a specification for socialism' and contains a
 four-page critique of 'Professional Power'. See Shelton Trust (1986), 7, 18–21.
33 Marx and Engels (1848), 82.
34 Braden (1978), 153.
35 Shaw (1979), 9.
36 For an extended account of claims made for the arts, see Belfiore and
 Bennett (2008).
37 See Allen Ginsberg's interview with Jeremy Isaacs, first shown on BBC 2 on
 9 January 1995, https://www.youtube.com/watch?v=822-QW4CTUc (accessed
 10 September 2015).
38 Morris (1894), 244.
39 For a useful discussion of this 'law', see Sowell (1960), 111–20.
40 For a list of all programmes made, see Bennett, 'An Experiment in Local Television
 Broadcasting in the Vale of Leven, Dunbartonshire', Appendix III.
41 See Theodor Adorno and Max Horkheimer, 'The Culture Industry: Enlightenment
 as Mass Deception, in Adorno and Horkheimer (1947), 120–67.
42 See Danchev (2011).
43 See, for example, Lewis and Miller (2003).
44 Bennett (2015).
45 Blake (1969).
46 Williams (1958), 64.

References

Adorno, Theodor, and Max Horkheimer. 1947. 'The Culture Industry: Enlightenment
 as Mass Deception'. Reprinted in Theodor Adorno and Max Horkheimer, *Dialectic of
 Enlightenment*, translated by John Cumming, 120–67 (Verso: London, 1979).
Adorno, Theodor. 1991. *The Culture Industry: Selected Essays on Mass Culture*, ed. J.M.
 Bernstein (Routledge: London).
Arts Council of Great Britain. 1978. 'Community Arts: A Report by the Arts Council's
 Community Arts Evaluation Working Group' (Arts Council of Great Britain:
 London).
Association of Community Artist. Undated. 'Draft Discussion Paper: Community Arts'.
 Held in the V & A Theatre and Performance Archives, 'Arts Council of Great Britain
 Records, 1928–1997', ACGB/113/58.
Belfiore, Eleonora, and Oliver Bennett. 2008. *The Social Impact of the Arts: An
 Intellectual History* (Palgrave Macmillan: London).
Bennett, Oliver. 1976. 'An Experiment in Local Television Broadcasting in the Vale of
 Leven, Dunbartonshire'. Report to the Scottish Film Council, Edinburgh.

Bennett, Oliver. 2006. 'Intellectuals, Romantics and Cultural Policy', *International Journal of Cultural Policy*, 12 (2): 117–34.

Bennett, Oliver. 2009. 'On Religion and Cultural Policy: Notes on the Roman Catholic Church', *International Journal of Cultural Policy*, 15 (2): 155–70.

Bennett, Oliver. 2015. *Cultures of Optimism: The Institutional Promotion of Hope* (Palgrave Macmillan: London).

Blackman, Peter. 1976. Letter to Roy Shaw. Held in the V & A Theatre and Performance Archives, 'Arts Council of Great Britain Records, 1928–1997', 10 March, ACGB/113/68.

Blake, William. 1969. 'The Marriage of Heaven and Hell'. 1793. Reprinted in *The Poems of William Blake*, ed. W.B. Yeats (Routledge & Kegan Paul: London).

Braden, Su. 1978. *Artists and People* (Routledge & Kegan Paul: London).

Buston, John (ACGB Regional Officer). 1976. 'Community Arts: Draft Letter to Martin Goodrich, Maggie Pinhorn and Peter Blackman'. Memorandum to Roy Shaw (ACGB Secretary-General). Held in the V & A Theatre and Performance Archives, 'Arts Council of Great Britain Records, 1928–1997', 26 April. ACGB/113/71.

Cassidy, John. 1977. 'Paper 7: Community Television Project, Dumbarton', in HMSO, *Leisure and the Quality of Life: A Report on Four Local Experiments*, vol. 2, 231–46 (HMSO: London).

Danchev, Alex (ed.). 2011. *100 Artists' Manifestos: From the Futurists to the Stuckists* (Penguin Books: London).

Gloucester Citizen. 1 August 1973. '"Cataclysm" was Full of Surprises – Some Unintended', 5.

Goodrich, Martin, Peter Blackman, and Maggie Pinhorn. Circular Letter. 1976. Held in the V & A Theatre and Performance Archives, 'Arts Council of Great Britain Records, 1928–1997', 20 April. ACGB/113/71.

HMSO. 1977. *Leisure and the Quality of Life: A Report on Four Local Experiments*, vols. 1 & 2 (HMSO: London).

Jenkins, Roy. (Home Secretary). 1976. 'Licence (under Post Office Act 1969) for Experimental Service of Local Television by Wire'. Reproduced in Oliver Bennett, 'An Experiment in Local Television Broadcasting in the Vale of Leven, Dunbartonshire', Appendix 1, 14–17. Report to the Scottish Film Council, Edinburgh.

Lewis, Justin, and Toby Miller. 2003. *Critical Cultural Policy Studies: A Reader* (Blackwell Publishing: Oxford).

Marx, Karl, and Frederick Engels. 1846. *German Ideology*. Reprinted with notes and introduction, ed. C.J. Arthur (Lawrence & Wishart: London, 1970).

Marx, Karl, and Frederick Engels. 1848. *The Communist Manifesto*. Reprinted with introduction by A.J.P. Taylor, trans. Samuel Moore (Penguin Books: Harmondsworth, 1985).

Mattarasso, François. 2015. 'Parliament of Dreams', http://parliamentofdreams.com/about/francois-matarasso/ (accessed 1 September 2015).

Morris, William. 1894. 'How I Became a Socialist'. Reprinted in *Political Writings of William Morris*, ed. A.L. Morton, 240–45 (Lawrence & Wishart: London, 1979).

Ross, Bernard, Sally Brown, and Sue Kennedy (eds.). 1980. *Community Arts: Principles and Practices* (The Shelton Trust: London).

Shaw, Roy. 1979. 'Secretary-General's Report: Patronage and Responsibility'. In Arts Council of Great Britain, *Thirty-Fourth Annual Report and Accounts*, 5–11 (Arts Council of Great Britain: London).

Shelley, Percy Bysse. 1821. 'A Defence of Poetry'. Reprinted in *Shelley's Prose*, ed. David Lee Clark, 275–97 (Fourth Estate: London, 1988).

Shelton Trust. 1986. *Culture and Democracy: The Manifesto* (Comedia Publishing Group: London).

Simpson, J.A. 1976. *Towards Cultural Democracy* (Council of Europe: Strasbourg).

Sowell, Thomas. 1960. 'Marx's "Increasing Misery" Doctrine', *The American Economic Review*, 50 (1): 111–20.

Stirling, Angus (ACGB Deputy Secretary-General). 1976. 'Steel & Skin: My comments on the letter of 10 March from P. Blackman'. Memorandum to Roy Shaw (ACGB Secretary-General). Held in the V & A Theatre and Performance Archives, 'Arts Council of Great Britain Records, 1928–1997', 14 April. ACGB/113/68.

Williams, Raymond. [1958] 1979. *Culture and Society 1780–1950* (Penguin Books: Harmondsworth).

From Handbooks to Live Labs: The Impact of Ideas from the 1970s and 1980s on the Training and Education of Community Artists Today

Janet Hetherington and Mark Webster

There has never been an obvious career pathway to becoming a community artist. In this chapter, we examine educational and training initiatives associated with the community arts sector and explore some of the issues that have impacted how it has evolved. We consider who controls and influences community arts training; the role formal and informal education providers have in this process; the implications associated with training and education designed to enable community artists to acquire skills to work in specific sectors or contexts; and finally, key contemporary and future trends.

Our perspective on this topic comes from our experiences as community arts workers whose work has led us to academia. Over the past ten years, we have led the Master of Arts (MA) in Community and Participatory Arts at Staffordshire University. Unlike our graduates, who often have little direct experience of community arts before they begin the course, we both learned 'on the job' and, to a certain extent, as participants on community arts projects; we can make lanterns, write funding bids, and know the value of a community cuppa in times of crisis! However, as our work became more closely aligned to local authorities, cultural institutions, and the NHS, we became aware of the need to share our experiences and help prepare other community artists to work in such contexts. As well as drawing upon our own experiences, we interviewed Katherine Dean (director of Sound Sense), Sandra Hall (co-director at Friction Arts), and Régis Cochefert (director of Grants and Programmes at the Paul Hamlyn Foundation) to help illustrate our perspectives.

The MA programme and research projects at Staffordshire University attempted to bridge the gap between theory and practice. We believe it is important to ensure that artists have the opportunity to learn about the history of the Community Arts Movement as well as gain research skills to enable local community artists to document their work and conduct their own research. Most importantly, we have endeavoured to create opportunities for community artists to consolidate their 'on the job' learning with (what we consider to be) useful knowledge and pedagogies associated with theories influencing community arts, as well as practical guidance to help them work in different sectors. Our students' backgrounds have been diverse and they include recent arts graduates, arts workers who own their own enterprises, a retired nuclear scientist, and professionals working in other sectors such as events management and healthcare. This diversity reflects the changing face of the community arts sector and is probably more diverse than some of the original cohorts of community artists in the 1970s. As with many postgraduate community arts programmes, it is not currently being taught (the last intake was in 2013), but we remain committed to provide training, education, and support for community arts workers through collaborative research and supporting the delivery of specific community arts projects.[1]

In 1976, a paper about community arts training was produced for the Arts Council of Great Britain's (ACGB) Community Arts Evaluation Committee, written by John Buston, regional officer to the Arts Council and Robert Hutchinson, a senior research and information officer (Buston and Hutchinson 1976). Based on a survey of 36 community arts organizations and involving 130 individual community artists, it explored the role that training and education providers could play. The writers recognized the contributions being made by further and higher education provision, ranging from the development of an arts input on community work courses in places like Manchester Polytechnic and Jordanhill College of Education in Glasgow to the art-form specific training that had been undertaken by many of the 'first generation' of community artists. In addition, it identified a range of skills required for a community artist including the 'virtues (and none of the smugness) associated with the notion of professionalism', arguing for 'consistent ability in the application of skills, respect for confidence, punctuality, efficiency and orderliness' and for the need for training in communication skills and for short intensive courses on 'some of the skills commonly used in community arts: for example, video, print layout, silkscreen, mural painting, writing and editing' (Buston and Hutchinson 1976).

Buston and Hutchinson's paper is of historic interest; however, it also usefully sets the scene for the issues concerning training and education that this chapter explores. Many of the questions which lie behind what is proposed in the paper – 'What kinds of training do community artists require? What is the role of further and higher education in providing training? What should be the balance between generic skills and art-form skills development? Who should be responsible for setting the training agenda?' – have never been fully resolved and remain as pertinent to the training and educating of community artists today as they were four decades ago.

Back to basics: What is training and education trying to achieve?

We begin by considering why the very notion of developing training and education for community artists was, and arguably still is, a contentious issue. Kathryn Dean (SoundSense)[2] summarizes one of the key challenges the sector faces: 'the questions we ask ourselves when we set out to understand training for community arts are complex. Are we training artists to become community workers or community workers to become artists? Are we aiming to involve more people in the arts or are we trying to change the world?' These questions are hard to answer definitively and it was no less difficult in the 1970s and 1980s. Owen Kelly, best known for his book *Community, Art and the State: Storming the Citadels* (1984), argued that a lack of clarity and a shared perspective on the ideas which lay behind community arts posed problems for every aspect of its future development. As discussed in more detail in Chapter 2 of this book, despite the efforts of the Association of Community Artists (ACA) to establish a unifying voice for community arts organizations throughout the 1970s, the movement has continued to be hugely diverse, and this has led to a lack of systematic analysis of the wide range of informal and formal education and training opportunities associated with community arts. It has also been argued that community arts work is actually representative of a series of 'movements' each distinguishable by their art form, approach, and the groups with whom they worked, meaning that approaches to training and education have often evolved in isolation and for very different purposes (Webster and Buglass 2005). If the experience of the last three decades has taught us anything, it would be that efforts to produce a single unifying voice for community arts work are likely to be unsuccessful. In no aspect is this truer than in relation to training. While it is argued by many

that the diversity of the community arts sector is as much a strength as it is a weakness, the same could be said for approaches to training. This, of course, has not stopped the discussion around training being contentious.

Disagreements about training have been fuelled by the philosophical and ideological mistrust of formal educational structures felt by many, although not all, community artists. The influential writer and activist Paulo Freire asserted that 'if it is true that thought has meaning only when generated by action upon the world, the subordination of students to teachers becomes impossible' (Freire 1996 [1970]: 58), and this notion of equality between community members, artists, and educators can be seen as characteristic of approaches to training in the early period of the development of community arts. Ideas relating to establishing professional standards or developing a more uniform approach to training and education were sometimes rejected out of concern that they would dilute the egalitarian and participative ethos underpinning community arts work. The Meeting of Experts on the Training of Animateurs at UNESCO in 1972 suggested that existing university courses should be modified to reflect the need for cultural *animateurs* (their preferred terminology for what we would now call community artists). However, they were impatient and saw the need for more immediate action to train *animateurs* in a time of 'multiplication and changes in mass communications systems, the growth of interest in cultural works and values and the call for decentralisation'. They wanted to see a more immediate programme of 'ad hoc and special training [based on] the need for proper balance between theory and practice and [...] the evaluation of the results achieved' and insisted that programmes like this would still be necessary even when the universities had managed to change their programmes of learning.[3]

Much of the education and training which took place in the 1970s was, therefore, self-facilitated and located in practice; emphasis was placed on individual motivation to learn specific skills and acquire a broad sociopolitical knowledge base. In an addendum to another paper on training for ACGB's Community Arts Committee, for example, it is noted that

> generally speaking, community artists do not recognise any qualifications in community arts and advise all students interested in actually working in the area that, on leaving college, they should work for at least one year with an established community arts group. It will also enable them to relate to a community and find out whether they have the ability and commitment necessary for this kind of employment. (Buston and Burge 1978)

However, moves were already underway to start offering formal educational programmes in community arts in some higher education institutions. This led to Kelly identifying a major challenge for practitioners: 'we have won the battle to have community arts recognised as a legitimate arts practice, and the demonstration that this is so is the large-scale interest being taken in community arts by educational institutions: polytechnics, arts colleges, etc. Our problem is that we have not constructed any definitions we can claim as our own' (Kelly 1984). Kelly's unease signalled a real fear that if community artists were not 'in the driving seat' it would be the training institutions themselves that defined the core skills and relevant training for the next generation of community artists.

These historical factors – the diverse nature of perspectives on and approaches to community arts, an inherent philosophical and/or ideological mistrust of formal structures and a concern that institutions and not the sector would define the training agenda – help to illuminate the tensions which have continued to be faced by community arts training and education providers. This is a sector that is value-driven and inclusive; and yet, its very virtues are so often the things which have prevented training and education from evolving.

Figure 9.1 Professional development

Formal education or vocational training?

Ivan Illich, writing in the 1970s, asserted that institutions such as schools have a tendency to end up working in ways that reverse their original purpose, and this perhaps partly explains why early attempts at training and education for community arts initially established themselves outside of formal education and training provision (Illich 1981). The works of Illich are particularly significant for community artists because his ideas were popularized within the radical left in the UK in the 1970s and represented a critique to establishment and conventional left positions which played down the role of cultural activism in bringing about positive social change. Illich, in common with other theorists and practitioners focusing on grass-roots change such as Saul Alinsky, put culture at the heart of their thesis which attacked conventional institutions and power hierarchies (Alinsky 1989). These arguments were important to many community practitioners, and not only artists, because they broke with the convention that cultural activity should be led by experts who were both talented and trained through traditional institutional routes.

What is also important to consider when looking at training in the 1970s and 1980s is the contested nature of who should be the subject, or the focus, for training. Conventional approaches to education and training would put artists at the centre of their model and focus training on making them better facilitators or more effective teachers. The Freirian model would suggest, however, that the power relationships involved in community arts projects should be more egalitarian and that everyone, from participant to partner, from artist to community worker, are all involved in learning. This kind of approach to training and education fits well into models of informal education practice but runs contrary to many of the formal approaches usually adopted by traditional training and education providers. There was then a further complication; on the one hand community artists valued the role of participants and all practitioners involved in the process of creating work, while on the other they saw the importance of gaining recognition for their own professional skills if the practice was to be sustained.

These factors led to a two-strand and, to some extent, contradictory approach to education and learning in the sector. A diverse and largely informal and vocational range of initiatives was developed and it was common for community arts organizations and artists themselves to independently facilitate these learning experiences; for example, Welfare State International focused on opportunities for informal peer mentoring and a fluid approach to dropping in

and out of placements and training provision. At the same time, work continued to formalize educational provision for the sector by providing programmes that in many ways duplicated the graduate routes that had initially been followed by much of its early workforce.

The Calouste Gulbenkian Foundation's Community Arts Apprentice Scheme, which ran between 1984 and 1988, is particularly significant because it was a vocational initiative developed in partnership with both community arts organizations and the Arts Council. The scheme was set up as a direct response to skills shortages in the fledging community arts industry and attempted to open up access to the sector for new types of practitioner and to give them experience of a wide range of practice. However, Rod Brooks in his evaluation of the scheme, *Wanted! Community Artists*, suggests that although it was hugely successful for the six or seven apprentices a year that were trained, it neither solved the employment problem, as it was too small to have a wide-ranging impact nor did it challenge the demographic profile of the industry, as the great majority of its learners already had further or higher education arts qualifications on entering the scheme (Brooks 1988). What it did do was to establish a curriculum that was essentially practice-based and which valued a range of people-based and administrative skills, which proved hugely influential in the setting up of later programmes of training. It was also successful because it was embedded in organizations and most of the learners went on to work in community arts, many of them in the same organizations where they had undertaken their placements.

In 1978, discussions had taken place between the Arts Council and the CNAA (the validating body for non-university based higher education courses) about the nature of the arts courses that were being created in the new polytechnics; courses with community arts content or options were being proposed in Dartington Hall in Devon, Newcastle Polytechnic, Alsager and Crewe College in Cheshire, Middlesex Polytechnic, Leicester Polytechnic, Trent Polytechnic, and in Liverpool's IM Marsh College (Buston 1978). By the mid-1980s, education providers had established training for would-be community artists in these and other conventional further and higher education settings.

However, similar to our experiences of maintaining a master's level programme, sustaining these courses has proved challenging. Most students do not go to university knowing they want to study to be community artists, and develop an interest only through being exposed to community arts practice during the course of their studies.[4] Thus, there have been long-term issues associated with recruiting students. There are a few notable exceptions to this,

such as the Community Music BA at Sunderland University that has been running successfully since 1990. Largely practice based, it gives students the opportunity to dedicate their learning solely to the development of community-based practice. The fact that it has flourished is a testament in no small part to the effectiveness of SoundSense that has worked with the University to support and sustain the course, but survival and success may also be linked to another factor. Higher education courses in creative practices such as music, dance, and theatre have generally had more success in sustaining courses with a high-social or applied content; for example, more recently, courses such as Applied Theatre at the Royal Central School of Speech and Drama (part funded by the Leverhulme Trust to develop work in social and community contexts) and the People Dancing Summer Schools (being delivered in partnership with De Montfort University). Hiles' recent study into what really matters to UK undergraduates on creative and media courses asserts that increasingly students refer to 'professionalism' and that they care about acquiring specific skills, which explains why core art practices have been able to sustain their existence (Hiles 2016).

The shift from community activism to institutionalized profession

Community arts of the 1970s and early 1980s was characterized by a quest for what community artists at the time called cultural democracy where the emphasis of community arts was on social and political change. Writer and practitioner François Matarasso explains, 'the development of community art in 1970s Britain occurred at least partly as the art world's response to the wider social changes of the time, just as its transformation in the 1990s was linked to the social and cultural changes going on then' (Matarasso 2013: 218). Early references to the role of community artist were often linked to specific skills associated with community activism and social change. Much of the training which existed served to raise awareness about how communities had the power to change power imbalance within society. A *Mailout* article in 1986 advertised seminars featuring 'Lessons from America?' which included sessions on Community Economic Development in the US and Alinsky Organizing (*Mailout* 1986). In 1986, Alan Badder, a community development worker who was involved in setting up the Whole Works community arts company in Crewe, reported the importance of Alinsky's rules of power to early community artists. According to Badder, the most important of his rules are that 'power is not only what you

have, but what the enemy thinks you have' and 'The major premise for tactics is the development of operations that will maintain a constant pressure upon the opposition' (Badder 1983: 6). *Mailout* suggested that community artists need to 'have the skills to actually involve people [and] the machinery and the ability to allow people to develop confidence in themselves by way of achievement' (*Mailout* 1986). The distinction between community artist and participant was often blurred, resulting in community-led and neighbourhood-based initiatives associated with training, which were situated within communities. An example of this is the informal training which took place on the Craigmillar Estate in Scotland, discussed in Chapter 4 by Andrew Crummy, which supported local women in particular to take up leadership roles in community activities (Crummy 1992). In a short film about that work, the film-makers associate the community arts activities taking place in Craigmillar with the appointment of a small group of neighbourhood workers and highlight the importance of using local knowledge and experience to tackle social problems.[5]

In something of a contrast, the proposals for training by North West Arts in the paper *Community Arts Training* (1981/1982)[6] serves to mark an important shift in attitudes to community arts training in that it proposes the development of artistic ability and administration skills as well as social skills for community work and proposals for the provision of this included placements, exchanges, and existing courses delivered by educational institutions. The desire for community arts work to be recognized by the arts establishment, such as the Arts Council, led to a wider debate about whether, as a movement, community artists wanted to work more closely with arts organizations, government initiatives, and the public sector or whether they wanted to continue as part of an activist political movement which operated outside of the system. The *Glory of the Garden* report by the Arts Council (1984) was, ironically, one of the first steps towards mainstreaming and creating specialized posts in relation to the role of a community artist (Arts Council of Great Britain 1984). Seen as one of the first public acknowledgments of the scale of the community arts sector across the UK, it gave a new profile to the work of community artists. Rather than being seen as a form of radical practice, which was located outside formal structures and in reaction to the government, the report suggested that community artists might be able to contribute towards addressing different social issues. There was a new acceptance that community arts needed to fulfil the needs of a far broader set of stakeholders. While this acceptance was what many in the sector had been striving for, very few saw the long-term effect that government endorsement would have on how community artists now trained and worked.

The *Glory of the Garden* report may have showcased the work of community artists but it did so using the rhetoric and mechanisms associated with formal institutions and state apparatus. It continues to influence how creative work is developed and defined; for example, Dorney and Merkin note in their study of the relationship between the Arts Council and regional theatre how theatres are expected to 'produce shows that are excellent (for ACE), educational (for the Local Authority), popular (for both funders) and challenging, and that draw in new audiences as well as retain existing ones' (Dorney and Merkin 2010: 199). A similarly broad range of expectations has been placed on the work of community arts since the mid-1980s, the time of this report. The report's legacy presented an opportunity to work with non-arts partners such as the NHS and to create a case to demonstrate the impact of the work but it also increased the number of stakeholders that community artists were expected to report to. It signalled a shift from a radical political movement where community artists learned 'on the job' and developed competencies in order to directly respond to the needs of the people they worked with. Community arts was becoming an institutionalized profession where artists needed to acquire specific skills to respond to the professional standards of the organizations for whom they were beginning to work.

The 1990s: Specialization, professional standards, and career progression

During the course of the 1990s, it became increasingly common to align community arts with specialist practices in other sectors such as arts and health, arts in prisons, arts and housing, and arts in education and in relation to mainstream art-form institutions such as theatres or galleries. In addition, the demands on what community arts work was expected to deliver were changing. Following a major survey of arts and communities, it was suggested that 'arts organisations should seek to build on the lessons of the last few years and continue to develop their skills in business and programme planning, in management, evaluation and building up earned income' (Community Development Foundation 1992: 96). Despite being so important in contributing towards the original values that underpinned community arts, activism and community work began to feature less frequently in the curricula of training institutions. Community arts courses in academia became more specialized with examples like the establishment of Roehampton's Art in a Community

Context Course, with a focus on visual arts, in 1995 and the HND in Community Performance at Clarendon College, Nottingham, in the same year. We later see the emergence of more industry-specific courses such as the MA Health and the Arts at Colchester Institute and Geese Theatre's training courses on theatre in prisons. Even community arts organizations associated with the early days of community arts began to align their training with academic institutions such as the MA in Cultural Performance with Welfare State International which the University of Bristol set up in 1999. This tendency towards more specialized courses influenced how we delivered our MA in Community and Participatory Arts at Staffordshire University (2002) that contained modules linked to specific vocational practices such as the Arts and Health module. Increasingly, we brought in professional practitioners who worked in sectors such as social care, criminal justice, and education as visiting lecturers. In setting up the course, we believed that it was important to link learning about the practices with direct experience of that practice. To facilitate this, students studying on the MA were encouraged to undertake their core work placements and projects with agencies directly linked to the areas of practice they were studying. Many of the students already lived and worked locally, so projects fed into a wide network of engaged practice and contributed to the broader social economy. Additionally, many students were mentored by the agencies where they developed projects and whenever possible students exchanged skills and experiences and supported each other's projects through a process of peer learning. In this way, the reflective work happening in taught areas of the course was directly related to a wide range of vocational practice happening in their work or in their placements.

This period also sees a growing appreciation that community artists needed to develop a more complex set of skills and competencies to be able to work in such a wide variety of social contexts and respond to increasing attempts to establish agreed high-quality standards for the work, something that continues to the present day. Reflecting on what is needed to be a community musician, for example, Kathryn Dean cites 'people skills' and the ability to reflect on practice and consider ethics, as well as skills in music technology and music improvisation. She believes that the music skills of musicians working in participatory projects are 'very different from those of a performing musician. It's much more important [...] that you are able to play well enough on several types of instrument – as it is to have high quality skills in any *one* of those types of instrument'. In 2011, the Consortium for Participatory Arts Learning (C-PAL) developed a competency framework, which is being

used by several community and participatory arts organizations across the UK for both recruitment and training purposes; this identifies twenty-six core competencies for workers related to creative practice, relationship building, personal excellence, and thinking. More recently, a suite of National Occupational Standards for community arts has also been developed. These initiatives were influenced by the views of those funding community and participatory arts practice, such as the Paul Hamlyn Foundation (PHF). Regis Cochefert, grants and programmes director for PHF, comments that

> often the interface between the community group and the arts organisation is a person, an artist, a workshop leader, an education manager. Therefore, PHF is very keen that these interactions are of the highest quality and therefore several things interest PHF; the quality of the art, the quality of the leadership resulting in participatory work and the quality of the experience from the participant's point of view.

What all this illustrates is that there is now a sharper focus on training and development with organizations feeling that they have a stake in producing high-quality practice produced by well-trained, multi-skilled artists.

Consideration of the simplicity, and yet grandiose ambitions, associated with the Welfare State's handbook (Kershaw and Coult 1983) provides an illustration of how much training for community artists has changed. This paperback book was a 'bible' to many community artists, inevitably well-thumbed and giving them direct instructions on not only how to produce work and events but providing the opportunity and tools to critically reflect on their work. Currently, specialist community arts training is delivered through a wide range of methodologies, including online learning, live laboratories, single modules, apprenticeships, peer-to-peer learning, and mentoring; there is a competitive market, with competing training and academic providers offering a variety of bespoke experiences: a long way from the handbook method.

In a world of portfolio careers, the distinction between the different sectors is less clear, and it is not uncommon for community artists to be involved across public, private, and voluntary sectors. Sandra Hall at Friction Arts explains how 'on the job' training is still critical for community arts organizations:

> we have always tried to create opportunities where people can learn from us. It helps us challenge how we work and how we explain our practice. We encourage people to share stories about who they are and how they have reached this point. These stories are so useful both in terms of us learning from each other's

experiences but also in encouraging newer community arts workers to think about what they do know rather than what they don't.

There is also often an international dimension to training; for example, the 'Residency' project involving staff from Staffordshire University, Warsaw University, and the University of Barcelona that 'embarked upon delivering artist residencies in Poland, Spain, and the UK, each involving an artist from a partner country which explored a model of learning that associated community artists with civic engagement issues'.[7] Both Hall's experiences and ours have emerged from closer relationships between educators, communities, and arts organizations.

The shift towards a more specialized approach to community arts has, therefore, placed training at an important crossroads. The desire to be accepted by mainstream organizations and to professionalize roles has led to the formalizing of training for community artists and many believe this is linked to improvements associated with quality practices within the different sectors within which artists now work. Competition for work in the sector has, therefore, driven the demand for qualified practitioners from commissioners and employers, so the supply of these qualifications has increased. Some feel that it has also enabled community artists to have the skills to develop portfolio careers, which are essential given current economic challenges although there is also cynicism as to whether such claims are realistic. There is a concern that the focus on training and new approaches has inevitably contributed to the depoliticization of community arts. There are those who believe that unless community artists' training is affiliated to the more radical values and practices associated with the Community Arts Movement of the 1970s, the sector will lose any ability to offer specialist arts skills alongside the ability to challenge and react to the oppression and injustices facing the communities within which they are based. There is, however, no necessary link between the drive to accreditation and the depoliticization of training. Although the agenda around the development of more formalized education has been driven by the needs of employers as much as those of students, the evidence would suggest that critical practice is alive and well in many participatory arts courses. In fact, it could be argued that by situating many courses within higher education, it ensures that students will continue to have a broad and critical understanding of the issues that drive the work, as critical educational practice is a vital part of all study at this level. Either way, this question will not go away and the dangers of co-option about which Kelly warned us forty years ago remain as vital a part of the discussion today.

Current training and educational routes into community arts

To conclude our review of the issues impacting training and educational routes into community arts, we assess current training and education opportunities to consider how the debates around community arts training and education have shaped what is now available to anyone interested in learning more about community arts. PHF's ArtWorks programme, which was established in 2011 after three years of extensive research, provides one of the first comprehensive studies into the training needs of participatory artists (including community artists) in the UK.[8] PHF's aim was to consider how training for participatory arts across the sector could support artists and also help them to sustain the work in the long term. As part of this three-year project, ArtWorks embarked upon a range of action research projects designed to explore the notion of training, education, and professionalism. The fact that the ArtWorks research was commissioned indicates an increased recognition of the work and needs of the community and participatory arts workforce. However, it is also indicative of a move towards training, education, and professional standards being defined more by the needs of funders and commissioners rather than the experience of practitioners. In 2012, ArtWorks commissioned a survey to map training initiatives in higher and further education.[9] What this revealed was that, although there were few courses at undergraduate level or below that focused solely on participatory arts, there were many that had introduced opportunities in existing arts courses for students to either study or practice community or participatory arts through placements or practice-based modules.

> There is a groundswell of documented, anecdotal and stakeholder evidence to indicate that a number of institutions are at varying stages of working towards refocusing and revalidating their courses to provide a clearer vocational grounding for arts students interested in beginning a 'portfolio career' incorporating work in participatory settings.[10]

This implies that, although the numbers of specifically participatory arts degrees and courses may be reducing, the numbers of arts and creative programmes, which reference or include elements of participatory arts practice may be on the rise. This tendency is further supported by the publication of the revised benchmarks for institutions validating degrees published by the Quality Assurance Agency (QAA) for higher education in 2015 which specifically reference 'applied, participatory and socially engaged arts' for the first time.[11]

Since the research was completed, the basis of funding for higher education has changed in the UK with the introduction of fees paid directly by students. This has had the effect of squeezing available resources even further, which has had considerable impact on the provision of postgraduate education leading to the closing of a number of community or participatory arts courses at this level. There are several reasons for this, according to a rare mainstream report in the British media on community arts training, ranging from colleges' lack of resources to their high staff turnover, 'which makes it difficult for institutions to build lasting relationships with the local community'.[12] But this only explains part of the problem. While it is true that the motivation to broaden the curriculum has been reduced as institutions compete for fee-paying students and strive for better results and higher positions in the league tables, it could be argued that tertiary education was already fighting an uphill battle against a sector that had traditionally been sceptical about its role in training. Mark Webster, one of this chapter's authors, had already highlighted the cynicism of the community arts sector towards institutions of higher education and the resistance of employers to engage with courses (Webster 2008). Nevertheless, there continues to be a range of courses for people interested in using a specific art form to work with communities, most often found in specific sectors such as applied drama or community music.

Training and education through employer and commissioner-led opportunities still appears to be buoyant, and the growth in apprenticeships, including degree apprenticeships demonstrates the popularity of this approach to learning. These courses often provide opportunities to better understand the objectives set by the organization or agency buying the artist's services and to acquire skills and competencies that will ensure the artist can adhere to the occupational standards required in the setting within which the work will be undertaken. For example, there are opportunities to acquire operational skills in areas such as health and safety and safeguarding. The National Alliance for Arts, Health and Wellbeing, which is representative of regional arts and health agencies, offers its members training and education and benchmarks to help artists develop their practice.[13] Voluntary networks such as NCVO offer a range of practical advice about community work more generally though sometimes specifically focus on community arts.[14]

Apprenticeships in community arts still exist though they bear little resemblance to the Gulbenkian scheme of three decades ago. Anyone over the age of sixteen and out of full-time education in England can apply for a community arts apprenticeship, which takes up to four years to complete and

offers young people a chance to 'learn on the job' and get paid.[15] The scheme places the apprentices in host organizations rather than working directly with freelance community artists and the emphasis seems to be on administration skills rather than creative techniques, or on managing the work rather than creating it. Preliminary work that has been undertaken by Creative and Cultural Skills, the sector body for the creative industries, to establish the apprenticeship context[16] shows that community arts can be considered as a career option – something which would have been unheard of in the 1970s and 1980s.

The final strand of current community arts and education training relates to opportunities created within an academic research environment. Initiatives such as the *Cultural Value Project*, funded by the Arts and Humanities Research Council (AHRC) aim to identify the various components that make up the cultural value of creative activities and to develop methodologies and evidence that might be used to evaluate these components of cultural value.[17] Although not the primary function of such research, schemes like this offer opportunities to engage in training in a research environment, while often simultaneously creating learning materials to help future practitioners. Also from the AHRC, the *Connected Communities* programme aims to achieve 'new insights into community and new ways of researching community that put arts and humanities at the heart of research and connect academic and community expertise' by addressing a number of core themes, one of which is participatory arts.[18] Directly and indirectly, these research opportunities pave the way to establish new approaches to community arts work as well as validating work, which has already taken place through reviews and retrospective analysis.

Future trends and conclusions

As in the 1970s and 1980s, periods of economic uncertainty and social unrest are when community arts thrive, and such experiences often give birth to new, alternative solutions and new perspectives and activities associated with learning, teaching, and training. Community artists in the 1970s and 1980s were calling upon educators to help develop a community arts workforce and this led community arts-related training and education to feature in the curriculum of education providers in tertiary education. In 2016, new technologies, diverse workforces, and research into community arts training have enabled community artists to adopt more collaborative learning models in which they are able to direct their own learning. From impact hubs to collaborative

workspaces, learning and education is being deconstructed by the community arts workforce and increasingly is associated with Freirean approaches to non-hierarchical learning and championing approaches whereby community arts workers can learn from each other rather than having to call upon an 'expert'. The hierarchical and often patriarchal structure dominating higher education is, therefore, under close scrutiny, as increasingly the role of the teacher and learner becomes interchangeable.

In some ways, it could be argued that despite attempts by institutions, commissioners, and the profession itself to develop and consolidate common approaches to training, the terrain for community arts training is as vibrant and diverse as it ever was. Even if we know more now than we did in the 1970s about what might constitute training or good practice, it seems that no one solution or unifying aim is going to unite the 'profession' into adopting a universal-training approach.

Since the 1970s and 1980s, initiatives such as ArtWorks and the work of professional bodies such as the Foundation for Community Dance[19] and SoundSense have helped community arts workers to be identified as a workforce. They have consulted with community artists and lobbied to ensure their training needs are clearly defined, as well as offering collective support and a professional affiliation to many freelance arts workers. While some workers still choose to be driven purely by political and social goals, many have been forced to adopt a more conventional, career-orientated approach to their work. On the positive side, this reflects the rise of a much more diverse and representative workforce than was ever the case in the 1970s and 1980s, and one that arguably values a more professional ethos and the recognition that this professionalization brings.

So, the debate has moved on – or has it? In 1984, Owen Kelly warned of potential takeover bids if the Community Arts Movement did not produce an accepted definition of community arts (Kelly 1984). Inevitably, Kelly's eyes were set firmly on the arts establishment and the organizations that he believed perpetuated its values. Without doubt, the inability to establish a definition of community arts, which also incorporated a commitment to social change or even social justice, did mean that in the 1980s and 1990s we saw arts organizations expanding their operations and vision to incorporate participation, quite often under the guise of audience development and they did not necessarily share a similar commitment to the social goals of more established community arts organizations. Some have argued that this illustrates that Kelly's warning has, in fact, come true. Others argue that the debate about definitions is largely redundant as the arts sector has merged with many other sectors and areas of social policy, and organizations

are now required to understand and report on the social, health, or educational impacts of their work. Nevertheless, even if the takeover bids have already taken place and community arts workers feel restrained by the needs and interests of the organizations they now work with and for, this chapter has demonstrated that the Community Arts Movement has established a robust legacy in terms of resources, experiences, networks, and evidence to help nurture the community arts workforce. This will not disappear; it can only grow and be used to ensure community arts workers feel supported and confident in their work to support communities.

Notes

1 A decision was taken to close the course in response to the changing needs of the community arts sector. Fewer community artists had access to funds and free time to enable them to participate in postgraduate study. We recognized that there were alternative learning models, which could be built into research, projects, and community-university partnerships, which were more relevant and achievable in the current climate.

2 Soundsense describes itself as 'the voice of community music'; http://www.soundsense.org/metadot/index.pl (accessed 3 June 2016).

3 http://unesdoc.unesco.org/images/0000/000017/001790EB.pdf (accessed 27 October 2016).

4 Research undertaken at Staffordshire University to investigate the viability of setting up an undergraduate degree course in community arts revealed that courses with community arts or related terms in their title often struggle to recruit students. Many institutions at the time of the research supported the development of option modules or placements in participatory approaches geared to towards students who developed an interest in community arts. Our findings were further supported by research undertaken through the Paul Hamlyn Foundation's ArtWorks' programme in 2012 that indicated that participatory approaches to art forms have survived in the FE and HE sector usually in the form of options or placements embedded into creative courses and often as the result of individual members of staff who have an interest or experience in participatory arts.

5 Plum Films (2013) *Arts The Catalyst. The Craigmillar Story*, https://vimeo.com/52005912 (accessed 15 December 2016).

6 'Community Arts Training 1981/82' (North West Arts Panel and AfCA) [V and A Theatre and Performance Archives, Arts Council of Great Britain Records 1928–1997: London].

7 http://residencyproject.eu/about-us/ (accessed 19 July 2016).

8 Paul Hamlyn Foundation (2016) Programmes. Available from http://www.phf.org.uk/programmes/artworks/ (accessed 19 January 2016).

9 Paul Hamlyn Foundation; Art Works, 2012, Mapping the Terrain: Higher Education and Further Education – Supporting Artists to Work in Participatory Settings.

10 Ibid.

11 http://www.qaa.ac.uk/en/Publications/Documents/SBS-Dance-Drama-Performance-15.pdf (accessed 15 December 2016).

12 Louise (2013).

13 http://www.westmidlandsartshealthandwellbeing.org.uk/be-reflective.html (accessed 20 June 2016).

14 National Council for Voluntary Services (2016) Practical Support. Available at https://www.ncvo.org.uk/practical-support (accessed 19 January 2016).

15 https://www.gov.uk/guidance/community-arts-apprenticeships (accessed 5 June 2016).

16 *Creative and Cultural Skills* (2016). Available at http://ccskills.org.uk/ (accessed 19 January 2016).

17 *Cultural Value Project* (2015). Available at http://www.ahrc.ac.uk/research/fundedthemesandprogrammes/culturalvalueproject/ (accessed 19 January 2016).

18 https://connected-communities.org/index.php/about/ (accessed 15 December 2016).

19 Community Dance (2016) Available at http://www.communitydance.org.uk/ (accessed 19 January 2016).

References

Alinsky, Saul, D. 1989. *Rules for Radicals* (Vintage Books: New York).

Arts Council of Great Britain. 1984. *The Glory of the Garden. The Development of the Arts in England* (Arts Council of Great Britain: London).

Badder, Alan. 1983. 'Alinsky Tactics', in *Friends and Allies. The Report. Salisbury, 22–24 April 1983*, 6 (The Shelton Trust: London).

Brooks, Rod. 1988. *Wanted! Community Artists* (Calouste Gulbenkian Foundation: London).

Buston, John. 1978. *Notes on Meeting between John Buston and CNAA (11 July 1978) to Discuss Creative Arts Courses with Community Arts Content/Option (ACGB/113/3)* (V and A Theatre and Performance Archives, Arts Council of Great Britain Records 1928–1997: London).

Buston, John, and Helen Burge. 1978. *Community Arts Training Proposal. Community Arts Committee (ACGB/113/3)* (V and A Theatre and Performance Archives, Arts Council of Great Britain Records 1928–1997: London).

Buston, John, and Robert Hutchinson. 1976. *Training for Community Artists. A Paper for the Community Arts Evaluation Committee (ACGB/113/3)* (V and A Theatre and Performance Archives, Arts Council of Great Britain Records 1928–1997: London).

Community Development Foundation. 1992. *Arts and Communities. The Report into the National Enquiry into Arts and the Community* (Community Development Foundation Publications: London).

Crummy, Helen. 1992. *Let the People Sing. A Story of Craigmillar* (Helen Crummy: Edinburgh).

Dorney, Kate, and Ros Merkin. 2010. *The Glory of the Garden: Regional Theatre and the Arts Council 1984–2009* (Cambridge Scholars: Newcastle).

Freire, Paulo. 1996 [1970]. *Pedagogy of the Oppressed* (Penguin Books: London).

Hiles, Marzenna. 2016. 'What Really Matters to Undergraduates on Creative and Media Courses: UK Study into Student Voice', *Journal of Media Practice*, 17: 21–27.

Illich, Ivan. 1981. *Deschooling Society* (Pelican Books: London).

Kelly, Owen. 1984. *Community, Art and the State. Storming the Citadels* (Comedia).

Kelly, Owen. 1984. 'Training Definitions and Power', in *Another Standard*, 26–27 (The Shelton Trust: London).

Kershaw, Baz, and Tony Coult. 1983. *Engineers of the Imagination. The Welfare State Handbook* (Bloomsbury: London).

Louise, D. 2013. Why are universities scrapping their community arts projects? *The Guardian*, 5 May, http://www.theguardian.com/education/2013/may/02/why-are-universities-scrapping-their-community-arts-projects (accessed 20 June 2016)

Mailout. 1986. 'Lessons from America?' *Mailout*, n.p, September.

Matarasso, François. 2013. '"All in This Together": The Depoliticisation of Community Arts in Britain, 1970–2011', in Eugene Van Erven (ed.), *Community Art Power. Essays from ICAF 2011* (Rotterdams Wijktheater: Rotterdam).

Webster, Mark. 2008. 'University Challenge', *Mailout*, 20–21, June/July.

Webster, Mark, and Glen Buglass. 2005. *Finding Voices. Making Choices* (Educational Heretics Press: Nottingham).

From Community Arts to the Socially Engaged Art Commission

Sophie Hope

Introduction

Some of the tangled roots of contemporary socially engaged art can be found embedded in the complex histories of community arts in the UK. It is therefore worth recalling the criticisms made by community artists about the implications of their professionalization back in the 1970s and 1980s. In this chapter, I consider contemporary commissioning practices of socially engaged art alongside observations that Su Braden (1978) and Owen Kelly (1984) made about the depoliticization of community arts through 'grant addiction' and the dangers of professional artists 'taking the arts to the people'. I begin by recapping on why community arts by the 1980s was criticized as becoming increasingly professionalized. I then introduce five recent commissions to illustrate the ongoing fluidity and complexities of artists working with others by focusing on the role the 'aesthetic third', intersubjectivity and uncertainty play in structured, funded projects. I conclude by reflecting on the implications of professionalization on the form and content of contemporary socially engaged art practices in relation to what went before.

Contemporary socially engaged art can be characterized as artist-led, non-object-based encounters, performances, and collaborations with others. A contested term, it has its roots in conceptual, performance and community arts, radical theatre, critical pedagogy, and community activism and is linked to definitions used in the United States such as, New Genre Public Art (Lacy 1994; Kwon 2002) and Dialogical Aesthetics (Kester 2004). The name has been around since at least the early 1980s, when in 1982 the Australian journal *Art Network* included a special supplement on 'Aspects of Socially Engaged and Community

Art' in which the editor stated: 'Community arts practice cannot afford to dissolve itself into a perpetual process of participatory social therapy' (Dolk 1982). Both Australian and British arts councils had been funding community arts since the early to mid-1970s leading to criticisms of established, top-down approaches by the early 1980s (Baldry 1974; Braden 1978; Kelly 1984; Hawkins 1993). The term 'community arts' became less popular in the UK and, by the mid-1990s, socially engaged art as a label was becoming more prevalent. The socially engaged art commission became normalized as a means for artists to sell their services for a fee, framed by the political shift in cultural policy which turned towards social inclusion agendas and forms of participatory democracy during the New Labour years of 1997–2010.

An artist's commission takes the form of a written or verbal contract between an artist and organization based on a proposal made in response to a brief written by that organization. The usual model for commissioning socially engaged art is for the organization, acting as the commissioner, to allocate funds to a particular project they want to carry out. The commissioner writes a brief outlining the aims and objectives of the project, the context, timescale, and budget and how they are inviting artists to respond (some briefs are more open than others). Depending on the curatorial approach, an artist might be invited directly to make a proposal in response to that brief, others may put out an open call. There are different approaches taken as to the selection of artists, it could be a curator's decision or there may be a steering group made up of stakeholders who interview short-listed artists and reach consensus based on a shared set of criteria (Cartiere and Hope 2007; Cartiere and Willis 2008).

While community or socially engaged artists might embrace fluid, overlapping, and messy encounters, the commission as a semi-visible frame is defined by funding, timescales, agendas, and expectations. These frames, over time, might be ignored, taken for granted, pushed against or refused. I want to explore here the interactions that take place in relation to that frame. Lynne Froggett et al. refer to 'scenic understanding' as an approach in psychosocial research where the actors, including the researcher are mutually influencing and related to one another (Froggett et al. 2011: 28, 29). My starting point is an acknowledgement of the need for complex, nuanced understandings of what happens in that frame or scene. Although people may all be working towards a clear, shared goal (e.g. a mural, campaign, play, exhibition, performance), there are inevitable, perhaps invisible power relations being played out which influence and respond to what occurs.

The terms 'community arts' and 'socially engaged arts' are formed and constructed through the conditions in which they were/are practiced. It would

be wrong to assume that all community art pre-1980s involved grass-roots initiatives and that subsequent socially engaged art only comes about through top-down commissioning processes. The potential problems of commissioning socially engaged and community art practices were already being played out by the late 1970s. My understanding of current approaches to socially engaged art practices stems from sediments of experience and experiment built up over time. Influences might be more embodied and tacit, passed on over generations through observation, informal teaching and conversation. Because of the lack of visible histories of community arts, certain examples become key reference points (e.g. the work of Suzanne Lacy, Allan Kaprow, Artists Placement Group, or Joseph Beuys), while other cultural activities slip further into oblivion. While the conditions from which socially engaged and community arts emerge are varied and context-specific, I argue that there is a thread that runs from the 1970s and 1980s to today: that is the continuing questioning of the political and financial framing of these practices.

In order to understand contemporary socially engaged art practices, I look at the scaffolding that surrounds the practice and the felt/experienced aspects of practice itself. I try to bring the practice (relational, dialogical, experiential)

Figure 10.1 Parachuting in

to the fore in an attempt to weave a dialogue between the realities of money and the poetics of practice in these contexts. Alana Jelinek reminds us to be wary of false claims of openness and being distant from commerce when 'in reality we are operating to police the boundaries of our practice' (Jelinek 2013: 106). This is an honest debate about those larger processes of production, distribution, reception, and consumption of which we are part and parcel.

Historical context: Critical voices of commissioning

Looking back at the debates surrounding community arts in the 1970s and 1980s allows a glimpse into an already fraught terrain which was battling with issues such as 'creative equality' between artists and communities, parachuting in artists to 'deprived' areas, questions of how funding was raised, the institutionalization of community arts through education, and the depoliticization of community arts with increasing funding addiction. In 1978, community artist Su Braden's Gulbenkian-funded research was published, which compared the practice of 'artists who were placed by funding bodies in new social contexts' with that of artists who had set up situations themselves. She referred to the gap between the concepts of the funding bodies and the artists who have set up their own residencies: 'This difference can be summarized in the conflict between the notion of popularizing art and the notion of artistic democracy' (Braden 1978: 113, 114).

> An artist 'placed' in a new context appears all too frequently to feel the job in hand is to take his or her art to the people, with the consequent expectation of a response or degree of participation that is based on a relationship between 'professional' and 'amateur'. (Braden 1978: 108)

Braden was aware of the dangers of an increasingly professionalized, short-term, project-based approach to commissioning community art and highlighted the lack of long-term funding, stressing that proposals should come from the communities themselves, rather than advertising for community artists to be 'placed' in communities (Braden 1978: 121). Braden wrote how contrived proposals relied on the 'unfortunate widespread view that community art can be prefabricated with a set of components' (Braden 1978: 123). Her study found that 'professional' artists responding to advertisements to work in deprived areas to 'animate' communities were rarely successful remarking that this was based on the confused misunderstanding of 'taking the arts to the people' and that 'the

causes of deprivation in such an area, apparent as they are, are ignored' (Braden 1978: 123). Braden preferred it if the artist was working in an area already, through a self-initiated project and then for the community to seek funding to keep the artist there. She stated how this required a new kind of long-term commitment from funders and suggested that one-off funding grants were both 'alienatory and temporary' (Braden 1978: 124). Later, Owen Kelly also suggested that 'raising funds collectively to pay for a community resource or activity can be a crucial means of raising the consciousness of those participating' (Kelly 1984: 125) and that fundraising was a 'vital part of community activity' rather than a 'separate and preceding chore' (Kelly 1984: 125). Kelly suggests 'our methods of organisation and our methods of raising money must be congruent with our cultural and political goals' (Kelly 1984: 126).

In the same year as Braden's publication, the first 'Art and Social Context' course was set up at Dartington College of Arts in Devon. Chris Crickmay, one of the founders, reflects on how the residency model they used 'required students to investigate and react to whatever they found – not just "weigh in" with a pre-formed idea. This was a "listening" model of art practice [...] starting with an "open brief" was the crucial factor' (Crickmay 2003: 125). He remembers that 'there was actually some determined resistance from many community artists to the idea of community arts being institutionalized through education' (Crickmay 2003: 124). He suggests that from setting up the course in the late 1970s, 'there has since been a profound re-configuration of the arts and an absorption into the mainstream of much of what we were attempting [...] many of the approaches to art that existed only as fringe movements when we began, have since become an integral part of official cultural policy' (Crickmay 2003: 131).

For one artist reflecting on the 1980s, community artists at the time were understood to be 'unemployed middle class people' and that by then there was concern over whether community art was 'working for working class people' (Anonymous 2014: n.p.). The increase in competition and need for validation by the funding bodies meant some community art workers felt the agenda was now being set by the funders rather than the practitioners or communities themselves. Arts officer at the Greater London Council at the time, Alan Tomkins, stated that 'many of the attempts to democratize "resources" have simply given an opportunity for the middle classes to increase their share and consolidate their ideological power' (Tomkins 1984: 22). Kelly was also concerned with the increasing professionalization of community art through what he called 'grant addiction' and lack of theoretical framework (Kelly 1984: 26). His critique was

that the 'liberal pragmatism served, early on, to cripple the political development of the community arts movement [...] we have become foot soldiers in our own movement' (Kelly 1984: 3). Community artist Karen Merkel also refers to the ways in which community artists were becoming more professionalized by the 1980s, that there was a 'journey from outsiders to activists to decision-makers' (Merkel 2009). As artists became more accountable, 'they had to become propositional, not oppositional', while they started off campaigning against things they now had to 'grow up' (Merkel 2009). Merkel also remarks how artists at this time were straddling practice and policy by being involved on funding panels and in their local authorities. Kelly points out this paradox as the desire for a 'liberating self-determinism' through art practice as cultural activism and the reality of artists as 'quasi-employees' of the state who in effect 'lessen the self-determination of those people with whom we worked' (Kelly 1984: 30). He notes that 'it is no longer their [the artist's] politics which inform their activities, but rather the politics of their employers' (Kelly 1984: 37). 'It was ceasing to be a movement of activists and beginning to become a profession' (Kelly 1984: 31).

While there was a rising criticism of the instrumental role community arts was playing, Ed Berman (Conservative politician Michael Heseltine's advisor in 1983) welcomed the professionalized status of community artist as service provider, stating that community art was the 'junior partner of the private sector – the partner with the public brief' (Berman 1983: 7–9). Investment in a commission could now be accounted for or justified in terms of savings in marketing, consultancy, or PR. This sounds all too familiar and is an ongoing quandary for any of us who are employed, contracted, or commissioned and begs the question: How do we avoid our practices being used as survival tools in an age of enforced austerity, a means of distraction, while the developers move in, or even as a direct means of delivering austerity and developer's agendas? As Gerri Moriarty asks: 'Does our work unsettle unequal power relations or does it confirm and support the status quo?' (Moriarty 2014).

Today's commissions are taking place within a different paradigm of power than the 1980s. Epistemological and ontological shifts in thinking about power has meant it is perhaps not so easily bracketed into binaries where there is a powerful force to be reckoned with. Power can now be considered to be something interwoven, inseparable, and constantly shifting. Commissioning is interlocked with instrumental agendas of private and/or public funders, which can be ignored and/or drawn attention to by those involved in the projects. The earlier concerns and criticisms of Braden and Kelly, however, are still relevant to contemporary practices, particularly

those that take the shape of a commission which in some ways has come to symbolize Berman's wishes for artists to be the 'junior partner of the private sector'. Seen as a string of fragmented short-term projects, socially engaged art has moved even further away from Kelly's dreams of a political movement of community artists.

Introduction to contemporary practices of socially engaged art

In this section, I introduce five recent commissions which reflect the legacy of the criticisms addressed above and the interim period which marked the normalization of parachuting in artists to 'deprived' areas due to funding agendas. As Kelly predicted, there is now a growing professional class of artists, curators, critics, and academics who are invested in the continuation of funding and that 'the final hurdle to the professionalism of community arts is training' (Kelly 1984: 37). We can see a manifestation of this in Paul Hamlyn Foundation's ArtWorks programme, which ran from 2011 to 2015 and sought to 'strengthen training and development opportunities for artists and develop a shared sense of excellence across the practice' (ArtWorks 2015). The ArtWorks programme reflects a recent move towards the professional development of a 'sector' with a 'code of practice' for those working in it. An ArtWorks working paper talks about the need to develop 'guidelines for [student] assessment to include best practice relating to reflection on process and product' (Mitchell et al. 2012: 73 in Kay 2012: 19). This marks a significant shift from the original pedagogical ethos of Dartington's Art and Social Context course towards the institutionalization of 'participatory' practices and seems to ignore the previous criticisms of Braden and Kelly, and some of these questions have already been taken up by Hetherington and Webster in Chapter 9.

The examples I look at here relate to a piece of research I carried out with Emily Druiff (director, Peckham Platform) in 2015 to map the timelines of five commissions with the artists, commissioners, participants, and collaborators involved in the projects. This resulted in a printed Social Art Map (SAM) illustrating the projects from these different perspectives (Druiff and Hope 2015). The projects we explored were: (1) an interactive installation at Peckham Platform gallery resulting from workshops with people living with learning disabilities and mental health challenges (*Money Distribution Machine* and *Other Useful Contraptions* by Kathrin Böhm commissioned by Peckham Platform with funding from University of the Arts, London, 2013–2014); (2)

a public performance on the pavements of Archway, London, about being seen where one dancer and one local person were watched by one audience member at a time through a shop window (*This Is for You* by Anna MacDonald, commissioned by Islington Council with AIR, Central Saint Martins, University of the Arts London, 2013–2014); (3) a play and film made with non-professional performers from East London (*Between You and Me* by Edward Thomasson commissioned by Chisenhale Gallery and Create, 2013–2014); (4) a mural exploring a history of the Becontree Estate in Dagenham (*This Used to Be Fields* by Chad McCail, commissioned by Create and Creative Barking & Dagenham with Arts Council funding, 2014); and (5) a series of workshops, collective educational activities, and installation on photography and labour with artists *Werker Magazine* and campaign group Justice for Domestic Workers (*Werker 10 – Community Darkroom*, commissioned by The Showroom's Communal Knowledge programme with funding from Mondrian, Paul Hamlyn, and Esmée Fairbairn Foundations, 2013–2014).

These five commissions are examples of short-term artists' commissions, each involving professional, paid artists being 'placed' in/with a particular place and/or group of people (only *This Is for You* resulted from an open call). In the case of *This Used to Be Fields*, the selection process was opened up to a panel of local residents, otherwise it was the curators/commissioners who decided who to commission. In the case of *Werker 10 – Community Darkroom*, the Showroom directly invited the artists' collective Werker. The starting point was not always the artists' practice, rather it might have been an issue (e.g. domestic workers' rights) or the decision to make a mural; but in each case, the brief for the commissions tended to match what the artists were already thinking about, rather than forcing their practice to fit the brief.

Across the five SAM case studies, there are different connections between artists and participants with most of the projects (apart from the Werker - J4DW collaboration) reflecting what Toby Lowe defines as 'Artist-authored participatory art' where 'an artist works with participants to realize a vision which the artist "owns" [... and] the participants contribute experiences and performances to help shape the content of the piece' (Lowe qtd. in Kay 2012: 9). This tallies with Froggett et al.'s observations that 'authorship may be distributed but most projects benefit from an artist-led desire for a strong aesthetic outcome' (Froggett et al. 2011: 105). Within the SAM cases, there were also elements of what Lowe calls 'Co-produced participatory art: activity that involves an artist working with participants to undertake a shared creative journey, for which the artist provides the initial inspiration and acts as a facilitator to enable participants

to explore their own ideas and creative experiences' (Lowe in Kay 2012: 9). In *Werker 10 - Community Darkroom*, for example, the dynamic between Werker, J4DW, and the Showroom was described by Louise Shelley, the curator, as a collaboration, reflecting the approach they take to finding 'common ground' and 'alliances' with the people they work with (Werker 10 2015). Werker also points out the way they work is as an opportunity for learning and exchange, building networks of solidarity and that they 'avoid hierarchical situations at all costs' (Werker 10 2015).

It is a complex mix of agendas and ideas which influence the process and direction of a project, despite the paid artist's name often being foregrounded. Hadrian Garrard (director of Create, one of the commissioners of *Between You and Me*) reflected that 'the best proposals almost always come out of someone you've had a conversation with [...] It's about the artists more than what they proposed' (*Between You and Me* 2015). For *This Used to Be Fields*, artist Chad McCail, for example, 'absorbed' the stories of local residents to design the mural through an informal process of learning about the history of the area; he says the 'onus is on me to listen to what people were saying and respond to what they really wanted' (*This Used to Be Fields* 2015). In these examples, there was often an acknowledgement of the expertise of the participants and an interest in the self-organized practices of amateur networks that happen alongside or among professional, paid labour, such as amateur drama clubs and worker photography movements.

There was also a question as to the endings of projects. While some links and relationships continue, the question was asked (by Anna Hart, organizer of *This Is for You*, AIR), how do we hold an ending? In the case of Werker 10, for example, there was not a clear ending. The two artists (collectively called 'Werker') remarked: 'we do not consider we are making an artwork that is closed and finished'; for their collaborators, J4DW, 'it's like an endlessly flowing river' and for curator Shelley, 'splinters and layers and other things build on top and out' (Werker 10 2015). In the other commissions, endings were more overt and there was discussion on the aftercare process. For the mural, there is a technical and logistical handover of the maintenance contract to the Council, for example, and for AIR, they were moving out of Archway and having to say goodbye to the area and the people they had worked with over the years. Zygmut Bauman in *Liquid Times: Living in an Age of Uncertainty* refers to the unending project-to-project experiences of a fragmented existence and the difficulty of taking time to stay still, 'solidify', and commit. This is often the situation of the organizations, artists, and participants who adapt to the next project, hand it over, and move

on. Garrard, for example, reflects on how Create wanted the chance to do something long term without the pressure of presenting something publicly. For the Showroom, it is sometimes difficult to carry on working with one artist on an ongoing collaboration, although Shelley and Werker continue to work with and support J4DW. For Böhm, there was a move during *Money Distribution Machine* away from producing a long-term strategy involving a social enterprise towards putting on a temporary exhibition. This was due to the circumstances of their community partner changing and the closure of the centre due to withdrawal of funding for that service. While the closure of the centre meant a longer-term collaboration was not possible, Peckham Platform embedded their work on mental-health issues in their mission and business plan. While thought patterns, tacit learning, and friendships might flow over into the next assignment, the conditions of endemic uncertainty continue to be the norm. The stresses and strains public sector organizations are under as they are forced to restructure or close was reflected in the projects we looked at. There are different pressures, approaches, and concerns over how to secure and allocate funding, for example, who gets paid and for what, when various sets of expertise are acknowledged as being necessary for a project to happen.

There are both continuities and interruptions in the life of an organization, project, and commission. Unforeseeable and erratic interactions swim among the more rigid structures of funding deadlines and formalities of authorship. While these commissions take on the forms critiqued by Braden and Kelly over thirty years previously, the relationships between people, place, and the structure of a project are not always a comfortable fit as different agents jostle to find their purpose.

The 'aesthetic third', intersubjectivity, and spaces of uncertainty

In this section, I go into more depth to explore the detail of these commissions in order to understand the interplay between artists and others. I want to get to grips with the nuances of interactions that might provide a link to previous community arts practices and critical discussions on the ways in which socially engaged and community arts projects are framed and understood. In particular, I look at Froggett and colleagues' notion of the 'aesthetic third' and Kester's writing on intersubjectivity to explore the contradictions in the commissioning process. I add uncertainty to this as one of the conditions of current commissioning practices, which perhaps helps to undermine or at least question the certainty

and formalities of the commission itself and links back to the resistance towards formalized, top-down commissions in the 1970s and 1980s.

Lynne Froggett and colleagues, in their research for New Model Visual Arts Organisations (2011), identify the transformative potential of socially engaged art in the 'aesthetic third', a notion they use to describe a third object between artists and others that can be shared (Froggett et al. 2011: 92). This aesthetic third 'resonates in the body and mind' of those who share it but also exists independent of them – 'it has a life of its own that can be put to use' (Froggett et al. 2011: 94). Similarly, Grant Kester has explored the dialogical aesthetics of socially engaged art, which 'requires that we strive to acknowledge the specific identity of our interlocutors and conceive of them not simply as subjects on whose behalf we might act but as co-participants in the transformation of both self and society' (Kester 2004: 79). He describes this as self-critical participation in a conversation or practical event that opens up the possibility to empathize with others in a way that may shift one's own perspective and experience. The space of art, he states, is where certain questions and critical analyses can take place that would not be tolerated elsewhere (Kester 2004: 68). Taking Bakhtin's notion of the work of art as a conversation, Kester develops a case for dialogic art that goes beyond avant-garde aesthetic criteria based on criticality, disruption, and rupture and instead looks at the transformative potential of an aesthetics based on reciprocity and collaborative encounters. The commission becomes a site of investigation, reflection, and action, a 'common' ground for 'intersubjective communication' (Kester 2004: 68). These intersubjective encounters are communicated between people (verbally or though non-verbal practice) and may result in people changing their minds, direction, or reaffirming their behaviours.

There may be multiple moments of 'aesthetic thirds' and intersubjective encounters in a socially engaged art project which are hard to capture and replay. J4DW's collaboration with *Werker Magazine*, for example, involved the artists less as directors than providers of methods for the campaigners to evolve, map, and distribute their work. The 'aesthetic third' could be understood as the Living Archive composed of photos taken by the domestic workers of their place of work. These images then became the space for intersubjective communication through a process used by Werker called Bilderkritik where the group, along with other activists, friends, and students take the images and analyse them collectively.

A characteristic of intersubjectivity and the 'aesthetic third' worth highlighting is that of uncertainty. This ambiguous space can be both an

attraction and aversion to people; a draw to experience something new and a repellent as it implies potential embarrassment, humiliation, or shame. Such uncertainty of what something entails and not knowing what expectations are placed on us can lead to a sense of anxiety. Walker and colleagues' general definition of uncertainty is 'any deviation from the unachievable ideal of completely deterministic knowledge of the relevant system' (2003). I have found Brugnach and colleagues' (2008) ideas about uncertainty that have emerged from the field of water management very useful in this context. They build on the work of Walker and colleagues and work towards a 'relational concept of uncertainty'. They explain the difference between 'epistemic uncertainty' being the imperfection of knowledge about a system (that there is more to know), and 'ontological uncertainty' which refers to the inherent variability or unpredictability of the system itself. Ontological uncertainty acknowledges the situated, partial, and subjective aspects of knowing. They add to this 'ambiguity', as ranging from unanimous clarity to total confusion caused by too many people voicing different but still valid interpretations (Brugnach et al. 2008: 4). While their field is water management, the principles of uncertainty they describe resonate in the socially engaged art commission where the frame of the project is interpreted differently, influencing how a situation is understood (Brugnach et al. 2008: 3) and shaping an interactive process. The situation itself may be inherently uncertain; it may also be unpredictable and chaotic. One might not have the knowledge to understand it and/or there might be different, conflicting ways of grasping it. These experiences of uncertainty can all be happening at the same time, making the 'aesthetic third' charged with mixed emotions. There are, however, distinct hierarchies of uncertainty and as Jelinek suggests, art has its own assumptions and 'knowledge forming discipline', the boundaries of which are policed. Knowledge of those boundaries and the knowledge used to justify and describe it are not equally available at the outset of a commission.

During *This Used to Be Fields* the mechanics of making the mural became a democratizing process (curator Mareijke Stedman in *This Used to Be Fields* 2015). Certainty over the final product 'cleared so much awkwardness and pretentiousness when we're communicating with people locally ... [it] cleared the decks for talking about ideas' (*This Used to Be Fields* 2015). The mural, as the aesthetic third, was the physical form the dialogic encounters took, and because of the technical aspects of making it, this drew in people that perhaps a more conceptual intervention would have alienated. There was a common goal which meant the painters were invested in getting it done. While this may come across

as people working to complete the visions of the artist, there is a mix of motives, rationales, and exchanges that occur in the space that complicates the simplistic version of one person wielding all the power over the others. The fixed goal of the mural allowed more uncertain approaches for local history to unfold. Stedman talked about how it was important to keep 'complicating a potential history of the area' by talking about histories in the plural. By dealing with gossip and rumour, the mural was about challenging the straight line of history, incorporating multiple politics, views, and memories. The result is partial with no one version of history highlighted over any other.

The conditions in which we encounter something familiar or unfamiliar might influence our relationship to it, such as knowledge of others involved, trust in an aspect of the scenario (knowing the place/people), the tone and language in which something is introduced, also the weather and how we feel that day. In an ArtWorks working paper, it is acknowledged that when making artwork in participatory settings 'playing with contradiction, collapsing boundaries and "holding" ambiguity (often for long periods of time) are familiar and commonplace' (Kay 2012: 22). Similarly, Froggett and colleagues found that socially engaged practice can create spaces and opportunities for new things to happen and that 'creating without preconceptions means fostering conditions rather than producing the object or situation, and tolerating uncertainty and indeterminacy' (Froggett et al. 2011: 95). They refer to how the arts often produce anxiety and that socially engaged art 'deliberately seeks to "make strange" the everyday, proposing that people look at what they take for granted in new ways' (Froggett et al. 2011: 97). In their study, they found that the organizations they looked at 'generally sought to deal with this situation by creating the conditions in which anxiety is rendered tolerable – for example through relational context, information, familiarisation' (Froggett et al. 2011: 97).

There are no straightforward desire lines between certainty and uncertainty, rather the commissions might create a space to sit with and share that uncertainty. Indeed, it is the uncertainty that might ignite interest in the first place. During *This Is for You*, for example, dancers touch the pavement with their hands and bodies, while a local performer brings an activity usually hidden into the street – the feeding of a child, the cutting of a key. These performances in the everyday context of the street are watched by one audience member from a converted shop window and others passing by. The 'aesthetic third' in this context, could be the form of the performance for one, with one watcher describing the feeling of being 'removed from but still in the world', and another reflects on the feeling of being connected to others in contrast to the 'anonymity and occasional dangerous

feeling of a modern city street' (AIR 2013). The performance culminated in the watcher receiving a phone call to ask how they want the performance to end, 'thus reducing the anxiety of contingency. It made people feel less like they were at the mercy of events' (MacDonald n.d.). The space held between watcher and performers is fragile and interspersed with the everyday sounds, smells, and movement of the street, as one of the watchers reflected: 'I felt for her [...] on London's streets, dirty and impersonal, I worried for her in case she might bump someone or be taken the wrong way by a passerby' (AIR 2013). Intersubjective communication did not happen verbally face to face but through watching and being watched over a distance. Both performers and watcher were being witnessed by passers-by, with the watcher becoming a performer in the process – 'I look into the landscape of the busy Archway community of people [and] it becomes clear to me that in my seeing I am seen' (AIR 2013). As the street became the scene, the watchers observed the interactions and avoidance tactics of the other people in the street. At the end of the performance, as one of the performers danced off into the distance, this intersubjective encounter was pushed further, imbued with emotion and significance as the relationship between them ended: 'as my dancer faded away I had a profound sense of loss and I wept because I was moved' (AIR 2013).

In the SAM case studies, there are inherent (healthy) contradictions in the processes being described, for example, between holding the uncertainty and being clear; between nothing being prescribed and having a clear goal. There is also a sense of push and pull between working to a brief and having an intuitive, responsive approach. It is perhaps in the spaces of uncertainty or unfamiliarity in these otherwise quite crowded commissions that we find complex intersubjective encounters loaded with trepidation, conflict, and unease, where people are trying to read each other, coax each other, and support some kind of interaction. Anna Macdonald, the artist behind *This Is for You*, has written about the psychoanalytical model of containment where the mother supports the child's needs while containing difficult parts of their experience – 'its rage and anxiety'. This relates to Winnicott's (1971) concept of 'holding' which involves 'chaotic, disorganised thoughts, feelings and sensations' being contained and therefore processed and 'rendered intelligible' (Froggett et al. 2011: 91). Macdonald suggests that 'it is the containing effect of the ending of *This Is for You*, that plays a role in releasing people's anxieties around loss, prompted, perhaps, by the ephemerality of the city'. The frame of the performance protects them by 'allowing them to feel safe enough to feel' (MacDonald n.d.).

While funding and reporting agendas might require evidence of certainty, Anna Hart and Tilly Fowler (creative producers and organizers at AIR, co-commissioners of *This Is for You*), encourage artists to work in new ways; they think of what they do as a testing ground for developing a public practice and for Anna MacDonald, they 'held the uncertainty' (MacDonald n.d.). This brings us back to the aesthetic third which 'detoxifies' strange unsettling experiences that it also evokes (Froggett et al. 2011: 97). However, rather than romanticize the concept of uncertainty, Anna MacDonald also spoke of the experience needed to cope with the uncertainty of improvisation, which was required of the professional dancers she worked with. This also relates to one of the rehearsal workshops for *Between You and Me* when the tap dancing teacher encouraged those attending to improvise but, as one of the participants noted, 'we weren't at that stage of confidence to want to do that' (*Between You and Me* 2015). To enter into a space of uncertainty requires safety, support and experience, some kind of structure, frame or safety net to hold inexperience takes the edge off the uncertainty. Richard Thomas, one of the local performers in *This Is for You*, explained how getting involved was a 'challenge for myself really, [to] step outside the box' (*This Is for You* 2015). This was perhaps made easier because he knew Anna and Tilly and was used to working with artists from the art school Byam Shaw, who used to come into his ironmonger's shop. For J4DW, working with artists meant 'we began to be more creative' and able to value and make visible their own work that is usually hidden (Werker 10 2015). This was possible because of the relationship they had built up with Louise Shelley and Werker based on trust and mutual respect. This exchange of ideas was a learning process for Werker, Shelley, and J4DW. For Shelley, for example, working with J4DW 'opens up blind spots we haven't acknowledged in our thinking' (Werker 10 2015). Uncertainty, then, comes with safety, trust (gaining and understanding and knowledge of each other takes time to work out), and an acknowledgement that not all encounters with uncertainty are equal.

This kind of uncertainty mixes curiosity with a coercive encounter in which one is unsure where the power lies. Spaces of uncertainty may be attractive to those with some degree of certainty to fall back on, but when uncertainty becomes the norm maybe it is some semblance of certainty that is craved? The embedding of ethical, political commitment into an artists' or organizations' approach/methodology is one way of doing this, such as mental health becoming embedded in Peckham Platform's approach and domestic worker rights continuing to inform the work of Werker and Shelley from the Showroom. Uncertainty, embraced by some as a fundamental ingredient to

opening up a process, is also 'managed' through resilience and risk aversion. The normalization of uncertainty (not knowing where the next payment will come from or who you can trust) comes with a paranoid sense of increasing individualization, competition, and pressure to learn the complex skills of adaptation and 'bouncebackability' (Evans and Reid 2014: xii). With the onset of formalized commissioning processes, there are still plenty of unexpected and uncertain encounters that influence the direction of a project. The projects here do not challenge the structures of the commissions, rather they produce mini-worlds of intersubjective encounters. While these micro-relational aspects of uncertainty might be shared across the time zones and geographies, the political and economic conditions in which they are framed are very different. A renewed critique of these conditions is, I would argue, much needed.

Conclusions

The critiques of the 1970s and 1980s made about community arts are still relevant today when one-off funding grants have become the norm. These commissions are constructed formulations of vested interests and accidental encounters that rely on negotiations and opportunities. The SAM case studies reflect complex intersubjective experiences where people at all levels of the supply chain are defining their own sense of agency and co-dependency. The journeys these projects take are messy and fraught with unequal, shifting power relations. The frameworks for a 'project' constructed by artists, curators, commissioners, and/or funders, necessarily change, morph and are challenged as people leave, participate in ways that were not expected or take things off in a different direction without asking. While commissioning frameworks create limited timeframes, objectives, and targets, the messiness of the uncertain process of interaction continues. This perhaps goes some way to explaining why subtle, playful provocations within some commissioned socially engaged practices today are more present than attempts at radical ruptures from the system that may have been attempted in the past. This may also be due to the fact that there are funders to please and careers to protect and so rocking the boat too much might jeopardize future funding and commissions. While the vision of the artist parachuting in to save the day might be replaced by a more complex understanding of the process of art being harmful, unhelpful, and perpetuating problems rather than overcoming them, the dominant public-facing narrative of funded commissions is often one of positivity, celebration, and plenty of

happy faces. Socially engaged art commissions are not grass-roots actions, if anything, they might provide 'invited' spaces but these are legitimate forms of behaviour which are 'sanctioned by donors and government interventions' (Miraftab 2004: 4). It is difficult, I would argue, for the commissioned project to become an 'invented space' where 'grassroots actions are characterized by defiance that directly challenges the status quo' (Miraftab 2004: 4). While there may be desires and motivations to dismantle the existing structural systems, this is not always the objective of socially engaged art projects which often result in methods of surviving those systems rather than overthrowing them (Miraftab 2004: 3, 4). By linking past critiques of community arts practice to contemporary commissioning practices, I have explored how these projects relate to government policies which reward artists for work with other people. The warning signs of professionalizing community arts practices were there in the 1970s and 1980s but have been buried under piles of evaluations and best practice toolkits. Today, practices of socially engaged and community arts continue with increasingly sophisticated modes of justifying them as engaging, critical, and significant. And yet it is the messiness and uncertain surprises that keep these projects from what Braden and Kelly feared – of being entirely co-opted and removed from the politics of the people and places they spring from. The projects remain locked into these structures that require certainty and yet rely on an 'aimless praxis' (Jelinek 2013: 159) of chance encounters and occurrences which continue to undermine and contradict the conditions in which they are made.

References

AIR. 2013. Yellow Feedback Forms from *This Is for You*, June 2013. Unpublished.

Anonymous. 2014. Notes by S. Hope from Audio Recording of Conference '1979 Revisited: The Cultural Production of "Structures of Feeling" under Thatcherism' (University of London: Birkbeck, 21 November 2014).

ArtWorks. 2015. *Creating the Conditions for Change*, Available at http://www. artworksphf.org.uk/evidence/creating-conditions-change/ (accessed 6 September 2015).

Baldry, H. 1974. *Community Arts in Great Britain* (Arts Council of Great Britain: London).

Bauman, Z. 2007. *Liquid Times: Living in an Age of Uncertainty* (Polity Press: Cambridge).

Berman, E. 1983. Interview with Ed Berman. *Another Standard*, Spring, 7–9.

Between You and Me. 2015. Social Art Map Timeline Notes by Sophie Hope. Unpublished.

Braden, S. 1978. *Artists and People* (Gulbenkian Foundation: London).

Brugnach, M. et al. 2008. 'Toward a Relational Concept of Uncertainty: About Knowing Too Little, Knowing Too Differently, and Accepting Not to Know', *Ecology & Society*, 13 (2): 30. http://www.ecologyandsociety.org/vol13/iss2/art30/ (accessed 16 December 2016).

Cartiere, C., and S. Willis. 2008. *The Practice of Public Art* (Routledge: New York).

Cartiere, C., and S. Hope. 2007. *A Manifesto of Possibilities: Commissioning Public Art in the Urban Environment* (LCACE and Birkbeck: London).

Chisenhale Gallery. 2014. A discussion on 12 July 2014 chaired by Andrea Phillips; with Edward Thomasson; Wendi Sheard, Hadrian Garrard and Laura Wilson at the Chisenhale Gallery looking at the process of commissioning The Present Tense and Thomasson's 18 month residency. Available at http://chisenhale.org.uk/audio_video/media.php?id=58 (accessed 6 September 2015).

Crickmay, C. 2003. '"Art and Social Context": Its Background, Inception and Development', *Journal of Visual Art Practice*, 2: 3.

Dolk, M. 1982. 'Special Supplement: Aspects of Socially Engaged & Community Art', *Art Network*, Summer/Autumn.

Druiff, E. and S. Hope. 2015. 'Social Art Map. An In-depth Study of 5 Art Commissions from 3 Perspectives'. Available at www.socialartmap.org.uk (accessed 9 March 2016).

Evans, B. and J. Reid. 2014. *Resilient Life: The Art of Living Dangerously* (Polity Press: Cambridge and Malden, MA).

Froggett, L., A. Roy, R. Little, and L. Whittaker. 2011. 'New Model Visual Arts Organisations & Social Engagement'. Psychosocial Research Unit, University of Central Lancashire. Available at http://clok.uclan.ac.uk/3024/1/WzW-NMI_Report%5B1%5D.pdf (accessed 9 March 2016).

Hawkins, G. 1993. *From Nimbin to Mardi Gras: Constructing Community Arts* (Allen & Unwin: Sydney).

Jelinek, A. 2013. *This Is Not Art: Activism and Other 'Not-Art'* (I.B. Taurus: London).

Kay, S. 2012. *ArtWorks: Learning from the Research. Working Paper 1* (Paul Hamlyn Foundation: London).

Kelly, O. 1984. *Community, Art and the State: Storming the Citadels* (Comedia: London).

Kester, G. 2004. *Conversation Pieces. Community and Communication in Modern Art* (University of California Press: Berkeley, Los Angeles and London).

Kwon, M. 2002. *One Place after Another. Site Specific Art and Locational Identity* (MIT Press: Cambridge).

Lacy, S. 1994. *Mapping the Terrain* (Bay Press: Seattle).

MacDonald, A. n.d. Containing the end of *This Is for You*, a site specific performance (Unpublished).

Merkel, K. 2009. Telephone Interview with Sophie Hope, January.

Miraftab, F. 2004. 'Invited and Invented Spaces of Participation', *Wagadu*, 1: 1–7.

Mitchell, C., S. Spencer, and A. Lockwood. 2012. Academics' perceptions of arts work in participatory settings: a report on research carried out as part of ArtWorks North East, University of Sunderland.

Money Distribution Machine. 2015. Social Art Map Timeline Notes by Sophie Hope. Unpublished.

Moriarty, G. 2014. 'Where Have We Come From?' Community Arts to Contemporary Practice. Available online: http://communityartsunwrapped.com/page/2/ (accessed 6 September 2015).

This Is for You. 2015. Social Art Map Timeline Notes by Sophie Hope. Unpublished.

This Used to Be Fields. 2015. Social Art Map Timeline Notes by Sophie Hope. Unpublished.

Tomkins, A. 1984. 'The State and Public Cultural Policies'. *Another Standard*, Spring, 22.

Walker, W.E. et al. 2003. 'Defining Uncertainty. A Conceptual Basis for Uncertainty Management in Model-Based Decision Support', *Integrated Assessment*, 4 (1): 5–17, http://journals.sfu.ca/int_assess/index.php/iaj/article/view/122 (accessed 6 September 2015).

Werker 10. 2015. Social Art Map Timeline Notes by Sophie Hope. Unpublished.

Winnicott, D. 1971. *Playing and Reality* (Tavistock: London).

Cultural Democracy: Developing Technologies and Dividuality

Owen Kelly

Introduction

In this chapter I want to argue that the impetus that fuelled the original community arts activists did not die, but rather lives on in a number of surprising ways. I also want to argue that we can continue to build upon its ideas and work, and to apply them to our changed and changing circumstances.

I will make this argument in several steps. I will begin with a (very) brief overview of the beginnings of the Community Arts Movement in order to locate it in time and space. I will point out some of its theoretical underpinnings, insofar as it had any. (Many community artists believed that we should concentrate on building a 'broad church', and we should therefore 'do' instead of 'debate'.) I will then look at some of the changes that have occurred in Britain and elsewhere in the last thirty years; changes that we might regard as solving some of the problems that community artists posed. I will look, for example, at ways in which we might argue that technological developments have rendered the ideas of community artists obsolete.

I will then look at some important developments in the cognitive sciences and ask how these impact on our ideas of community and individuality, before suggesting that the notion of *dividuality*, a concept that draws many of these ideas together, serves both to substantiate the claims that community artists made thirty years ago and to act as a rallying call for a reinvigorated movement in the twenty-first century.

A very short personal history

The Community Arts Movement came into being retrospectively, by which I mean that it began when a number of people noticed that their interests and work aligned and overlapped, and looked for a label to describe their common interests. It had at least three distinctive starting points in the work of alternative arts labs, disillusioned artists, and creative activists.

The Arts Lab movement began when Jim Haynes opened the original Arts Lab in Drury Lane in London in 1967. Within a year, UFO and Middle Earth had opened in London and similar arts labs had begun operating in Birmingham, Brighton, Cambridge, Halifax, and Liverpool. The Arts Lab lasted for two and a half years and, as Jim Haynes noted in his final newsletter, it

> was many things to many people: a vision frustrated by an indifferent, fearful, and secure society; an experiment with such intangibles as people, ideas, feelings, and communications; a restaurant; a cinema; a theatre (Moving Being, Freehold, People Show, Human Family, etc.); underground television (Rolling Stones at Hyde Park, Isle of Wight, Dick Gregory All-Night Event); a gallery (past exhibitions include Yoko Ono & Lennon, Takis, et al.); free notice boards (buy/sell, rides to Paris); a tea room; astrological readings; an information bank (tape, video, & live-Dick Gregory, Lennie Bruce, Michael X, Michael McClure …); happenings (verbal and otherwise); music (live and tape including The Fugs, Donovan, Leonard Cohen, Third Bar Band, Shawn Phillips, Kylastron, etc.); books, magazines, and newspapers (Time Out, IT, SUCK, OZ, Rolling Stone); information. (Haynes 1969)

Jim Haynes had previously helped to found the Traverse Theatre in Edinburgh and, thus, also in some ways, represented the second thread that began community arts: the growing number of formally trained artists who had become disillusioned with the traditional gallery and performance systems, and sought to move beyond what they perceived as their limitations. Cornelius Cardew, for example, had been a leading British avant-garde musician and composer since he served as Stockhausen's assistant at the end of the 1950s. He formed the Scratch Orchestra in 1968 but abandoned it in 1972 to produce deliberately political music and became part of People's Liberation Music. David Harding served as town artist for the Scottish new town Glenrothes from 1968 to 1978, where he created public art under a contract that stated that he should 'contribute to the external built environment of the town' (Harding 2005). When Harding left his post, Glenrothes appointed Malcolm Robertson to succeed him. He served as town artist from 1978 to 1990.

In London, Jamie McCullough created Meanwhile Gardens, a project that began when he crossed

> the bridge over the Grand Union Canal near Westbourne Park Station. Looking down, he saw a long, narrow strip of wasteland between the canal and the road running parallel to it. In his mind's eye he began to re-shape it, using a bulldozer for hands. There would be an open air theatre, a skateboard rink, allotments, trees and flower beds, boats and boat building, and … he pulled himself up short. Yes, there would have to be a bulldozer and someone must make a start. But he also saw that for the dream to come to life, it would need to be the local people's creation, to build, develop, maintain and manage. (Richard Mills in McCullough 1978: iv)

The third thread came out of the growing political and social movements such as Release that attempted to incorporate creativity into radical struggle. Release was founded in 1967 by the artist Caroline Coon and Rufus Harris, who had studied painting at Saint Martins. They also organized concerts on Sundays at the Round House, north London, called Implosion, which operated as a charity to support the 'alternative society'. Implosion ran from June 1969 to October 1973.

Out of this trio of overlapping interests, the Community Arts Movement began to emerge in the early 1970s. My personal involvement began with my voluntary work at South Island Workshop, a young people's arts workshop based near the Oval in Lambeth, which grew into a part-time job, which in turn drew me to the Association of Community Artists (ACA), led at that point by Maggie Pinhorn of Alternative Arts and Martin Goodrich from Free Form.

Not everyone who called themselves community artists engaged in the same kind of practice. Some people were directly working with tenants. Some people printed or painted and loaned their skills to radical campaigns. Some people documented and some people investigated. In the beginning we had two things in common. We all shared a series of beliefs about why we did what we did, although we sometimes expressed them in different language. We needed each other to develop our ideas, and so we networked. This formed the strength of the ACA. We began to form informal groupings as we realized that we had potential friends and allies.

My involvement deepened when Dermott Killip, Kevin Nessling, and I founded Mediumwave in Brixton in 1978. In the next twelve years, we worked regularly with Cultural Partnerships, FreeForm, and Paddington Printshop in London; with Jubilee Arts in Sandwell, as well as groups like Radio Doom from Liverpool and Valley & Vale from Wales.

Mediumwave grew out of a series of long conversations between Dermott, Kevin, and me, in which we tried to work out what a community arts group should do, and how it could best do it. We decided that people faced systemic problems in communicating their own beliefs and feelings in the face of a powerful and dominant set of industrialized media, and that we would help best by trying to develop community communication tools that worked in practice while, at the same time, fostering theoretical ideas about how communication might become a democratic process. This led us to explore a number of different avenues.

We created photography projects based around pinhole cameras and plate cameras. Partly inspired by Terry Dennett from Photography Workshop, the originators of Camerawork, who had led photography sessions at South Island Workshop, we created a template pinhole camera that we screen-printed onto card. We calculated the focal length and exposure times of these cameras, and we could therefore use exposure metres to produce controlled images. In this way, we moved beyond introducing people to the idea of taking and developing their own images to looking at the kinds of images they could produce. For us, pinhole photography created a consensual photographic practice. You could not 'capture' an image of someone with a pinhole camera, because they had to agree to stand still for one or more minutes in order to produce a recognizable image (cf. Kelly and Killip 1981). We used this technique to reflect on the narrow range of images that the media industry used and to propose alternatives.

To show these photographs, and to distribute them around community centres in Lambeth, we designed and built One Square Yard, a mobile stand three feet by three feet that maximized the amount of display space, while requiring very little time or skill to assemble. It fitted in even the smallest public space. We used this to document community events in ways designed to make them feel important, glamorous, and worthy of pride. For a large bonfire party in Brockwell Park, for example, we collaged and hand-tinted large over-exposed monochrome images that both worked as visual art and served to stimulate local discussion.

When Portastudios became cheaply available, we established Contagious Tapes, a local music and performance collective, which used an extremely cheaply built recording studio in Brixton. We duplicated and released thirty-eight cassettes from a variety of singers and musicians and then sold them at performances and by mail order. Both the weekly music magazines, *Sounds* and *NME*, reviewed them. The thirty-five tapes Contagious released sold between 10 and 800 copies each.

During this period several people left and joined Mediumwave. Dermott Killip left to work with the GLC and Greater London Arts, and Hania Janiurek and Henry Iles arrived. It became clear to us that technology was developing in ways that would give communities forms of power over their own communications that they had never had before. Portastudios cost approximately £500 and offered four-track recording previously available only on an hourly basis in professional studios. Desktop publishing began to replace roneo-style duplicators and offered a similar increase in quality. More and more it made sense for community groups to raise funds to purchase their own equipment rather than rely on ours. Increasingly, we taught people how to use their own equipment and then left them to it.

We continued to edit and produce *Lambeth Arts*, a regular magazine documenting local arts activity, and *Another Standard*, the magazine of the Association of Community Artists. We devised The Y Library, an open online digital library for cultural activists. Hania Janiurek moved to New York in order to establish The Y Library as an international project, but unfortunately, we had had the idea four or five years too early and it failed. When we spoke to funders and investors about bulletin boards and the inherent power of internet-based communication, they had no idea what we meant. We had attempted to use bulletin boards for a project that would seem simple common sense once the world wide web had entered people's lives.

At this point, Lambeth Council wanted us to return to offering travelling art-based workshops on adventure playgrounds, while we felt that we had discovered, through several years of experience, that this did not work. We knew that we needed to build relationships with playleaders and teenagers before turning up to set up a darkroom or plug in an Apple Macintosh, otherwise the event lacked any kind of context and served only as a meaningless diversion. The local authority itself had gone through many changes and the new staff appeared to want us to adopt a service role with little apparent concern about what these services might achieve.

We therefore ended Mediumwave by announcing that we would apply for no more funding. We did this because we felt that we had completed the task we had originally set ourselves. The theoretical ideas that fuelled our work still remained in force. We did not believe that we had solved any of the underlying issues that they pointed to.

We had worked with three ideas at the heart of our work: the dangers of radical monopoly, the liberating power of accepting collective authorship, and the need to find ways of establishing cultural democracy.

Radical monopoly: The dangers of exclusive control

Ivan Illich coined the term 'radical monopoly' to describe 'the dominance of one type of product (or service) rather than the dominance of one brand' (Illich 1973: 35). He suggested that this occurs whenever 'one industrial production process exercises an exclusive control over the satisfying of a pressing need, and excludes non-industrial activities from competition' (Illich 1973: 5). He first proposed this idea in *Tools for Conviviality*, where he used the example of the highway system in Los Angeles which, he claimed, had reshaped the city so that travel by foot or bicycle had become impossible. Designers had rebuilt the city with the automobile in mind with the result that walking to the shops or walking to work had become impossible for almost everybody. The automobile had, therefore, moved from being a luxury item that enables people to travel further, faster, or in more comfort, to become a necessity without which people became disenfranchised.

Illich claimed that radical monopolies represent a mode of social organization beyond that of simple capitalism; even where they seem to form part of a capitalist system. A radical monopoly does not merely serve demands that have an independent existence. It also begins to shape the demands that it claims to service. Asserting that it represents the only feasible solution to a social problem, it rapidly becomes the only feasible solution. Illich suggests that this process has remained invisible in large part because we act as though we want 'politics to be concerned with the distribution of maximum industrial outputs, rather than with equal inputs of either energy or information' (Illich 1973: 5). He argues that the conventional option

> leads to specialization of function, institutionalization of values and centralization of power and turns people into the accessories of bureaucracies or machines. The second enlarges the range of each person's competence, control and initiative, limited only by other individuals' claims to an equal range of power and freedom. (Illich 1973: 12)

This process has occurred not only in the manufacturing of goods and the designing of cities but also in the creation of culture. Nothing about the invention of sound recording in 1877 by Thomas Edison, or the demonstration of long-distance radio communication by Guglielmo Marconi about twenty years later, made the arrival of disc jockeys inevitable. Disc jockeys came into being through cultural and not technological processes. They arose as part of the process of centralization that occurred as culture became subject to the same

mass-produced industrial processes as frozen foods. States claimed ownership of the airwaves and granted monopoly licences to access these scarce resources. Broadcasters needed to fill up airtime and playing pre-existing music proved an inexpensive option. Radio disc jockeys proved a cheap way of differentiating one stream of broadcast recordings from another, especially when different stations broadcast the same music.

Collective authorship: The genius of groups

During the 1950s and 1960s, and into the 1970s, the Arts Council of Great Britain (ACGB) acted energetically as a promoter of one particular radical monopoly. It promoted the idea of the artistic canon, the Great Tradition, which viewed all cultural activity as existing within a hierarchical tree structure, like an organizational chart for a large corporation. Only the activities at the top of the tree deserved support, for they constituted 'real art' of national and historical significance. The lower activities might amuse people, might attract audiences, but they did – and could – not enlighten them as the proper arts did. This view allegedly stemmed from the book *The Great Tradition* by F.R. Leavis, in which he claims that real art opens the recipient to an 'awareness of the possibilities of life' (Leavis 1948: 2). Leavis' book begins by declaring that 'the great English novelists are Jane Austen, George Eliot, Henry James and Joseph Conrad'. This note of dogmatic certainty set the tone for the decisions of policymakers and led to lengthy arguments about topics such as whether we could ever consider photography an art, or should view it as a mere craft. These arguments carried forward a late nineteenth-century Social Darwinism that led easily to the view that European culture began in ancient Athens and now stood taller and more highly developed than any other cultures in the world; and that all cultures aspired to the greatness of Shakespeare or Beethoven, but no other culture had succeeded. From this perspective, Indian and African cultural works held an anthropological interest, and might serve as amusing diversions, but we could not claim that they had the same capacity as the works comprising *The Great Tradition* to open us to an 'awareness of the possibilities of life'. The Arts Council argued that cultural activity existed within a natural hierarchy, and in an article published in *Arts Today*, Roy Shaw explicitly stated that we should be prepared to recognize that 'a first class performance of *Twelfth Night* is a more valuable experience than a first-class performance by Billy Connolly' (Shaw 1985: 27).

Community artists, almost by definition, opposed this mode of thinking. We agreed with Raymond Williams that 'all that is gained by an arm's length is a certain notion of removal of directly traceable control' (Williams 1979: 166). We argued that the Arts Council took the tastes of one small group, the group with their hands on the levers of the state, and then presented them as the natural cultural tastes of civilized people everywhere. Indeed, community artists regarded the whole idea of individual genius as mistaken at best, and a deliberate trick at worst. As I have written previously,

> The idea of 'individual' creativity, removed from social influences and springing whole from some secret internal landscape, is a deception. It is advanced at the expense of social co-authorship because, crudely speaking, it is bad for business. The mysterious genius which is alleged to lie behind 'individual' creativity has twin advantages. Firstly it creates what are, by definition, scarce resources, which can be bought and sold for profit. The notion of genius effectively prevents the intellectual marketplace from being flooded with cheap goods. Secondly, the idea of rare genius creates, in the minds of those who have not been told they have it, a feeling of inferiority. This feeling of lacking something makes them willing and eager to consume the products of the genius of others, in whatever packages it is sold. This is neither coincidental nor wholly unplanned. It is just one example of the way the high-intensity market operates within an advanced capitalism. (Kelly 1984: 65)

We believed that creativity arose from within groups and that all art, even allegedly individual activities such as novel writing, arose from within the social interactions of the author.

Cultural democracy: A necessary assertion

This difference manifested itself in an apparently arcane battle over terminology. At the time, many community artists regarded this battle as irrelevant to the practical work, the 'real work', but it ended up defining that work to its detriment. The battle might have seemed arcane, then, but it turned out to have a fundamental strategic importance. The Arts Council, under the leadership of Roy Shaw, talked about 'arts for everyone' as they attempted to respond to accusations of elitism. They talked about the need for a democratization of culture. Community artists, on the other hand, talked about the need for cultural democracy. The difference in phrasing marked a sharp difference in beliefs. In an article in *Arts Express* answering Roy Shaw, I wrote that

'Arts for All' does not begin to address the problems that the *Great Tradition* poses, if we take the idea of multi-cultural democracy seriously.

The idea of cultural democracy represents an attempt by a wide group of people to address these issues. We argue that what is needed is a genuine cultural pluralism, in which the idea of a 'scale of values' is replaced by the idea of many localised scales of value, arising from within communities and applied by those communities to activities they individually or collectively undertake.

We argue that people should have rights of access not just to cultural outputs, but to the means of cultural input. In a complex democracy, common meanings should be created democratically or, at the very least, the means by which they are created should be open to democratic scrutiny and available for democratic decision. (Kelly 1985: 18)

The argument that we made asserted that culture formed a necessary part of society and that a politics that ignored this would remain incomplete. The Shelton Trust, the charitable arm of the Association of Community Artists (discussed in detail in Chapter 2), inaugurated a campaign for cultural democracy and hosted a series of regional events. We also tried, with some success, to place the idea on the agenda of trade unions with whom we worked.

Technology: Shifts in the cultural landscape

Our struggles with the Arts Council over the ideas and values of cultural democracy occurred at a time when an influx of new inventions looked set to change the landscape in which we worked. The 1980s saw an influx of radical new technology that answered, or appeared to answer, some of the main issues that community artists had been addressing. We faced miniaturization, the changed roles that this gave consumers and producers, an unprecedented change in the speed with which technology developed, the arrival of personal computers, and the rapid spread of the world wide web.

These began with the drive to miniaturization. Sharp had introduced the first commercial pocket calculator in 1969. Ten years later, Sony introduced the Walkman which ended the location-bound nature of music, and changed the way that people used music. Miniaturization also created a rise in semi-professional media production. As mentioned before, the new Tascam Portastudio, first introduced in 1979, enabled a wave of bands to home-tape themselves with professional results – and then to self-release their albums on cassette. The distinction between producer and consumer begins to blur

whenever the costs of production come down. In 1980 the futurist Alvin Toffler, who had coined the phrase 'future shock', invented a term for this: 'prosumer' (Toffler 1984). He predicted that the roles of producer and consumer would begin to merge; and that users would begin to generate their own content.

The arrival of digital computing increased both the speed of this change in many areas – and the magnitude of its social effects. At the end of 1972, Atari had released the first arcade game and Magnavox had introduced the Odyssey, a games console that played through your television. In the early 1980s, people started buying home computers such as the ZX Spectrum and the Commodore 64. On these, one person – working or playing on her own – could program games and applications. So computer gaming began as another area where users generated their own content – and self-published it. Programmers and users formed part of the same prosumer communities.

Although many people began to attach their computers to the Internet and make use of email and bulletin board, life online achieved mass popularity after the adoption of the world wide web, beginning in 1992. At this point, many technological determinists declared that a new age had begun, and that most, if not all, of our cultural problems had ended. Stewart Brand, the founder of the Whole Earth Catalogue, famously declared that 'information wants to be free' (Brand 1987: 202). John Gilmore, the fifth person employed by Sun Microsystems and a long-time digital activist, announced that 'the Net interprets censorship as damage and *routes around* it' (see Elmer-Dewitt 1993), implying that totalitarianism had become suddenly impossible.

Looking back, we can see several common threads in these stories. In each case, a technological innovation lowers the entry cost to a method of production, and activists then begin blurring the line between production and consumption. Activities that previously required specialist knowledge and equipment now become available to everyone. In 1985, for example, West London Media Workshop reported on how ecstatic people became when they saw themselves on a television screen, and realized that they could make audiovisual statements themselves. Thirty years later, twelve-year-olds can create their own YouTube channels and upload videos of themselves in the realistic hope that they will garner millions of viewers.

Many have concluded from this that some or all of the issues that community artists addressed have now been solved by advances in technology. Roneo-ed newsletters have given way to Facebook pages, video workshops have disappeared in the age of mobile phones and tablets, the need for photography exhibitions and film showings in community halls have been replaced by

YouTube, Vimeo, Flickr, Instagram, and so on. (We might note in passing that the belief that censorship has become impossible seems to have faded away in the light of revelations about mass surveillance that the net has most certainly not 'routed around'.)

This kind of furore has happened in every electric medium from silent movies to the web. In each case, this turns out differently from the way the cheerleaders promise. Radical change seems possible for a short time, and during that period many things *do* change, but after a short while industrial corporations find ways of reasserting their dominance, or new industrial corporations arise in their place.

At the start, when nobody knows how a new medium is supposed to work, there is a space for innovation. In each case that space closes after a short period, as formats become traditions and audiences learn to demand what they have come to expect. Facebook has, for many people, come to define what they understand and mean when they talk about social media, and the interactive cut and thrust of discussion forums and bulletin boards has been replaced by the mass broadcasting of cute lowest-common-denominator memes. We have come to define social as meaning the quantity of cat videos and 'life-affirming' slogans that we consume each day.

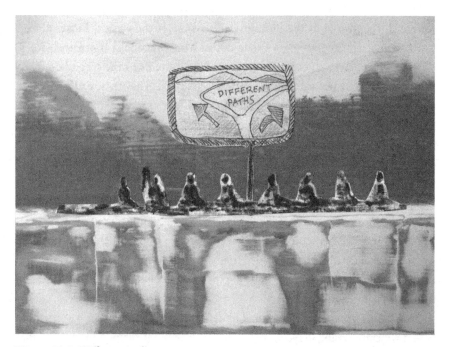

Figure 11.1 Different paths

Centres of narrative gravity: Being us

Anyone living through the last thirty years would have found it difficult to avoid noticing the technological developments and the social changes they brought about. Computers and mobile phones have changed social norms and rendered public behaviour visibly different. However, the growth of consciousness research and the lessons we can draw from this remained much less obvious, since it received comparatively little publicity. Among other things, it corroborates much of what community artists believed and did. I now want to discuss briefly some of the major implications of this work, before I attempt to show its direct relevance to the beliefs and ideas of community artists.

Several experiments conducted in the 1970s and 1980s indicated that our views about ourselves contain fundamental flaws. We think less than we think we do, and our consciousness does not contain a single coherent narrative but rather a number of contending and contradictory impressions that we arrive at retrospectively. I will briefly sketch just two of the most important examples.

In 1976, Paul Kolers and Michael von Grünau created *The Color Phi* experiment (see Dennett 1991: 114–15). In this, subjects looked at a screen. A dot appeared briefly at the top left corner of a screen, and shortly after, a second dot appeared at the bottom right corner of the screen. Most subjects viewing this reported seeing a single dot moving diagonally down the screen. Kolers and von Grünau then coloured the first dot red and the second dot blue. When they asked the subjects to describe in detail what they had seen, they claimed that the dot had abruptly changed colour *in the centre of the screen.* How did they know it was going to turn red and not green or yellow; and how did their brains know that the dot they thought they could see moving would change colour at all?

In 1983, Benjamin Libet, a researcher in the physiology department of the University of California, decided to try to determine the time that a subject becomes consciously aware of their decision to move a finger (see Dennett 1991: 154–67). He asked his subjects to move a finger at a time of their own choosing, and to say exactly when they decided to make the movement. To his surprise and dismay he found that, first, our body begins to act; second, we 'decide' to act; and third, we perform the bodily action.

The Color Phi experiment seemed to demonstrate that we observe something before we can possibly have seen it. Libet's experiment seemed to indicate that we act before we decide to act. Taken together they formed part of a wider set of

findings, all of which seem to suggest that people have a very wrong impression of how their minds work. (I have written about these experiments and their consequences for our view of ourselves in much more detail elsewhere [Kelly 2015: 133–70].)

The American philosopher Daniel Dennett has suggested that the only sensible way to deal with these results begins with taking them at face value and then dealing with the logical and philosophical consequences (Dennett 1991). He suggests that we can best view consciousness as an abstraction like the word 'voice', and not as an object of any kind. When I claim that I have lost my voice, I do not intend people to go looking for it. I mean to suggest that the various parts of my body that usually enable me to speak do not work properly at the moment. I have a throat and vocal cords and they make a characteristic set of sounds. My voice does not exist in addition to these; rather, I use the word 'voice' to describe their total effect.

Dennett also suggests that we should regard all thoughts as retrospective judgements. When we ask ourselves what we can see around us, our brain collects a mass of data and tries to assemble it into a plausible narrative. Once we have this story then we use it to tell ourselves what we have seen. This explains the colour phi effect. When Kolers and von Grünau asked their subjects to describe what they had seen, they assembled their experience from the sensory data and memories at hand. Crucially, they assembled their experience after the event, not during it.

Following from this, Dennett claims that we do not have a continuous consciousness. We do not think as often as we think we do and we don't retain static memories. Rather, our memories are reconstituted and reconstructed every time we think of them. Our memories also form stories that we tell ourselves; stories that can change in their retelling as our current needs and desires change. He suggests that we would do better to think of ourselves not as possessing a unified consciousness but rather as *centres of narrative gravity*.

Putting these together: what it is like to be human, is to be stories all the way down. Our sense of consciousness arises from the sum total of all the narratives we have taught ourselves, from external and internal sources, and all the multiple narratives that other people have taught us. That in turn underlines the fact we live and behave as social animals before we come to believe that we exist as separate individuals.

In 1989, in *The Selfish Gene*, Richard Dawkins proposed that we could view Darwin's idea of genetic evolution as one example of a large class of possible replicators, and he proposed that 'we need a name for the new replicator, a noun

that conveys the idea of a unit of cultural transmission, or a unit of imitation' and coined the word 'meme'. He proposed that memes

> are tunes, ideas, catch-phrases, clothes' fashions, and ways of making pots and building arches. Just as genes propagate themselves in the gene pool by leaping from body to body via sperms and eggs, so memes propagate themselves in the meme pool by leaping from brain to brain by a process which, in the broad sense, can be called imitation. (Dawkins 1976: 207)

Since Dawkins first proposed this hypothesis, Susan Blackmore has investigated memes in considerable detail, building up a theory that suggests that not only do our ideas originate socially, rather than within our separate heads, but that their transmission occurs socially. We do not, as we often imagine, have ideas in fits of isolated inspiration. Instead ideas arise in the social spaces between us and spread by infecting suitable candidates. We are stories all the way down in a media landscape of our own historic devising – a landscape that we have learned to treat as though it is an external force.

This landscape includes the proto-medium language, the memes that humans have enabled through language, the tools humans have developed through spreading memes, up to the mass media and social media within which we currently tell and listen, send and receive. Knowing that we are social animals that have learned the trick or the skill of pretending to be separate individuals, we can turn ourselves round and attempt to co-author rather than to be authored; to act as communal narrators with regard to our views of ourselves, our relationships, and our place in our lived world.

Knowing that life is a communal play, we can choose to step up to play our part in authoring the play. And, knowing what is actually going on, we can devise tools to better equip ourselves to do all this, which neatly encapsulates everything that community artists set out to achieve from the moment they first recognized themselves as a movement.

Community, art, and dividuality

The above discussion suggests that women give birth to little mammals who become socialized into human beings; that from the very beginning this socialization takes the form of joint and collective activities (first mother and child, then parents and child, then local adults and child); and that only later, at the age of three or four, does the child develop the theory of mind that enables

them to play at being an individual; and only later still do they come to mistake the play for 'reality'.

It would be much more accurate to say that we live our lives, not entirely as individuals but, much of the time, as *dividuals*. The anthropologist Chris Fowler says that in 'a dividual state a person is full of potential, and is plural' (Fowler 2004: 21). This term was coined by McKim Marriot, professor of anthropology and social sciences at the University of Chicago and, as Fowler noted,

> sidelining the individual is not an attempt to dehumanize the past but to better illustrate how human beings may be situated in the world and recognize that human experience internalizes features of that world in a highly significant way. (Fowler 2004: 86)

This idea also appears in African cultures. The idea of *Ubuntu* has been translated as 'A Person Is a Person Through Other People'. This encapsulates more or less the same idea as I have been proposing: that we arrive in the world as animals and become people through social interaction. Michael Onyebuchi Eze has pointed out that this

> suggests to us that humanity is not embedded in my person solely as an individual; my humanity is co-substantively bestowed upon the other and me. Humanity is a quality we owe to each other. We create each other and need to sustain this otherness creation. And if we belong to each other, we participate in our creations: we are because you are, and since you are, definitely I am. The 'I am' is not a rigid subject, but a dynamic self-constitution dependent on this otherness creation of relation and distance. (Eze 2010: 190–1)

The ideas that powered the Community Arts Movement are not 'communist', or even 'socialist' at heart; rather they spring from a different and more active view of human beings and society. This view suggests that we literally make each other up. As Raymond Williams wrote, 'In this form of thought, the ground of human nature is common; the "individual" is often a vain or eccentric departure from this' (Williams 1976: 162).

The process of industrialization broke this apart for only in the nineteenth century did 'the phrase "an individual" – a single example of a group – [become] joined and overtaken by "the individual": a fundamental order of being' (Williams 1976: 163). As we move from the industrial age to an information age, in which agencies like Facebook and technology like mobile phones change everything from our sense of space and time to our relationship to concepts like privacy, we will find an increasing need, once again, for dividuality and dividual

relations. And we will find that this has lain at the heart of the community arts project all the time.

Conclusion

In this short chapter, I have tried to trace a route from the beginnings of the Community Arts Movement to the present day. My purpose has been to look at whether we should, in retrospect, regard community arts as a temporary fad like flared trousers or glam rock, or whether it still has something to offer the world in the early twentieth century.

Certainly many of the specific challenges it addressed have been met by technological developments and the social changes that have accompanied them. Few people today require the intervention of a trained professional to make and edit a campaigning video and upload it to the web. The underlying reasons for the work remain, however. To the surprise of only a few, Facebook and YouTube have not delivered cultural democracy but have, instead, promulgated an updated radical monopoly in which teenagers dream of 'going viral', and people consume endless videos of other people falling over in a way that, for them, defines social media. The democratic web that John Perry Barlow dreamed of has started growing into another area of mass consumption.

Community artists worked towards building tools for collective creativity, and a social awareness of the possibilities inherent in this. In the last thirty years, advances in consciousness research have served to strengthen their case. The concept of *dividuality* enables us to locate our core theoretical ideas within a larger current, while providing us with a solid reason for believing in the soundness of our ideas and their continuing relevance.

The battlegrounds have shifted a few miles, but the battle continues.

References

Brand, S. 1987. *The Media Lab: Inventing the Future at MIT* (Viking: New York).

Dawkins R. 1976. *The Selfish Gene* (Oxford University Press: Oxford).

Dennett, D.C. 1991. *Consciousness Explained* (Little, Brown & Co: New York).

Elmer-Dewitt, P. 1993. 'First Nation in Cyberspace', *Time International*, 49, 6 December.

Eze, M.O. 2010. *Intellectual History in Contemporary South Africa* (Palgrave Macmillan: London).

Fowler, C. 2004. *Archaeology of Personhood* (Routledge: London).

Harding, D. 2005. *Glenrothes Town Artist 1968–78*. Available at http://www .davidharding.net/article12/index.php (accessed 17 April 2015).

Haynes, J. 1969. 'Newsletter 01, 28th Oct 1969'. Available at http://www.jim-haynes .com/letters/index.htm (accessed 10 October 2015).

Illich, I. 1973. *Tools for Conviviality* (Marion Boyars: London).

Kelly, O. 1984. *Community, Arts & the State* (Comedia: London).

Kelly, O. 1985. 'In Search of Cultural Democracy', *Arts Express*, October, 18, 19.

Kelly, O. 2015. *Ambient Learning & Self Authorship* (Aalto University Press: Helsinki).

Kelly, O., and D. Killip. 1981. 'The Second Photography: Cameras as Convivial Tools', *Camerawork*, no. 22: 16–19.

Leavis, F.R. 1948. *The Great Tradition* (Faber and Faber: London).

McCullough, J. 1978. *Meanwhile Gardens* (Calouste Gulbenkian Foundation: London).

Shaw, R. 1985. 'Can a Million Flowers Bloom?' *Arts Express*, August/September, 25–27.

Toffler, A. 1984. *The Third Wave* (Bantam: New York).

Williams, R. 1976. *Keywords* (Fontana: London).

Williams, R. 1979. 'The Arts Council', *The Political Quarterly*, 50 (2): 157–71.

Conclusion: Opening a New Space
for Cultural Politics

Alison Jeffers and Gerri Moriarty

*If we look back over recent centuries, the successes are truly spectacular, and
we ought to keep reminding ourselves of them, and of the incomprehension, the
confusion, and the distaste with which the proposals for things now the most
ordinary parts of reality were received.*

Raymond Williams, *The Long Revolution* (1961)

*It's like someone has put down a big piece of carpet over an allotment and a
few little things have come up through the pinholes in the carpet. There may be
other stuff waiting down there that we can't see yet.*

Nigel Leach, community artist

In 1983, historian Shelia Henderson compared the Community Arts
Movement with feminism, suggesting that the feminist movement, despite
its diversity which contained conflict and disagreement, had nevertheless
opened up a new space for sexual politics (Henderson 1983). The world
can be understood in a different way because of feminism despite its many
different interpretations and manifestations. We suggest that a similar claim,
albeit on a smaller scale, could be made for the Community Arts Movement
and that this book goes some way towards supporting this. Despite its
diversity as a movement and lack of agreement on many issues, community
arts nevertheless opens up a new space for cultural politics and fresh ways of
thinking about culture and how to practise the arts. Community artists were
and are interested in changing how people encounter and experience art,
shifting it towards the vernacular and everyday, a tool for communication,
expression, and protest. Following a discussion of the role of dissent and
the tactics of dissent in opening a new space for cultural politics, we frame

our findings within the outcomes of a research event, 'Unwrapping Hidden History', which took place in the summer of 2015. We conclude by reflecting on some contemporary practices, using the main terms of the debate that has threaded its way throughout this book – the relationship between culture, democracy, and the right to make art.

The rhetoric of dissent

We have concluded that community artists in the 1970s and early 1980s are best understood not through the figure of the revolutionary, as has sometimes been suggested, but of the dissenter. This is the person 'standing on the mat in front of the automatic doors – insisting that the door [keeps] opening' as Clare Higney wrote in her report on community arts and the trades union movement (Higney 1985). In the words of comedian and activist Mark Thomas 'An Act of Dissent is a simple way of saying, No, I do not accept this [...] It is a rebuttal of the thin end of the wedge' (Thomas 2015: 8). For Raymond Williams, the dissenter is a figure 'who, though he cannot reverse the trends, keeps an alternative vision alive' (Williams 1961: 376). Dissent is 'a mainstay – not a luxury, a nuisance, or a malfunction of democratic governance' and 'without dissent, there is no democratic polity of adversaries and thus no politics, only forced unity and unmitigated enmity' (Ivie 2005: 279). Dissenters may be accused of disloyalty, especially in moments of crisis, but they are actually loyally providing a 'constructive influence [and] a safeguard against simplistic thinking' (Ivie 2005: 279). Robert L. Ivie is thinking on a much larger scale about the role of dissent in a democratic society in the post-9/11 United States, but his ideas about the strategies used by dissenters are relevant here. Despite the fact that community arts as a recognized, discrete, living movement has passed, the ideas of cultural democracy that underpinned it have been kept alive into the twenty-first century by dissenting voices.

Dissenters operate largely through rhetoric 'deliberating or demonstrating, debating or protesting' and, in examining what he calls 'the rhetorical heuristics of dissent', Ivie draws attention to De Certeau's thinking on tactics and strategies (Ivie 2006: 79). Strategy is available to those with the 'symbolic and material resources' to initiate and defend it, while tactics are 'mobile operations devised and executed by a weaker party to oppose the strategies of the stronger opponent' (Ivie 2006: 80). Community activist Saul Alinsky, who was influential in the development of community arts in the 1970s (Badder 1983), writes that 'tactics

means doing what you can with what you have. Tactics are those consciously deliberate acts by which humans live with each other and deal with the world around them' (Alinsky 1989: 126). In the rhetoric of dissent, tactics include 'the turns or tropes, figures, arguments, and other tricks of speaking and operating that undermine the powerful' (Ivie 2005: 281).[1] Rhetorically, changes in thinking can be achieved by manipulating speech to produce a 'jarring effect of fresh perspective by means of planned incongruities and linguistic impieties' or juxtaposing 'conventionally contradictory terms in order to revise their relative value and to suggest new ways of acting and seeing' (Ivie 2004: 30). One example of this tactic can be seen in the very naming of the term 'community arts'. Although it has become unremarkable and, in many ways, is disappearing from our cultural landscape, at the time of its conception the name must have jarred in its combination, being used to describe the apparently incongruous pairing of these two phenomena – community and art.

We have thus far made no explicit mention of the images that have been created for this book by Jennifer Williams which operate in this way. Jennifer worked with the speech of the artists who were interviewed for this book to create a series of illustrations that pay very close attention to the metaphors

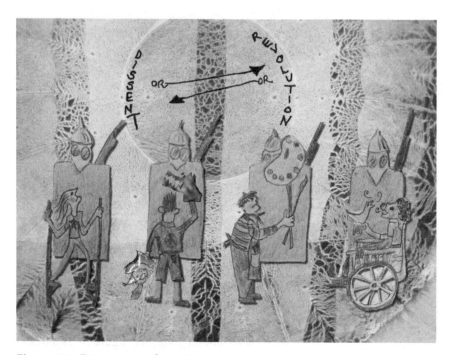

Figure 12.1 Dissent or revolution?

and other turns of speech used by artists to describe the early days of the Community Arts Movement. The images that she has produced create a sense of familiarity, partly because they are based on phrases that readers might recognize. However, in illustrating them the metaphor behind them is revealed which generates a slightly jarring quality, asking the reader to reconsider the apparently familiar. Jennifer's method of populating everyday recognizable backgrounds with slightly disquieting little human figures is a tactic which invites readers to shift their perspective by stopping to think about how to interpret these common phrases in relation to the ideas explored throughout the book.

We offer two further examples to show how the rhetoric of dissent operates on a tactical level. Both use the everyday, low-tech method of hand-painted placards manipulated by a group of people. The first example, already cited in Chapter 3 by Gerri Moriarty, involved an act of dissent on behalf of community artists against the hegemony of traditional artistic values epitomized at the time by the Arts Council. She describes how a group of community artists held up placards where they could be seen from the Arts Council offices in London with the composite image showing a rose with blood dripping from its thorns surrounded by dandelions on one side of the cards. When they turned them around, the other side proclaimed 'Never Mind the Roses', alluding to the so-called centres of artistic excellence, and 'Fund the dandelions' referring to community arts. Another example using similar tactics was offered by Graham Marsden who worked at Telford Community Arts and this involved working with a group of local women to create a dissenting message for the Queen. Hearing that she was visiting Telford in the early 1980s, they made a composite image of placards that said 'God Save the Queen' on one side, 'all regal purple, beautifully lettered with a red, white and blue border', which they held up as the Queen's car approached. As the car went past, they turned the cards to show the slogan 'God Help Telford's 1 in 5 jobless' (Marsden 2010). Both of these dissenting acts used rhetorical tactics to make their point: the ubiquity of an everyday weed juxtaposed with the decadent individualistic rose to draw attention to inherent unfairness of imbalanced support for different sorts of art; a piece of political opportunism designed to send a message, not just to the Queen but to the media who the participants hoped would pick up on the story – which they did. The demonstration and final placard image being used to close coverage of the royal visit, and being shown on all three ITN news bulletins that day, with a combined viewing figure of 18 million (Marsden 2010).

Historical and contemporary space for dissent

As part of the research for this book in the summer of 2015, we staged an event at the University of Manchester which brought together five community artists who had worked in the 1970s and early 1980s with five artists who are currently working in community, participatory, or socially engaged art.[2] The rationale for this aspect of the research was to give artists the opportunity to work through practice and to actively explore some of the similarities and differences between the early days of the Community Arts Movement and a range of community, participatory, or socially engaged arts practices today. We will use the activities and the discussions that came out of this event as a way to shape the conclusion to this book, examining ideas about dissent then and now. All quotations used in this section arise from the artists who took part in that event and we have tried to attribute these where possible.

It was in the political arena where artists felt the work had changed most. Many agreed with Kuljit 'Kooj' Chuhan that community arts now feels more formulaic because funders and sponsors of the work need 'outcomes' which makes it very difficult to 'experiment or allow participants to take a lead'. Chris Charles suggested that community artists are 'having to hunt for the funding to keep the work going and in doing that they adapt to the agenda of the funder rather than the communities they're working with to keep afloat'.[3] Some artists agreed with Kooj Chuhan that the work felt more constrained and less organic than it appears to have been in the past when he stated that 'the work now is very instrumental in that it targets so-called marginalized people and is about meeting specific outcomes. It seems to me that in the past there was more freedom to veer away from the original objectives'.[4] For some, this lack of flexibility places a lot of strain on the artist but, more importantly, makes it difficult to build up strong partnerships with the community groups with whom they work. For Cathy Mackerras, 'There is a lack of clarity about what constitutes participation. What now constitutes authorship and who is in control?'[5] The overt leftist politics of many community artists is much less in evidence now and there is much less sense of 'going against the grain'. The ways in which community arts activity has become co-opted to become what Kooj Chuhan called 'a useful tool for certain outputs that large institutions want' was frequently commented upon.[6]

There was a strong sense that work in contemporary participatory arts was more compatible with the democratizing culture paradigm whereas the Community Arts Movement had pursued the cultural democracy model. Discussants felt that there was nothing inherently 'wrong' with participatory

arts but that this kind of work was incompatible with those artists who wanted to look actively at social change and injustice. Cathy Mackerras pointed out that

> in my understanding, there is a big difference between participatory and community arts and it's important to separate them. Participation, which is in no way a bad thing, just to make that clear, has become widely accepted and mainstream in some ways and is a good opportunity and is creative and empowering and is positive. But my understanding of community arts, and why I went into community arts, was that it was about authorship and whose hands does authorship lie in? Community arts is about people who have not had the opportunity to express their point of view, their experience, what they want to say and that is not the same thing as participation. You can have a great time participating in music, dance, drama, anything, but it's about whether it actually says what you want it to say. Community arts is about the process of working with a group of people, developing a shared understanding of something, refining your ideas and all that and to me that's what the community arts movement that I belonged to was about. I think you can't put participatory and community arts together.[7]

Kooj Chuhan agreed that the key to many of the differences between community and participatory art was authorship and how 'responsibility as a community artist is about helping people to develop an understanding and analysis of their own situation which is a bit more than just helping people to "find a voice". That's not an easy thing to do and it's always a challenge and the space to do this is becoming smaller'.[8]

One big difference for community artists working now is the ways in which they correspond to the communities within which they operate. For Cathy Mackerras, the importance of living where the work took place was of central importance. 'We were based in a geographical community – namely housing estates and neighbourhoods of the new town – where there was some common interest around health issues and women's issues, lots of common issues. One of the things at the moment is that artists tend to work within communities of interest rather than geographical communities'.[9] These communities of interest tend to be clustered around health, disability, and citizenship and, as such, the arts work tends therefore to be focused on these issues. Issues of class, poverty, and inequality have moved down the agenda since the 1970s. Even then, as the artists from that period frequently noted in the research, discussions about class were often couched in euphemistic terms that talked about working with 'communities' or with 'ordinary people'. Cathy Mackerras felt that it was not that class as an issue was avoided but that, because artists were living in specific

communities and responding to local needs, 'in a sense we didn't have to use class terms because it was self-evidently the way we were working'.[10] Nevertheless, the move away from working in identifiable geographically bounded communities entailed a move away from what might be called class politics and towards a politics of identity that has characterized the more interest-driven work since the 1990s.

Technologies and resources for dissent

In the age of the internet and new multimedia technologies such as Snapchat and Facebook, it might be assumed that there have been dramatic changes in the art forms and techniques used by those artists, non-professional artists, and communities who choose to work together to make art. Indeed, all the practitioners who attended the event in Manchester acknowledged the impact of new technology on how they went about making work, but perhaps more significantly on how they documented and disseminated work. For example, an activity which characterized the work of many early community arts organizations – the printing of campaign posters for radical organizations and community groups – is now a rarity. As Rick Walker commented, 'Why run a poster campaign when you can organize an online petition and a Facebook event?'[11] This trend is picked up by both Kelly and Bennett in this book; the means of making films, music, and visual arts and of documenting performance have been placed within the reach and means of many more people than in the 1970s and new digital platforms, such as Comma Press's McGuffin, National Theatre Wales' online community, and Battersea Arts Centre's Scratch, which support creative collaborations and the dissemination of products and creative proposals, are developing at a rapid pace. The impact of rapid technological change was seen as both a positive and a negative by artists at the Manchester event; Chris Charles commented that 'working with technology feels like a great "leveller" because participants will often know a lot about how to do things, and so bring a certain amount of their own perspective into projects'.[12] Kooj Chuhan observed that

> there is a better knowledge of what is out there in the world, but also an ability
> to indulge in a very narrow experience and understanding of that. I think we
> all have internet fatigue from the jaw-drop triggering and shallowness of media
> saturation and this makes it difficult to get a fresh perception on realities and
> power structures.[13]

In many other regards, the similarities between the technologies and techniques used by artists of the 1970s and early 1980s were greater than the differences. It was relatively easy, for example, to pair artists up according to a shared art form; on this occasion, we chose drama, print, film, and textiles and, if more resources had been available, other art forms such as music, writing, and visual arts could also have been represented. The concept of 'the workshop', as discussed in Chapter 2, gave all of the artists a common starting point; no one queried what was meant by the event being based on this format and everyone had an immediate shared sense of what was expected, about the rhythms of a workshop activity, and about what could be achieved in the time available. Rick Walker, who had worked at Greenwich Printshop in the 1970s, visited printer Sally Gilford's print shop in preparation for the day and noted that the setup was very similar to the print shops he had been familiar with in the 1970s except for the absence of the familiar smell of the solvent-heavy inks that were used at that point. Contemporary practitioner Karishma Kusurkar observed that not only did she and Graham Marsden, who had started work in the 1970s, share an interest in textiles but they were both concerned with questions of identity and non-traditional ways of storytelling.

The majority of the artists involved had also helped to found small organizations or businesses, both in the 1970s and in the present, which suggests a high degree of entrepreneurial ability and a determination to find a way to meet identified social and cultural needs. Rhiannon White says of the company she co-founded in 2008, for example,

> it was during the time of the recession that we created Common Wealth [...] we were frustrated because we thought that we didn't fit into normal theatre and actually what about theatre for people who come from similar backgrounds to us? It didn't exist [...] so we created a theatre company that was for socialists and for working class people and for people who didn't think that it belonged to them.[14]

Community arts practitioner and maker Tom Thompson's view, based on his experiences in the 1970s and 1980s, displays a similar sense of determination:

> I've always felt that resources are never a problem. I know that sounds a very odd thing to say but I believe that the difficulty is in getting the enthusiasm for something and once you've got the enthusiasm, you'll find ways of getting the money whether it's begging, borrowing, stealing or getting somebody to give you a grant. I believe it's infinitely possible to do that and I don't know whether

that's still the case today. I think it's probably harder today but I still think there are ways and means.[15]

Deep cuts to UK public sector budgets mean that it is indeed more difficult to identify the resources to support this work than it would have been in the past. Artists commented that companies that could rely on anything up to 50 per cent of their income coming from subsidy in the past were now lucky to receive 6 or 7 per cent in this way. Many small arts organizations are adopting a mixed economy model, where commercial earning capacity enables some of their socially engaged artwork to take place and there is more reliance on private trusts and foundations and on National Lottery funding. For individual practitioners, the change has been even more fundamental as Graham Marsden explained, 'the whole funding structure has changed. It requires the people who are funding you to share the understanding and the vision of what community arts can do rather than bringing in an artist to commodify, or to decorate an event'.[16] Alternatively, it is possible to see ways in which continued reliance on one source of funding may have made community arts vulnerable to specific agendas and that spreading support across a range of sources has enabled those community artists who have a strongly developed sense of their own purpose and practice to maintain more autonomy. It is also the case that different supporters of the work bring different constituencies to community arts which involves encounters with different ideas and practices as new areas are explored.

New spaces for dissent

While political, economic, social, and technological factors have changed considerably in the last four decades, two of the philosophical questions which lay at the heart of community arts practice – what *is* the purpose of art? and who has the right to make art? – continue to resonate and inspire artists, often with interesting consequences. The binary model of cultural democracy, coming from the grass roots and supported primarily by organizations that were outside the mainstream, and the democratization of culture paradigm located primarily in the large cultural institutions which extended 'access to cultural works to mass audiences who do not have ready access to them for lack of income or education' (Evrard 1997) is blurring. Lyn Gardner, one of the very few mainstream critics to have taken the time to consider community-based arts practices, has identified what she calls 'marriages of convenience' between theatres and community

groups and contrasted these with 'projects that bring theatre-makers and community groups together as genuine co-creators'.[17] The questions raised by community arts practice help to explain the nature of the difference and provide a spectrum against which to discuss and evaluate contemporary practices. There are a number of locations where we might observe this reduction in the gap between cultural democracy and the democratization of practice and we offer a few here.

Some of the UK's larger cultural organizations are currently redefining their purposes; for example, Battersea Arts Centre, which began life in 1974 as a community arts centre, has redefined its mission from 'invent the future of theatre' to 'inspire people to take creative risks to shape the future'. Its artistic director, David Jubb, writes: 'Our definition of theatre and what it can achieve has become much broader. Battersea Arts Centre's new mission recognises that we not only make theatre but that we use it to create change. It recognises that we are not only an arts organisation, we are also a learning organisation and a social change organisation.'[18] Amgueddfa Cymru National Museum Wales aspires to be an 'activist museum'; over the next three years and building on its existing experience, it intends to build deep connections with community partners and communities in order to nurture community agency and develop new models of shared authority. A key part of National Theatre Wales' strategy is to be embedded in the communities of Wales and TEAM, its open access network of 1,000 members from across Wales and 23 countries worldwide, collaborates with NTW, creates work in their own communities, gives feedback to the company, and helps it make decisions about the future.[19]

Smaller organizations and individual artists often still lead the way in demonstrating how art can contribute to social change, with some referencing the same cultural influences that inspired practitioners in the 1970s and 1980s. Despite the reservations of community artists in the 1970s about some of the work of Joan Littlewood (discussed in Chapter 2), an example of this is the development of her Fun Palaces; its manifesto reads: 'We believe in the genius of everyone, in everyone an artist and everyone a scientist and that creativity in community can change the world for the better. We believe we can do this together locally with radical fun – and that anyone, anywhere, can make a fun palace.'[20] Another example might be Virtual Migrants, whose 'Next Breath' project presented a series of single-screen video works, audio works, live collaborations, and an interactive work based on collaborations with local artists and people in Glasgow, Derby, West London, and Plymouth offering intimate portraits and reflections on asylum and refuge. One of Virtual Migrants artists,

Kooj Chuhan, spoke at the Manchester event of his company's intent: 'we're not just simply allowing people to represent, or "give voice" to what they feel and experience, we're after something that gets to what creates this situation in the first place'.[21] There are echoes here of Cathy Mackerras and Graham Woodruff's ambitions, co-founders of Telford Community Arts, who said in 1978, 'It is our belief that community arts activities should aim towards a situation where everybody's right to artistic expression is recognized, where people participate in all the creative and decision-making processes involved, and ultimately, where they control and are responsible for their environment and the issues that affect their lives' (Lane 1978).

Some places continue community arts activities perhaps through acts of collective memory. Helen Crummy prophetically, and correctly, declared of the Craigmillar Festival: 'It is still buried in the Criagmillar psyche – buried in the psyche. One day, it will flower again'.[22] Toxteth in Liverpool might be another example: following projects like the one described by Cilla Baynes in Chapter 2, Free Form helped to set up the Granby Street Festival, one of the first multi-cultural festivals in Liverpool in the 1970s. Toxteth is now the home of the Granby Workshop, a social enterprise and contemporary arts project which won the 2015 Turner Prize for Assemble, an art, architecture, and design collective whose practice 'is interdependent and collaborative, seeking to actively involve the public as both participant and collaborator in the on-going realization of the work'.[23]

As these contemporary examples illustrate, in order to dissent, you have to know both what you are dissenting from and have a sense of what you are proposing as an alternative. This is the way in which community arts opens up a new space for cultural politics. The praxis of community arts provides a measure, or a benchmark for dissent, against which it is possible to assess the myriad projects and programmes that now claim to 'involve the public' or 'engage communities'. Thinking about questions of access and participation through the lens of community arts opens up a series of important questions that must be asked of all projects that place access or participation at their centre. Does access to cultural facilities, resources, and practices opened up for people through projects and programmes remain open after these finish or close down in the longer term? What is the nature of the participation on offer – is it peripheral, engaged, or core? In what ways is the work being co-authored or co-created? Who makes what decisions and to what extent is there shared authority? If we take on the idea of cultural theorist Stuart Hall that culture is a 'critical site of social action and intervention, where power relations are both established and

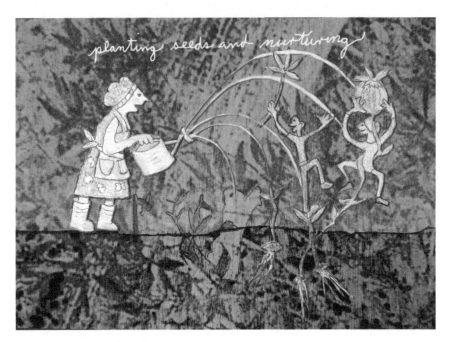

Figure 12.2 Planting seeds

potentially unsettled' (Hall qtd. Procter 2004: 16), to what extent, is this taking place in the work under consideration?

During the interviews with community artists working in the 1970s and early 1980s, we were continually struck by the number and range of horticultural metaphors being put to use to describe the work at that time, the opening quotation from this chapter being a case in point. This is the case as the artists look back at the work today, but if we think back to the rose and dandelion story in Chapter 3, we can appreciate that the language of seeds and growth was important at the time. Throughout the research, we have considered metaphors as 'a way of knowing' (Nisbett qtd. Sandelowski 1998: 378) and have been concerned to take them seriously because we believe that 'using a metaphor is a serious theoretical exercise' (Becker qtd. Sandelowski 1998: 379). Metaphors have provided a strong organizing principle and a way to talk about this complex, hard-to-define, often contradictory, frustrating, and dissenting activity that has been, and is, community arts. Of course, it has not been possible to cover the entire scope and practice of community arts, past or present, but we hope that this book might bring this under-researched practice to light, thereby contributing to the ongoing conversation about the relationship between people and art. By bringing a body of work that has been neglected and misunderstood into the

public arena, we hope that readers will be able to make their own connections to similar bodies of work in the present, and in other times and places. Not only that but, to echo the words that opened this chapter, we hope that being aware of the questions that community arts grappled with during its lifetime will influence the projects that might emerge from the seeds yet to germinate.

Notes

1 James Thompson draws attention to this in the cognate field of applied theatre (Thompson 2009).

2 This project was supported by the Paul Hamlyn Foundation and the University of Manchester. The artists were paired up according to the art form that they usually worked in – film and video, textiles, making, drama, and print – and asked to plan and run a workshop with a small group of people. The participants for these workshops came from a range of cultural organizations in Greater Manchester and all had past experience of being involved in community arts projects. The brief was deliberately open, so that the artists could decide, for example, whether one would run the workshop with the other supporting or they would co-deliver the workshop; our only stipulation was that the thirty-five participants, who were contributing their time to help our experiment, would enjoy the workshop and find the experience valuable. All the artists were interviewed during the day (in their art-form pairs) about their experiences of working together with questions specifically addressing similarities and differences between historic and contemporary practices. The day ended with a facilitated discussion with practitioners and students which enabled everyone to review key themes and issues emerging from the experience.

3 Charles, Unwrapping Hidden History, July 2015.

4 Ibid.

5 Mackerras, Unwrapping Hidden History, July 2015.

6 Chuhan, Unwrapping Hidden History, July 2015.

7 Mackerras, Unwrapping Hidden History, July 2015.

8 Chuhan, Unwrapping Hidden History, July 2015.

9 Mackerras, Unwrapping Hidden History, July 2015.

10 Ibid.

11 Walker, Unwrapping Hidden History, July 2015.

12 Chuhan, Unwrapping Hidden History, July 2015.

13 Ibid.

14 White, Unwrapping Hidden History, July 2015.

15 Thompson, Unwrapping Hidden History, July 2015.

16 Mackerras, Unwrapping Hidden History, July 2015.

17 https://www.theguardian.com/stage/theatreblog/2015/jun/25/why-every-artist
 -should-be-a-community-artist (accessed 1 July 2016).

18 https://batterseaartscentreblog.com/2015/05/25/a-new-mission-for-battersea-arts
 -centre-and-our-next-steps/ (accessed 1 July 2016).

19 Amgueddfa Cymru National Museum Wales' successful application to PHF More
 and Better fund (access given privately to GM) https://nationaltheatrewales.org
 /team (accessed 1 July 2016).

20 http://funpalaces.co.uk/about/ (accessed 8 July 2016).

21 Chuhan, Unwrapping Hidden History, July 2015.

22 Plum Films, 'Arts the Catalyst: The Craigmillar Story', https://vimeo.com/52005912
 (accessed 1 July 2016).

23 http://assemblestudio.co.uk/?page_id=48 (accessed 1 July 2016).

References

Alinsky, Saul D. 1989. *Rules for Radicals* (Vintage Books: New York).

Badder, Alan. 1983. 'Alinsky Tactics', in *Friends and Allies. The Report. Salisbury, 22–24 April 1983*, 6 (The Shelton Trust: London).

Evrard, Yves. 1997. 'Democratizing Culture or Cultural Democracy?' *The Journal of Arts Management, Law and Society*, 27: 167–75.

Henderson, Sheila. 1983. 'Firmly Within History', in *Another Standard*, 20–21 (The Shelton Trust: London).

Higney, Clare. 1985. *Not a Bed of Roses. Arts Development Officer in the Trade Union Movement* (The Gulbenkian Foundation: London).

Ivie, Robert, L. 2004. 'Prologue to Democratic Dissent in America', *Journal of the European Institute for Communication and Culture*, 11: 19–35.

Ivie, Robert, L. 2005. 'Democratic Dissent and the Trick of Rhetorical Technique', *Cultural Studies Critical Methodologies*, 5: 276–93.

Ivie, Robert, L. 2006. 'Academic Freedom and Antiwar Dissent in a Democratic Idiom', *College Literature*, 33: 76–92.

Lane, John. 1978. *Arts Centres. Every Town Should Have One* (Paul Elek: London).

Marsden, Graham. 2010. Interview with Alison Jeffers and Gerri Moriarty.

Procter, James. 2004. *Stuart Hall* (Routledge: London and New York).

Sandelowski, Margarete. 1998. 'Writing a Good Read: Strategies for Representing Qualitative Data', *Research in Nursing and Health*, 21: 375–82.

Thomas, Mark. 2015. *100 Acts of Minor Dissent* (September Books: London).

Thompson, James. 2009. *Performance Affects: Applied Theatre and the End of Effect* (Palgrave Macmillan: Basingstoke).

Williams, Raymond. 1961. *The Long Revolution* (Pelican: London).

Index